Discriminating Sex

THE ASIAN AMERICAN EXPERIENCE

Series Editors
Eiichiro Azuma
Jigna Desai
Martin F. Manalansan IV
Lisa Sun-Hee Park
David K. Yoo

Roger Daniels, Founding Series Editor

A list of books in the series appears at the end of this book.

Discriminating Sex

White Leisure and the Making of the American "Oriental"

AMY SUEYOSHI

In solidarity and struggle,

August 2019

UNIVERSITY OF ILLINOIS PRESS
Urbana, Chicago, and Springfield

Publication of this book was supported by the College of Ethnic
Studies at San Francisco State University.

Library of Congress Cataloging-in-Publication Data
Names: Sueyoshi, Amy Haruko, 1971– author.
Title: Discriminating sex : white leisure and the making of the
 American "Oriental" / Amy Sueyoshi.
Description: [Urbana] : University of Illinois Press, [2018]
 | Series: The Asian American experience | Includes
 bibliographical references and index. | Identifiers: LCCN
 2017031738 (print) | LCCN 2017058305 (ebook) | ISBN
 9780252050268 (e-book) | ISBN 9780252041785 (hbk :
 alk. paper) | ISBN 9780252083259 (pbk : alk. paper) | ISBN
 9780252050268 (ebk)
Subjects: LCSH: Sex role—California—San Francisco—
 History—19th century. | Marginality, Social—California—
 San Francisco—History—19th century. | Leisure—
 California—San Francisco—History—19th century. | Chinese
 Americans—California—San Francisco—History—19th
 century. | Japanese Americans—California—San Francisco—
 History—19th century.
Classification: LCC HQ1075.5.U6 (ebook) | LCC HQ1075.5.U6 S84
 2018 (print) | DDC 305.309794/61—dc23
LC record available at https://lccn.loc.gov/2017031738

For Tina Takemoto,
without whom I would never have found happiness

Contents

Acknowledgments

Discriminating Sex first took form in 1998 while I was a graduate student at University of California, Los Angeles. At the time, it was still considered somewhat radical if not foolish to consider a project at the intersection of Asian American studies and sexuality studies. As I scrambled to find colleagues willing to work with me, I also struggled to create a narrative that felt empowering for queers in its critique of white racism and heteronormativity. In 2002 I took a six-year hiatus from the project to publish what would become my first book, *Queer Compulsions*, which more clearly drew out the existence of Asian American queers in turn-of-the-century San Francisco. While the narrative did not end happily, its publication freed me to acknowledge what has been all along the central argument of the present work—whiteness and its ramification on Asian Americans even in "wide open" San Francisco. Without a doubt it is always less pleasurable for ethnic studies scholars to dedicate themselves to researching whiteness rather than empowerment among communities of color. Yet through this project I have come to embrace the power of unveiling white supremacy, particularly where it is not readily visible. While we can all recognize burning crosses in the front yards of Black families as an act of terror against African Americans, it may be less easy to see how the forging of gender and sexual freedom among middle-class whites can directly produce racial repression.[1] To that end, I hope that *Discriminating Sex* can keep us mindful of how our own efforts to forge pleasure might disenfranchise others. Indeed, as America becomes increasingly

"minority majority," a population in which people of color outnumber whites, the challenge will turn toward how we, people of color, treat each other as we gain more access to resources and power.

I must first thank Janice Reiff, Laura Edwards, and the late Miriam Silverberg for courageously taking on this project when no others would. Michael Salman graciously stepped in to assist in the final hours when Miriam Silverberg became ill. Daniel Lee and Stacey Hirose patiently read the earliest iterations of this project when I had not yet formulated an argument. Valerie Matsumoto generously gave me her unused copy cards. Librarians at the History Room at the San Francisco Public Library dedicated countless hours to answering compounding inquiries and pulling endless shelves of boxes. More recently, gender-studies faculty and graduate students at Indiana University, Bloomington, made suggestions to the manuscript as it neared its final form. REGC, a philanthropic giving circle of Asian Pacific Islander queer women and transfolks in the San Francisco Bay Area, graciously funded the final stage of this project. I thank Renae Moua and Tina Takemoto, who meticulously proofed the manuscript before I sent the final copy to University of Illinois Press.

My greatest debt of gratitude goes to San Francisco State University, where I have grown tremendously as a teacher, scholar, and, more recently, administrator. Here, colleagues, staff, and students in the College of Ethnic Studies and Sexuality Studies committed to social justice and community organizing have never questioned the value of my work or my personhood. Perhaps only at SFSU could a gender queer of color live relatively peaceably and thrive professionally. Finally, I thank my mentors Tomás Almaguer, Kenneth P. Monteiro, Lane Hirabayashi, and Peter Boag for providing unfailing support and critical feedback as I finalized the manuscript.

Discriminating Sex

Introduction

At the turn of the twentieth century, a particular fever swept across San Francisco. Couples in alarming numbers brazenly locked lips underneath lampposts and on park benches. "Osculatoria insectivorata," or the "kissing bug," had struck the city.[1] Divorce, too, climbed precipitously. And crowds filled theaters where young boys impersonated little girls and white women crooned "Negro" love songs to their "choc'late" girlfriends.[2] *The First Born*, a play on Chinese sexuality, sold so many tickets that the revenue patched the Alcazar Theater's nearly $20,000 debt.[3] Residents seemed to revel in a cesspool of immorality, doing whatever they wanted without concern for decorum.[4] In 1900 Sadie Brown proclaimed, when police found her in an opium den, that Chinese men made better husbands than white men.[5] Two years earlier, football player Nora Sullivan fled from the field when her disapproving mother showed up at her game in hopes of institutionalizing her.[6] A jumble of public expressions and pronouncements of gender and sexuality appeared to confirm turn-of-the-century San Francisco's reputation as a "wide open town," a liberated community of people able to act on their own desires, as well as an "international city," a municipality that knew how to live with its racially diverse inhabitants.

However, a mountain of sex acts that often traversed boundaries of race and gender testified to more than just the power of individual will in a magnanimous

city that seemed to embrace all. They cohered to tell a provocative tale of misogyny and white supremacy. Writers, illustrators, and city commentators avidly discussing new freedoms in middle-class gender and sexuality framed white women as provocateurs while fueling racialized characterizations of particularly the Chinese and Japanese. San Francisco would be neither as wide nor as open as many have presumed.

Discriminating Sex details a city immersed in playful contestations of gender and sexuality in newspaper reports, cartoons, short stories, novels, theater, and popular songs just as its Asian population underwent historic shifts. The city's population of Chinese had dropped dramatically by the end of the nineteenth century, after federal immigration restrictions in 1875 and 1882 had ostensibly halted the entry of Chinese women and men into the United States. Japanese men then had just begun arriving in significant numbers. Asians would occupy center stage in public debates throughout the nineteenth century. Reporters, writers, and illustrators engaged in shaping San Francisco's cultural norms relied on Chinese and Japanese imagery to animate the city's desires around gender and sexuality as well as race and immigration. As critics expressed concern over high rates of divorce and attributed it to the "modern" woman, representations of Japanese women flooded the city as symbols of "traditional" femininity. When San Francisco obsessed over its sexual excess, newspaper reports, short stories, and theatrical productions specifically pathologized Chinese women as evil prostitutes destroying morality. Moreover, barbarous Chinese men and artfully feminine Japanese men represented competing ends in the debate over appropriate middle-class masculinity. These discussions took place in a largely good-humored culture of public discourse, even as social conservatives fretted more imminent moral doom.

Lighthearted representations that enhanced San Franciscans' leisure lives with humor and scintillation would take on significant implications for Asian America. Representations of Chinese and Japanese would produce stereotypes compelling to San Franciscans since they served as a mirror for prevailing mainstream shifts in gender and sexuality. While sexually charged diverging characterizations of Chinese versus Japanese initially signaled how the city distinguished one from the other, they immediately began to merge. *Discriminating Sex* thus details how white middle-class cultural movements to forge gender and sexual fulfillment in turn-of-the-century San Francisco initially distinguished Chinese from Japanese and then discriminated against both communities in the cultivation of a pan–Asian American stereotype—a single image of the "Oriental" laden with gender and sexual meaning.

San Francisco

From 1900 to 1924, remarkable growth defined San Francisco. The population increased by almost 50 percent from 342,782 to 506,676. The city, as the center of banking, finance, and economic prosperity for the West Coast, drew hundreds of thousands of migrants looking for opportunities. The 1897 discovery of gold in Alaska, the Spanish–American War, the rebuilding after the 1906 earthquake and fire, the establishment of a municipal railway, and the Great War all facilitated San Francisco's rapid expansion.[7] The census counted 95 percent of the population as "white" in the first decade of the twentieth century. Among them, 74 percent were foreign-born or children with foreign-born parents. In 1920, still 66 percent of the white population came from immigrant households. Germans, Irish, and Italians made up the majority of San Francisco's foreign-born population. Chinese, Japanese, and African Americans respectively represented significantly smaller percentages, never rising above 2 percent, 1 percent, and 0.4 percent of the general population. The census at the time counted Mexicans and other Latinos as "white," though discriminatory practices treated them as nonwhites in their daily lives.[8]

Single young men dominated the city that encouraged a freewheeling culture of adventure that included sexuality. Droves of men first descended on San Francisco in hopes of getting rich during the Gold Rush in the late 1840s.[9] Decades later, the city continued to remain more male than female in its population. Women made up 43 percent to 46 percent of the general population between 1900 and 1920. Among communities of color, the ratio of men to women remained more disparate. In 1910, for example, women respectively only made up 10 percent, 18 percent, and 37 percent among Chinese, Japanese, and African American communities. While 70 percent of America's Asian population lived in California, gross numbers of Chinese and Japanese certainly remained miniscule.[10] In the same year, the U.S. census also counted fifty-six American Indians in San Francisco, of whom eighteen were women.[11]

With so few actual Asians in America, characterizations of Chinese and Japanese relied heavily on the active imagination of writers, illustrators, and actors who likely never had any meaningful interactions with Asians. They built productive careers as "expert" ethnographers of "Oriental" people and culture on topics most relevant to themselves and their readership rather than any Chinese or Japanese reality. These racialized productions centrally defined the city's leisure culture, a "cultural frontier," according to historian Barbara Berglund, that solidified the city into a civilized, hierarchical American metropolis. As San Franciscans

produced images of Asians for their own amusement, Chinese and Japanese became the single "Oriental" in American imagination. This Asian hypervisibility driven by San Francisco's particular Asian obsession would come to restrict Asian American lives in significant ways.[12]

San Francisco Histories

Discriminating Sex departs from the existing scholarship on San Francisco not only in its focus on intimacy and desire but also in its particular placement of the expansion of white gender and sexuality as central in race building in America. Turn-of-the-century San Francisco histories focus on the city's incredible growth and its unscrupulous city politics. A growing laboring class developed into a powerful political force by 1920.[13] Publications addressing communities of color in San Francisco employ racism motivated by white sociopolitical and economic interests as the primary lens of analysis in the racial formation of communities of color.[14] My work may most closely mirror Clare Sears's work on laws banning crossdressing in nineteenth-century San Francisco. She argues that these legal prohibitions did more than just construct normative gender, but in fact reinforced inequalities broadly. *Discriminating Sex* adds to Sears's work by asserting that movements for gender and sexual freedom, rather than restriction, additionally propagated racial inequality in turn-of-the-century San Francisco.[15]

While earlier scholarship on Asian American representation in San Francisco has detailed a virulently racist, unchanging genealogy of anti-Asian images, more recent critics examining representations nationwide have asserted that characterizations are diverse, changing, and at times contradictory for the purpose of negotiating white anxiety rather than solely as an act of anti-Asian animosity.[16] *Discriminating Sex* relies on these developments in literary and cultural studies to underscore how depictions of Chinese and Japanese in fact did not stay the same within a twenty-year period, at times taking on completely opposite meaning even in a single city. As a historical work, *Discriminating Sex* works to impose a linear logic on what has become all-too-familiar representations, linking them to broader historical movements in gender and sexuality. Without a doubt, the sexualization of racial subjects is historically contingent. Historian Deborah Gray White placed the origin of characterizing the African American woman as the lascivious Jezebel or the loyal Mammy specifically in pre- and post-Emancipation print culture, when Southern whites hoped to justify the rape of African American women and the benevolence of slavery as a familial institution.[17] Thus, as timeless as racial stereotypes such as the Oriental geisha-prostitute might appear, *Discriminating Sex* in fact ties the origins of these characterizations to specific moments in the history of U.S. gender and sexuality.

Disciplinary Framing (Historiography)

Histories of nineteenth-century American urban leisure culture form the foundation of this work. Many of the earlier works, such as those by Roy Rosenzweig, Kathy Peiss, and Eric Lott, have focused on the formative role of the working class, in part as a push-back against long-held beliefs that anything of significance in terms of "leisure" or "culture" originated in the middle and upper classes. *Discriminating Sex* in its argument most closely parallels Lawrence Culver's more recent work on the development of white middle-class leisure in Southern California as dependent on the labor of people of color.[18]

Within gender and sexuality studies, this book builds on the work of feminists such as Lynn Gordon, Christine Stansell, and Elaine May, who have cited the turn of the twentieth century as a period of increasing possibilities for women in America. Additionally, Susan Stryker, Jim Van Buskirk, Lou Sullivan, and Roger Austen have specifically pointed to gender and sexual transgressors—those one might call "queer" in the twenty-first century—as active players in San Francisco more than a hundred years ago.[19] Publications in queer studies, such as those by David Halperin, Michael Warner, and Judith Halberstam, underscore the radical potential of defying norms of sexuality, gender, and appropriate behavior. By centralizing gender and sexuality as a cultural force that produced racializing discourse in San Francisco, I shed light on how gender and sexual liberation can be directly tied to racial denigration.[20]

My work additionally nods to whiteness studies in its assertion of how pursuits of white pleasure and freedom incited the popularization of Chinese and Japanese stereotypes that have become a defining feature of the Asian American experience today. While most publications such as those by Karen Brodkin, Noel Ignatiev, and Thomas Guglielmo address how ethnic whites "became white" or were already "white on arrival," my project aims to foreground Asians and recenter gender and sexuality in whiteness studies. By detailing gendered and sexualized representations that distinguished Chinese from Japanese in the 1890s, this work aims to clarify how Asians *came* to look alike in the American imagination in the 1900s for the enrichment of white leisure. This argument mirrors George Lipsitz's assertions on how the accrual of white material wealth came at the expense of communities of color, yet diverges from his work in its taking up culture as the central point of inquiry.[21]

Literary critics and cultural theorists often point to the instability of whiteness and existing gender and sexual norms as provoking anxiety and inciting projections onto racialized others such as Asians.[22] I, however, assert that stability in existing hierarchies in fact facilitated safe explorations of gender and sexuality that would then popularize titillating images of the Chinese and

Japanese. Indeed, historian Gail Bederman noted that the supposed turn-of-the-century "crisis in masculinity" was likely not a crisis. No evidence suggests that men "lost confidence in the belief that people with male bodies naturally possessed both a man's identity and a man's right to wield power." While many continue to understand the turn of the twentieth century as a moment of gender insecurity, James McGovern may have more accurately characterized it as a time when Progressives embraced a "virility impulse," suggesting masculine supremacy rather than precarity.[23]

The American "Oriental"

The American "Oriental," while similar in its form and function to theorist Edward Said's *Orientalism* in its European understanding of the Southwest Asia and North Africa, marked itself as different in its centralizing of East Asians to articulate longing and desire. With the closing of the American Frontier in 1890s, the United States more aggressively extended its imperial tentacles across the Pacific, sweeping specifically Chinese and Japanese into their American version of the "Oriental."[24] Mari Yoshihara noted a simultaneous peak in interest in Japan on the East Coast as white women incorporated Japanese themes in household activities and accessories.[25] *Discriminating Sex* in turn places one origin of the formation of the pan–Asian American "Oriental" at turn-of-the-century San Francisco when imaginations motivated by gender and sexual exploration among whites fueled a conflation of Chinese and Japanese culture and people.

I contend that a pan-ethnic Asian stereotype began to develop with the entry of Japanese into America in the 1890s, but only after the United States and more specifically San Francisco perceived them to be distinctly different from Chinese—a difference magnified and disseminated through middle-class whites' exploration of their own gender and sexuality. Asians in America did not always look alike but became conflated in the American imagination by the very tool that initially distinguished Chinese from Japanese in the United States.

Methods (Sources)

City publications, leisure culture, government documents, and personal papers suggest a variety of ways in which people imagined and lived moral and racial San Francisco between 1890 and 1924. I used more than one thousand newspaper articles and illustrations, 160 essays in literary journals, two hundred entries in satirical weeklies, six plays, seventy-two felony case files, thirty-two immigration case files, thirty oral histories, and twenty-two personal collec-

tions to determine existing ideologies about gender, sexuality, and race in the city. *Discriminating Sex* begins in 1890, since the first significant wave of Japanese began to migrate to the city during this decade, diversifying the Asian population that was at that time nearly all Chinese. The influx of Japanese, occurring in tandem with the rise of an aesthetic movement called Japonisme, incited new discourse around Asians in the city's print and leisure culture and coincided with turn-of-the-century shifts in middle-class gender and sexuality taking place across the nation. The book ends in 1924 with the passage of a federal immigration act that laid out clear ethnic and moral hierarchies in its articulation of suitable Americans.

The turn of the century marked several notable shifts in not just gender and sexuality but also in leisure culture. While "genteel reformers" through the nineteenth century occupied the position of dictating "official culture" through the founding of museums, art galleries, libraries, and symphonies, by the 1890s their "children" strove to immerse themselves in worlds outside the frame of "respectable," pursuing topics on communities of color and the urban poor. Developments in printing that now allowed the widespread dissemination of inexpensive books and periodicals mixed with a motivation to engage in leisure as an "edifying activity" through poetry, fiction, and the visual arts. Print culture came to crucially inform this new generation's cultural desires.[26]

The city's dailies, namely the *San Francisco Call*, *San Francisco Chronicle*, and the *San Francisco Examiner*, in their battle to outsell each other, frequently reported on gender and sexual tales to lure more readers. In 1898 the *Wasp* criticized the *San Francisco Examiner*'s fabrication of smut to sell issues, noting that the *Examiner* had "as much prestige as an ash barrel." The *Wasp* accused women reporters specifically of participating "joyfully" in the sensationalism.[27] Competition between the dailies would become so heated that violence would often erupt as editors and owners turned on each other with fists and at times even revolvers.[28] Rather than consider each published item as an authentic account of what actually occurred, I used newspaper articles and illustrations as reflecting contentions over shifting gender and sexual norms. As historian William O'Neill noted, "the most legitimate function of the press is its way of articulating the deep anxieties of the literate masses."[29]

In addition to the city's newspapers, the literary journal *Overland Monthly*, which began in 1868 with Bret Harte as its first editor, published large numbers of racialized gender and sexual narratives. Founder Anton Roman hoped for articles that would resonate across the nation. The journal, however, quickly became a western magazine. While Roman sought to draw migrants and therefore "civilization" to the west, Bret Harte mesmerized readers with his "quaint comed[ies] and sentimental melodrama[s]" stamped with the "Golden Gate."

The journal thus took up issues that preoccupied the west, such as the environment and its resources, and focused particularly on San Francisco issues, such as its ethnic makeup and sociopolitical struggles. Writers fashioned themselves as bohemians, free spirits eager to explore different cultures and ideas and push Americans to think outside of themselves. They brought knowledge and therefore "liberty" to their readership. While the journal had long passed its more famous days under the editorship of Bret Harte, in 1900 the *Overland Monthly* nevertheless remained the most prominent literary magazine of the west. According to Ernest May, the journal mirrored the western mind, and more specifically California. By the beginning of the twentieth century, the *Overland Monthly* had become the "organ" of San Francisco.[30]

Among readers bored with the stultifying conventionality of established periodicals, satirical publications such as the *Wasp*, a weekly journal of opinion, grew in popularity. Self-styled editors produced a flurry of magazines such as the *Lark* and *Le Petit Journal des Refusees* that eschewed seriousness and poked fun at the city's social trends.[31] Though best known for its scathing attacks on the Chinese and municipal politics, by the 1890s the *Wasp* primarily featured satires on contemporary gender and sexual anxieties. When the journal debuted in 1876, it promised "to be generally useful, and at all times fearless, bold, and independent, not owned or controlled by any man or party of men who might wish to use its column for venal purposes."[32] The *Wasp* aspired to be boldly independent and chastised those who violated "public trust." With origins in the Democratic Party, the magazine additionally vowed to "attack no man because of his nationality, religion, or previous condition of servitude."[33] Notably, the *Wasp*, in its frequent derision of the Chinese, clearly failed in its declaration "to attack no man because of his nationality." Still, entries from the *Wasp* as well as other satirical journals singled out the most compelling social issues of the day.

The fact that San Francisco's population was highly literate meant that, in theory, material from the *Call*, *Chronicle*, *Examiner*, *Overland Monthly*, and *Wasp* was widely accessible. According to the U.S. Census, from 1900 to 1920 the illiteracy rate for the city's general population hovered between 3 percent and 2 percent. Rates of illiteracy among foreign-born whites and African Americans were a bit higher, between 2 percent and 5 percent.[34] Relatively high literacy rates suggested that the city's prolific print culture likely reached a significant number of San Franciscans. Moreover, sensational images of gender and sexuality brought to life through Asian rather than white protagonists signaled more than just an urban culture that alienated the racially different. Deliberate distortions in

popular literature in the late nineteenth century in fact revealed contradictions and fears that society intended to conceal about itself.[35]

In theater as well, acts with gender and sexual themes frequently appeared. In the earliest years of the twentieth century, before moving pictures would dominate leisure culture, San Franciscans frequented theaters to enjoy vaudeville acts and musical comedies. Theater historian Misha Berson described San Francisco as having "tremendous passion" for theatrical entertainment. Family acting troupes, pioneer theater producers, circus troupes, Chinese operas, Shakespearean tragedies, minstrel shows, and ballet extravaganzas existed even before adequate food supplies or decent streets. Thus theater served as the primary source of public diversion in San Francisco between 1870 and 1906.[36] Collections at the San Francisco Performing Arts Library and Museum reveal the types of acts that particularly engaged local residents at the turn of the century. Tales of romance and sexual scandal drew curious audiences, and the local press ardently covered the action on stage.[37] Yet leisure culture did more than simply entertain. It additionally functioned as a space within which society tackled pressing ideological shifts by creating more palatable public images of potentially disturbing lifestyle changes.[38]

Outside of the burgeoning world of leisure, criminal and immigration court cases additionally addressed gender and sexual themes in their detailed accounts of "white slavery," prostitution, bawdy houses, obscene mail, felonious assault, and rape. Criminal and immigration case files traced the city's policing of gender and sexuality. Immigration cases recounted government efforts to oust mostly Chinese and some Japanese women they believed had entered America for "immoral purposes." In the records of the California Appellate and Supreme Courts, cases from San Francisco included charges of abortion, adultery, divorce, sodomy, rape, crimes against nature, fornication, bigamy, abduction for prostitution, disorderly houses, and illegitimate children. Defendants ranged from budding entrepreneurs eager to make money off birth control to violent men angry over abandonment by their girlfriends.[39]

Recovered scrapbooks, diaries, photographs, and oral histories also provided insight into the intimate lives of men and women who believed their lives worth preserving. Western writer Charles Warren Stoddard, Japanese community leader Yonako Abiko, and Police Chief John F. Seymour are but three examples of the twenty-two prominent individuals or families whose collections also shaped this study. Along with oral histories, particularly those of the Chinese American Oral History Project and the National Japanese American Historical Society, people's private collections reveal how individuals imagined gender, sexuality, and race.

Looking Ahead

Six chapters trace how initially Americans were generally unfamiliar with the Japanese versus the Chinese in the 1890s; how whites at the time drew distinctions between Chinese and Japanese with diverging connotations; how these racialized characterizations served as projections of expanding norms of white middle-class gender and sexuality; and how the proliferation of these stereotypes would then begin to merge to create a single "Oriental." The book as a whole argues against notions of early twentieth century San Francisco as a freewheeling, sexually liberated, racially tolerant city even amid numerous divergent sex and gender acts that daily enlivened the imaginations of San Franciscans through newspapers, magazines, theater, popular songs, and public events.

Chapter 1, "A Peculiar Obsession," details how Japan in the 1890s was largely a mystery to Americans broadly. Chinese, on the other hand, evoked strong sentiments of clear antipathy, particularly in San Francisco. As increased numbers of Japanese arrived, clear distinctions arose between Chinese and Japanese as two separate races, most visibly in the city morgue's processing of unknown Asian bodies. This differentiation between the two ethnicities further underscored San Francisco's obsession over its Asian population, even as they claimed to have no "race problem." City officials took pride in their home being an "International City," though communities of color and indigenous people would never have considered it to be a racial utopia. Indeed, San Francisco's embrace of its immigrant population and diversity would only be available to whites, as Native Americans, African Americans, and Asian Americans often became derided as a collective group rife with immoralities and doomed to extinction.

Chapter 2, "A Wide Open Town?" interrogates San Francisco's mythical reputation as a town where "anything goes." Pairings of men of color with white women occurred in the city press without the violent rage it provoked in nearly every other part of the United States at the time. Homoerotic imagery and writings also proliferated with little to no controversy. While the acceptance of these activities might signal an embrace of the diverse people and lifestyles, it in fact pointed to the opposite. Precisely because of overwhelming and unquestionable dominance of white supremacy and heterosexuality, narratives of interracial mingling and same-sex love that might otherwise challenge the status quo served merely as entertaining anecdotes without any threat to the existing social order.

Chapter 3, "Deliver Me from the Brainy Woman," links the city's active engagement in the rise of the modern woman to the inception of geisha imagery in leisure culture. As women in San Francisco grew more athletic and asser-

tive, moral conservatives blamed higher rates of marital failure on the modern woman who refused to fulfill appropriate women's roles. Images of obedient, self-sacrificing, petite Japanese geishas flooded leisure culture just as American women seemed to be abandoning more "traditional femininity." The romanticized representations would neither reflect realities of Japanese women nor benefit those Japanese living in San Francisco even as they appeared complimentary in depictions of Japanese traditions. The discursive embrace of Japanese femininity would solely be for the pleasure and enrichment of whites in their exploration of appropriate middle-class womanhood.

Chapter 4, "Prostitution Proliferates," links growing sexual freedom for whites to the rise of depictions of Chinese prostitutes in the late 1890s. White sex workers flocked to San Francisco for economic opportunities in a city where local officials supported rather than policed "immoralities." Young people additionally defied earlier conventions of courtship by going out on dates instead of getting acquainted in living room parlors under the watchful gaze of a chaperone. College coeds also enjoyed wearing more revealing clothes and expressing themselves in a sexually forthright manner in public spaces. While images of Chinese prostitutes proliferated, Chinese women involved in sex work remained at an all-time low at the turn of the century, when American-born whites dominated the sex industry as willing rather than enslaved workers. The depictions that misrepresented Chinese women as morally bankrupt would more accurately reflect white women's modernizing sexuality as it simultaneously bolstered and justified the policing of Chinese women's presence in San Francisco.

Chapter 5, "Managing Masculinity," traces how explorations of ideal manhood among middle-class whites would be projected on both Chinese and Japanese men. On the eve of the twentieth century, Chinese symbolized a degraded savage masculinity and Japanese embodied feminine civility just as middle-class whites sought to find balance between primal and over civilized masculinity. Within five years, however, the representations would switch as the Chinese became civilized, educated men who valued education for their daughters and the Japanese became oppressive fighting automatons. These polarized representations distinguished the two Asian ethnicities from one another even as the actual characteristics more accurately reflected realities of white masculinity.

Chapter 6, "Mindful Masquerades," places popular gender impersonators alongside Japanese and then Chinese immigrants to illuminate how whiteness rendered one form of masquerade as profitable and another as futile. White women and men took to the stage to magically traverse sex in front of audiences

wild with enthusiasm. Japanese, however, who crossdressed as American in hopes of acceptance received only persecution and alienation. Xenophobes who went as far as to accuse Japanese wearing western clothes as trying to deceive whites also simultaneously vilified Chinese for allegedly not adopting American clothing. This chapter juxtaposes gender impersonation and immigrant dress to underscore how white supremacy rendered one method of accessing power and passing as acceptable and others not.

Chapter 7, "Conscience Aroused," traces San Francisco's disinterest in gender and sexual narratives in the context of nationwide shifts in leisure culture away from print media and toward more industrialized commercial forms of entertainment. As public discussions of gender and sexuality decreased, so too did racialized narratives centrally tied to considerations of gender and sex. Yet the quiet would do little good for Asians in America. An earlier flood of conflicting characterizations for Chinese and Japanese ironically resulted in similarly unjust treatment from American authorities. Law enforcement officials would profile Japanese as well as Chinese women as prostitutes. Employment opportunities for Japanese men remained relegated to the same menial positions as those for Chinese men, rather than work befitting an aesthete or a samurai. Moreover, as racialized gender and sexual representations decreased in number, the initially distinctly divergent representations of Chinese versus Japanese increasingly merged. These depictions formed the beginnings of a pan Asian American caricature, an "Oriental" simultaneously geisha, prostitute, aesthete, pimp, samurai, and later homosexual in a single body. The making of the American "Oriental" thus came about through a mishmash of gendered and sexualized racial representations deliberately and specifically born from white desire and pleasure.

Negotiations of gender and sexuality took noticeable priority at the turn of the century, taking center stage in San Francisco's leisure culture. Reports of incidents involving appropriate and inappropriate sex and gender acts appeared prominently in newspapers, journals, satirical weeklies, and theater houses even more often than coverage of governmental politics and international crises, painting a colorful and contentious gender and sexual terrain. While these narratives appear to reveal the power of individual passions, they more broadly illuminated how regimes of power and privilege based on race and class would become inescapable in the pursuit of pleasure. *Discriminating Sex* elaborates on not just the obvious—that discussions of morality are inherently racialized—but also the less apparent: that exercises in gender and sexual freedom in fact clarify the ubiquity of white privilege and supremacy.

A Peculiar Obsession

The Chinese and Japanese Problem in the "International City"

In August 1918, officials dragged out a body in overalls with a matching blue sweater and jacket from the San Francisco Bay near Pier 28. The medical examiner decisively logged him in as "John Doe Japanese" in a ledger of unknown dead despite the fact the body had deteriorated beyond recognition.[1] Without a definitive guide on how to ascertain the ethnicity of unidentifiable bodies, the examiner likely drew on his own personal assumptions to mark this particular John Doe as Japanese. The size of the body could have suggested that he was Asian and not white. His lack of a queue and his American clothes may have signaled that he was Japanese rather than Chinese, since whites had long perceived Chinese immigrants as "unassimilable" in their seeming refusal to adopt American hairstyles and dress. Yet by 1918 Chinese San Franciscans had increasingly abandoned their queues and wore American outfits, rendering themselves more similar in likeness to Japanese rather than how San Franciscans typically assumed Chinese to appear. This particular John Doe Japanese had so severely decomposed that only his hair remained. Amid these realities, for examiners to assign ethnicity with any consistent accuracy would have been a miracle. Still, dozens of only the apparently Asian men were named with ethnic designations as "John Doe Japanese" or "John Doe Chinaman." Record keeping at the medical examiner's office powerfully reflected not only San Francisco's specific obsession with Asians but also how the city viewed Chinese and Japanese men as clearly distinct from each other. As Japanese gained sociopolitical

visibility at the turn of the century, whites would initially perceive Chinese and Japanese as two separate racial groups with vastly different meaning, in stark contrast to how America would later come to see all "Orientals" as "the same."[2] San Francisco's particular attention toward Chinese and Japanese as racially noteworthy, as well as different from one another, would set the stage on which middle-class whites would expand their own gender and sexual norms in a city that prided itself as "international."

After close to thirty years of vilifying the Chinese, by the 1880s Americans and particularly San Franciscans had extremely clear ideas about the "Mongoloid." When Chinese first arrived as laborers after the 1848 discovery of gold at Sutter's Mill in California, they proved indispensable in their willingness to take on backbreaking, life-threatening unskilled labor at low wages that no white laborer would agree to do. Chinese labor built railroads that connected remote towns and populous city centers across the nation. Chinese also cultivated agricultural lands deemed unworkable by white farmers. Sinophobes, however, almost immediately transformed the Chinese man's seemingly unique ability to overcome extreme obstacles as "unhuman," and therefore barbaric and uncivilized.[3] He became a "heathen" and also a sexual threat to white women. Characterizations of Chinese women as "slave girls" rendered them degraded as well, for their participation in prostitution. Without aggressive expulsion, many feared that Chinese immoralities would poison the entire nation.[4] Anti-Chinese sentiment culminated in the 1882 Chinese Exclusion Act, the first and only federal immigration act that excluded a group of people explicitly on the basis of race or ethnicity. The Chinese American population dropped precipitously soon after, and by the 1890s America's most virulent form of anti-Chinese sentiment had come to an end.

With the rise of Japanese immigrants, studies on race presume that contempt for Chinese transposed itself onto the Japanese as the new "Oriental." Anti-Chinese sentiment, too, had originally been a transference of anti-Black sentiment in the wake of emancipation.[5] The conflation of Chinese and Japanese remains axiomatic in Asian American history, a self-evident given that requires no investigation in the face of the ominous reality that Asians have always appeared individually indistinguishable to white America. Certainly, a long American legacy of transposed racisms easily explains away the need to interrogate the presumption. White supremacists with little creativity had simply overlaid old hatreds onto new people. Yet, on the eve of the twentieth century, whites did not necessarily assume Japanese to be the same as Chinese. In fact, few Americans had a clear sense of Japanese people and culture.

Unfamiliar Japan

In 1894 Lafcadio Hearn, after living in Japan for four years, published *Glimpses of Unfamiliar Japan* in hopes of educating the West about the "mysteries" of "strange Japan." According to Hearn, nothing of significance had been published on Japan since 1871, and even those studies imparted only data from official records or "sketchy impressions of passing travelers." Hearn recounted that in terms of Japanese inner life—its religion, thought, and "the hidden springs by which they move"—"the world knows but little." Japan, which had heretofore been rendered practically "invisible," would now be unveiled in these "glimpses" in his chapters on Buddhism and summer festivals.[6] As the "preeminent interpreter" of Japan to the West, Hearn in his romantic depictions of Japanese folkways lauded Japanese religion and culture as superior to those in America. The subsequent works he published—one book a year until his death in 1904—significantly shaped how the American public would come to imagine Japan.[7] The *New York Times* declared that Japan would not be understood by "western barbarians" had it not been for Hearn. The "Anglo-Saxon" should be grateful to Hearn for "his unfolding" to the American audience the Japanese civilization, "hoary in wisdom and ripe in charm."[8] Some believed his popular publications would likely end notions of the "degraded heathen" in considerations of the broader "Oriental."[9] Notably, in Hearn's earliest writing totaling close to seven hundred pages, what would later become highly charged icons of Japanese culture—namely, the samurai and the geisha—were marginal, if not nearly absent.[10]

In successive years, Japan's visibility would rise bit by bit in American popular consciousness due to a number of factors, including reports of Japanese military gains and mounting anti-Japanese sentiment from American xenophobes directed against immigrants. The publication of two extremely influential books, however, may have most significantly expanded visibility if not accurate knowledge on Japan. Though not immediately popular, Inazo Nitobe's *Bushido: The Soul of Japan* in 1899 and Ruth Benedict's *The Chrysanthemum and the Sword* in 1946 both sold millions of copies internationally in the decades following their release.[11] In the late nineteenth century, however, America still remained generally unfamiliar with Japan except for Hearn's recently published "glimpses." The turn of the century proved to be a crucial period in the formation of how Americans viewed Asians as a racial grouping as they sorted through their sentiments for both Chinese *and* Japanese people and culture for the first time.

Glimpses of Unfamiliar Japan and *Bushido* piqued interest in the "Mikado" just as Japonisme, an aesthetic movement among middle-class whites who embraced

Japan as having cultural value, also captured Americans. This attraction to Japan, described by art historians as an affair between "lovers," fueled the incorporation of Japanese culture into the United States as middle-class whites hoped to thwart malaise brought on by what they saw as their own over civilization. Japanese-themed afternoon teas, "kimonas," and art became all the rage.[12] Through an Orientalist lens, Japan became a site of exotic traditionalism to enhance American leisure. A century earlier, Americans such as George Washington and Phineas T. Barnum had embraced Chinese things and ideas to "suit their own agendas" in a previous form of Orientalism, specifically Chinese, called Chinoiserie.[13] Increasing interest around Japan in the aesthetic and consumptive context of Japonisme sparked an entirely different set of discourse from the despised Chinese of the mid-nineteenth century.

Members of the Bohemian Club of San Francisco, a community of adventurous and culturally inquisitive writers and artists, may have considered themselves the most knowledgeable American experts on Japan in the late 1890s in their pursuit of internationalism and adventure. Moreover, bohemians specifically embraced Japanese rather than Chinese culture. The group erected a *daibutsu*, or giant Buddha, for one of their retreats in Muir Woods. Essayist Joaquin Miller also liked Japanese boys "best" among the many young men he invited to live with him in his home, called "The Hights," in the Oakland hills. Women writers such as Blanche Partington, Léonie Gilmour, and Ethel Armes all found themselves drawn to rising poet Yone Noguchi for his specifically Japanese artistry. What a number of women perceived as Noguchi's "mystical" disposition might otherwise be characterized as moodiness in the absence of Orientalism. Western writer Charles Warren Stoddard, known by literary historians as San Francisco's first gay author, specifically drew upon Japan as a land of high art and exquisite poetry in his attraction to young Japanese men. Notably, neither Miller, Partington, Gilmour, Armes, nor Stoddard would evoke China in a similar fashion nor even mention China and Japan in the same sentence as a possible equivalency in their discussions of beauty and art.[14] Perhaps the most famous aesthete bohemian, Oscar Wilde, more explicitly advised San Franciscans against bringing specifically Chinese art into their homes during a lecture titled "Art Decoration" at Platt Hall on the corner of Bush and Montgomery Streets. He noted, "You have no need of it any more than you have need of Chinese labor."[15]

Chinese and Japanese, too, were keenly aware of how whites perceived them as different from each other. Chinese refused to completely transform their clothing to American style, even as they knew that whites denigrated them for their seeming inability to "assimilate." Many opposed becoming too American in appearance and manner and looked down on fellow Chinese who tried to pass as Japanese by donning western clothes. Chinese men warned of Americanized Chinese women

as too flagrantly sexual in their style, even as they largely accepted Chinese prostitutes without moral judgment.[16] Writer and Chinese Canadian Sui Sin Far, who became an advocate for the Chinese American community during her time in San Francisco, created a dastardly villain Lum Choy in her popular short story "A Chinese Ishmael" in the *Overland Monthly* in 1899. He was a westernized Chinese man who deliberately sought to pass as Japanese.[17] Choy's characterization illustrated how Chinese viewed Japanese as distinctly degraded in their ingratiating attempts for white acceptance through American dress. Japanese officials conversely pressed their citizens to wear American clothes and westernize so as not be seen negatively as intractable, nationalistic Chinese.[18] In Sui Sin Far's social circle, a number of mixed-race individuals of white and Chinese heritage passed themselves off as Japanese, Mexican, or Spanish to avoid the particular stigma of being Chinese.[19] The stark difference in how Americans viewed Chinese versus Japanese appeared abundantly clear in the late nineteenth century not just to Far but to all the mixed-race Asians who sought to hide their Chinese heritage.

Anti-Asian San Francisco

While Americans increasingly placed cultural value in Japan, Japanese and Chinese alike faced innumerable acts of similar discrimination and violence. As increasing numbers of Japanese entered the United States, immigrants from Japan reported being stoned, called "Jap," spat upon and harassed by gangs of young white men and teenaged boys each time they ventured out into public. Japanese student-laborers who had traveled across the Pacific Ocean hoping for an American education found themselves trapped in a cycle of drudgery as they provided domestic service to white families in exchange for free room and board. Too tired to attend school after they finished their domestic duties, Japanese men attempted to escape the often unreasonable demands of a white matriarch by taking up other menial jobs with even less security, such as dishwashing in a restaurant. For those able to pool resources and start a business, vandals regularly smashed out their window storefronts. In 1900 a statewide movement against the Japanese grew out of San Francisco as officials began to clamor for legislation banning Japanese immigrants that mirrored the 1882 Chinese Exclusion Act. Five years later one of the city's leading daily newspaper, the *San Francisco Chronicle*, launched an anti-Japanese editorial campaign. In 1906 the San Francisco School Board then directed all school principals to segregate Japanese and Korean children into the "Oriental School" where Chinese had already been relegated since 1859.[20]

In the half-century before the Japanese arrived in significant numbers, immigration officials incapable of seeing Chinese as individuals had misnamed all newcomers with the first name "Ah." Legislators, too, initiated a series of

ordinances deliberately aimed at curbing the livelihood of Chinese during the 1860s and 1870s. The Sidewalk Ordinance that prohibited people from using poles to carry items on the sidewalk would render illegal the primary way Chinese peddlers carried heavy goods balanced carefully between two ends of a single pole. A number of the ordinances would later be ruled unconstitutional or be repealed, such as the $4 monthly fee on specifically "Chinese fisherman" or $2.50 monthly police tax only for "Mongolians." These restrictions, whether long or short lived, reflected the significance of anti-Chinese sentiment coursing through multiple levels of government. Additionally, municipal graft fueled sex trafficking into the city as American government officials and law enforcement lined their pockets with profits on the backs of Chinese women forced into prostitution. A faltering Democratic Party would also use anti-Chinese sentiment to bring new membership, unity, and motivation to the group. In 1886 arsonists targeted buildings in Chinatown, burning alive thirteen Chinese. Indeed, Chinese could only enter industries deemed undesirable, such as laundry, cigar rolling, and the manufacturing of women's underwear. When their businesses expanded, drawing large numbers of white clientele, merchants organized boycotts to run the Chinese competition into the ground.[21] By 1890 what had once been a growing Chinese community even amid severe persecution had declined.[22] While previous publications often cite the white working class as anti-Asian, political scientists Brian Gaines and Wendy Tam Cho have noted that across socioeconomic status "all Californians hated Asians."[23]

International San Francisco

Ironically, San Francisco took pride in being different from the rest of the nation as an "International City." According to whites, no "race problem" existed, meaning there was no problem with African Americans, until the 1940s, when jobs supporting the military effort brought a large number of rural Blacks from the South. John Hood Laughlin in the *Overland Monthly* declared, "We are San Franciscans. . . . We bear malice toward none; we have charity for all." William Howard Taft also described San Francisco as "a city that knows how," referring to its physical beauty as well as its race relations.[24]

Certainly, how whites perceived San Francisco's racial state hardly reflected the real-life prejudices that Blacks, and for that matter any other San Franciscan of color, endured daily. San Francisco restricted African Americans along with Chinese and later Japanese to jobs that whites found "unattractive," such as domestic service. Excluded from racist unions and small in numbers, Black San Franciscans had few economic opportunities and no political power even as they had the right to vote.[25] Activist and entrepreneur Mary Ellen Pleasant

could only find wage work as a live-in "mammy" with wealthy San Francisco families as she initiated lawsuits against various streetcar companies for disallowing her to ride due to her race in "Jim Crow San Francisco."[26]

The city, however, did appear to be a better place than other regions of the United States where gangs of whites beat, raped, and set aflame African Americans. White women frequently attended these spectacles of violence with a blanket and picnic basket to witness the brutalization of African Americans.[27] In contrast, most of San Francisco's segregation laws were abolished by 1900, and Blacks frequented most public places of accommodation, rode public transportation, and attended integrated schools. Historian Albert Broussard asserted that "not one Black was ever lynched" in San Francisco and no "race riots" took place before the 1960s.[28]

In 1910, San Francisco clearly distinguished itself in terms of its racial politics when an African American boxer notorious for his relationships with white women won the ultimate signifier of virile masculinity. A little over two hundred miles northeast of San Francisco in Reno, Nevada, Jack Johnson, the first African American world heavyweight boxing champion, thrashed Jim Jeffries, a popular white former heavyweight champion, in a boxing ring on Independence Day in 1910. The victory was a bitter pill for whites to swallow.[29] Race riots of whites brutalizing African Americans broke out in "virtually every city and town in the United States," according to historian Al-Tony Gilmore.[30] For many whites, Johnson's win over Jeffries symbolized their worst fears, Black male supremacy over white. The boxing match served not just as a test of physical prowess but also as sexual performance and access to white men's most prized possession, white women.[31]

San Francisco, however, responded in markedly different ways than the rest of the nation. The "masculine element" of the city had largely taken "Johnson's end" even with the white Jeffries's home-state advantage as a Californian. A columnist for the *Examiner* predicted Johnson's victory, citing that Johnson was "the smarter boxer," "held down for years on account of his color." As the African American trounced the white heavyweight champion, a joyous shout went up among a crowd of spectators at the *Chronicle* office. A "happy 'I-told-you-so' air" pervaded the large group of men.[32] Racial bias did disable some white San Franciscans from responding agreeably to Johnson's victory. To cigar dealer Garnet Ferguson, who self-avowedly came from "down where we think a white man can whip a whole passle of men of Johnson's color," Jeffries's loss was a "big blow." Ferguson noted, "It is a shadow on the white race. It's awful." He could not bear to look his friends in the face.

Yet the overwhelming majority of local opinions of the big fight freely recognized Johnson as the better boxer. San Francisco mayor P. H. McCarthy declared

San Francisco Chronicle.

VOL. XCVI. SAN FRANCISCO, CAL., TUESDAY, JULY 5, 1910. NO. 171

JACK JOHNSON WINS EASILY IN THE FIFTEENTH ROUND

The Black Champion, After Landing at Will Many Times, Knocks Out His Opponent

JACK JOHNSON, WHO CONFIRMED HIS TITLE TO THE HEAVY WEIGHT CHAMPIONSHIP OF THE WORLD BY DEFEATING JAMES J. JEFFRIES AT RENO YESTERDAY

City newspapers featuring Jack Johnson's easy victory over Jim Jeffries diverged from more racist reactions of the fight nationwide. "Jack Johnson Wins Easily in the Fifteenth Round," *San Francisco Chronicle*, July 5, 1910.

that "the best man won," since not only was Johnson younger, but he was also "equally if not [a] more scientific boxer." Grand Juror F. L. Turpin noted, "The result was exactly as I had anticipated." Manufacturer C. H. Herrington commented on Johnson's "perfect" physical condition asserting, "You must realize Johnson is the greatest fighter in the ring." Others, such as Police Captain Eugene

Wall, warned explicitly, "Race prejudice should not interfere with judgment in boxing contests." Even the Chairman of the Board of Police Commissioners Joseph Sullivan observed that most people thought Johnson would win, though they did not want to admit it. African Americans in the city refused to bet on the fight because they believed the bout would certainly be fixed in favor of Jeffries. After all, Jeffries would never enter the ring if there was a risk of losing to a "negro."[33]

The *San Francisco Examiner* went as far as to explicitly denigrate white masculine prowess in the face of Black masculinity. The day after the fight, Alfred Henry Lewis, well-known for his "virile prose," declared in bold letters on the front page "Black Is Faster and Cleverer: Hits Harder, Cleaner, Oftener" as he reported on how Johnson arose from the fight without even a "scratch." Another headline blared "The Negro Won His Victory over the White Man with Ridiculous Ease" for an article that detailed how Johnson "whipped" Jeffries in "every one of the rounds."[34]

In these representations of the Johnson fight so different from those in the rest of the country, San Francisco whites appeared unconcerned with what his victory might mean for African American masculine sexuality and white women. Historian Willard Gatewood described the city's sentiments toward African Americans as deeply ambiguous wherein "respect and support coexisted with antipathy." Without a doubt, scholars of African American history such as Quintard Taylor and Albert Broussard underscore the continued existence of racism, even as San Francisco appeared more racially progressive than other American cities at the time.[35]

While the city prided itself on supposedly not terrorizing its African American population as did other parts of the United States, it appeared particularly obsessed with its Asians. In 1907 John L. Cowan declared that while the "Negro problem [was] a problem for the South," the "yellow race" was the "problem facing the people of the Pacific Coast."[36] Anti-Japanese agitator Herbert C. Jones's letter to Stanford University president David Starr Jordan in 1913 clarified how Japanese signified an irresolvable race problem. As Jones urged Jordan to support legislation to restrict the rights of Japanese, he explained, "The white man and the Negro have come in conflict, and the Negro has submitted. The Japanese neither submit [n]or die."[37]

Asian Obsession

In the first two decades of the twentieth century the morgue took special care to specify the race of only the Chinese and Japanese in the city. In the absence of any identification, officials likely used appearance and location of the body

to discern its ethnicity. A badly decomposed body with a black queue found off Pier 38 in February 1912 became "Unknown Chinese." Examiners labeled a man wearing a "Chinese blouse" floating in the bay near the bulkhead between Washington and Jackson Streets as "John Doe Chinaman." In September 1923 another "John Doe Chinaman," just twenty-five years old, died in a boarding-house in Chinatown at 884 Washington Street while wearing a dark suit. In January 1909 officials named a body found in the San Francisco Bay at the foot of 16th Street dressed in a white cotton shirt and blue and white pants as "Un-known Japanese," likely because of his western dress and his location far from Chinatown.[38]

Yet after the 1910s, not only had Chinese men begun comporting them-selves in American styles, Chinese and Japanese had also lived and socialized in overlapping circles for more than a decade. In 1914, when Chinese Wong Hon passed away anonymously at the Central Emergency Hospital, he wore a grey and blue-lined vest over a pink shirt with a grey sweater, matching socks, and white suspenders.[39] Murdered Ng Wyee Ming, a Chinese cook at the Wal-dorf Café, wore western clothes and had been living in a Japanese rather than a Chinese lodging house on 528 Pine Street.[40] In fact, many Chinese lived and socialized peaceably alongside Japanese even as newspapers highlighted their conflicts rather than collaborations, further reinforcing an ethnic divide more imagined than real. In December 1902 the *Call* predicted a prolonged feud be-tween Chinese and Japanese residents in San Francisco when a member of the Sam Yups in an alleged act of reprisal fatally shot Japanese cook S. Isozaki on Jackson Street.[41] Reports of these rivalries marked Chinese and Japanese as vastly different from each other, sometimes even violently so. While the clothing and location of the body proved unreliable indicators of ethnicity, the medical examiner's assignment of ethnicity in a handful of circumstances appeared to have no basis in even this flawed logic. The body that the coroner identified as fifty-year-old "John Doe Chinaman" in 1918 had short hair with no queue and could easily have been Japanese.[42]

Notably, officials assigned race to only the Asian bodies and did so with pronounced confidence. The morgue labeled African Americans and those who might have been Mexican as well as whites as simply "John Doe." Potential Lati-nos appeared often with racially ambiguous notations under "complexion," such as "Dark—looks like a Mexican" or "Swarthy (resemble Mexican)." Descriptions appearing under the "features" also indicated a possible Mexican when the notes under "complexion" did not—"Full (Mexican type)," "Full (Mexican or Span-ish)," or "Spanish or Mexican type, High cheekbones." As officials speculated about Mexican and Spanish ethnicity, exemplified through the use of phrasing such as "looks like," "resemble," or "type," they more conclusively labeled Asian

bodies with no qualifying terms as simply "John Doe Chinaman," "John Doe Japanese," or "John Doe Jap."[43]

Even after the 1906 earthquake and fire, as bodies piled up faster than the morgue could properly record, the medical examiner never failed to specify ethnicity for only the Asians with names such as "No. 2 Chinaman" and "John Doe Jap," even as he left the remainder of the entry form unfilled in his haste to process a large number of bodies. Remains also found in burned out buildings more than two months after the earthquake and fire also became "Chinese bones" whereas all the others were simply labeled as "human bones," as if bones became markedly different from those human when Chinese.[44]

Medical examiners also recorded the "color" of Chinese and Japanese differently from one another. Officials almost always marked Chinese as "yellow" whereas they more frequently marked Japanese as "brown." Out of two hundred Chinese bodies between 1906 and 1911, the medical examiner's office labeled all but one "yellow" under "color." Notably, half of the Japanese bodies appeared as "brown," the remaining half "yellow," indicating how the introduction of Japanese provoked differentiation along with potential for conflation in the city's negotiation of how to categorize the Japanese. For those such as "Unknown Chinaman" found in November 1908 and "John Doe Japanese" found in September 1911 with facial features so badly decomposed that the medical examiner listed them as "gone," the certainty with which the city morgue assigned Asian ethnicities powerfully pointed to the city's self-perception as being able to see Chinese and Japanese as so obviously distinguishable from one another even when the difference could not actually be seen.[45]

The First City

The city's peculiar obsession with Asians and the way they imagined Chinese and Japanese would shape the way the rest of the nation viewed Chinese and Japanese as well. San Francisco stood as an important gateway for the solidification of American Orientalism, not just as a destination for the nation's Asian immigrants but also as a significant point of origin from which whites first began to imagine Chinese and Japanese in America. Historian Yong Chen asserts that San Francisco emerged as "the most significant and largest Chinese American community" from 1850 to 1943. Chinese immigrants themselves called San Francisco "dabu," meaning the "the big city" or "the first city."[46] The city became home for the first and largest number of Chinese newspapers in the United States.[47] As the most visible Chinese city, San Francisco occupied a prominent place in white American consciousness and served as "storm center" for anti-Chinese agitation.[48] Yong Chen noted, "Chinese San Francisco tells us

a great deal about white America's efforts to designate the proper space for the Chinese in society . . . in its emerging racial hierarchy."[49]

The city proved critical for Japanese American history as well.[50] Though Japanese had been migrating to the United States since the 1880s, 1891 marked the beginning of the first significant wave of laborers to arrive.[51] A sudden and dramatic rise took place, resulting in 42,457 immigrants arriving in the six years after 1901 due to recruiting efforts of Japanese emigration companies and labor contractors.[52] The three largest contractors, companies founded by prominent businessmen such as Hasegawa Genji, Wakimoto Tsutomu, and Abiko Kyutaro, worked out of San Francisco.[53] Additionally, the first Japanese Buddhist temple, Japanese Methodist Church, and Japanese Association of America all began in San Francisco.[54] The Japanese immigrant press also originated in San Francisco with the start of several daily newspapers, *Soko Shimbun* in 1892, *Kimmon Nippon* in 1893, *Shin Sekai* a year later, and *Nichibei Shimbun* in 1897.[55] Statewide efforts to restrict Japanese immigrants' livelihoods thus predictably grew out of San Francisco.

The city served not just as a landmark for Asians in America but also as a springboard for how the rest of America would come to understand Asians. When Sui Sin Far traveled to the Midwest, she attended a social gathering where her friends, not knowing she was Chinese, commented that "a Chinaman is more repulsive than a nigger," since Chinese men provoked "creepy feelings." Japanese men however, were "different altogether." There was "something bright and likeable about [Japanese] men."[56] The rise of the Workingmen's Party of California a decade earlier in 1870s San Francisco had directly relied on the rhetoric of lascivious, debauched, and diseased Chinese men who posed a predatory threat to white women and their morality.[57] Popular representations of Chinese and Japanese as different could be understood in salons even in the middle of America, despite the fact that the very same whites could not recognize a person of Chinese heritage standing in front of them.

The federal government, too, accommodated the West Coast's specific need to at first count and then later differentiate between Chinese and Japanese. Chinese appeared in the census as a racial category in 1860 as "Mongoloid" only for California. Ten years later, census officials decided to count Japanese as a separate category under "color," different from Chinese. Through the 1920 census, the "color or race" category remained "White," "Black," "Mulatto," "Chinese," "Japanese," and "Indian," with an accommodation for "Other" as an option that was added in 1910.[58] While prevailing assumptions largely see the census as a scientific enterprise, political scientist Peter Skerry underscores how categorization especially with regard to race and ethnicity is a "political undertaking" shaped by local, state, and national interests.[59]

Countless historical works also trace how dozens of federal and state laws to restrict Chinese and Japanese livelihood in the United States grew from anti-Asian agitators in California and more specifically San Francisco. The 1875 Page Law, federal immigration legislation that targeted the exclusion of Chinese women based on what Sinophobes perceived as their inherent degraded state and tendency toward prostitution, grew from municipal laws implemented throughout the 1850s that targeted Chinese women in San Francisco's fight against immorality and sex work.[60] California state alien land laws beginning in 1913 that prohibited immigrants ineligible for citizenship—namely, the Japanese—from owning land grew directly from fears of a Japanese takeover of California fanned by San Francisco newspapers and implemented by politicians such as Hiram Johnson, who cut his teeth in the city.[61]

San Francisco stood as a gateway not just for Chinese and Japanese immigrants and those who came to hate them but also for writers and artists who declared their love of the West in its embodiment of adventure and the exotic. The *Overland Monthly* and its editors and contributors, many of whom found home in San Francisco, shaped popular views of Chinese and Japanese through its national circulation. Widely respected writers and editors of leading magazines and monthlies participated in the commercialization of American culture.[62] Through the *Overland Monthly*, Americans gained access not just to the West broadly but also to a San Francisco state of mind.

Writers strategically sought to publish a larger number of shorter essays that would draw interest for financial viability. In the 1880s, literary culture had taken a significant turn to making profit though voluminous sales rather than exceptional literary content. Publishers focused on producing slender books and serials rather than intricately detailed, luxurious hardcover volumes, which proved more expensive. Print technology facilitated this new culture of publication. Accessible reading material became a fierce competitor in the literary market.[63] The shift away from traditional bookselling gave writers more opportunity to publish shorter works with faster turnaround. Those who hoped to sell their short stories had to consider audience tastes more seriously to create appealing essays.

In a cultural and literary market where consumers devoured titillating ethnic stereotypes of a particular San Francisco variety, writers took best advantage for profit as they also shaped larger American consciousness in how to think about the Chinese and Japanese. George Amos Miller, a pastor at Grace Methodist Church, deliberately catered to San Francisco's fascination with Japanese women in the *Overland Monthly* while also projecting his image of Asian femininity to a nationwide readership.[64] When A. B. Westland sought to pub-

lish his two Chinese-themed essays, he made sure to send one to the *Overland Monthly*.[65] In 1897 and 1898 Mary Bell submitted two consecutive essays on the Chinese for publication in the *Overland Monthly* when her previous publications in other magazines had addressed romance and sexuality among whites.[66] Out of Thomas B. Wilson's ten submissions to the *Overland Monthly*, more than half addressed Japanese or Chinese themes.[67] Sadly, Asians writing in America, such as Sui Sin Far and Yone Noguchi, who also addressed Chinese and Japanese themes faced difficulty selling their works to publishers.[68]

Many of the white essayists who wrote of diverse cultures believed themselves to be educating less worldly readers to humanize people different from the white race. In San Francisco particularly, their writings stimulated interest among a population that took pride in what they believed to be one of the most diverse and racially tolerant cities in America. As adventurers in search of "truth" and "progress," they often disregarded conventional constraints to creatively construct narratives that made sense of the diverse world around them. Minnie Wakeman Curtis, considered by readers to be an expert on Japan, grew up immersed in a culture of adventure and internationalism that characterized San Francisco's literary and art scene. Raised in Oakland, her family enjoyed longstanding ties with bohemian writers such as Mark Twain. Her father, a "representative Californian" and one of the most popular steamship commanders out of San Francisco, cultivated relationships in his many ocean voyages with traveling writers. Her father's travels and worldliness fostered Curtis's interest in writing about "far-away" cultures as an adult.[69]

Curtis and other writers of her bohemian ilk perceived themselves as markedly different from rabid xenophobes who chased down or stoned Japanese on the street or published racist tirades denigrating races and cultures different from their own. Still, even these internationalist bohemians unabashedly published anti-Asian content. Ernest Peixotto, who wrote ethnic stories from California, painted Italians with romance and beauty while depicting Chinese and Japanese as distinctly alien. To Peixotto, the Italian Quarter had a "double character" both "American" and "Italian" while the "heathen chinee" furtively sold peanuts. Peixotto also depicted elderly Asian men in Golden Gate Park's Japanese Tea Garden with their "thin, white" beards and "skin baked brown as terra cotta" as more like ceramic figurines than actual people.[70] Similarly, when Charlton Lawrence Edholm reported on the festivities celebrating the arrival of a new baby in San Francisco's "Little Italy" with the "lustrous-eyed girl" and the "anointed and boutonnierred uncle," he juxtaposed the jovial event with the "tawdry squalor of the Chinese quarter."[71]

Whiteness in San Francisco

San Francisco's embrace of its Italian population further differentiated the city from the rest of the nation in terms of race relations. Between 1890 and 1914, during the height of Italian immigration to the United States, much of the nation portrayed Italians as morally inferior, ferocious, and barbaric.[72] In San Francisco, however, "self-made" Italian Americans who presumed themselves to have created a "model" Italian colony prevented a massive influx of poor Southern Italians from flooding their neighborhoods. The Northern Italians who dominated and immigrated with more education and financial resources than their Southern counterparts appeared less different phenotypically than existing European Americans in the city. The prevalence of Catholicism in California also eased the religious persecution of Italians as Catholics. California whites more eagerly included Italians as well as Irish into their racial category in the face of a more "alien" population of Asians and Mexicans.[73]

San Francisco explicitly incorporated Italians in significant ways as opposed to Chinese and Japanese. In 1900 writer Winfield Scott cheered intimate interaction or "assimilation" with Italians. "The inevitable progress of the melting pot was in full progress" with Italians, fearing neither their presence in the public schools nor their dominance of the city's polity.[74] Two years later Mayor James Rolph in his dedication speech at the Panama Pacific International Exposition officially declared the city's affection for Italy and its people. "Men and women of Italy . . . San Francisco is proud of you. I, as mayor, thank you from the bottom of the heart for this that you have given us, this that you have done for the exposition. Between Italy and America, between Italy and California, between Italy and San Francisco is a bond of love that will never break. The waters of the Mediterranean, the waters of the Adriatic, the waters of the Pacific may never meet but the blood of Italy and the blood of San Francisco will ever flow, as it does today, in the same veins."[75] Conversely, the image of mixing with Japanese struck such horror that the federal government hosted a hearing at the St. Francis Hotel on the state of Japanese immigration and the potential problem of interracial interaction with whites.[76]

San Franciscans welcomed Italians as becoming part of their American selves. By the 1930s, the San Francisco Italian community had "arrived," according to historian Richard Dillon. The city elected its first mayor of Italian descent, Angelo J. Rossi, in 1931. Notably, San Francisco would not elect its first Asian mayor until 2011, Chinese American Edwin M. Lee.[77] Historian Rudolph Vecoli noted that though Italian Americans were "not just plain white

folks," they remained "white" nonetheless in California, in the midst of Native Americans, Mexicans, and Asians.[78] Even among the better intentioned who explicitly embraced Asia, the fundamental assumption that nonwhites were inferior to whites underlay their works. These writers implicitly upheld whites as the standard of normativity in their exploration of these curious cultures.

For all of San Francisco's pride as a place that had "charity for all," the welcome may have more specifically been only for its white population, of which three-quarters were foreign born or whose parents were immigrants. With whites making up 95 percent of the city's populations, embracing ethnic whites stood in for the large part if not the entirety of San Francisco's generosity toward its diverse inhabitants. In 1897 the *Wasp* declared Chinese degeneracy would ultimately bring their extinction as had occurred among other races. "The immoralities practiced among [the Chinese] are fitting [them] for extinction, and as the Red Indians have almost disappeared from this country, and the blacks are doomed in Africa, so the scythe is being whetted for the Mongolian. [O]nly a blind man . . . can not read the writing on the wall."[79]

An illustrated series for the *Chronicle*, the "Rag Tags," also plainly revealed racial as well as gender politics in the city. The cartoon always featured an Englishman, a Native American, a Chinese, and a dog amid an enormous number of white working-class men making mischief. In November 1897 an illustration of Thanksgiving dinner featured a smaller "children's table" separate from the larger main table at which all the Rag Tags are eating. The Englishman had a seat at the main table in the upper right corner of the image even as he is being harassed. At the small table in the lower left corner sat the Native American man, the Chinese man, and the white woman, illustrating clearly how not only people of color but even white women were excluded from the main table. Indeed, in its placement of the Native American at the smaller table for this Thanksgiving cartoon, the scene appears particularly ironic, since indigenous North American people who saved white settlers from starvation are central in the origin of this American holiday.[80]

In 1900, when the *San Francisco Call* warned of the dangers of granting citizenship to its ethnic minorities, white immigrants—even those from "less desirable" parts of Europe—remained noticeably absent. The article expounded on the possibility of adding Japanese, "our most recent parasites," to the already motley crew of American Indians, African Americans, and Chinese. Aghast at the proposition, the *Call* declared, "Are the [Japanese] to join Hole-in-the-Air, Sambo, and Ah Sin in the harlequinade that will make an election booth look like a museum of races? . . . all to be made equal in a black and tan republic that will be made to look like a kennel filled with litters. . . . California will not pay a

The Rag Tags Celebrate by Sitting Down to a Thanksgiving Dinner.

"The Rag Tags Celebrate by Sitting Down to a Thanksgiving Dinner," *San Francisco Chronicle*, November 21, 1897.

cent nor cast a ballot to see the show."[81] In the exclusion of specifically European immigrants who comprised the overwhelming majority of the city's immigrant population, the *Call* revealed how whiteness, even when not explicitly articulated as such, would be held as a premium in the city. Representations such as these would hardly indicate an "International City" welcoming of different people, particularly those of color.

At the turn of the century, San Francisco grappled with an influx of new immigrants, this time from Japan. Few Americans would have a clear picture of what Japanese culture signified just as Japonisme, an aesthetic movement that embraced Japanese culture for its artistic value, began to draw American popular attention. Through the lens of Japonisme, Japan would signal widely divergent connotations from those of Chinese who had already been living in the city for four decades. Cultural cachet for Japan, however, would not necessarily translate into more acceptance for the city's Japanese, as both groups endured rampant anti-Asian discrimination and violence. Notably, San Francisco touted itself

as an "International City," one that embraced diversity even if its residents of color would fervently disagree. As a landmark for America's Asian immigrants, the city would also become particularly obsessed with its Chinese and Japanese population in life and in death. This racial politic with a peculiar focus on Asians laid the terrain upon which white San Franciscans would work out their own gender and sexual explorations during a nationwide movement that pushed for more freedoms for women. The following chapters trace how San Francisco, in its public discussions, short stories, newspaper reports, and theatrical productions, centralized Chinese and Japanese in their own negotiations of white middle-class gender and sexual norms, and therefore came to popularize and solidify the conflation of Chinese and Japanese into the singular "Oriental."

CHAPTER 2

A Wide-Open Town?

White and Heterosexual Supremacy in Permissive San Francisco

Open sexuality and lawlessness defined San Francisco since its beginnings as an American frontier town. Rowdy migrants to the city during California's Gold Rush in the middle of the nineteenth century had transformed the previously more tranquil town of what Mexicans had formerly called Yerba Buena into a place of licentious entertainment and vigilante government. Morally suspect enterprises spurred flamboyant growth. By 1900 sex work and gambling supported by administrative graft grew to become big business fueling a "live and let live" sensibility. Sex districts flourished at the foot of Telegraph Hill and the Barbary Coast, inciting anti-vice campaigns, which ironically drew even more national attention to the city's adventurous if not inappropriate sexuality. The sanctity of marriage, too, seemed out the window as divorce climbed and more women defied the demands of their husbands. Attempts to purge the city of its supposed immorality in turn publicized its sex acts, bolstering what Nan Boyd called San Francisco's "calling card" as a city of sexual permissiveness.[1] In this context, good-humored reports of interracial marriage and same-sex companionship existed part and parcel in a city that came to be known for its unconventional attitudes toward sexuality. Indeed, public displays of jumbled gender and sexual acts appear to confirm San Francisco's notoriety as a "wide open town," an unconstrained community of people able to act upon their own free will.

Yet the city's seeming favorable enactments of cross-racial affairs, same-sex love, and its ability to praise men of color as having positive traits of manliness in its print and leisure culture could take place precisely because of overwhelming white supremacy and heteropatriarchy that rigidly structured residents' imaginations and lived realities. Whites had uncontested political, cultural, and social control, and heterosexuality prevailed to such a dominating degree that sexual orientation never entered the vast majority of people's minds as something to consider. In fact, approving reports of women defying gender expectations more pointedly revealed the hurdles women faced in defining their lives rather than expanding freedoms. Men of color, more specifically the large numbers of Asian men appearing in the press, primarily served to entertain readers rather than uplift the image of Chinese and Japanese men in the city. Same-sex intimacy and homoeroticism existed acceptably in a world that could only see heterosexuality. Indeed, the popularity of "coon shouters," white women who sang of their love for African American women, markedly embodied how what could otherwise be apparent transgressions of race and desire took on wide appeal with audiences secure in their white and heterosexual supremacy. Structures of race, sexuality, and gender that bound rather than freed the vast number of San Franciscans looking from the bottom up facilitated a public culture of leisure that appeared liberated in its daily affairs. Those deemed sociopolitically marginal hardly experienced San Francisco as a place of freedom.

Interracial Commitments

In March 1898 the *San Francisco Chronicle* celebrated the union between Barbara Gebhart and Reverend Yoshisuke Hirose as "a romance of the Pacific slope with an Oriental tinge." The two had met in San Francisco and while tutoring one another in their "native tongue(s)," they fell in love.[2] The city's uniqueness as "wide open" felt true to white contemporaries of the time if not to the Japanese immigrants who daily faced abuse on the street. As San Franciscans engaged in public discussions of interracial affairs without condemnation, in the rest of nation fears of men of color as beasts coveting white women fueled racist hysteria. More typically, representations of Asian and African American men as sexual predators dominated popular, legal, and political discourse in the last quarter of the nineteenth century. In New York City, social reformers and journalists viewed relationships between Chinese men and white women as morally flawed. Chinese laundries and restaurants came to symbolize particularly dangerous places where Chinese men would assault or seduce white women in

the early 1900s. Violence also mounted against South Asian men throughout the Pacific Northwest when whites perceived them as sexually threatening to white women and children at the beginning of the twentieth century.[3] Additionally, assumptions of African American men as rapists hungry for white women sent whites into a violent frenzy, particularly in the American South. Pervasive animosity against men of color and fears surrounding their sexual threat manifested in lynchings across the country, events that often drew hundreds and in some cases thousands of whites eager for a diversion. These gruesome acts of racial violence became a popular spectacle, according to Amy Louise Wood, an acceptable leisure activity that assuaged white fears of the "black brute rapist who lustfully yearned to attack and violate the white woman."[4]

In San Francisco, however, good-humored accounts of Asian men with white women and a smaller number of reports of African American men with white women proliferated even in the context of a California state law that explicitly forbade interracial unions between whites and those identified as "Mongoloid" or "Negro."[5] While laws could powerfully signal structural inequalities, they did not necessarily dictate individuals' attitudes or actions. When the *San Francisco Chronicle* reported on Japanese dentist O. A. Hara, who married white dance instructor Bessie Gay, the paper described the groom as "clever and good looking for one of his race," a fine dresser who wore "tasteful and valuable but not ostentatious jewelry, such as a neat diamond stud and a pretty watch chain." "The story makes an interesting romance," the article approvingly concluded.[6] For the affairs of Emma House as well, who married two Asian men consecutively, the local paper recounted her first husband as a "talented young Chinese."[7] P. W. Hinton, an African American man of considerable community standing and known as the "lucky Negro," won $15,500 in two lotteries, built a beautiful cottage, married a "buxom" white widow, and lived for a time a life of "happiness and luxury." The *Chronicle* notably pinned the failure of their relationship on the misconduct of his callous white wife who had left him destitute after recklessly spending his winnings. Just before he killed himself, Hinton told his brother-in-law Ed Fay, "Tell Mamie I love her still."[8]

In clear departures from marital convention as well, the local press painted interracial affection in rosy hues. I. R. Burns abandoned his wife Hattie in San Francisco to marry mixed Chinese and Native Hawaiian "beauty of fashion" Bessie Afong in Hawai'i. Though still married, Burns traveled to Honolulu to court her assiduously. The *San Francisco Chronicle* related the impending marriage in a positive, almost fairy-tale-like tone despite Burns's tendencies toward marital infidelity and potential bigamy. "Love has usually found a way in the Afong family, whose marvelous history reads like a piece of fiction."[9] In the

case of one "Chinese Lothario," Ah Wong, the *San Francisco Call* reported with good humor on the philanderer who had a white lover, Annie King, in addition to a Chinese wife. To the *Call*'s surprise the two women appeared to be "on the best of terms and devotedly attached" as they clung "with utmost fervor" to the Chinese "Don Juan," "the head of two households."[10] When Brooklyn girl Josephine Claudius caught the eye of a Chinese nobleman Li Hung Chang while she rode her bicycle out of Prospect Park, the *San Francisco Chronicle* reported it as a "pretty story." "It was an unexpected honor on her part, and came about through the well-known fondness of the Chinese nobleman for young people." His carriage rode abreast her cycling figure as "his watchful, inquiring eyes followed the charming little bicyclist" until he could no longer delay arrival at his own destination. When Chang spied her again on his way to the Broadway ferry, he had the girl called to the carriage and asked her to come visit him at the Waldorf Hotel. This New York tale of stalking, voyeurism, and perhaps even pedophilia served as a "pretty story" for the *San Francisco Chronicle*.[11]

In 1897, when George Tauchi gunned down his lover Mary Castillo in her home, the local press reported on the incident with exceptional calm, blaming the failure of the relationship on Castillo rather than the clearly unstable Tauchi. According to the *San Francisco Examiner*, Tauchi and Castillo had lived together for a year when Castillo decided to leave him and move to Oakland, presumably to live with another "Japanese admirer," K. Tsundi, at 761 Washington Street. The *San Francisco Call* presented a manipulative Castillo who had "induced" Tauchi to buy a lodging house on 505 Dupont Street, which he had difficulty managing due to poor spending habits. Tauchi then sold the lodging house and gave the money to Castillo. The *Call* reported that she then "squandered" all of it in "riotous living" and refused to give Tauchi "a cent."[12] The *San Francisco Chronicle* also cast suspicion around Castillo's character by suggesting her involvement in sex work. For eight months, she had lived at the Sunset House, "where her rooms were frequented by Japanese." Tauchi had been "lavish in his expenditures upon her and when he had no more money and was out of employment," Castillo sought to "get rid of him." An angry Tauchi dropped by the house to destroy all the clothes and gifts he had given to the unfaithful Castillo to "revenge himself" on Christmas. Then, on the afternoon of December 26, Tauchi arrived at the Sunset House again and began arguing with Castillo in the hallway after finding a number of Japanese men in her room. According to Tauchi, he carried a gun in hopes of scaring her into being more devoted. After hearing shots, Louis Fau, the proprietor of Castillo's residence, rushed into the hallway to find Tauchi holding a gun over Castillo. She declared, "He has killed me," before collapsing.[13]

The San Francisco press did not immediately criminalize Tauchi or his Japanese associates as print media typically did for men of color in other parts of America at the time. City papers initially reported that Castillo had died of "fright" since medical examiners could not find a bullet wound despite numerous witnesses who saw him shoot at her. Only after the coroner found the bullet that had perforated Castillo's heart and lung did the *Chronicle* correct itself, declaring in a headline, "Mary Castillo Did Not Die of Fright."[14] Authorities also decided not to charge Tauchi's friend, Y. Nishiguna, for harboring a criminal and obstructing justice when he hid Tauchi in his home on 321 O'Farrell Street and then lied to the police who came looking for Tauchi. In fact, the judge recommended the courts proactively work to gain the trust and cooperation of Asians in the community to help solve more cases.[15] Nishiguna agreed to testify against Tauchi in exchange for not being tried as an accessory to the murder. When the prosecution found Nishiguna's testimony useless, the judge reinstated the charges, which the district attorney then summarily dropped.[16] While another article in the *San Francisco Call* concluded in a more predictably racializing manner, "The wily Japanese comes out on top," the release of Nishiguna signals something notable about San Francisco. Nishiguna received the district attorney's benefit of the doubt that he had told all that he knew. He had then returned home unmolested. Nishiguna's brush with the law could have ended much differently.[17] In other parts of the United States rabid whites manipulated or disregarded the legal process in meting out their own ideas of justice through acts of extreme violence, such as abducting and lynching suspects of color and their accessories without a trial.

Moreover, when the *San Francisco Examiner* carefully traced Tauchi's "jealous rage," the paper's use of passive voice to recount how he destroyed Castillo's clothes disassociated him from his aggressive obsession. A tan broadcloth jacket with a fur collar "had several long cuts in the back" and "the shears had been run in an awkward irregular manner nearly around the wrist." Castillo's pink and red wraps made of elderdown, a tennis flannel, and a blue dress with a silk front "had been cut up in the same way." While the *Examiner*'s account explicitly detailed Tauchi's assault by shears upon Castillo's belongings, the use of passive voice distanced his responsibility in his monstrous actions. The damaged clothes, rather than a crazed, scissor-wielding Japanese, loomed more prominently in readers' minds as the *Examiner* concluded, "The ruined apparel represented an outlay of $30 to $40." Notably, not a single sentence used Tauchi's race to more dramatically characterize the crime.[18]

Even when the *San Francisco Call* more actively attributed to Tauchi the destruction of Castillo's possessions, the accounts maintained his humanity by

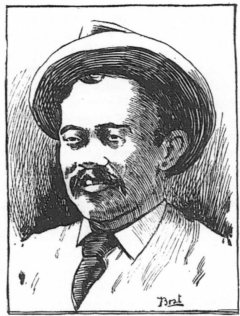

JEALOUSY CAUSED HIM TO KILL A SPANISH GIRL.

In this illustration of George Tauchi from the *San Francisco Examiner*, he appears without typically racializing facial features such as slanted eyes and buckteeth. "Fright Did Not Kill Her," *San Francisco Examiner*, December 28, 1897.

highlighting the couple's love for one another. The paper reported: "Maddened at what he termed her perfidy, he took out his knife and cut two of her best dresses in shreds." In this account Tauchi also "mutilated" a photograph of her sister's baby. The "unfortunate" Castillo, fearful of Tauchi's "ugly mood," requested the proprietor of the lodging house to not allow Tauchi access to her room. When the proprietor suggested she report Tauchi to the police, Castillo "amid tears" said she loved him and "emphatically refused to have him thrown in prison." Tauchi also declared his love for Castillo, albeit maniacally, since he stated that he would "make her the subject for the Coroner" rather than "see another man have her."[19] Later, the *Call* additionally gave voice to Tauchi's denials that he had wanted to kill her. In this version, Castillo had accidentally fallen into this gun. Tauchi explained, "I like Mary and wouldn't shoot her for the whole of Japan. Why would I shoot her? She was my best girl, but others tried to take her away

from me." As violently obsessive as Tauchi appeared in these accounts, love between the couple still prevailed as the dominating theme.[20]

Just a few years later in another investigation of a murdered white woman, this time in New York City, police immediately assumed Chinese Leon Ling killed his girlfriend, Elsie Sigel, since authorities found her body stuffed in a trunk in his room. No witnesses confirmed the event, and Ling could never be located. Hysteria quickly spread across and outside the city, which led to the criminalization and harassment of both Chinese and Japanese men as well as Asian-and-white couples in the New York area. Without a trial, any evidence, or even a suspect, New York journalists, law enforcement, and the general public operated on the presumption that all "Orientals" were dangerous murderers who preyed on white women.[21]

Differences in the specific cases of the Castillo as opposed to the Sigel murder may have contributed to the variation in public reaction in San Francisco versus New York City. Ling was a Sunday-school pupil who became friends with the missionary Sigel. Conversely, the unemployed Tauchi, well known along the waterfront as a man "quick to quarrel," loved Castillo, who had fallen into the "fast life" and mingled easily with Asian men. Sigel was the daughter of a well-known Civil War general in the Union army and her family figured prominently in New York social circles, whereas the "Spanish" Castillo, who was merely described as "a native of Watsonville," could have more accurately been Mexican. Many Californios, or Mexicans with roots in California before the U.S. takeover in 1848, identified themselves as "Spanish" at the turn of the century. In fact, in the days before the murder, Castillo's mother wanted to send Mary and her sister tamales, a comfort food more attributable to Mexico than Spain.[22] Certainly Sigel's higher racial and social status, as opposed to Castillo's, could have contributed to a deeper sense of loss for local whites in New York. Yet the several witnesses who heard or saw Tauchi repeatedly shoot Castillo could have just as easily stirred heightened outrage. San Francisco, however, appeared to hold interracial intimacies in a unique manner. Representations of Tauchi's murderous love mirrored other neutral to positive city depictions of interracial intimacies, signaling a distinctly San Francisco politics of representation.

The local press additionally wrote freely of white women actively seeking out the company of men of color. These depictions diverged significantly from nationwide reports that often portrayed white women as innocent victims forcibly kidnapped into white slavery. White women as free agents pursued their own fulfillment even if it resulted in not-so-desirable outcomes. Thirty-five-year-old Sadie Brown, who authorities commented "had seen better days,"

frequently visited opium dens with her friends Ah Sing and Ah Chin. She confessed to police officer David Murphy that she may marry Ah Sing because he would treat her "better than any white man."[23] Mary Castillo from Watsonville also chose to live in the largely male community of San Francisco's Chinatown for several years until police forced her to move out.[24]

When twenty-year-old Gracie Piggot and eighteen-year-old Lina Carillo leaped from an Oakland ferry in an attempt to kill themselves, the local press focused on the two women's general misfortune rather than the potential scandal of their interracial intimacies. Authorities described the intoxicated Piggot as a "dissipated blonde" who had seduced the "pretty" Carillo of "Spanish extraction" into frequenting "Negro resorts" since she had not been successful in supporting herself. The "beautiful," "gray-eyed" Carillo had run away from her parents' home in Los Angeles just five months earlier. Further detail evoked sympathy for Carillo: "The freshness and youth and the quivering young mouth of the girl made it hard to believe that her life was what she so frankly confessed." The proprietor of the boarding house where Carillo lodged stated, "She's too good for this sort of thing." The *Chronicle* concluded their report by anticipating efforts to rescue Carillo from her "life of shame."[25] San Francisco newspaper accounts such as these that reported on interracial affairs without outrage and positioned women as pursuing men of color marked the city as notably different from other parts of the nation. In the American South when activist Ida Wells-Barnett suggested in a pamphlet, titled "On Lynching," that white women might in fact be in sexual pursuit of African American men, violent public outrage and threats to her life forced her to flee to Europe.[26]

In San Francisco, however, white women and not their partners of color appeared as the root of the problem. Similar to Mamie Fay, who pushed the African American P. W. Hinton to suicide, and also Mary Castillo, who spent George Tauchi's savings, the press blamed Lina Carillo's friend, the "blonde" and "drunk" Gracie Piggot, as the cause of Carillo's demise into a life of moral turpitude. White women almost always appeared as the cause of heterosexual failure, confirming how pervasively misogyny also informed representations. When the *Call* reported on two stabbings in a single article, one of which was committed by an "abusive" African American waiter named Nat Wall who went in search of his white wife he believed had left him, the headline declared "Women Cause Two Stabbings," blaming the women for the violence rather than the actual knife-wielding men.[27]

The account of Ah Jim, a Chinese man who repeatedly assaulted Mrs. H. B. Holmes with a kiss on her way to work, further reveals San Francisco's depictions of interracial intimacies as far from threatening. Holmes, in her own words, had

nothing but "disgust" for the "repulsive looking creature" who she later discovered to her "horror" was an "ugly-looking old Chinaman." While the *San Francisco Call* recounted Ah Jim as a "snake" that "glided out of the shadow of the Donohue building," the article's overall tone appeared largely lighthearted over the racial trespass. The opening sentence described Ah Jim as having "earned the distinction of being a kisser" and that his "amorous propensity" would "likely land him in the County Jail." The headline also used the more positive term "bestowed" in describing how he gave Holmes the nonconsensual kiss. When coworkers suggested that Holmes "club" the "insulter," the *Call* noted that she refused to adopt such a "drastic measure" and instead reported it to the police. Notably, Holmes declared, "I have no hard feelings against the man."[28]

The *San Francisco Chronicle* began its account of the event with even more sympathy for Ah Jim's misbehavior. "The adoration of Ah Jim for a woman not of his own race has resulted in his arrest." His love, which was not in and of itself degraded or disgusting, resulted in police intervention only because it had not been directed toward another Chinese. Later headlines that comically declared "Stolen Kisses Land a Chinese in Jail" and "Six Months for a Kiss" underscored how the local press viewed the legal consequences of Ah Jim's kiss as attention-catching in its absurdity.[29]

The courts, however, took the matter of Ah Jim far more seriously. Authorities sentenced him to an unusual six months of jail time when other "mashers," men who "flirted" or made nonconsensual sexual advances, received no penalty. Just six years earlier, Judge Wallace, serving in the San Francisco courts, did not even know the meaning of the term "mashing," let alone that it could be a criminal offense punishable by imprisonment. Four years before Ah Jim's conviction, Judge Seawell reversed the decision of the police court in the case of Charles Basche, citing that "mashing" was "not a crime." The police court had initially fined the aged English artist $100 and sentenced him to sixty days in prison after he "ogled" and attempted to "mash" Isabella Warn. Judge Seawell noted that although Basche's behavior was "reprehensible," "it did not constitute a breach of the peace and was not an offense for which the law provided a penalty." Not until 1907 would "mashing" become a "serious charge."[30]

Since the municipal code did not explicitly articulate "mashing" as a crime, police arrested men under alternate indiscretions, such as "indecent behavior" or "disturbing the peace." Notably, city ordinances in the 1890s had no formally stated penalties for these two categories of misbehavior either. Not until 1903 did the municipal code outline a distinct punishment for "indecent behavior" as not to exceed a $500 fine, six months of prison, or a combination thereof. Ah Jim, sentenced to six months of prison in 1897, had received one of the maximum

sentences six years before the formal penalty had even been established.[31] Indeed, as lighthearted as the press's treatment of Asian-and-white affairs appeared, the representations did not necessarily indicate a laissez-faire existence for San Francisco Asians and their private lives. A Chinese man who wound up in court likely faced stern judgment by a criminal penal system that had little empathy for Asians. In the case of Ah Jim, the police court invoked the harshest penalty for an act that officials in fact loathed to declare as a crime, particularly when the perpetrator was a white man, as was the case with Charles Basche. Outside of the courtroom, however, mashing in San Francisco still proved markedly different than in the rest of the nation. The label of "masher" would only be available for white men, according to historian Estelle Freedman. Men of color, including Asians who exhibited similar behavior, would simply be "rapists," their actions frequently inciting mob violence.[32]

Personal testimonies have certainly detailed white San Franciscans' intense animosity toward Asians at the turn of the century. In a report by the Japanese consulate, Torao Kawasaki noted that couples of Asian men and white women socialized exclusively within San Francisco's Asian community due to hostility from whites.[33] Moreover, white women for the most part held open contempt for Asian men. Artist Yoshio Markino described how women glared at him with disgust and actively moved away from him whenever he took a seat on the trolleys in 1890s San Francisco.[34]

The county clerk's office also prohibited Asian and white unions in case after case, even as city newspapers documented judges in the criminal courts encouraging interracial commitments. When Komaro Umeji and Ellen From appeared before the marriage-license office in 1905, officials denied them a license under legal prohibitions, and From became indignant. "There are lots of Japanese and Chinese married to white women," she exclaimed. One city official replied, "I cannot help that. They must have gone somewhere else to get married." As Umeji and From exited, ardently engaged in a hushed discussion, the official had articulated an option that many couples before them had already taken.[35] In another courtroom, Judge Joachimsen granted Ruby Merrill leniency when a Chinese man arose in one of the front seats and "begged" in "pigeon" English that his white girlfriend not be sent to jail for vagrancy. He promised to marry her and support her with his "fantan joint" on Sacramento Street. When the court asked Merrill if she would marry her Chinese lover, she blushed through the rouge on her face and answered, "Sure thing, your honor." The couple, however, returned from the county clerk's office crestfallen, denied on the grounds of the California law prohibiting the marriage of a white to a "Mongolian." The two vowed to travel to China if necessary to marry. Judge

Joachimsen declared he would dismiss the vagrancy charge when the Chinese groom-to-be showed the tickets to China. "Would Marry a Vagrant," declared the headline of the *Chronicle*, signaling the undesirability of the white woman, not the Chinese man, as a marital partner.[36]

Extensive scholarship has documented the subversive nature of interracial intimacies in America during this period. According to Rachel Moran, these unions blurred social categories and spawned racial ambiguities as a challenge to white male supremacy.[37] At the federal level, alien Asian men proved particularly undesirable marriage candidates for white women. Under the terms of the 1907 Expatriation Act, American women marrying Asian men not born in the United States would lose their citizenship and assume their husbands' nationality.[38] In an additional affront to Asians in America, the Cable Act in 1922 allowed many American women in binational marriages to repatriate and regain their United States citizenship except for those who married men ineligible to citizenship, namely Asian immigrant men, whom federal law prohibited from becoming naturalized until the mid-twentieth century.[39] Laws discouraging binational marriages were not just racist but also sexist, as they privileged American-born white men while limiting the rights of Asian immigrant men and American women. Historians of interracial unions such as Martha Hodes's thus document how defiant, if not revolutionary, interracial lovers lived acceptably only on the outskirts of society. The white women often came from questionable backgrounds. Society shunned these couples for their social improprieties.[40]

Yet representations of San Francisco's interracial commitments noticeably consisted of unions comprising a different set of circumstances. Highly publicized interracial couples often came from the most educated social spheres. Testimonies from white spouses highlighted how marriage to Asians brought qualities aligned with standards of American high culture. Few saw themselves as debunking a social order in which civilized whites occupied the top rung or as participating in anything as notable as revolutionary. When white woman Emma Fong defended her marriage to Chinese Walter Fong in 1897, she framed it as enhancing her social status. Emma herself noted that her marriage had opened her life to a type of people morally and intellectually "superior to the average." She had been "socially helped up rather than dragged down" because of her marriage to a man with "broad scholarly attainments."[41] F. W. Eastlake, who conducted the Tokio School of Language in Japan, justified his interracial marriage by noting that his Japanese wife was of "noble birth" and that the Japanese were in no way related to the "Mongol" race. Eastlake claimed to have "indisputable proof" that the Japanese were a mixed race descended from a hardy tribe

from Siberia closely allied to the Finns and a race of people from the Himalayas who had made their way to Japan through present-day Taiwan.[42] In these public pronouncements, whites defended their unions by underscoring the "nobility" of their Asian spouses, going as far as to assert that they were biologically closer to the "Caucasian" rather than the "Mongoloid." These interracial lovers might in fact have felt disgusted by the injustice of racism among proponents of antimiscegenation. Nevertheless, so pervasively would white supremacy reign that there existed no room to even forward an antiracist argument critiquing the hateful racial bias that persecuted these commitments. As white spouses asserted the nobility of their Asian partners and claimed them as being nearer to white than "Mongoloid," bigotry in fact facilitated these relatively sympathetic portrayals of interracial unions.

Ultimately, interracial romance in the local press served to amuse rather than scandalize San Francisco readers. In 1897 when the *San Francisco Call* declared, "Lee Yuen Is in Love," the paper lightheartedly told the story of a one-way romance. "Tell it not among the yellow beauties of Chinatown lest there be tearing of ebon hair and welling of briny tears from eyes wont to sparkle—for Lee is in love with a white girl. They would be sad at finding it out, yet she is not exactly glad." The object of Lee's affection, Jane Whitebeck, arrived in San Francisco to perform in the production of *Gay Coney Island*. Chinese storekeeper Lee Yuen fell in love when Whitebeck walked into his shop while touring Chinatown. The *San Francisco Call* sympathized with Lee, describing him as "courtesy itself," "a bright fellow" with a mission-school education, and "American enough to fall in love then and there." The paper less sympathetically portrayed a callous Whitebeck by detailing how she accepted gifts of bracelets and sandalwood at her hotel room and immediately shut the door on Lee, who had delivered the items himself, "smooth-shaven, smiling, [with] a new button in his cap." While the *Call* appears to side with Lee in this unrequited romance, the article's purpose is to humor readers through Lee's very failure in obtaining Whitebeck's affections. "Cupid's dart had worked havoc with the Chinaman's tender heart," the paper declared, adding (in an act of further condescension), "a love-sick Chinese is more persistent than a local flea." The *Call* then printed his handwritten love letter to Whitebeck in its entirety for all the city to read in a final blow of humiliation to the rebuffed Lee.[43]

The *San Francisco Chronicle* in 1902 reported in a jocular tone on another spurned Chinese lover. Ah Sam, who "aspires to the higher civilization of the Occidental" and hoped to have its accompanying "amenities," found only grief, "owing to the discouragement of an American woman." Police arrested him when he began casting loud aspersions upon Gertrude Lee, the white wife of a

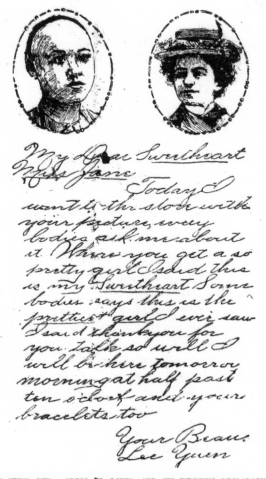

LEE YUEN, THE ACTRESS HE LOVES AND HIS WRITTEN DECLARATION.

Lee Yuen's love letter, according to the *San Francisco Call.* "Lee Yuen Would A-Wooing Go," *San Francisco Call*, December 30, 1897.

Chinese man, after she rejected his advances by dousing him with a bucket of cold water. The *Chronicle* humorously commented that Ah Sam had "essayed the gentle art of 'mashing.'"[44] For the San Francisco press, affection between white women and men of color even in the case of murder served as a site of interest and humor rather than a threat to the existing norms of love, marriage, and white male supremacy. As unique as these seemingly accepted interracial

representations appeared, they revealed another form of racial and gender deni-gration. San Francisco readers, largely middle class and white, found pleasure in accounts that gave little dignity to Asian men and even less gravity to assaults upon white women.

Same-Sex Intimacy

At the turn of the century, same-sex affection appeared also to exist as accept-ably in San Francisco as did interracial intimacy. Individuals who found "love" with members of the same sex nurtured intimate long-term commitments in the form of innocuous yet intense "romantic friendships." Many of these friend-ships grew from late Victorian homosocial environments, composed almost entirely of whites with more education or financial means who congregated for camaraderie, common intellectual interests, or a civic purpose. For some, these "friendships" existed concurrently with heterosexual marriage, while others chose to remain single. Bohemian networks of writers and artists across the United States and Europe appeared to be particularly conducive breeding grounds for romantic friendships among men. In other single-sex communities at the turn of the century, the terms of acceptable same-sex intimacies could be even broader. Relationships between vagrant boys and men existed peaceably "on the road" along the West Coast even while middle-class morality frowned on these unions, according to historian Peter Boag.[45]

In San Francisco, homoerotic images and narratives appeared particularly visible in the city's print culture. In 1898 the *Chronicle* sympathetically detailed a tragic ending for two men who had lived together and loved each other for more than thirty years when James Currier accidentally killed Edward Kirtley as Currier split kindling.[46] In an article titled "The Months Embrace," three white women cradled one another tenderly in the *San Francisco Call*. An illustration of the president of France and czar of Russia greeting each other in the *Wasp* showed the two of them shaking hands and leaning into one another in what appeared to be a kiss. In the masthead of the *San Francisco Call*'s column "In Childhood's Realm," two small girls posed kissing each other on the lips.[47] In 1897 two women in mannish attire and their same-sex union sparked curiosity rather than condemnation in the city press. Lady Eleanor Charlotte Butler and Sara Ponsonby dressed in "strange costume . . . partly made up of masculine garments." A nobleman later sparked "a romance within romance" when one of the women became drawn to him.[48] From Oklahoma as well, the *San Francisco Chronicle* noted with an entertaining tone a club of twenty young society ladies from Ponca City. The club prohibited members from marrying and forming any

relationships except platonic friendships with men. If a "miscreant maiden" broke her vow by marrying, members punished her by attending her wedding in pointed caps and white gowns and masks. "The young ladies are thinking of forming a football team," concluded the article on this "unique bachelor club."[49] Representations of same-sex affection and commitments proliferated in a non-pejorative manner.

San Francisco seemed more tolerant of even explicit same-sex sexuality, considered absolutely unacceptable in other locations. Writer and journalist Edward Prime Stevenson used the pen name Xavier Mayne to reveal how sex between men flourished in the Presidio District of San Francisco in the late 1890s when elsewhere in the country "homosexual intimacies [were] severely punishable." Mayne described "philostrats" of the city flocking to the area to satisfy the demands of soldier prostitution. He noted, "Amiable young men were to be had so plentifully that their tariffs fell to nominal prices and the lodgings of particular amateurs were fairly invaded."[50] Essayist Oscar Wilde, whom English authorities persecuted as a "sodomite," also held continued respect in San Francisco, though he and his family faced irreparable damage to their character in Europe. The San Francisco press expressed approval for Wilde that remained nonexistent in London. Shortly before his release from prison for committing sodomy, Wilde appeared in a large, dignified photograph in the *San Francisco Chronicle*. Reporters declared his return to the literary world from his new home in France.[51] The *Wasp* in 1901 also reported on "one of Oscar Wilde's brilliant comedies," *The Importance of Being Earnest*, as drawing an "intelligent" and "appreciative" audience. That Wednesday night at the Columbia Theater the enthusiastic public who "rolled up to hear the coruscations of his brilliant wit" amply proved how Wilde, even after his "dire disgrace and wretched death," remained popular.[52] Six years later Henderson Archibald in the *Overland Monthly* praised Wilde's life works, including *De Profundis* and *The Ballad of Reading Gaol*, both literary works that grew directly from the consequences of his same-sex relationships. Archibald noted, "The tendency of humanity, after a sufficient lapse of time, is to overlook many faults in the man who possesses the virtue proper to his own profession. Wilde was assuredly a personality of whose life art formed the dominant note."[53] The San Francisco press embraced Wilde for his amazing literary achievements, reducing his same-sex sexual acts to merely a "fault" rather than a crime against humanity.

Still the city's seemingly more accepting attitude toward same-sex intimacy had more to do with heteronormativity or the overwhelming dominance of heterosexuality than a politics of open sexuality. While legal and medical experts had explicitly begun to address "sex inversion" and "homosexuality"

within their professional fields, public discourse on desire in terms of explicit heterosexual, homosexual, bisexual, or any sexual identity existed minimally at the turn of the century.[54] San Francisco may have been particularly behind in joining the wave of homophobia just beginning to gain ground on the East Coast. The seminal novel *A Marriage below Zero* published in 1889 that took up the subject of "homosexuality as a distinct social predicament" did not reach San Francisco until 1899. Alfred Cohen, under the pseudonym Alan Dale, traced the harrows of Elsie after marrying a young gay man. Even though at first Elsie agreed to a marriage without physical intimacy, her marriage became insufferable, especially since the husband, Ravener, would run off with his older male lover every evening. At the end, Ravener commits suicide. The tale not only painted homosexuality as tragic, but it also served as a warning to innocent women against the duplicity and treachery of homosexual men. Notably, San Franciscans appeared wholly unconcerned with protests the distribution of the book had raised a decade earlier when "benevolent" critics in New York publicly declared it as "an enemy of the human race." San Francisco received the book with no public outcry against this significant work that literary critic Richard Kaye described as bringing the horrors of same-sex sexuality into American homes. According to Kaye, *A Marriage below Zero* was the first fictional work to synthesize medical and legal comprehension of same-sex sexuality and pose it as a threat to the middle class.[55]

Four years later in 1903, when perhaps the city's first gay novel appeared on shelves, no one except the author appeared terribly concerned.[56] *For the Pleasure of His Company*, by Charles Warren Stoddard, revealed a contested masculinity as well as a vague sexuality in protagonist Paul Clitheroe. His friendship with Foxlair and Roscius took on undeniably homoerotic tones, and the one woman with whom Clitheroe developed a romantic interest lacked "woman[ly]" traits, taking on a male persona as "Jack."[57] San Francisco reviewers and readers hardly mentioned and likely did not even notice the homoeroticism and gender ambiguity in Stoddard's book. In 1904 the *San Francisco Post* described *For the Pleasure of his Company* as a record of his life, giving insight into the lives of local notables and those who treated Stoddard kindly. The *San Francisco Call* called it a "beautiful idyll." Reviewers commented on the novel's lack of structure and airy unreality, describing it as "insincere" more than pointing fingers at its alarming homoeroticism.[58] A few may have been aware of the potential implications of his book. Jack London called Stoddard "the love man." Rudyard Kipling, on the other hand, predicted that many, upon reading the book, would misunderstand Stoddard.[59] For Stoddard also, the publication appeared too sincere and painfully honest. The character Paul Clitheroe was based on Stoddard himself. He

felt "stark naked" and fretted, "How I did give myself away in that book!" He cried as he clutched his autobiographical novel, "Tis my life—my whole history of failure! I feel shame in such a clear exposition of myself." Yet no controversy arose. In fact, so uncontroversial remained the book that in 1907 the Spinner's Club reprinted one of Stoddard's chapters in a collection of sixteen tales by other well-known western authors.[60] In the late nineteenth century "homosexuals derived certain advantages from the reticence, bordering on obliviousness, of bourgeois culture," according to literary critic Roger Austen.[61] Unspoken and assumed heterosexuality ruled, thus allowing what might be otherwise subversive sexual subtexts to exist without censure.

Indeed, the city leaned toward denying the existence of same-sex sexuality even when "unnatural desires" loomed directly in front of the public eye. When sculptor Douglas Tilden erected a sculpture titled *Mechanics Fountain* in the South of Market area in the 1890s to celebrate the white working class of San Francisco, some controversy arose over the public nudity of the monument and the homoerotic desire it could arouse. A group of life-size, nearly naked men worked together at a giant machine. Their visually pleasing muscled limbs and chiseled torsos embodied virility and power, defining an ideal masculinity confirmed not in the company of women but of men. One male commentator noted that the sculpture was "unhealthy for the young minds of San Francisco," though he approved of Tilden's artistic design.[62] In a world where few people could even consider divergent sexualities to viably exist, however, Tilden's work, despite its provocative form, remained as an acceptable public monument.

As late as 1914, to an audience that preferred to not see same-sex sexuality as a reality, a white man could successfully convince a San Francisco courtroom that he did not commit same-sex acts. Fifty-six-year-old Samuel Robbins successfully appealed his conviction of committing a "crime against nature" with sixteen-year-old Sydney Newmark. In September 1913 the two went into the bathroom of Newmark's home at 1638 Baker Street after playing ball in the yard. Robbins proceeded to lock the door and pull the shade halfway down a frosted window. The young man confessed to intimate relations with the older Robbins upon interrogation from the landlady, who had crept down the hall and listened at the bathroom door out of suspicion. Robbins, however, insisted that the two were merely washing hands. According to court documents, the time elapsed in the bathroom was not unusually long. Nor was the friendship of a middle-aged man with a teenaged lad anything to cast suspicion upon the former. According to Robbins's defense in these days of the "big brother movement," thousands of men throughout the country systematically cultivated the friendship with boys to influence mature thought. The association with men would aid in the development

of the best qualities of children. The defense argued that men should not be convicted of degrading crimes upon mere suspicion and the coerced account of an "accomplice." The appellate court agreed with Robbins, allowing a new trial that would reverse his conviction in 1915.[63] In doing so, the San Francisco appellate court demonstrated their inclination to disbelieve the existence of same-sex sexuality in the face of an alternative morally acceptable explanation. The court in the end upheld the authority and integrity of the white man Robbins as opposed to honoring the testimony of the youth or the woman. Yet, in the early decades of the twentieth century, authorities along the Pacific Northwest vilified South Asian men as "Oriental degenerates" who took up with white male youth.[64] In the courtroom, it seemed yellow and brown men would less likely obtain the same benefit of the doubt that Robbins received from compulsory heterosexuality and the privilege of being white.[65]

San Francisco authorities policed explicit same-sex acts as deviant behavior as well, even as the city's print culture embraced same-sex intimacy. From 1897 to 1905 officials made seven to fourteen arrests each year for "crimes against nature."[66] In 1905 city authorities clearly stated their intolerance of sex between men when they convicted John Carroll to seventeen years in state prison for having "carnal knowledge" of Frank Derby, an individual the court presumed to be male. The appellate court later reversed the decision when testimony revealed Frank to be female.[67] In San Francisco's Bohemian Club as well, in which Western writer Charles Warren Stoddard stood as a prominent figure, white males acceptably cultivated close relationships among themselves, producing imagery with homoerotic tone, yet explicit homosexuality remained forbidden.[68] Stoddard and many of his associates thus chose to live "double lives," hiding the more "homosexual" parts of their lives even in the most queer-friendly circles of the time.[69]

Queer "Coon Songs"

At the Orpheum Theater in 1898 a white woman, Flo Irwin, sang of her love of an African American woman, "a yaller gal" who spurned her for another of a lighter shade. Irwin crooned, "Oh come back ma' baby if you ever want to save me for I've badness in ma' mind less you gwine to treat me kind come back ma' baby an' be ma' cullud lady, or I'll sure carve dat nigger when we meet."[70] A year later white woman Querita Vincent popularized a song about another man flirting with her girlfriend, "de warmest choc'late baby in de land."[71] On the San Francisco stage, white women singing "coon songs" about what whites presumed to be African American love and romance drew citywide popularity. These performances

that on one level simultaneously enacted same-sex and cross-racial affection powerfully clarified the ubiquity of white supremacy and heteronormativity in turn-of-the-century San Francisco. These singers appropriated "Negro love" for their own amusement under the cover of the overwhelming assumption that only heterosexuality could exist. As white women took the stage as themselves to shout out what they believed to be African American heterosexual love, their acts animated existing anxieties about gender and sexuality among whites while ridiculing city Blacks.

The city mirrored the rest of the nation in its "coon song craze" of the 1890s. More than six hundred songs were published within a decade, and the most successful tunes sold in the millions of copies.[72] The "coon shouters," or white women who entertained audiences with tunes of typically African American life and love, were part of a trend of largely Jewish women who vocalized music and lyrics written by emerging Black and Jewish composers. Unlike minstrelsy, where white men would blacken their faces with a burnt cork and act out a song, coon shouters usually appeared as themselves—white women rather than blackened male impersonators—to merely sing.[73] According to Pamela Brown Lavitt, notable coon shouters as a demonstration of vocal artistry and skill "did not push from the diaphragm" but instead "transpose[d] the music upwards a fifth from C to G." In the upper ranges coon songs became "as thrilling as a Comanche war cry."[74] Connotations of Native Americans as noble savages with virile masculinity further charged these vocalizations as sexually titillating.

While these performances clearly ridiculed African Americans, they served as acts of transgressions for the white women who sang them.[75] They provided an avenue through which marginalized women, large, Jewish, or both, could successfully assert themselves in mainstream theater. Women who were "too big and ugly" to be "sexy" onstage, such as May Irwin, fell into coon shouting.[76] Many of them who were Jewish hid their identity, only to reveal it in coded language to the knowledge of just the Jewish members of the audience.[77] For the African American songwriters, the success of the "coon songs" proved to be a complicated matter, since, according to Daphne Brooks, it became "a source of bread and butter for the very individuals it mocked and scorned." Black songwriters as well as producers and performers profited financially in the creation of racist pop songs while busily setting out to nurture and fund "a newly moneyed class of artists intent on developing a black musical theatre of an entirely different order."[78] For African Americans involved in coon songs, it became a form of political activism as young, cosmopolitan black musicians and performers began to challenge their racial status and thus participate in the creation of modern discourse.[79]

Without a doubt these songs reflected white racist characterizations of African Americans. Their explosive popularity nationwide served as an aesthetic instantiation of whites' anxieties about African American social mobility. In content and message, these songs typically addressed post–Civil War legislative gains and socioeconomic autonomy for African Americans.[80] In San Francisco, however, the topic of love, marriage, and romance overwhelmingly dominated these popular songs. From the collection of recovered song sheets from the *San Francisco Examiner*'s weekly series of musical hits between 1897 and 1904, thirty-nine touched on issues of gender or sexuality. Sixteen of these explicitly addressed African Americans and spoke to their devotion to love and commitment. Explicit denigration of African Americans had fallen out of favor as the city began to pride itself as more accepting of diversity and thus more civilized than other parts of the nation. By the 1890s, minstrelsy, as solely racist humor, could no longer sustain a San Francisco audience as it had been able to forty years earlier.[81]

Thus, as middle-class whites publicly debated their own fickle love, performances of "Negro love" became an additional site through which whites negotiated their own shifting romantic rather than sociopolitical affairs. Caricatures of African American men depicted them as dedicated to commitment and marriage, albeit foolishly, as divorce among whites appeared on the rise. In 1898 white woman Anna Meld took to the stage to sing of being treated poorly by the only woman she loved. She had done all she could to make her "black gal shine," spending all her money on clothes and other gifts. Yet her generosity would not be enough when someone more successful at the racetrack would come and steal "ma gal an' all ma clothes, an' left my flat dead empty." She dreamed of violence against the man. Yet if "Roxy'd jes' come back an' try to half right," she would forgive her "for this once."[82] In 1901 Clarice Vance also projected African American male devotion when she sang of her "girl" leaving her for another man. Because she loved her she would not "hold her to stay" nor "raise a row." As she sent her off, she gave her all her money, made her take the front-door key, and told her when she grew tired of "roamin' dat she could come right back."[83] In its highlight of African American men's commitment to love and marriage despite difficulties, these songs placed the responsibility of successful commitment upon men, pushing back against prevailing claims in the mainstream press that modernizing women were at the root of the city's divorce problem.

For some audience members, these performances could be construed as remarkable for their potentially same-sex and cross-racial content in its embodiment of a white women singing of love to an African American woman. For sure,

a growing urban middle class frequented theaters for entertainment to vicariously fulfill desires that social mores otherwise restricted.[84] Yet overwhelming and unquestioned heterosexuality as well as white supremacy rendered these performances as mirrors of white privilege and heternormativity, even as they might read subversive to those more hopeful of transgressive acts. For Jewish women not considered white by anti-Semites, racialized performances reified their access to the privileges of being white even as they remained "not-white."[85] The obvious embodiment of lesbian love, for a woman of color no less, would become virtually illegible for the larger number of people who attended these performances.

In 1899 white woman Georgia Cooper at the Tivoli Theater sang of the prospects of her new Filipino girlfriend. "I'm gwine to Manilla soon an' get this southern coon an then I'll show the nigs in this town style. When I go down the line with this foreign gal of mine, I'll sing this song and set the niggers wild. Dark? Well, yes but not too shady. Goodness knows I love this baby. I'se gwine to wed this gal next May down on Manilla Bay."[86] Cooper's enactment of songwriter G. J. Yenewinne's "My Phillipino Lady," rife with racial epithets and denigrations, reveals how white male supremacy in particular motivated these performances.

At the end of the Spanish–American War, African American men found new dignity and respect as military heroes in America's efforts to expand their national influence beyond the borders of continental North America. In 1898, as the United State sought to wrest control of Cuba away from Spain, Theodore Roosevelt's white "Rough Riders" would have been "utterly annihilated" had it not been for the African American soldiers who rescued them and went on to capture San Juan Hill. As soon as Black men gained public recognition for being as good as—if not better than—white men, whites anxious about their own feeble masculinity and racial supremacy began to erase the history of the African American "Buffalo Soldiers" not just in Cuba but in the Philippines as well. The Spanish–American and Philippine–American wars became defining moments when African American men demonstrated unparalleled wartime bravery and sacrifice becoming "shining beacons of black manhood," as described by Andrew Amron. Black men came to embody the ideal late-Victorian man in their discipline and respectability.[87] Increasing numbers of soldiers in the face of American racism sympathized with Filipino freedom fighters seeking to gain independence from the United States. Many African Americans remained in the Philippines after the war.[88] White Americans, however, refused to allow African American soldiers to become a symbol of race pride and solidarity among different peoples of color, both domestically and internationally, according to

Christine Bold. Thus the "coon song" that poked fun at an African American soldier marrying a Filipina deliberately worked to not only devalue Black men but also to undo African American racial pride and international solidarity with Filipinos against white supremacy, ideas circulating broadly within Black popular culture at the time. Indeed, as white women on stage creatively engaged in shifting norms of womanhood and romance, their popularity soared precisely because of a superstructure of inequality along race, gender, and sexuality that would never allow a white woman to actually sing a love song to a Black woman on the Orpheum Theater stage.

Unconventional racial and sexual crossings appeared particularly permissible in San Francisco in print and on stage. By 1900 the city had established itself as a place of immense sexual freedom, so much so that by 1906 the city instituted reforms to "clean up" what conservatives perceived to be a morally chaotic city.[89] Yet the perceived chaos of the city could take place precisely because of the city's entrenchment in order. The proliferation of these seeming transgressions more powerfully signaled the solidity of the status quo. In a world where whites and heterosexuality ruled the norm, interracial affairs and same-sex sexuality would hardly register as any sort of social threat. Misogyny, too, significantly shaped the tone of city's representation of gender and sexual acts in newspapers, journals, and magazines. Accounts frequently devalued white women's voices, questioned their integrity, and in many cases blamed them outright for all forms of failed relationships with white men and men of color alike, even when it resulted in their murder. The city's extensive proliferation of gender, sexual, and racial crossings would be less about renegotiations of power and privilege and more about how an uncontested hegemony could in fact facilitate the peaceful existence of seemingly divergent racialized gender and sexual expression.

Mayor James Rolph aptly summarized the city's openness as one that facilitated amusement and entertainment, a signature of San Francisco's life and character. "We ask the world to come here and revel." The mayor's invitation, however, would not be an open call for everyone. Wide open San Francisco served as a playground for the pleasure of a select group of people. Irate citizen William Cole in 1918 protested that "the dirty sneaking skunks of the morals squad [were] a stench in the nostrils of manly men."[90] In a world where men of color and all women had no access to the term "manly" in its reference to ideal masculinity, the city implicitly understood that its valuation of freedom revolved around the leisure of white men. Thus as uniquely "wide open" as San Francisco may have appeared, the city's ability to "live and let live" could ex-

ist because of its unyielding structures of power and privilege rather than any openness to radical change. In their stability then, the city could publicly engage in conversations that may have rendered less established and more contested regions of America topsy-turvy.

Notably, as nonthreatening as interracial and same-sex intimacies appeared at the turn of the century, changing norms of womanhood and its impact on marriage concerned white men in the city to a greater degree, as evidenced by the larger number of articles, short stories, and social commentary on the modern woman and divorce. In other parts of United States as well, white women's sexuality appeared as the most threatening social issue in the late nineteenth century. In New York City, authorities viewed literature on women's independent sexual pleasure as supremely obscene.[91] As San Francisco embarked on a new century, women's growing independence also figured in as the most pressing sociocultural shift.

"Deliver Me from the Brainy Woman"

The Modern Woman and the Geisha

After only six weeks of what was initially "wedded bliss," Harry D. Cobb could no longer stand the company of his new wife. He had hoped she would polish his shaving mug daily and treat the birdcage to a "matutinal massage." The bride, however, refused and instead began wearing Harry's neckties. It was more than he could take. He already spent nights in a stifling room since she objected to sleeping with the window open. The two divorced in March 1900. Harry's expectation of a dutiful wife, the bride's adamant refusal, and her additional raid upon her husband's neckties aptly summarized the difficulties that appeared to confound San Francisco couples at the turn of the century. In newspaper articles, illustrations, and journal essays, husbands lamented their subjugation under "petticoat" government, and women increasingly asserted themselves in ways previously considered unwomanly.[1]

San Francisco joined other cities in a nationwide rise in divorce and a growing cultural movement to modernize womanhood into what many called the "New Woman." Greater expectations for a fulfilling marriage along with increased geographic mobility and women's economic independence empowered more unhappy people to dissolve their marital commitments.[2] In San Francisco, literary and visual images of Japanese women grew exponentially alongside lively debates around new womanhood and its consequences on marital bliss. In newspapers, journals, and theater productions, tiny Japanese girls enveloped in flowing silk robes contentedly stayed inside the home and cheerfully served

white men. While the heightened production of geisha narratives and imagery might appear as merely another moment in America's long engagement with Orientalism, their increased articulation occurring on the heels of the "New Woman" point to how white women's explorations of gender and sexuality in fact fueled racialized productions of romanticized Japanese femininity. The rise of the modern woman thus popularized a specific notion of Japanese womanhood, thereby birthing the mass consumption of what would become the indelible Asian feminine stereotype of the geisha in America.

The Modern Woman and Her Problems

From 1890 to 1900 the number of divorces nationally had almost doubled, from thirty-three thousand to fifty-six thousand. For several years divorce had multiplied five times as fast as the population.[3] In San Francisco it appeared to be particularly a white, middle-class problem. Many divorcing couples had multiple residences, including vacation or beach homes. Others employed cooks and servants. Lillian Snyder, an heiress of a well-known capitalist who owned a large portion of Oakland, filed for divorce in 1898.[4] When May J. Shaw's husband turned off the gas to their house on 333 Haight Street as he left, May packed her trunks and lived in the Langham Hotel for a week.[5] In 1901 when courts found Ann Gorman guilty of extreme cruelty, her husband won seven-twelfths of community property, including the "homestead."[6] Two years later when Thurlow McMullin decided to leave his wife, he had the maid pack his bags.[7] Mamie Bacon had to sell her diamond bracelets and jewelry to buy bread for her children when her millionaire husband Frank Bacon abandoned her.[8] With automobiles and stocks in companies, San Franciscans seeking divorce appeared, in the city press, to subsist at a higher level than those in the laboring classes. Moreover, Reverend W. Guy Smith, pastor of the First Christian Church in Oakland, accused his wife Laura of adultery and demanded a divorce when in fact he was having an affair with the superintendent of the Christian Sunday school, Mary Browning, a woman of unblemished reputation and the daughter of a wealthy rancher.[9] According to the *San Francisco Chronicle*, the working class would never jump to divorce so quickly. For those poorer, divorce only came as a "remedy" to overworked or abused mothers and drunken fathers. Divorce was a luxury for those with financial wealth, its high rate attributable to the "fickleness of the gringo."[10]

Alarmed social scientists and religious leaders blamed the trend on the modern woman who refused to stay exclusively in the domestic sphere. The "New Woman" had more education, led a physically active life, and enthusiastically

ventured out of the home to take on more public roles both in social reform and paid work. According to historian Lynn Gordon, women's colleges such as Radcliffe and Barnard at first defined the role of the nation's educated woman. The evolution of women's athleticism from "calisthenics" to "sport" also originated in New England colleges such as Vassar and Smith.[11] An unencumbered, savvy, and healthful woman such as the "Gibson Girl" flowed from the imaginations of artists who worked feverishly for popular magazines circulating out of New York City.[12] Urban areas throughout the nation experienced an infusion of women into public spheres previously occupied solely by men.

San Francisco publicly engaged in expanding ideas of appropriate femininity. The *Chronicle* declared that baseball, running games, marbles, and even football enhanced girlhood. Girls began to play games their grandmothers had previously thought unfeminine. Dolls, too, fell out of fashion for girls as boys increasingly picked them up.[13] The *San Francisco Call*'s home-study series for young girls featured fierce, independent, nontraditional women such as crossdressing warrior Joan of Arc, renegade author Jane Austen, and battlefield medic Florence Nightingale.[14] In 1901 the cover of the *Wasp* featured new career opportunities available to women graduates in theater, art, and various other fields.[15] President of Stanford University David Starr Jordan stated, "We are getting tired of women who are kept in when it rains and when the sun is too strong. We want women who know something."[16]

The local press highlighted how women seemed especially well suited for certain professions. Women made better candidates for administrative appointments in education, and analysts asserted that housewives would be more likely to give information to a census taker of their own sex. Female construction workers also seemed prudent, considering women spent the larger part of their time in the home. Application of her skill would enrich the home, making it more cozy with better design. Women as firefighters, blacksmiths, lighthouse keepers, and undertakers received praise for their independence, intelligence, and strength.[17]

Shifts in womanhood did not come without protest. One Stanford University professor claimed physical prowess coarsened feminine nature. Women, he argued, should focus on the domestic duties of motherhood, where nurturing without recognition surpassed the work of any "rollicking red cross nurse" in nobility and superiority.[18] Older women also advised younger women to be more "shy" and "staid."[19] Traditionalists warned of the hazards of women's physical activity. Cardinal Gibbons in a San Francisco sermon blamed women's increasing ventures outside the home for "wrecking families." New inroads made by women "robbed them of all that is amiable and gentle and leave only masculine

boldness and brazen effrontery." Gibbons warned, "We find women especially in higher circles neglecting her household duties, gadding about, never at peace unless she is in perpetual motion, never at ease unless she is in a state of morbid excitement, she never feels at home except when she is abroad."[20] For the most vocal critics, the modern woman, strong willed and smart, lay at the root of the "mad march of divorce."[21]

Women appeared to dominate men in all areas of marital affairs. In December 1897 cashier Frank A. Taylor laid himself in an alley near the corner of Market and Taylor and waited for authorities to find him to convincingly dramatize a story of being drugged and robbed. He feared telling his wife that he had spent $42 at a nearby saloon. A poem titled "A San Francisco Romance" expounded on how love between women and men in the city appeared particularly contentious. "Do you love me as you used to / In the past and over years? / 'Yes,' she says, 'I love you madly, / Even as I love you then; / But I've married in your absence, / And divorced three other men.'"[22] In this "San Francisco romance" and countless more, the woman consistently appeared as the fickle destroyer of stable, long-lasting love.

In fact, traditional values rather than radical thinking undergirded much of what appeared to be a movement for greater economic, political, and social freedom for women. During a talk at the University of California at Berkeley, clubwoman Roberta Burdette highlighted the virtues of higher education in the creation of an ideal wife. "By making her home work pre-eminent the wife will benefit the world."[23] While San Franciscans reportedly preferred women who knew the difference between a "logarithm" and a "log," support for women in schools existed in the context of the women's reproductive value since "education made better mothers."[24] Reverend A. J. Wells, who favored suffrage and asserted that liberating women from the necessity of marrying would only further "ennoble . . . marriage," cautioned against "the brainy woman with a mission."[25] The adjutant general also refused to hire a woman applicant because of her gender, even though she was the only individual who passed the civil service examination, which required the knowledge of five modern languages, including the ability to translate into English various technical military works of French, Spanish, German, and Italian.[26] While significant changes took place in the public role of women, a fundamental ideological shift seemed less forthcoming.

A profile of famed boxer Cecil Richards, the "latest debutante in California pugilism," expanded existing portrayals of women boxers while relying on traditional notions of femininity.[27] Women boxers typically appeared as a spectacle in flashy circulars such as the *Police Gazette* that catered to the lower classes in New York City. Women with their hair cut short to prevent pulling fought in

tights to an audience of hecklers rather than viewers awed by their pugilistic skill. In more private matches, women fought stripped to the waist in front of gawking male audiences.[28] By calling Richards a "debutante" the *Chronicle* immediately elevated Richards's social status within a highly stigmatized activity for women by reinforcing her appropriate femininity. "Anyone who expects to see an Amazon or Cuban warrior, or a strapping 6 footer splendidly muscled will be terribly disappointed," stated the *Chronicle*. Though clever, quick, and aggressive in the ring, "on the street this young warrior wore a modish coat and a hat that is a fetching confection of violets." The article warned playfully, "Underneath the fur . . . she's a tiger cat." Though Richards hoped to fight men after beating all of her women opponents, she "modestly" noted that she might last six rounds of two minutes rather than knocking out her male opponents. The *Chronicle* likened Richards to a "blossomed rose," pink and white without rouge or powder, with curly, riotous red hair, big brown eyes, red lips, and dimples. The paper's praise and emphasis on Richards as a flower, explicating her beauty and gentility amid her formidable physical prowess, revealed the acceptability of women's athleticism only when framed around softer ideals of womanhood. As women made inroads into areas previously considered inappropriate for women, their entry remained limited. Richards, who used a pseudonym, in fact refused to reveal her family name.[29]

San Franciscans appeared to be uniquely conservative in forwarding women's independence compared with other Californians. Movements for women's suffrage had radical origins in the West in all but urban areas such as San Francisco. In the early 1900s, political pundits looked to California to see if women would gain the vote, since the Golden State was both "the most conservative" and "the most powerful" of the Pacific Coast states. San Francisco as a city voted against women's suffrage even as all the neighboring counties voted for it in the measure's successful passage in 1911.[30] No doubt the city proved hesitant in promoting women's political participation even as it publicly lauded the modernizing woman.

In fact, San Franciscans seemed to support their own specific version of the modern woman, which they called the more pleasant "Frisco Girl" and adamantly opposed what they perceived as the vulgar "New Woman" from the East Coast. One popular song, "Frisco Girl," particularly highlighted local women's appealing ruggedness in swimming, rowing, lawn tennis, golf, and other outdoor sports. The "Frisco Girl" sown uniquely from California's soil was athletic, independent, and intelligent.[31] She walked, wheeled, drove, sailed, rowed, swam, and knew the secrets of the mountain trails. She brought down wild game with celerity and skill, yet still knew how to dress appropriately for any

occasion.[32] The *Chronicle* reported, "The California woman is decidedly up to date, and not only goes into court as a full-fledged attorney, but in the guise of official reporter. . . ." "[They are] equal of their brothers in rapidity, exactness, and conscientious discharge of duty."[33] With intellectual accomplishments as well, she undoubtedly left some "bleeding hearts strewn along her track."[34] D. Stephenson, instructor of the San Francisco Golf Club, scoffed at "the lily-white, fade-away society girl of the yesteryears" and praised the city's "golf girl," with her rosy cheeks and accompanying freckles from outdoor exercise.[35] The frontier specifically had cultivated the best of these new feminine qualities embodied most notably in the "Frisco Girl" as opposed to the "New Woman."[36]

Despite the city's assertions about the uniqueness of the "Frisco Girl," her qualities proved not so different from those of the "New Woman." The insistent differentiation between the two, more significantly, may have signaled San Francisco's aversion to what it believed to be a more radical version of modern womanhood. In its very naming, the use of the term "girl" as opposed to "woman" forwarded a more youthful, less threatening reconfiguring of the modern woman who would remain perpetually in adolescence. Author Willa Cather similarly created a less radical, western "New Woman" in her 1913 novel titled *O Pioneers!* through her protagonist Alexandra, who mirrored many of the characteristics of the modern woman as a single, independent, managerial, and strong-willed entrepreneur. For Alexandra, however, her situation was not a choice. She had been pressed into responsibility after her father's death in order to honor his mandate that she "not lose his land." Willa Cather deliberately drew a nonthreatening figure described by literary critic Reginald Dyck as a "reluctant New Woman pioneer."[37] Ironically, as the modern woman out west sought to detach herself from the distastefully more radical "New Woman" of the East, both versions would have similar implications for women of color. Within a transnational frame, the "New Woman" propagated racism and western imperialism by relying on the logic of furthering women's rights to bolster civilization against the threat of brown barbarians.[38] The "Frisco Girl" would be no different.

Geishas

Amid increasing visibility on new ways of being a woman and its link to divorce, representations of Japanese women as geishas and submissive courtesans filled newspapers, magazines, and theater houses. In photographs "pretty teahouse girls" clutched each other and gazed innocently into the camera. In poetry and short stories "sweet" and "doll-like" Japanese women arose from a mystical

setting, such as in a "tiny garden," sipping tea, when a white man would swoop in and capture her heart.[39] In Hester Benedict's essay on Captain Gluck, a fair young Japanese bride in soft kimono and silk zori would shine star-like in his home and "make the whole world radiant."[40] George Amos Miller wrote of Japanese women smiling daintily as they even gave up their hair to make cables for temples.[41] Clive Holland's novel *A Japanese Romance* detailed a "blindly loving" Japanese wife abandoned by her English husband.[42] Representations of Japanese women as soft and devoted contrasted sharply with images of the stronger, independent "Frisco Girl."

In these accounts Japanese women appeared consistently within the home. Their location contrasted sharply from reports of white women who not only "invaded" the public sphere in work but also those who gallivanted in venues considered morally questionable for young "ladies." At pool houses throughout the Tenderloin District, white women made bets on horses and the stock market. In 1900 a group of women gathered regularly on Monday afternoons in room 10 at 632 Market Street. Other women frequented pool houses owned by Crowley & Raggett at 109 Powell Street, Kohn & Anderson at 36 1/2 Geary Street, Heany at 110 Ellis Street, and J. S. Purdy in the Columbian building.[43] Images of doting domesticated Japanese women titillated the imaginations of San Franciscans who mourned the loss of "traditional" femininity even as they enthusiastically explored new modes of a more "modern" woman. Romanticized Japanese women served as fantasy geishas with a comforting, unimposing warmth in a romantic world where individuals increasingly perceived the light of white American women as harsh.

In the Leonard Sawvel's short story "Nita, Child of the Sun" published in the *Overland Monthly*, Nita fulfilled the request of her patron Bob Cummings to dance at his mother's party despite Nita's grave physical illness. Nita, "wreathed in smiles," painstakingly rose to greet Cummings. "She was the geisha now, dainty, piquant, sweet—ready to entertain." "Her inky eyes, looking up into his, flashed strangely through their mist." With her "little ears and whitest neck," she swayed her "light body . . . to and fro in stately rhythm," as her ankles peeped out in "tiny brocaded, jeweled slippers." As she finished her performance, she collapsed. Cummings rushed to the bundle of silk and picked her up in his "strong" arms. "Nita," he whispered into her ear, pressed her close, and then kissed her. Her "tiny" hands closed "feebly" about his neck as she whispered, "Most beloved," and died.[44] Nita sacrificed her life to indulge the whim of the white man.

The emphasis on Nita's petite body next to the broad-shouldered six-foot-one Cummings underscored the dainty fragility of Japanese women as overbearing American women grew taller, broader, and more muscular. In 1898 an

illustration in the *Wasp* titled "An Embarrassing Order," two daughters towered over their diminutive father, who demanded that they take off their bloomers to go bicycling. Posturing defiantly, they smugly responded, "Ah—do you want to have us arrested?" In 1905 an article on trapeze artist "Miss Capitaine" featured a photograph of her back as she flexed her arm at ninety degrees. Impressive muscles bulged from her biceps, triceps, deltoids, and rhomboids, "writhing and whipping" under her "smooth skin." When the *San Francisco Chronicle* recounted sixteen-year-old Nora Sullivan's determination to play football despite her parents' disapproval, the paper described the "female pigskin kickers" as "Amazons."[45] Depictions of small Japanese women directly contrasted with emerging images of taller, athletic white women who asserted themselves forthrightly.

Japanese women eager to sacrifice themselves appeared particularly devoted to husbands. Kate Simpson-Hayes detailed the story of "Little Madame Na-mura" who worked hard to raise her children. Na-mura's husband could have been a schoolteacher in Japan but he took the first job offered to him in the United States. He drove a scavenger's cart until a stoning inflicted by racist

Rippling back muscles of trapeze artist "Miss Capitaine." Blanche Partington, "With the Players and the Music Folk," *San Francisco Call*, January 29, 1905.

youth split his head open and caused various injuries that "maim[ed]" him. He began a new job chopping wood and asked his wife to assist him until one day a tree fell on him and killed him. Na-mura struggled to make ends meet, taking on multiple jobs, including one as a cook at a camp for laborers. So impressed were the workers that they collected money for her to take a break when she gave birth to another baby.[46] Na-mura symbolizes a consummate helpmate who even after the death of her husband births his second child, reinforcing her bond to her deceased spouse and her role as maternal caregiver. Simpson-Hayes painted an impressive story of self-sacrifice and perseverance particularly poignant in the face of seemingly self-centered, fickle white women who all to eagerly abandoned relationships. Cultural critic and advice columnist for the *San Francisco Call* Dorothy Feinmore regularly pressed her women readers to be more patient. She noted, "Love . . . require[s] work." The popular columnist who appealed to middle class whites promoted the value of a slowly building, restrained form of love driven by rationality and devotion rather than an affair that burnt out quickly due to individual passion.[47]

In actuality, Japanese women also defied conventions of family and marriage to forge their own happiness. Countless *issei*, or immigrant women, unhappy with their husbands, boldly left their marriages. Notices searching for runaway wives sprinkled the Japanese American daily newspapers. Yujiro Sakuragai offered $150 for the return of his twenty-three-year-old runaway wife, Maki Sakuragai. Niichi Kawamura suspected that his wife, Nino, ran off with Goichiro Nakatani; he posted pictures of the two to *Shin Sekai* in hopes of his wife's recovery. Thirty-seven-year-old Tora Oshima's husband also offered a $25 reward for knowledge of her whereabouts.[48] Hisako Hibi disobeyed her father's directions to return to Japan with him to get married at the age of nineteen. She remained in San Francisco and supported herself through odd jobs to educate herself rather than marry.[49]

A smaller number of defiant Japanese women, in fact, publicly appeared in the mainstream dailies that catered to white readers. Recently widowed Tama Yuwaoko risked death when she refused the marriage proposal of her late husband's friend Shinzero Matamoto. Enraged by her response, Shinzero shot Tama three times with a .38 caliber on Fifth Street in Oakland before shooting himself.[50] Across the Pacific Ocean in the town of Toyama, Kihei Asauchi's wife, Fuji, also appeared in the *San Francisco Chronicle* when she divorced her husband with the support of her father after ill-treatment from her husband. Not only had Kihei squandered all their property while married, he later blew his wife into "ten pounds of scattered flesh" after rolling a bomb underneath her chair while she was nursing her new baby.[51] Violent husbands forced women who as-

serted themselves to pay with their lives. These narratives, however, also served to demonstrate the monstrosity of Japanese men amid the growing presumption that Japanese women were dedicated wives and mothers. These racialized accounts of intimate partner violence allowed whites to feel righteous in their own masculine civility and further feel protective of their imagined innocent geisha.

San Francisco newspapers and journals committed to the production of the Japanese woman as a devoted wife conversely punished fictional Japanese women who diverged from their appropriate role. Those who became westernized faced irreversible tragedy. In Olive Dilbert's short story, protagonist Umeko found herself homeless after she abandoned her traditional Japanese husband, Taro, for the more Americanized Satsumoto. With a big white plumed hat perched on her head, Umeko sashayed out the door to be with Satsumoto-san, a smooth talking "gentleman" who expounded on the virtues of divorce and women's independence. A year later she returned disheveled to Taro's doorstep. She spoke of the harrows of being married to Satsumoto, offered to cook Taro a traditional Japanese meal, and vowed to stay by his side forever. Taro, however, had found a new Japanese wife.[52] In this short story, Umeko, a symbol of lost traditional femininity as a ruined Japanese woman, explicitly embodied swirling discussions around the modernizing white woman. The *Chronicle* similarly wrote of Japanese serving maids along coastal Japan spoiled by "western civilization." They had grown "saucy, familiar, abrupt, rough, and rude as compared with their sisters of former days" who were, "pretty and gentle mannered," "deferential."[53]

Ironically, in the courtroom, Japanese women who did not conform to American values of female sexuality faced the threat of deportation. Judge Cook pushed to deport fifteen-year-old newlywed woman Kotsuru Iki on the basis that she had not yet had sexual intercourse with her husband. According to the judge, she had not "consummated" their marriage and thus their legal union was invalid.[54] As the city's literary and visual images promoted the charm of Japanese women's innocence and sexual inexperience, authorities would persecute the teenaged Iki along white American standards of sexual knowledge.

When a musical play *The Geisha* opened at the Tivoli Theater on October 17, 1897, patrons continued to fill the seats to capacity nightly into its third week to see white women as cheery Japanese "geisha girls."[55] The girls sang of their light, accommodating nature. "Merry little geisha we! Come along at once and see, ample entertainment free, given as you take your tea."[56] The main female character, Mimosa, was "a charming little geisha—quite the nicest girl in Asia." When the protagonist, the Englishmen Fairfax, flirtatiously explained to Mimosa that the "English, French and German misses do not ask me what a kiss

is—they are all expert at kissing," Mimosa begs in her singsong manner, "Will you teach me please? I believe I am quick and clever, and I promise I'll endeavor, in the task to do you credit if your pupil I may be!" Fairfax then instructs her to place her "pretty lips together in a dainty little pout" as he steals a kiss. He teaches "Japan's fair daughter to flirt and kiss like the little white miss."[57]

Popularity for *The Geisha* climbed amid an "osculatory epidemic" sweeping San Francisco. According to the *Wasp*, store clerks would soon kiss their customer in gratitude, domestic help would kiss their employers after a raise, and writers would entice publishers to print their work for a kiss.[58] Kisses also apparently had become a commodity to be traded for services. When Herman L. Peters and Julia Goldie officially married at the courthouse, the husband had no funds and the wife had forgotten her purse. The *Chronicle* reported that Justice of the Peace L. Herrington allowed Goldie to pay the debt in kisses to himself and two other city officials at $1 a kiss.[59] Mimosa of the *The Geisha*, in her ignorance around kissing and flirting, appeared like a virginal maiden in comparison to white women who had become pathologically loose with their kisses.

Critics in other cities railed against the absurdity of *The Geisha*. East Coast reviewers noted that "cheap puns" and "mumbo jumbo" prolonged the script, rendering the musical "incoherent" and "uncomfortably stupid," "with no way out of difficulty [except to] leave the theater."[60] *The Geisha* hardly reflected anything Japanese "except in a western and frivolous way." Another reviewer speculated that only the varnished wigs and costumes were actually of Japanese origin.[61] Yet San Francisco audiences found *The Geisha* amusing, an entertaining window into the culture of Japan. Young society buds found the production compelling, since the romantic and sexual interludes likely felt relevant to their own shifting romantic norms.[62] In this musical comedy, Japanese geisha girls diverged from white women in their timidity, sexual innocence, and gratitude for any male attention, even when it resulted in rejection and betrayal. In *The Geisha*, Cunningham leaves Mimosa after her first kiss and returns "only speaking of an English Miss." Rather than feel angry, deceived, or despairing, Mimosa responds, "You love for as long as you can! A month, a week, or a day sir, will do for a girl of Japan!"[63] *The Geisha* narrated a romantic tale of East meeting West and aptly summarized San Francisco's popular imagination of Japanese women as innocent martyrs of white man's sexuality.

In Japan, femininity proved to be "a carefully taught art—an etiquette centuries old—which leaves not one gesture, posture, tone, expression, word, or glance to be unstudied." Minnie Wakeman Curtis explained, "The smiles, caressing voice modulations, the flattering attentions of the most antique artifi-

ciality, yet are sweeter than honey." The femininity ritual included, "above all to obey some man, any man, father, son, husband, brother to serve, to please, never to contradict, never to be disagreeable in act word, tone, of look, to be cheerful and gay, joyous, guileless, infantile, to chatter bright nonsense, to laugh infectiously, carefully to affect all the artless mannerisms of a pretty affectionate little child."[64] The *Call* noted, "Our girls are taught that their supreme object is to be brilliant society women, while the Japanese girls are taught that it is their greatest honor to become good mothers."[65]

Ironically, images of Japanese feminine gentility did little to productively shape Japanese women's experiences in America. In job listings for domestic service in which appropriate femininity would be a plus, Japanese women proved to be in little demand in employment compared to their white cohorts. White immigrant and American-born women advertised their skills and often attached comments about their feminine demeanor, identifying themselves as "comely," "attractive" or "refined" to appeal to potential employers. The few Japanese along with Chinese women who advertised did not utilize gendered descriptions. Such self-characterizations may have been inconceivable to Asian women, who were rarely hired for their attractive or refined femininity. Employers who sought out "feminine" domestic help specifically solicited Swedish, French, or German women. None requested Japanese or Chinese women.[66] In fact, white San Franciscans generally believed that European immigrant women or Japanese men made the best servants.[67]

White women essayists, too, detailed Japanese women's feminine and sexual desirability. Gertrude Holloway wrote of carefully courting a Japanese woman, secretly desiring a kiss. She observed the Japanese woman in the shadows of a nearby nook, afraid of scaring her away, fixated on her "features fair" and "lips framed for a kiss." The Japanese woman spotted Holloway and smiled. She then retreated, leaving Holloway wounded by "Cupid's feathered arrow."[68] Poet Grace Hibbard additionally enacted what she believed to be a Japanese romance in the *Chronicle*. As she sang to the moon underneath the window of her "sweet," her heart pined "ting-a-ling." Hibbard assumed the perspective of a Japanese man pining away for the affection of a Japanese woman. She wrote, "I am a minstrel poor,/ Ting-a-ling, ling-a-lee,/ What can she care for me?"[69] Though Holloway and Hibbard most likely wrote to appeal to white male desire for Japanese femininity, as white women they also literally engaged in articulating desire for Japanese women.

Women declaring love for another woman might have carried great potential for alternative readings, particularly during a time when "romantic friendships" between middle- and upper-class white women appeared relatively common.

These socially acceptable relationships among education- and reform-minded women proliferated from the 1880s into the early 1900s, until critics grew increasingly concerned about the prevalence of homosexuality in America and discouraged female intimacy as "lesbianism."[70] Yet during a time when same-sex sexuality would hardly register among the general public and whites commonly appropriated people of color for leisure, a writer's literal engagement with same-sex sexuality became lost in the face of the unquestionable presumption that romance could only occur between a man and a woman. These works reflected a web of romanticism around Japanese femininity that both white men and women produced amid shifting norms around white womanhood.[71]

For sure, women in Japanese San Francisco existed in very different ways from the images dominating white leisure culture. Issei cartoonist Henry Kiyama drew Japanese women as lumpy and large, often physically dominating their more diminutive husbands. They exerted control, carrying out decisions concerning the household. Kiyama drew scenes in which wives inadvertently put their husbands in headlocks. He undoubtedly used strong Japanese women as a comedic device rather than an empowering feminist statement. In his illustrations, sexually desirable women were more often white than Japanese. Still, for Kiyama and the local Japanese with whom his cartoons resonated, marriage to a Japanese woman and romantic fulfillment meant much more than the simply added companionship of obedient, dutiful wives.[72]

Additionally, Japanese women in San Francisco, though infantilized in the city press, could hardly afford to be as naïve as their representations appeared. Ryoko Maruoka, a schoolteacher in Japan, was far from an exuberant teenager eager for romance when she came to the United States to join her soon-to-be husband. In Japan she had just met one prospective groom who was "looking for a beauty." She explained, "I was the eighth to be interviewed. Since I was no beauty, I was resigned to not getting married." Her married older sister then encouraged Maruoka to travel to the United States to meet her husband's younger brother, who was still unmarried. Maruoka reasoned, "I felt that if I didn't like him for a husband I could tour the U.S. and return to Japan." When she arrived in San Francisco, she felt instantly relieved when she spied that her future husband had come to meet her.[73]

Japanese women also pursued some of the very goals of the modern woman that whites asserted Japanese womanhood to be fundamentally against. In 1898 Una Yone Yanagisawa graduated from University of California at Berkeley as the first Japanese women to do so from any American college. The *Chronicle* noted, "As a student in social sciences, she had an enviable record for brightness and industry, mostly in English and History."[74] Shige Kushida caught the attention

of her future husband while she preached on San Francisco street corners in an effort to rescue wayward Japanese American women. Kushida had already founded the Women's Christian Temperance Union in Japan before she came to America.[75] George Shima's daughter pursued a graduate education in botany at UC Berkeley after graduating from Vassar, despite her mother's protests that she learn housekeeping instead.[76] Japanese American community leader Yonako Abiko attended peace conferences, church meetings, and Japan society meetings regularly.[77] She often traveled alone for various meetings and visits. She took the train to Palo Alto and even hopscotched the nation from Ohio to Pennsylvania to New York.[78] Throughout the 1920s Abiko, a prominent and well-respected woman, attended shows at the Chinese YWCA, addressed Japanese students at the YMCA, attended ballgames, and frequented museums such as the Palace of the Fine Arts. She spent much of her summer months eating "fancy sandwiches" and ice cream.[79]

In fact, during the late Meiji and early Taishō periods the Japanese government issued edicts that encouraged women to develop their intellect and pursue education for the purpose of becoming better mothers.[80] Japanese women in America as well discussed the benefits of American childcare and education, including birth control, in a regular column of the Japanese American newspaper *Nichibei Shimbun*.[81] This ideal of modern Japanese womanhood notably took on similar motivations as those in the United States in which educating women became important for its reproductive value—a fact that San Francisco whites immersed in exploring their own meanings of modern womanhood failed to see.

Japanese women in San Francisco also openly supported women's suffrage. Even as an older generation of Japanese in America believed that the younger generation advanced too rapidly toward "modern ideas," the community largely supported women having the ability to vote.[82] Ironically, public figures or seeming "experts" on Japanese culture such as Mabel Nitobe, a white woman married to renowned economist, educator, and Japanese diplomat Inazo Nitobe, would more profoundly affirm American views of Japanese women as homebound. Positioning herself as Japanese, Mabel explained, "We women in Japan do not bother ourselves with affairs which belong to the men. We devote ourselves exclusively to the upbringing of our children." With confidence she declared, "I can say, . . . the women of Japan will not ask for equal suffrage within the next two generations at least."[83]

Moreover, increased visibility on Japanese femininity took place under the fundamental assumption that the Japanese were inferior to people in the West. *The Mikado* derisively ridiculed Japan even though its author, W. S. Gilbert, wrote the comic opera in reference to British social anxieties rather than Japanese.

Social offenders eligible to be beheaded included the "nigger serenader and the others of his race, the lady from the provinces who dresses like a guy, and who doesn't think she waltzes but would rather like to try, and that singular anomaly, the lady novelist, I'm sure she'd not be missed."[84] Gilbert noted that when he found the aristocracy of old Japan was called "samurai," he decided to keep clear of historical accuracy to facilitate rhyming phrases. Literary critic W. A. Darlington notes that it was obvious, "to Englishman, anyhow," that Gilbert had not thought of representing real Japan in the creation of *The Mikado*.[85]

Yet protests against the opera popped up in various cities previously because of its offense to Japan. In 1910, New York reviewers openly insulted the production as "old-fashioned" and "out of tune with modern conditions." Since *The Mikado*'s original debut in the 1880s, "Japan . . . ha[d] stepped to the front to take among the world's greatest powers so that today we laugh with the Mikado not at him."[86] In London, Parliament found *The Mikado* so offensive and unrepresentative of Japan that the foreign secretary, Lord Chamberlain, banned its performance in England out of respect for Japan, even though no complaint had been issued from Japan at the time.[87] San Francisco critics, however, predicted a long run for the "pleasing opera," effusively complimenting the "sparkling musical comedy."[88]

For those who had never visited Japan or had any significant contact with actual Japanese people, this comedy served as an invaluable window that shed light on the Eastern nation. Gilbert used Japan specifically as the setting in which white actors appeared in yellow-face. The son of the Mikado of Japan, Nanki Poo pursues his love, Yum-Yum, who is betrothed by arranged marriage to a tailor who recently became a lord high executioner of the town of Titipu. After a series of circuitous plot digressions, character disguises, and mistaken identities, Nanki Poo marries Yum-Yum at the conclusion of the play. Some theater critics have interpreted *The Mikado* as not racist, since Gilbert's intention was never to represent Japan. However, *The Mikado* became pejorative as audience members laughed at outrageous Japanese characters and left the performance reveling in the merriment of a comedy that relies on the fundamental assumption of Japanese culture as ridiculous.[89]

While *The Mikado*'s gender and sexual themes intended to represent British social anxieties, issues in the comic opera also mirrored San Franciscans' own debates about appropriate gender conduct. Yum-Yum's name, which is hardly Japanese, infantilized the Japanese maiden into a charming treat. She appears innocent and pure—a girl who hesitates to allow her fiancé to kiss her in public even in the last remaining days before the wedding.[90] As Gilbert wrote *The Mikado* to illuminate existing anxieties of his own world and not those of Japan,

he created compelling images of Japanese society that also appealed to white San Franciscans' own explorations of modern womanhood. In the ensuing decades, college women and church groups throughout San Francisco enacted the popular libretto. As late as the 1920s, Sonia Sunwoo, a Korean American woman who grew up in San Francisco, recalled participating in the production of *The Mikado* at her elementary school.[91]

The theatrical use of Japan as a site of ridicule becomes sharply apparent when juxtaposed to the significantly smaller number of representations of the city's Italian theater, an alternative venue upon which San Francisco played out its anxieties about its disappointing "decrescence of romance."[92] Italian theater in which Italian Americans played Italian characters celebrated rather than poked fun at Italian culture. In 1906 J. M. Scanland positively reported on the boisterous festivities of the Italian quarter in San Francisco. Young, unmarried women who swapped dates nightly held an endearing, adventurous, and notably innocuous feminine sexuality. Italian love, with its women who flirted and talked openly about their sexuality, is what made the "gay world" the "sweetest." Women delighted theatergoers, adding "fuel to the flame, [by] coquettishly plac[ing] the tips of [their] fingers to . . . full-rounded lips, and with a delicate sibilant noise, tossing [kisses], fresh and warm to the audience."[93] Ernest Peixotto wrote eloquently on the beauty of Italians in his book *Romantic California*. Men of diverse masculinities, full of "Italian character," from "a decrepit but proud marquis" to a "country clown with spiked wig," all viably competed for the attention of one "pretty milliner."[94] Peixotto's personal ties to the city's Italian community informed the tone of his writing. Shops of bologna sausages, tagliatini, tortellini, and reginni on Dupont Street had fascinated him as a youth.[95] Though Italian dramas would use humor as a theatrical device, it would never be in a way that derided Italian culture.[96]

A smattering of essays cited Italians as models of romance and female marital commitment in the face of widespread discourse on the difficulties of marriage. Western writer Charles Warren Stoddard declared Italians as embodying "passion as the ecstasy of love," "a race that for ages lived in the land of love."[97] Tour guides noted Italian cities as the "most romantic."[98] During the dedication for the Panama Pacific International Exposition in 1915, city officials hailed Italy as the "land of romance."[99] Jans Van Dusen and Mabel Nelson Thurston wove tales of Italian women committing themselves to staying married despite extreme suffering.[100] The press applauded Italian poet Vittoria Colonna's loyalty and nurturing ways as she tended to artist Michelangelo when he grew old. For the *Call*, Colonna's actions serving the needs of others rather than forwarding her own poetry guided "girls" into ideal womanhood.[101] In 1898 *Wasp* commentator Paul

Pry more explicitly stated that the Italian fashion of preparing young women for marriage proved better than the American way.[102]

In sharp contrast, Japanese women and their marital relationships appeared decidedly inferior even as they became a symbol of a lost ideal. When Bernard Moses praised the women as the "life" and "buoyancy" of the Japanese people even in their subordinated position, he declared that they could be "chirrupy and happy" because there was not so much expected of them. With this "inequality of the sexes," Moses explained, "there could be no such thing as romantic love." Cardinal Gibbons's juxtaposition of white women with Asians also pointed to the degraded state of gender in Japan. "Ungrateful Christian women should have felt lucky not to be enslaved like their Asiatic sisters."[103]

White women, even if they had a history of mental illness, also appeared to be better mothers than Japanese women for their own children. Hegini "Jimmy" Yamaguchi died at age five when his foster mother, Ida W. Hale, shot him and herself at their home on Filbert Street. Hale had previously tried to kill herself by shooting herself in the head, causing blindness in her right eye. According to Hale, she had "found" the Yamaguchi baby in "pitiable condition" when he was just three months old and had been fostering him since.[104] Yet the San Francisco Foundling Asylum had no log of the Yamaguchi baby in their custody or a record of Hale's application to foster a child that would have included a home investigation, as it required for other cases.[105] The sixty-one-year-old Ida Hale, thinking of her own mortality, grew unbearably anxious about losing him to his birth mother after her own death. She began planning the murder-suicide several days in advance and insisted that her husband participate.[106] For the *Chronicle* this "double tragedy" underscored the power of "love" rather than the injustice of an unstable white women who may have in fact kidnapped rather than legally fostered a boy whose birth mother worked as a nurse at the Japanese hospital. As dedicated wives and mothers as Japanese women appeared to be in the city's leisure culture, in real life the press would privilege white motherhood, even when it was homicidal. In an additional twist, nine years later Kisa G. Tanaka, an assistant of the Americanization program of the YWCA, underscored Japanese women's particular skill at raising children. "I have found that the Japanese have the healthiest children in the city." She declared, "They are robust youngsters and quite different from the average American child."[107]

By the 1920s as San Franciscans' heightened anxiety over divorce and thus gender roles passed, so too did the city's fascination with Japanese femininity. Articles on failed marriages typically remained buried underneath larger articles, conveyed in terse, dry, language, and occupied little space. When the *Call and Post* reported on Martha Hyman's divorce from her husband, Daniel Hyman,

the brief article that took up just two inches of space listed the husband's faults with little judgment.[108] When the Leideckers filed for divorce, the *Call and Post* reported the philandering husband's numerous girlfriends in its barest bones with no additional comment.[109] These accounts diverged significantly from earlier prolonged articles on divorces laced with humor or sarcasm. Articles just twenty years earlier reported on "recreant" wives, "wayward" husbands, and couples marrying "hastily" to people they initially believed to be "angels."[110] Less prominent placement and matter-of-fact reporting style of marital falling outs reflected the newspapers' decreasing reliance on divorces to draw in readers.

Charles Lorrimer, who had earlier written of fantastic geishas, revealed his own epiphany on the reality of Japanese femininity as early as 1909. "The nesan, by the way, is one of the charms of Japan which inconsequent writers never tire of glorifying; her daintiness and winsomeness are dwelt upon in every book that is written about the country. But we found the nesan seldom dainty and rarely winsome. She flatly refuses to have her hair combed more than once a week, and her 'charm' is chiefly found in the absurd curiosity she constantly exhibits toward the traveler."[111] As Lorrimer discussed the particulars of the nesan or Japanese maiden, he articulated the folly of writers' romanticization of Japanese women.

In 1924 Stanford University's Survey on Race Relations noted with surprise that the dainty geisha did not necessarily exist among the local Japanese community. Observers noted Shimeko Shima, for example, as being unusually big for a Japanese woman. Her daughter also, though a "pretty girl," was "rather large for the Japanese type, as are many of those born in this country." While she served food "beautifully" with much "grace" and "deftness," she baffled reporters because she did not seem foreign enough in her manners and habits. Shima's daughter also liked to read American fiction and popular magazines.[112] While geishas had long been out of the spotlight of city newspapers, journals, and theater, notions of Japanese womanhood had already been solidified, thus circulating expectations of Japanese women even onto a committee of scholars charged with investigating the social conditions of "non-European" residents of the Pacific Coast. Stanford University served as the administrative home of this "Survey of Race Relations."[113]

If social critics had truly been invested in furthering models of marital commitment, available statistics most obviously pointed to the Chinese community. Chinese divorce rates loomed remarkably low compared to whites. No divorced women appeared in the 1900 or 1920 manuscript census in San Francisco, and only one in 1910.[114] Chinese men as a group also had the lowest rate of unmarried

men, at 39 percent. Many of them, historically referred to as "bachelors," in fact had wives in China. Ironically, Japanese had the highest rate of unmarried men, at 64 percent.[115] Columnist Dorothy Feinmore, who wrote regularly for *San Francisco Call*, announced in 1905 that Japan in fact had the "highest rate of divorce."[116] While neither lower divorce rates nor higher rates of marriage necessarily indicate marital bliss for the Chinese, they do underline how data generated by San Francisco officials themselves had little to do with how the city characterized its ethnic populations. As Japanese geishas filled San Franciscans' imaginations as fulfilling a lost femininity, the Chinese as possible models of romance would be the furthest thing from people's minds.

Turn-of-the-century San Franciscans ardently believed cataclysmic change in womanhood and marriage was afoot. Moral conservatives blamed the rise of the modern woman as causing marital unrest and heterosexual conflict. Proliferating fantasies of geishas offered a way to articulate an alternative femininity apparently lost among whites. Essayist Charles Lorrimer explicitly made the link when he noted in the *Overland Monthly* that Japanese women were "rare exotics" with more patience than "American girls."[117] Notably, by 1913 at least one white woman appeared wise to exactly how fleetingly and conditionally Americans approved of Japanese femininity. In the *Overland Monthly*, Mary Gibbons Cooper published a short story about a Japanese servant Hana, who works always in full kimono in the Brayton family home as she cleans and takes care of an infant. When the son comes home from Harvard to rest from an accident, he quickly forgets about his American girlfriend and falls in love with Hana. When the matron of the house realizes the new object of her son's affection, she takes Hana out shopping and re-dresses her in Western clothes. The son loses interest after seeing Hana awkwardly move about in dress and heels and makes an astounding overnight recovery, leaving San Francisco for Cambridge and reconnecting with his girlfriend. In this essay, the author Cooper traces how the son is superficially attractive to Hana, due only to her exotic signifiers of Japanese-ness, such as the kimono.[118]

In the end, San Francisco had been suffering neither from a radical reconfiguration of femininity nor a decline in romance. As rates of divorce increased steadily in California, such was the case in the rest of the nation as well.[119] In 1900, California had only the fourteenth-highest average proportion of divorces in a state-by-state comparison. In the earliest years of the twentieth century, Nevada held the reigning title as the divorce state.[120] If the "reckless" onslaught of divorce would destroy San Francisco, other regions of the United States should have already crumbled under marital chaos.[121] Amid growing

national anxiety about rising divorce rates, San Francisco came to epitomize the epicenter of failed marriages perhaps because of its very public discussions—despite statistics that proved otherwise.

Moreover, the spotlight on Japanese femininity would not translate into a better life for Japanese in San Francisco. Deemed as inferior and posited as targets of ridicule, issei women faced denigration and limited access to privileges that women with more appropriate gender and sexuality enjoyed. Romanticized Japanese femininity became merely another vehicle to box the image of Japanese women. Whites oblivious to the lives of actual Japanese women immersed themselves in their own negotiations of gender and its impact on marriage though the imagined geisha. As much as the city discursively engaged in what they perceived to be pressing shifts in womanhood and romance, their various "crises" in fact reflected inevitable shifts taking place across the nation. Japanese women, to their detriment, would then be forcibly implicated in this false alarm around the alleged destruction of white middle-class love and marriage. Representations of Japanese women in San Francisco formed the beginning of a specifically Asian American stereotype to be dispersed across a nationwide culture of leisure just taking root in the United States.

Prostitution Proliferates

"Mrs. Flirty" and Willing Chinese Slaves

A "real Chinese play" titled *The First Born* mesmerized San Franciscans in 1897, filling the Alcazar Theater to capacity for three months.[1] So enthusiastically did theatergoers attend *The First Born* that it pulled the Alcazar out of its $18,000 debt. The play, which ran for fourteen weeks, remained the longest-running production in San Francisco until 1923. According to the *San Francisco Call*, the playwright Francis Powers, a self-proclaimed expert of Chinatown, succeeded in representing the "Chinese standpoint." A "masterpiece" such as this one "full of sights and sounds and smells of Chinatown" had never been seen previously on the American stage and "may never be seen again."[2] The play traced the immoralities of two Chinese women, one a prostitute and the other a woman consumed with sexual passion who abandons her child. Its popularity coincided with America's most zealous and best-recorded campaigns against prostitution and "white slavery," the kidnapping of white women into forced sex work. Between 1900 and 1918, moralists across the nation condemned prostitution as a blot upon America's soul. San Francisco joined the nation in negotiating what constituted appropriate sexuality that walked a fine line between new heterosexual interaction in the wake of increasing urbanization and outright sex work. As San Franciscans explored shifting mores of white female sexuality, representations of sexually immoral Chinese women took center stage in print and leisure culture. These projections onto Chinese women not only underscored how whites racialized their moral anxieties at the turn of the century but

also revealed how liberatory cultural movements for whites became restrictive ones for people of color.

In San Francisco, sex work flourished on Pacific, Jackson, Washington, and Kearny Streets as a lucrative and legitimate endeavor that frequently received municipal support.[3] Large beehives that housed women, called "cow yards," also gained notoriety in the early 1900s. According to the 1904 Grand Jury Report, one house at 620 Jackson Street received cooperation from the city government in the face of protests and statutory law. With the mayor's personal sanction, police staged arrests, only to release women on nominal bail set by Superior Court Judge Cook. Military officials at the Presidio also accused city officials of granting saloon licenses to businesses located at its entrance that attracted "the lowest class of women" who took advantage of drunken men on payday. Writs of injunction issued by the courts of equity also kept open houses of disrepute that police officers frequented. Tessie Wall, a well-known city madam, annually bought several tickets to the policeman's ball. She often started parties by throwing a $1,000 bill on the bar and yelling out, "Drink that up boys! Have a drink on Tessie Wall."[4]

Two of the largest houses of prostitution, Nymphia and the Municipal Crib, together accommodated more than five hundred sex workers between 1899 and 1907. Nymphia, with its three stories and U-shaped structure, held 450 rooms, each containing a bed, chair, and washbasin. When Father Terrence Caraher closed Nymphia in 1903, the Municipal Crib opened in 1904 in Chinatown with three stories and ninety rooms. Sex workers of all ethnicities inhabited the rooms.[5] City officials shared in its revenue. Two months after the 1906 earthquake and fire destroyed the building, owners once again rebuilt and reopened for business with a four-story building of 130 rooms. A year later, when Police Chief Biggy forced the closure of the Municipal Crib, his dead body washed up along the edge of the San Francisco Bay. Authorities suspected the murder as the work of those who opposed his efforts to stem sex work in the city.[6]

While moralists blamed immigrants for proliferating prostitution, women born in America made up the disproportionate majority of sex workers in the United States. A study in 1911 reported that immigrants formed 40 percent of the population but only 28 percent of prostitutes. American-born individuals made up 60 percent of the general population but composed 72 percent of sex workers. Many of these women deliberately entered the industry as a lucrative economic endeavor rather than being kidnapped or forcibly sold into slavery. In Chinatown as well, a neighborhood known for its Chinese immoralities, thirty-five houses of white sex workers thrived in the late nineteenth century.[7] Indeed, white "immoralities" also proliferated in Chinatown, particularly since white San Franciscans refused to allow bawdy houses into their own neighborhoods.

Previous scholarship has detailed how vociferous protest against prostitution signaled not just an aversion to sex work itself but greater concern about a general rise in inappropriate conduct. Antiprostitution movements in fact reflected anxiety surrounding threatening social movements. Worry over "white slavery" more specifically signaled widespread concern about the safety and morality of white women seeking jobs in large cities. The prostitute and the female wage laborer were, according to Pamela Haag, structurally identical as exemplars of urban women, simultaneously exploited and morally corrupt.[8] In a study of reports from the city's vice commission, Alan Hunt detailed how concerns about "casual prostitution" and "commercial vice" revealed how inextricably recreation and vice became intertwined as moral concerns. Thus, socializing in an ice cream parlor where men were encouraged to buy "treats" for women raised anxiety around how even consensual sex might in fact be prostitution.[9] White slave narratives reinforced patriarchal and restrictive ideals of female sexuality by frightening women about the consequences of independence and nonmarital sex.[10] Social conservatives in San Francisco similarly interwove prostitution with multiple worries about the city's alleged sexual degeneracy. City health officials fretted over proliferating sexually transmitted diseases such as syphilis and gonorrhea. Moral authorities protested not just vice and crime in the city's many notorious brothels but also other "vile practices and debaucheries," declaring that "immoral" activities generally corrupted the "youth of the city" and "led astray" girls of "tender years."[11]

Sexual Excess

Open displays of sexuality seemed to be seeping in everywhere as more San Franciscans appeared engaged in unconventional modes of dating. Illicit lovers communicated with each other in the personals sections of city newspapers outside the watchful gaze of their parents or partners. Unable or unwilling to receive letters or visitors at home, they used the dailies to facilitate their private affairs. Using initials and incomplete or pet names, most ads designated meeting times and places, others pleaded for a response or reminded their partners of a promise. In March 1897 Sam reminded Alice to leave the "signal" in the window and expect him "rain or shine." In another ad, "L" reassured perhaps another Sam, "I don't see why you should be afraid; he goes east Wednesday night."[12] Two months later an anonymous writer pleaded to "EM," "Hope all is not off between us; I give in; where can I see you?" "DD" also declared to "FA," "Never failing; increasing love, more and more; how can I ever thank you; blessings be with you."[13] Same-sex couples may also have reached out to each other

through the personals as well. "BLONDE" wrote to "BRUNETTE," "Hope you haven't forgotten about Saturday."[14] "K" called "H" a "dandy" and asked, "when shall I see you?"[15] Across race as well, personals may have facilitated connections. "Tamales" spotted "Blue Eyes" on the street and inquired about a possible meeting.[16] Several couples maintained ongoing relationships through the personals. "Ever Ready" traveled by boat across the bay to meet "Pet" regularly at the Market Street station while "Bat" met "Ball" on Sundays at 2:30.[17] Public communications such as these contributed to moralists' alarm that young people in particular practiced increasingly unrestrained sexuality.

Nationwide, courtship norms had begun shifting in the first quarter of the twentieth century. Unlike their nineteenth-century counterparts, couples more likely engaged in weekly visits rather than nurturing intimacy through extensive letter writing. Particularly in urban areas with accessible streetcars and trains, individuals in love could court each other through physical meetings without writing a single letter. Couples frequented the many public amusements available in a growing metropolis—restaurants, dance halls, or vaudeville theaters—spaces that became charged with erotic adventure.[18] Thus when "Peanuts" met "Almonds" at the "usual time and place" or when "Fizz-bang-boom" arranged a rendezvous with "Oh-Ah" on Sunday at the "Cliff," San Franciscans also participated in these new modes of socializing in a public world away from family parlors and community-sponsored events.[19]

As robust as personal advertisements appeared in the city for setting up dates, they still remained an atypical means of communication. For much of the nation, most couples continued to "call" on each other in the woman's home after an initial introduction through family or friends. There, they met with parents and shared in refreshments. Couples played cards or tiddlywinks, read aloud, made fudge, or even attended parties, church socials, or musical events to get to know one another better. Those wealthy enough to have a phone used it to arrange meetings or communicate brief thoughts.[20] Individuals who used dailies to communicate at the turn of the century likely found conventional ways of "calling" to be unavailable or impractical in their efforts to fulfill unconventional intimacies.

Sexuality broadly seemed wild in San Francisco among men with little self-restraint. When Justice Brody united in marriage John Byrne and Josephine Copeland and kissed the bride to congratulate her as he had done with many previous brides, the offended bridegroom pounced upon the justice, punching him for his liberties.[21] According to *Wasp* columnist Tabitha Twiggs, men "who take pleasure in forcing their attentions upon defenseless women" appeared to have their run of San Francisco since authorities who thought little of "mashing"

turned a blind eye to these "boors." San Francisco seemed "especially rich in th[is] species of human fungus." In no other city had Twiggs seen such "open and wanton insult of womanhood" as in the few blocks along Kearny and Market Streets. Nowhere else would such vulgar and annoying "mashing" be tolerated. Rumors circulated that dentists drugged their patients in preparation for dental work, only to make advances while their subjects remained unconscious. "Men who eye passersby and others who mingle with the crowd, obnoxious males from the palsied doddering octogenarian to the puny watery eyed youth of twenty" abounded on the streets of San Francisco.[22] The *Wasp* commended the action of two women who took justice into their own hands and "horsewhipped" a young man who offended them.[23]

Social conservatives, however, more often held women responsible for the moral crime of public sexuality, even in a town with larger numbers of "boors." Stewardess Hattie McDonald had to defend her integrity when steward John Victory at the Receiving Hospital accused her of being the "willing recipient of caresses and kisses" of a friend who called on Saturday night. McDonald's supervisors equated open affection at work with neglect of duty. McDonald defended herself by explaining that a visiting old friend had whispered something confidential into her ear.[24] Columnist Tabitha Twiggs also cautioned her neighbor "Mrs. Featherbrayne" about her daughter. "I saw [Amelia] out at the Park sittin' on a bench in front of everybody and allowin' a young man to make love to her in the regular end-of-the-century fashion, not seemin' to care whether anybody took notice of them or not. It was a cold snappy day, but that foolish daughter didn't seem to know the difference between the thermometer at fifty degrees and a July morning, for she didn't have so much as shoulder-cape on." Twiggs reported that Amelia must have been blue with cold without even knowing it. She kissed her beau openly underneath a bright street lamp. When people passed along the sidewalk, the couple "stood there on the step just as if they were glued together."[25] She detailed the public affections of youthful San Franciscans with particular disgust, noting their foolhardiness in matters of romance and sexuality. "Let a San Francisco girl get smitten with a San Francisco young man, and a cold in the head, to say nothing of rheumatism, chills and fever, influenza, grip, and all the rest of it is certain to follow. Why? Open-air love-makin' that's what it does."[26] Twigg's column in its satirical illumination of alternative norms in women's sexuality and courtship conceded to these shifts even as it mocked the changes as impractical and ridiculous.

Theater advertisements and reviews often featured women in revealing fabric and off-the-shoulder dresses. When Juniori, a famous beauty of the Parisian stage appeared in the *Wasp*, the contours of her breasts and nipples cast faint

shadows through her gauzy top.[27] When the photograph of actor Juniori caused commotion, the *Wasp* facetiously explained, "Several society beauties thought that their photographs had been spirited from their boudoirs and published."[28] For sure, San Francisco's society girls often took to the stage in short skirts and low-cut tops for various benefits. Their photographs graced local news-papers as they raised funds for organizations such as Emanu-El Sisterhood at the Columbia Theater.[29] Another profile in the *Wasp* featured a woman thespian wearing only a wrap on the bottom half of her body. Although her back faced the camera, her slightly turned posture revealed the outline of her breast.[30] The sisters of one young lawyer cried in horror upon their brother's marriage to an actress who wore elaborate petticoats, an item that "decent" women would not wear.[31] As "San Francisco gentlemen" sought out actress wives considered by social conservatives to be "notoriously outside the pale of society," more society women, in emulation of their titillating sexuality, adopted their style.[32]

In 1900, when New York officials jailed Olga Nethersole for offending public morals in her production of *Sapho*, San Francisco audiences eagerly awaited her arrival in their city. Nethersole performed Clyde Fitch's adapted version of Alphonse Daudet's original *Sapho*, in which Fanny, an unmarried woman, became pregnant and struggled to choose between two men—one recently out of prison and the other a more "respectable" yet abusive soon-to-be-lawyer.[33] As copies of Daudet's *Sapho* sold in large numbers on the streets of New York for five cents, newspapers condemned the drama as immoral. Alan Dale of the *New York Journal* described it as "never human, always lascivious," an appropri-ate "study for the psychopathologist." William Winter of the *Tribune* called it "morbid trash." The *Evening Post* warned that vice, when fascinating, proved particularly dangerous.[34] *Sapho* hardly passed as acceptable entertainment in New York City, and officials quickly terminated the play's production.[35] European cities also found *Sapho* scandalous. The London-based *Academy and Literature* confirmed *Sapho*'s American controversy as understandable. In Dublin, Ireland, the *Freeman's Journal* advised theatergoers to "stay away." *The Independent* noted that people who attended the performance would "surely be guilty of immorality."[36] In contrast, San Francisco newspapers appeared remarkably sympathetic to Nethersole over her arrest. The *San Francisco Call* labeled her New York captors "prudes." The paper mocked the ensuing con-troversy, noting, "Because the drama of 'Sapho' as presented in New York has been condemned as indecent, some wild reformers have jumped to the con-clusion the book is equally bad, and now a member of congress has moved to have it excluded from the mails." The book had been circulating in the United States for fifteen years or longer and had become universally regarded as a

masterpiece of modern French fiction. The *Call* noted, "It would seem a little bit too late to have a spasm over it now."[37]

In San Francisco, those who sought increased freedom seemed to gain more ground in contestations over changing norms of sexual expression. While Twiggs criticized "old, fat women" of her generation—"flippety, floppety, and untidy"—following fashion and social mores by wearing "disgraceful" shirt-waists without corsets and flirting shamelessly with men, her column in its very title, "Old Maid's Diary," poked fun at old-fashioned ideas of women's sexuality. Twiggs diverged so sharply in her opinions about romance from those of her friends "Mrs. Shoddy" and "Mrs. Flirty" that their interactions at times ended in fisticuffs.[38] The *Wasp* additionally scoffed at moralists' concerns over indiscriminate kissing. "The kissing bug (osculatoria insectivorata) is now claiming attention. This miserable cuss is first cousin to the common bed bug (vulgus bedbuggus). His favorite territory is the nose. Following the kiss the nose begins to swell until it resembles a seed cucumber. We understand several socialists have been kissed by kissing bugs. The bugs are suffering from blood poisoning."[39] Publications' open mockery of moralists' protests signaled the extent to which broad cultural support for more open sexuality outpaced social conservatives.

"Enraged Wildcats"

As whites explored new avenues of sexual openness for women, representations of Chinese women as sexually immoral littered newspaper articles and fictional narratives. Whites rendered Chinese women as prostitutes or prostitute-like. Essays vividly described "angry gang[s] of hatchet men, and the female keepers of the brothel fight[ing] like enraged wildcats" to keep their businesses open and women ready to work. They claimed Chinatown's licentious dens seduced white men where yellow-faced procurers trafficked in human flesh. "Boys" would be "ruined by hags."[40] In 1900, when federal laws permitted Chinese men of merchant class to bring their wives from China, the *Call* warned that the number of Chinese slave women imported to work as prostitutes would soar.[41] San Franciscans, appealing to the federal government for assistance in eliminating Chinese brothels, protested the immigration of "wretched Mongolian women" whose only "value in this state . . . [was] . . . for immoral purposes."[42] Chinese women as prostitutes served as an easy articulation of the city's dilemmas of sex for sale.

Yet in 1900, 339 (or only 16 percent) of Chinese women worked as prostitutes. Ten years later the census listed only 7 percent of Chinese women as prostitutes. In fact, as early as 1880 the number of Chinese prostitutes had already dropped

precipitously. While the census counted 1,565 Chinese prostitutes in 1870, ten years later only 305 existed. Many of these women left the trade and entered into matrimony.[43] Thus by the 1890s, Chinese women in San Francisco were less likely to live as sex workers than they were thirty years earlier. In the earliest years of the twentieth century, Anne H. Chinn remembered all the Chinese women around her assisting with their husbands' business, though she had heard of women brought as wives and turned into prostitutes. Chinn's own mother sold chickens and vegetables, often singing to herself as she prepared for a day's work.[44] May Lum, who lived on Grant Avenue, remembers women of her mother's generation working from home doing odd jobs such as sewing. In 1918, at the age of fifteen, Lum herself began working in a candy store on Market Street and later in an exclusive women's clothing shop, both owned by "Americans." Her older sisters worked as telephone operators as teenagers at San Francisco's Chinese telephone exchange.[45] Ruth K. Wong's mother worked as a midwife in the Chinese community at the turn of the century.[46] Chinese American Stella Louis spent her weekdays working in San Francisco. At age fourteen, she started working as a mother's helper for a Swedish family. Later she worked for a dollar store on Market Street and then at an Oakland dry-goods store, in addition to watching over her younger siblings.[47] In 1905 activist Ng Poon Chew with Patrick Healy insisted that the wives of the few hundred Chinese were all "chaste, [p]ure, keepers-at-home, not known on the public street" as they responded to increasing accusation of Chinese women as immoral.[48]

Chinese Canadian essayist Edith Maude Eaton, who wrote under the pen name Sui Sin Far, set out to publish more realistic depictions of Chinese in America.[49] Her short stories, which appeared in journals widely read by San Franciscans, such as the *Overland Monthly*, *Sunset*, and *Westerner*, depicted Chinese San Franciscans and more broadly Chinese North Americans with dignity and sensitivity.[50] In 1899, "A Chinese Ishmael," reformed gambler of noble lineage Leih Tseih saves a dainty Chinese slave girl from the bondage of sex work and marries her.[51] In "Mrs. Spring Fragrance" Chinese American Laura enjoys an innocent romance that culminates in marriage with "ruddy and stalwart" Kai Tzu, "noted as amongst baseball players as one of the finest pitchers on the Coast."[52] In "Land of the Free," Far traces the story of a young Chinese couple whose newborn is taken away from them at the port of San Francisco because the infant has no papers. When the heartbroken parents are finally reunited their child, the toddler rejects the parents after having been raised by white missionaries.[53] Through these essays, Far reveals not just the injustice of sinister representations but also how an America unfairly suspicious of its Chinese community caused great suffering for loving Chinese people.

Far had moved to San Francisco in 1898 to join her sister May. She found community in San Francisco's Chinatown when her employer, the *San Francisco Bulletin*, sent her to canvass the area for subscribers. The women and their husbands quickly adopted the mixed-race Far, affectionately commenting on how her hair and coloring, as well as her love of tea and rice, reflected her Chinese background.[54] In her commitment to a Chinese American community that she came to consider family, she explored the lives of what literary critic Amy Ling describes as "humble, law-abiding" immigrants and children who shouldered the daily toils of living as immigrants in America. Far wrote essays on Chinese San Francisco to correct misrepresentations of Chinese whom whites depicted as immoral. Asian Americanists assert Far's fictional works as the first to sympathetically and extensively address Chinese in North America from an "insider" perspective.[55] Despite existing realities and Far's efforts to rescript the dominant narrative, representations of Chinese women as degraded prostitutes more powerfully appealed to whites, as evidenced by Far's failure to become popular with her true-to-life depictions of Chinese Americans.

In short stories, Chinese women appeared as deliberately manipulative and evil, seeking out partnerships for money rather than love. In Marguerite Stabler's "The Story of Modern Delilah," Sooy Yet, a horribly unattractive Chinese maiden of marrying age, seduced the wealthiest man in Chinatown, Man Toy. Man Toy eats a poisoned dinner at Sooy Yet's father's restaurant. Sooy Yet watches with "evil little almond eyes" as his head proceeds to swell into unimaginable proportions. She then applies a soothing lotion to his head that in fact induces blindness. A miserable but wealthy blind Man Toy then buys Sooy Yet at an extravagant price, believing her to be an incommensurable beauty with a heart of gentle nurturing femininity. Sooy Yet, an evil temptress, betrayed the trust and generosity of a wealthy man for her financial gain. Stabler's choice of language additionally suggested Sooy Yet's role as prostitute by describing her initially on "display" in her father's restaurant storefront window who was later "sold" into marriage. Her father and Sooy Yet both fiendishly plotted to extract the highest price for her. The outward appearance of marriage masked her role as a cunning, willing prostitute for the right price, her father serving as the pimp to deceive one of their own countrymen.[56] Sooy Yet's wrongdoing articulated not only degraded Chinese womanhood but also her corruption of marriage, since money rather than love motivated her desire to join with Man Toy.

The story of Sooy Yet resonated with middle-class anxieties around proliferating prostitution as well as what appeared to be a trend in choosing spouses based on financial gain rather than love. *The Lark* announced a "decrescence of romance," tracing cupid's arrow from 610 BC Greece to 1897 San Francisco.

While Cnemon professed to Myrtale, "I shall have no thought of sleep, nor life, nor death, nor aught, but gazing in thine eyes," more than two millennia later Charlie wrote to Mamie less eloquently. "You know that I love you better than anything on earth. . . . Of course I haven't got much money, but I am sure when your father knows how much I love you, he will help us. We could be very happy darling, on six hundred a month. I do love you and I hope your father ain't going to prevent our happiness."[57] Charlie's heartfelt proclamation fell short of poetry, as his intention to live on an allowance subsidized by his father-in-law could hardly be described as a labor of love.

Alongside furniture sales and dentist ads, individuals advertising for marriage cited money as both a qualifier for their own eligibility as well as the appeal of future spouses. "Young widower, 27 years of age, fairly good looking and possessing $10,000 desires to meet young lady of prepossessing appearance; object matrimony." "ATTRACTIVE lady, 29 wishes gentleman companion of 40 to 60 years of age; must have plenty of means."[58] The *Wasp* facetiously encouraged young men to choose wealthy widows and unmarried women with large bank accounts. An additional cartoon showed a woman who reported her fiancé declaring, "I love the ground you stand on." Her girlfriends smugly inquired, "Were you on your own property at the time?" For individuals such as Mrs. Baumgarten, the possession of her future husband's house served as her sole motivation to marry. As soon as she found out that her husband had deeded his house to a friend she filed for divorce. In 1902 "marriage a la mode" meant finding a man who would be a devoted husband, with riches and as well as rank.[59] Marriage seemed to have become largely an economic affair, a financial union that perhaps all too closely resembled morally suspect sex-for-pay.

The press simultaneously underscored Chinese women's willing engagement in prostitution. In March 1897 police officers recovered sixty Chinese women and sent them to the Chinese Presbyterian Mission Home, which provided a refuge for Chinese women rescued from sexual slavery. At the Mission Home white women missionaries taught Chinese women Christian ethics and values in preparation for their new American lives.[60] Reporters noted that many of the women displayed open defiance, showing no deference to law enforcement officials. Some sat sullen, others cried, a few were terribly frightened, but more sulked. Adorned with fancy clothing, bracelets, rings, and large diamonds, the Chinese women refused the offer of a home. "They would have none of the Christian courtesy."[61] Local police witnessed an endless stream of "Women of Nymphia" getting arrested. As soon as authorities released the women, they immediately "made tracks to their former haunts," proceeding to prostitute themselves without pause.[62]

Discourse around Chinese women's alleged complicity in their own bondage became a racializing project as well, in making Chinese as racially different not just from whites but also from nonwhites. In 1897 the *Chronicle* declared that San Francisco was "still a slave-holding city," drawing parallels of the forced prostitution of Chinese women to the African slave trade as it also drew distinctions. Chinese women were "as truly slaves as Dred Scott or Frederick Douglass ever were, but what is worse, were willing slaves, who resisted all attempts to set them free, literally 'with tooth and nail.'"[63] In some cases, court records appeared to confirm Chinese women's explicit embrace of sex work. When counsel gave Wong Ah Quie, who worked on the corner of Dupont and Pacific Streets, three options—remain in house of prostitution, live in the Chinese Mission Home, or go back to China and live in nice home—twenty-four-year-old Wong replied that she preferred to continue doing sex work in San Francisco. "I wish to go back and be a prostitute; I do not want to go to China."[64] As much as court transcripts might record an individual's statement verbatim, Wong's socioeconomic situation illuminates how unspoken multiple truths would clarify her "wish" for sex work.

The "choice" of prostitution remained a complicated issue when few viable alternatives for livelihood existed for women. Lack of economic opportunities in a patriarchal society fueled the exploitative business of sex work as financially lucrative for many impoverished women at the turn of the century.[65] Christian socialist and Berkeley mayor J. Stitt Wilson in 1913 declared how market forces fueled the exploitation of women. "This market for women's bodies, this vast army of women for the market . . . through your factories stores and shops to the brothel is the rotten pus running out of your respectable, legalized, church sanctioned capitalist system of industry." He declared the twentieth century as committing the "crime of social rape" upon women. Wilson concluded, "Capitalism must be abolished."[66] San Francisco law enforcement, attorneys, immigration officials, Chinese "highbinders," and family associations regularly resorted to extortion, violence, and legal manipulation to maintain the profitable business of sex work. Many Chinese women believed that even if they escaped, they could never be assured of complete safety, even in the most remote towns. The eyes of the tongs, Chinese associations that organized much of the sex work, stretched across America through intricate networks. Even more women perceived prostitution as a form of filial loyalty to support their families in China.[67] Many Chinese also found American authorities such as the police and the court system frightening. Despite the hardship of continued forced sex work, their own ethnic communities felt more comforting—an invaluable space of comfort in anti-Chinese America.

In the 1920s Sue Fah, who worked as a prostitute on the corner of Sacramento and Kearny Streets, finally accepted the assistance of the Chinese Presbyterian Mission Home only after believing for years that she indeed was helping her husband pay off the debt he incurred for her immigration to the United States. She had awaited her "happy family life" after what she believed would be a short period of sex work. Sue Fah remained adamantly loyal and devoted to the man who sold her into sex work. She firmly believed he was her husband. After a wedding ceremony in China, she arrived in the United States with her husband only to have him tell her that he had to borrow $1,000 to bring her to this "beautiful country" and that she must also work to pay off the debt, and only then would they be free to have their own lives. Despite her terrible condition, she initially declined the Mission Home's offer for support in leaving her husband. She returned to her husband only to have her newborn son taken away from her. She was then whisked away to Chicago, where she continued her servitude. Only after a family friend spotted her in Chicago was she able to contact the Mission Home again for assistance.[68] For Chinese women who held marriage and family first and foremost at whatever cost, representations of them in print and leisure culture that filtered through an anti-Chinese lens simplified their complicated situations in the most derogatory fashion.[69]

Literary and visual images of immoral Chinese women that whites found compelling for their own situations held grave implications for the Chinese community. Government authorities believed that two-thirds of Chinese women immigrants, regardless of their status as wives, daughters, or mothers, entered the city as prostitutes or as polygamous wives. Other commentators declared that all Chinese women were "destined to live and die as prostitutes."[70] Even those who purportedly experienced the more real aspect of Chinese sex work confirmed generalizations of all Chinese women as prostitutes. Margaret Culbertson at the Mission Home described Chinese women who entered the United States as "all frauds." She declared, "Every Chinese woman landed is sent to a brothel."[71]

Pervasive negative ideas about Chinese female sexuality motivated officials at Angel Island Immigration Station to suspect the eligibility of all Chinese women due to their allegedly immoral character.[72] In 1900 authorities asked newlywed wife Liu embarrassingly intimate questions, such as whether she "had any relations as man and wife since [being] married?"[73] Officials also sought to deport Chan Haw after intimidating her into giving a confession. Methodist missionary Carrie Davis, Chinese language interpreter Lily Shem, and local authorities had literally kidnapped Chan Haw, told her that her husband had abandoned her and that the only way she could remain in the United States was to attest to being a prostitute and go to the Mission Home to learn English.[74]

Proof of United States citizenship could not even protect Chinese women from the threat of deportation as "immoral" immigrants. Authorities arrested Yee Ngoi as she shopped for women's clothing on Sullivan Street. Inspector Gardiner approached Yee as she stood in the doorway of Quong Cheong, led her into an unfamiliar house, and then charged her for being in a house of ill repute. Although her husband testified that she was in fact not a prostitute, the prosecution noted that a "Chinaman's veracity was doubtful at best." Authorities refused to acknowledge testimony from Chinese men as legitimate due to their presumed moral degradation as well. These men, after all, would sell even their wives and daughters into sexual slavery. In 1901 the courts ordered Yee's deportation, even though her papers indicated she was born in the United States.[75]

Similarly, Leong Sin Muey faced deportation despite witnesses who confirmed her birth and early childhood in the city, including a doctor who had treated her for a cough when she was two years old. Officials claimed she had admitted to being a prostitute. She allegedly arrived in San Francisco in 1897 and was sold into slavery, adopting the prostitute name Shing Yow. Yet Leong protested that she was working as a cook in a Chinese house. "I do not know what a prostitution house is. I was cooking in this house. I did not look for prostitution."[76] While immigration scholars have more generally attributed the low numbers of women immigrants from China to the United States to values of traditional China that limited female mobility, historian George Anthony Peffer cited gendered immigration law and government harassment of Chinese women as inhibiting their migration to America.[77]

"Pretty almond eyes [that would] fill you with surprise"

Around 1902, however, a notable shift occurred. In the city's daily press the number of articles on Chinese prostitutes decreased significantly, as did articles on inappropriate sexual conduct among whites. For the *San Francisco Call*, nineteen to forty-four articles on Chinese sex workers or "Chinese slaves" appeared between 1897 and 1901, yet in 1902 only two appeared out of a total of approximately twenty-two hundred articles on Chinese generally.[78] By 1904, out of 5,256 articles on the Chinese in the *Call*, only two addressed "Chinese slaves." In the *San Francisco Chronicle* as well, articles on Chinese prostitutes occurred only once or twice every other year after 1902. In the *Overland Monthly*, only three more stories on Chinese slave girls appeared in the two decades that followed 1902.[79] A decline in reporting on sexual misconduct generally accompanied the press's seemingly decreasing interest in reporting on Chinese prostitutes. For the *Call*, stories on "immoral" behavior broadly dropped from 101 articles in

1897 to forty-four articles just five years later in 1902. Tabitha Twiggs and her sarcastic comments about the state of gender and sexuality in San Francisco did not even appear once in the *Wasp* in 1902.

In fact, in 1901 a major cleanup of Chinatown's brothels took place as local authorities jailed prominent city whites who partook of and profited from the sale of Chinese girls and women. When Police Chief Wittman began his "crusade against immorality" by arresting building owners who rented out their property for "immoral purposes," sixty-five complaints reached his desk. According to the *Call*, it quickly became apparent that the "profits of Chinese depravity were shared by some well-to-do Caucasians." Courts named Frank J. Sullivan, the brother-in-law of the mayor of San Francisco James D. Phelan, as principal defendant among more than fifteen others who could be called aristocrats of the city. Authorities also arrested United States Vice-Consul in Canton H. L. Eca Da Silva for facilitating the exportation of Chinese women to America for immoral purposes. Da Silva, who was Portuguese and Chinese from Macau, had previously served as the interpreter for the Chinese Bureau in San Francisco. He blamed the *San Francisco Chronicle*'s inflammatory journalism for his imprisonment.[80]

A tide of new city ordinances regulating gender and sexuality then began flooding the city's legal books in 1903. Within eighteen months, the San Francisco Board of Supervisors passed twelve ordinances governing gender and sexual expressions and acts. From outright prostitution to mere utterances of bawdy language, the city clamped down on its legal if not social permissiveness, multiplying by twelve the number of previously existing ordinances regulating gender and sex.[81] On June 11, 1903, the city legislature approved three ordinances. Number 835 prohibited the use of bawdy, lewd, or obscene language within the hearing of two or more people in a public place or highway. Ordinance 826 made unlawful the playing of music in dance houses and drinking places between the hours of 1 A.M. and 6 A.M.[82] Five months later, on November 25, 1903 lawmakers enacted another two ordinances. Number 1059 prohibited participating in lewd, indecent, or obscene acts. Then a week later ordinance 1360 prohibited people from disturbing the public peace by uttering within the hearing of two or more persons any bawdy, lewd, obscene, or profane language, words, or epithets. Officials also passed five additional ordinances to limit prostitution between 1903 and 1904. Ordinance 1054 in 1903 made soliciting for prostitution unlawful. In the following spring, ordinance 1159 mandated the business of prostitution illegal in any house, room, building, and ordinance 1179 declared the use of a building for prostitution illegal. Within two weeks, on December 15, 1904, two additional ordinances made it unlawful to be a visitor or inmate in a house of

"ill fame." By 1904 the city had systematically dictated what types of behavior would be appropriate in the city's sexual culture. Increased municipal governance likely fostered more security and less worry over uncontrolled sexuality running rampant. This would also translate into fewer implications of Chinese women in public negotiations of sexual anxiety and change.

Yet all would not be placated after the passage of the barrage of morality codes. The grand jury in 1904 still articulated anxiety over the "colossal" houses of prostitution filled with "fallen" women as well as the large number of white men who entertained themselves in the underground dens of Chinatown. In 1910 the Committee on Public Morals and Places of Amusement called for more vigilant surveillance of prostitution, dance halls, whites gambling with Chinese, and displays of immoral articles in shop windows, all of which "corrupted" the minds and morals of youths. The report called for city authorities to deal with the "social evil" in as efficient a manner as other cities did all over the world.[83] The grand jury also recommended that police regulate dancing, and the coroner's office suddenly took special interest in the storage of women's corpses. "The bodies of women brought to the morgue are kept in a place separate from those of the men and are attended to by matrons who see that every care and respect is shown."[84]

Still, the city's most heated angst over sexual excess and degeneracy had subsided by 1910. In the following year, San Francisco seemed to take pride more publicly in a culture of open yet city-managed sexuality. Voters supported Jimmy Rolph for mayor when he had promised "a wide-open town" and responded to the "problem" of prostitution by saying he would "leave it alone, just regulate it."[85] This regulated open sexuality came to define San Francisco's policy as the rest of the nation panicked over "loosening morals." In 1910 the San Francisco Board of Health had met with various state, municipal, and religious organizations to limit the spread of several diseases through systematic medical supervision. The coalition set geographic boundaries on the practice of prostitution and established the Municipal Clinic.[86] Officials required women involved in sex work to submit to regular exams at least twice a week at the clinic to prevent the dissemination of venereal diseases. Women would then carry clinic cards to prove their regular maintenance to law enforcement officials.[87] The San Francisco Municipal Clinic, which promoted public health by monitoring the sexual health of city sex workers, caused controversy among social reformers who looked down upon the city's willingness to tolerate the presence of the "social evil." While national reform movements such as the American Society of Sanitary and Moral Prophylaxis called for the extermina-

tion of prostitution, San Francisco sought to live with prostitution under careful watch since its extermination seemed impossible.[88]

Julius Rosenstirn, medical doctor and chairman of the Advisory Committee of the Municipal Clinic, commended San Francisco's realistic approach to prostitution. He accused states that attempted to enforce stringent laws of not recognizing the "true condition of affairs" and "paint[ing]" over social problems "with rose-colored tints." He called the actions of the moral purity reform movement "reactionary measures of those who worship the shrine of shattered antiquated idols, and who are offering as a sacrifice, the nation's health." Rosenstirn had read the works of contemporary sex theorists extensively and understood sexual desire as the "ultimate expression of the loftiest sentiment that moves the heart of humanity." He perceived the ecstasy of sexual desire as inspiring beautiful works of art by sculptors and painters, poets and musicians. Rosenstirn criticized moral regulators and quoted Freud as saying that many grave disorders of the nervous system are caused by the suppression of sexual desire. He promoted Havelock Ellis as arguing that "love and hunger are the foundations of life and the impulse of sex is just as fundamental as the impulse of nutrition."[89] Though Rosenstirn appeared to have little interest in the structures that bound women into prostitution and the power dynamics that underlay sexuality, he kept abreast of the latest sex-positive theorists of the early twentieth century.[90] Rosenstirn and other like-minded San Franciscans represented the newest sexual ideology in the city by recognizing how natural passions in fact benefited society. Only after pressure from progressive abolitionists from all over the United States who threatened to boycott the city's upcoming Panama Pacific International Exposition in 1915 and unleash a barrage of negative national publicity did San Francisco's mayor and businessmen decide to close the clinic for white sex workers to protect the city's reputation and economic investment in the exposition.[91]

The grand jury, however, refused to submit completely to the closure of the Municipal Clinic. Their final report accused other cities of "smug hypocrisy" and a "holier than thou" attitude. "Whatever else San Francisco may be, and whatever faults she may have our city is not a hypocrite. Its vice is on the surface and may easily be seen by anyone who goes in search of it. Our saloons are entered by the front door and not by skulking through a side entrance and back door of adjoining building as is done in some places where one sees no saloons on public streets. Our red light district is brilliantly lighted up and is easily found by anybody who wants to find it." Though the report confessed that evident vice did not necessarily prove to be a good urban characteristic in and

of itself, it proved "rather better" than deluded pretenses of moral cleanliness. "A sore on the surface is far easier to eradicate and cure than a disease which is driven deep within and covered up in the system under a pretense that there is no disease."[92]

By the mid 1910s prostitution as a problem appeared "solved." The *San Francisco Examiner* declared the city's most notorious red-light district "a thing of the past."[93] Authorities proudly deemed "the great task accomplished." Officials had "clean[ed]" up the city by shipping more than one thousand "little girls" outside of the Barbary Coast or placing them under the care of clubwomen. Not everyone would be convinced of the city's declarations of moral cleansing. The previously mentioned socialist J. Stitt Wilson mocked San Francisco for its sudden affliction of "acute moralitis." The police department pounced upon the Barbary Coast to relive some artificial moral zeal. To "whiten up some of its vile sepulchers," the city as "civic quackery" implemented actions to expunge "social evil." Wilson called San Francisco's efforts as a "fiasco" and derided the city for trying to keep up with Los Angeles's "civic whiteness." Delusional consciousness motivated the city's shouts of moral victory. Officials only "cleaned the outside of the cup." Wilson elaborated: "Clean businessmen make clean profits, while men, women, and children suffer."[94] Despite Wilson's skepticism, the city's print and leisure culture seemed less interested in discussing the immoralities of sex work and other obscenities.

With decreasing anxiety around sexual degeneracy, the few portrayals that appeared of Chinese women more frequently drew them sympathetically, evoking a femininity not based in immorality. Suen Shee, Don Quai, Toy Vim, and more than twenty others trying to escape prostitution or poverty all appeared as "pretty Chinese" in the *Call* between 1902 and 1912.[95] In 1908 essayist E. V. Robbins went as far as to suggest that, in fact, the British instituted the sexual enslavement of Chinese women when it began its colonial rule of Hong Kong, which then drew out the criminal classes of China. Robbins declared this Western introduction of sex work as "the misfortune of the Orient" that overran "Chinese social morality."[96] These representations became particularly notable not just in depicting Chinese women as attractive rather than repulsive but also in how Chinese culture no longer appeared inherently immoral but rather as a casualty of Western imperialism. In 1913 Roy Temple wrote a tragic poem of a young Chinese wife "thrown aside, forgot[ten]" by her husband.[97] Young Chinese women now appeared as victims rather than enthusiastic purveyors of prostitution. L. Clifford Fox in the *Overland Monthly* described a fifteen-year-old girl sold in Hong Kong to a Chinese merchant in San Francisco. She was disguised as sailor and placed on a trans-Pacific liner to America. Yet, "privation,

torture, assault was the lot to which she fell." Ten days after she landed in San Francisco, immigration officials found her "cooped up in a single room." She had suffered "unspeakable cruelties and might have died a miserable death."[98] In 1917, when George Amos Miller wrote a book on China devoid of prostitutes, reviews praised his work. Chinese women became sensitive, thoughtful "ladies" to be pitied under the duress of unjust relationships.[99] By 1920 white San Franciscans enjoyed singing along to a popular tune that described Chinese women as having "pretty almond eyes" that would "fill you with surprise," as observers gleefully watched them flirting with Chinese boys in Chinatown.[100] A year after women's suffrage was ratified at the federal level, Chinese women also became feminists in the local press. In 1921 American born Chinese Ruby Gunn, a "chic maiden" attired in costume "both American and Chinese," was "fighting for freedom" in her assisting a growing movement for voting rights and educational advancement for women around Guangzhou.[101]

As early as the 1870s, the image of the sexually diseased Chinese prostitute had loomed large in sociomedical discourse in public-health and urban policy. Public-health officials constructed the Chinese syphilitic prostitute as particularly dangerous only after they discovered that white men also visited Chinese women for sex—so much so, officials legislated the 1875 Page Law that barred the entry of "immoral women" specifically for the Chinese.[102] In leisure culture, however, Robert Lee observed that the Chinese woman was almost "invisible" and "absolutely voiceless" during the nineteenth century. According to Lee, the Chinese prostitute could not be made a subject of popularity because such publicity would unveil the "forbidden and unspeakable" alliance between Chinese and white men that facilitated the extremely profitable commodification of Chinese women.[103] Chinese women's invisibility in popular entertainment in the nineteenth century, however, might be more powerfully attributable to the fact that whites had no need to evoke the Chinese prostitute in leisure culture until middle-class white women increasingly exercised assertive sexuality. The theatrical hit "The First Born," appearing on stage in 1899, the very last year of the nineteenth century, was neither random nor coincidental. Turn-of-the-century anxieties about unrestrained sexuality incited a racialized projection onto Chinese women in popular culture, since San Francisco whites refused to articulate fears of their own female sexuality through themselves. Moralists and religious leaders in San Francisco narrated fears of "white slavery," which was in and of itself a projection of turn-of-the-century anxieties of white women's more assertive and public presence, through the coercive induction of Chinese rather than white women into prostitution.[104] While sex work generally existed

prominently in San Francisco since the Gold Rush in 1849, not until the 1890s did the white "prostitute" appear in the *San Francisco Call*. Noticeably, the immoral Chinese woman also began appearing in the *Call* with more regularity in the same year. Attorney Robert Ferral, who frequently represented the Chinese, explicitly linked white and Chinese female sexuality when he spoke in court about the unjust negative attention Chinese women received as supposed prostitutes. "White girls are going to ruin every day in this city, and no raids are made for their benefit. It is only the Chinese who seem to have any attention on this score." In Ferral's opinion, not only did the Mission Home profit by the crusade against the immoral Chinese prostitute, but Chinese women were also being unjustly persecuted by the presumption that they needed saving at precisely a time when whites likely needed just as much "rescue work."[105] When literary and visual images of Chinese prostitutes flourished in 1890s San Francisco, American-born prostitutes overwhelmingly outnumbered the immigrant, and young white women increasingly displayed their sexuality more publicly. Writers, playwrights, and illustrators then popularized and disseminated representations of Chinese women as willing sex workers amid expanding middle-class white women's sexuality. When city fears about its prostitution problem and sexual excess subsided in the 1910s, so too did characterizations of Chinese as prostitutes in leisure culture. As the most urgent social concerns shifted away from sex work, depictions of Chinese women in fact became more sympathetic.

However, earlier notions of Chinese women would never completely disappear. In 1924 the U.S. Department of Labor, assuming all Chinese women to be prostitutes illegally in the country, relied on the Mission Home, who would only know the faces of women fleeing sex work, to identify Chinese women for deportation as well as unclaimed bodies of dead.[106] Moreover, when John Ratkovich sought to insult J. Rose in 1920, he first called her a "dirti hor" and then used an insult that anyone could easily understand. "Fuck you chine town woman," he wrote in an angry letter.[107] A small window of cultural dissemination through the city's leisure culture at the turn of the century would have an irreversible effect in how whites perceived Chinese women, particularly when the issues resonated so deeply in their own personal lives. These iterations reflected how ideas about Chinese femininity had become powerful icons of broadening and, at times, contentious sexual behavior for white America.

Managing Masculinity

The Heathen, the Samurai, and the "Best Oriental"

During the 1890s, as managerial, entrepreneurial, and professional occupations grew for white men, middle-class manhood took stock in its gentility and respectability. Building strong moral character and control over impulse remained central. Yet, as burly immigrant men formed labor unions, entered city politics, and pushed against middle-class rule, civilized Victorian manliness increasingly appeared inadequate. Women also arrived as competitors into traditionally male work spheres. A more urban and less agrarian America grew anxious about becoming overcivilized and seized robust masculinity as an antidote to the ravages of modernity, such as neurasthenia, a distinctly "modern" disease of nervous weakness and fatigue.[1] In San Francisco, manliness became a contested terrain on which men would be judged for their integrity. When Antone Gerget, editor of the local *Slavonian Weekly*, decried wife beating as "unmanly," a fellow countryman approached Gerget on Mission Street and assaulted him for what he perceived as a personal insult. James F. McGauley also fought tooth and nail to prove in court that he had not acted "unmanly" when his wife sued him for divorce.[2] In the *San Francisco Chronicle* questions of manliness or ideal masculinity peaked between 1890 and 1900 with more than twenty-seven hundred articles, advertisements, and listings that addressed appropriate or inappropriate masculinity.

As middle-class whites sought to refashion ideal manhood as a balance between civility and virility, parallel characterizations of Chinese and Japanese

men and their masculinity proliferated. Japanese masculinity exuded artistic femininity. Portrayals of Chinese men in newspapers, journals, and theater marked them as degenerate and beast-like. Within a decade, however, depictions of Japanese would shift to become largely savage as Chinese became genteel. Divergent characterizations of Chinese and Japanese men that placed one ethnicity in stark juxtaposition to the other represented white men's best and worst masculinity. These misrepresentations of Chinese and Japanese served as a workspace to expand definitions of appropriate white middle-class masculinity. For sure, blatant racism motivated these characterizations, but also less discernible whiteness—a sense of entitlement for self-enrichment without a care about its consequences for communities of color—marginalized Chinese and Japanese in the city.

Asian Americanists since the 1970s have detailed the emasculating and unjust implications of the earliest representations of Asian American men. Robert G. Lee detailed how Chinese men appeared as a "third sex" threatening domestic tranquility in the nineteenth century. Jachinson Chan asserted that even the later image of the dangerous rapist Fu Manchu in fact desexualized Chinese men. Yet when sociologist Yen Le Espiritu surveyed existing scholarship on Asian American gender, she noted that "Asian men have been cast as both hypermasculine and feminine" in order to legitimate a variety of discriminatory practices. Literary critic Rachel C. Lee has further pointed to how contradictory depictions of Asian American masculinity that worked together rather than against each other illustrate the complexity of white racism at the turn of the century.[3]

Undoubtedly, racism and Orientalism alongside developing international and domestic affairs enabled and fueled one-dimensional representations of Asians.[4] Juxtaposing whites' discussions of their own masculinity alongside representation of Chinese and Japanese men, however, additionally reveals how racialized depictions originated in whites' explorations of their own manhood. White middle-class comprehension of their own gender and sexuality in fact formed the specifics of racialized characterizations for Chinese and Japanese.

Degenerate Chinese

In the 1890s, after more than ten years of reprieve in negative characterizations, images of Chinese men as sexually degenerate reappeared. The *Chronicle* reported in 1897, "Chinatown's rich men are rarely satisfied with monogamy. Like the Turk, the yellow capitalist wants as large a harem as his means can afford." When the United States Supreme Court granted Gue Lim the right for himself

and others of the merchant class to have his wife live with him in America, the *Call* cried that "slave dealers [were now] ready for business." "Imposter" men would bring in "fake" wives for the business of prostitution. In the popular play titled *The First Born*, Francis Powers created a male protagonist, Man Low Yek, who bought girls from China under the guise of marrying them and then sold them into sexual slavery. Evil Chinese men also drugged and seduced "white girls" as young as thirteen into opium dens. Critics protested their menacing and disgraceful presence in the city because of their thirst to sell "white girl[s]" to Chinese purchasers as well. "[T]heir whole lot [should] be sent back to China."[5]

Sinophobes decrying immoral Chinese men arose in tandem with numerous reports in the city's dailies of white men misleading white "girls" into turpitude. The *Call* accused John Wanner of "unmanliness" when he claimed in court that he in fact was not married to his wife Monika Wanner because he was already married to another woman in Europe. He hoped to avoid paying monthly alimony for her and their child when she filed for divorce.[6] Local dailies accused Horace Poulin of "unmanliness" in 1900 when he had sex with teenager Amy Murphy and then shortly after broke off their relationship, driving Murphy to kill herself. She had been happily living with Horace, awaiting him to fulfill his promise to marry her when she turned eighteen. Yet when Horace discovered she had previously been institutionalized, he told her "he wanted nothing to do with her." *The Call* condemned his behavior in their headline, "Poulin Escapes Punishment for Moral Crime."[7] Countless accounts of white men behaving badly to their wives or to women to whom they promised marriage diverged significantly from how actual Chinese men approached marriage in a state that not only prohibited the entry of morally suspect Asian women at the turn of the century but also legally banned marital bonds between "Mongoloids" and whites.

Chinese men held unshakeable faith that romance and marriage improved their quality of life, even more so than disillusioned middle class whites who publicly critiqued the restrictive life of marriage. In the 1910s Chinese publicly declared ultimate fulfillment in marriage through poems published through a noted San Francisco Chinatown bookseller. San Francisco Chinese published *Jinshan Ge Ji* and *Jinshan Ge Erji*, two books with more than sixteen hundred poems by Chinese men that revealed not only the struggles these men faced in anti-Chinese California but also their longing and concern for their wives and families.[8] Through metaphor, Chinese men dreamed of their wedding night. "I am in harmony with two delights in the fragrant bedroom: Tonight, I've finally tasted the scent of rouge and blossom." Others wrote more explicitly of the joys of being with their wives, "furtively . . . fondl[ing] . . . breasts." Separated husbands

imagined their wives in China pining away for them, debilitated beyond action. Wives at home waited "hearts aching," "brows besieged with sorrow." "Hurry home to share my pillow." "Spare me from growing cold and lonely under our jade-green quilt." "Just come home rich or poor, I simply don't care anymore!" "My precious youth [has] gone to waste." With detail and eloquence, husbands expressed the torment their wives back in China might have endured. "My loved one is far away. / Alone, by the railing, I look around aimlessly. / Many times, depressed by a bright, full moon/ My body aches and twists with ninefold grief and pain. / A heart left hanging. / A deep love that can not be severed. / Just how can we be reunited and share companionship again?/ Spare me from sleeping with only a cold quilt and pillow."[9] Sensations of women's sexual arousal flowed from their imaginations. "I am intoxicated as an apple blossom, in union at night, deep in passion, lips meeting lips."[10] In poems that expressed the suffering of women with distant husbands, these men demonstrated desire for emotional closeness rather than distance from their wives. These declarations diverged sharply from middle-class whites' declarations of their own disappointments with marriage. An entry in the *Wasp* underscored widespread derision of marriage in the city. "SHE—I wonder why there are so few marriages in May. / HE—Perhaps because most of the fools are in April.[11]

For Chinese men who longed for marriage with a woman in the face of extreme structural barriers, acting out in any way that would deliberately destroy a marital commitment was a luxury that few could likely imagine. In the first quarter of the twentieth century, Chinese immigrants Luke Chess and Wong Don Hang devoted themselves to the women they married, even as they continued to honor their unrequited "first loves" in their hearts.[12] In San Francisco's popular imagination, however, fictional accounts of degenerate Chinese men ran alongside real-life accounts of unmanly white men sexually exploiting women. These narratives vilified Chinese masculinity as dishonorable in the face of questionable white manliness.

In 1899 Jo Hathaway in the *Overland Monthly* depicted Ah Foy Yam, a slender creature from the underworld tolerating the verbal abuse from white miners for whom he fried ham and made pancakes.[13] The miners shouted requests for coffee, hash, plates, bowls, salad dressing, and more coffee. "Take yer beans, ye blasted ijut, and bring on me finger-bowl," one miner yelled as the Chinese cook raced to serve him. Yam cursed in frustration each time the Italian and Irish miners came in, so much so that it "turned the milk blue." He always, though, answered back politely. Hathaway detailed the "Mongolian's" spacious sleeves holding a knife and speculated on his deep frustration. While "his skinny hands look sometimes awful thirsty fer a life," the "satanical" Yam would ultimately

never be a match for white manhood. Each morning American and foreign-born white men alike humiliated the "sickly" Yam, who relied on serving white customers for his livelihood.[14] Ah Foy Yam, who lacked integrity, independence, and strength, embodied a less-than-ideal man.

Yet if Ah Foy Yam had been white, he could hope for recovery. Companies offered cure-alls for men that gave strength to weak knees and tired limbs and boosted self-confidence in the city's dailies such as the *Call* and *Chronicle*. Products to "restore manhood" could transform gaunt, frail men into muscular hunks and turn droopy mustaches full and perky. Electric belts could be purchased to restore manliness to weak men who suffered from "consumption" or excess in their younger years.[15] "Be a Man Now," declared one advertisement for the *Call* selling houses and stables, implying that property ownership defined manhood. San Francisco newspapers, in their offerings to improve manhood, underscored the value of robust men, defined by financial independence, intelligence, and health. Extensive pictorials encouraged young boys to reflect integrity and strength. Dressed in military uniforms or clutching a riding crop, exposés featured boy models such as Roy Lawrence and Edward Beattie in distinctly masculine outfits that signaled might and vigor modeled after military heroes such as General Dewey.[16]

As advertisements targeted whites to "restore manhood" or "be a man," health officials implicated Chinese men as carriers of sexually transmitted diseases. Dr. Hart reported how Chinese workers in particular "damned" cigars manufactured in San Francisco. "[S]yphilis, common among the Mongols and the most dreaded and horrible disease that human flesh is heir to, is the rule rather than the exception among the men who finger tobacco leaves and place the ends of the cigars in their mouths to make the leaves more easily adhere together." "Germs of syphilis and 'consumption,' the chinaman's favorite disease," attacked innocent men through cigars they smoked. Hart encouraged residents to patronize only "white" cigar rollers. Historian Nayan Shah details how public health officials perceived and depicted Chinese as diseased and a threat.[17]

According to city's vital statistics, however, Chinese hardly dominated the residents dying of sexually transmitted diseases. Syphilis, among other illnesses, was most prevalent among male whites, and officials carefully monitored its rate in the city. From 1897 to 1905, when depictions of Chinese as diseased ran most rampant, the municipal reports counted fifty-three deaths from syphilis, of which thirty-one were white and twenty were Chinese.[18] In 1910 the city mortuary reported seventeen syphilis deaths, all of which were white. The Chinese, who made up to 2.5 percent to 4 percent, of the city's population did represent

a disproportionate 38 percent of the deaths before 1905. Yet even at the county hospital, whites comprised nearly all of the patients admitted for genital disorders. According to three annual reports from city and county hospitals between 1897 to 1905, medical officials dealt with eighty-four cases of venereal disease, fifty-six of gonorrhea, nine of syphilis, and two of infected scrotum, all of which were "white." Officials additionally recorded one burned scrotum and one contusion of the testicle, both "white." Three reports from 1908 to 1912 reported 112 gonorrhea, sixty-five syphilis, and two infected vagina cases. Records classified only one of the cases as "yellow," the remainder "white."[19] For sure, these records may not necessarily record the actual rate of sexually transmitted diseases among Chinese. Many likely pursued their own community resources for assistance with matters of health. City hospitals also discriminated against Chinese and often prohibited them from accessing Western medical care even if they so desired. Yet these accessible public health records on genital disorders in their rawest form point to mostly whites as carriers of sexually transmitted diseases. Negative characterizations of Chinese male sexuality reflected the city's vigilance around its own largely white genital problems.[20]

Despite proliferating representations of Chinese as conveyors of illness, a significant number of whites in fact appeared to trust Chinese men as purveyors of good health rather than bad. Chinese American Ora Munson's father practiced Chinese medicine in San Francisco before the 1906 earthquake and fire and had only "American" patients.[21] Alfred Lee's father, a dental technician, served mostly Chinese patients but had a significant white clientele as well.[22] To the dismay of anti-Chinese critics, city whites frequented Chinese "quack" doctors and dentists for both Eastern- and Western-style medicine. In 1897 the *Wasp*'s warning against diseased and inept Chinese doctors revealed how many in fact saw them as effective. "A great number of poorer citizens, especially women, go to these Chinese doctors, thinking they are cheaper than their Caucasian brethren. When they lie at death's door or when their children are taken away from them they mourn. It is their own fault for trusting the heathen."[23] As sinophobes projected images of Chinese men as sickly, conservatives hoped to stem what they perceived to be a significant number of whites seeking healthcare from Chinese.

Essayist Mary Bell's short story in the *Overland Monthly* on allegedly wretched Chinese masculinity served as a powerful projection of white middle-class gender and sexual mores. In the story, house servant Sing Kee, who works for the Right family, invites his wife Dew from China to join him upon encouragement from his employer, Mrs. Right. Chinese colleagues of Sing Kee, however, kidnap Dew. Sing Kee then assumes that Dew has killed herself, since he had

instructed her to do so rather than face the degradation of sex work. Depressed, he takes up opium, quits his job, and moves to Chinatown. Seven years later, Mr. Right, passing through Chinatown on a Sacramento streetcar, sees a "poor, unsightly wretch tottering into a smoking den." It was Sing Kee, "craving to gaze through opium clouds at the dream-form of Dew."[24]

While Bell notably depicts Sing Kee as capable of love in his immense grief for Dew, she privileges the values of whites by citing Mrs. Right as the one who encourages a "normal" form of marriage for Sing Kee to live with his wife in the back cottage rather than leaving her in China to take care of his mother. Indeed, the surname of the white family as "Right" is likely not a coincidence in their assertion of correct sexuality. Chinese people and culture ultimately undermine Sing Kee's attempts for romantic and sexual normalcy. Misdeeds of the Chinese kidnappers, Sing Kee's own mandate to Dew to kill herself if she is ever forced into prostitution, and finally Sing Kee drowning his sorrows in presumably the Chinese drug opium all work to ruin Sing Kee's life despite the Right family's intervention.

Though Chinese values propel Sing Kee's demise, the story more closely aligns with familiar narratives of white slavery circulating among middle-class whites rather than Chinese in San Francisco. Among the Chinese, prostitutes were more often young women and girls in China sold to sexual slavers rather than wives of Chinese in America kidnapped for sex work. Dew's disappearance thus more closely aligns with the white slavery narratives that traced the kidnapping of innocent young white women forced into sex work to protest state-supported, commercialized prostitution.[25] Many of the court records in fact reveal that if a Chinese woman were to be kidnapped while in America and associated with sex work, the culprit would not be a Chinese "highbinder" but rather the Presbyterian Mission Home or United States law enforcement officials who pulled women out of their doorways and accused them of being a prostitute to forcibly "rescue" and frequently deport them. Additionally, few, if any, Chinese men in America would have told a woman to kill herself if she was forced into sex work. Numerous writings by Chinese men reveal how they believed taking on a wife who had previously been involved in sex work was a legitimate road to happiness. Poetry published by San Francisco Chinese courted prostitutes to quit their work and find matrimonial bliss. Stanzas advised women to find a "good man," "get hitched," "while there's still time to reach paradise."[26]

Moreover, whites represented nearly all the arrests under the federal Comstock Act passed in 1873 to enforce American morality. Under the act, officials arrested men for sending "obscene" materials through the United States

Postal Service. These items included publications, advertisements, gadgets, and devices that served "prurient" purposes. Envelopes or postcards bearing defamatory statements, intimate communications between lovers, and any vulgar expression thought to be "filthy" and "obscene" all fell under the purview of the Comstock Act. In San Francisco, violations involved some birth-control materials; however, individuals' and their personal letters made up the bulk of the arrests.[27] In 1899, when Ivor Evans from Sixth Street wrote an "obscene" letter to Emma Rosener, stenographer of Nevada National Bank in San Francisco, he began, "Dearest and Daintiest Emma, My Rose of Purest Passion," and included sixteen lines in rhyme titled "A Lesson in Love."[28] John Johnson sent an "obscene" letter to his "much beloved bride," Louisa Johnson of 775 Folsom Street in 1901.[29] Officials charged Americo Nassano with sending a letter to Elsa Weck with "indecent, filthy proposals" and an "obscene" postcard, "too vile for the courts."[30] In 1913, when Frank J. Mitchell vowed in a letter to "Mr. Hirsch" to no longer play "sucker," he found himself in court.[31] While a handful of cases between 1890 and 1924 did seek to prosecute Asians, all involved Japanese men rather than Chinese. Frank Mukai wrote an "unacceptable" love letter to "Miss Mary" in the same year and hoped for a response. Authorities also stopped Minoru Maita when he attempted to send a "lascivious lewd, obscene" pamphlet in Japanese to I. W. Amoto of Eighth Street in Oakland. The pamphlet, titled "S. F. Japan Herald," was Maita's daily publication out of his Golden Gate Avenue office. Bunzo Washizo, too, sent "lascivious" material in Japanese to "Japanese boy, George" on Rhode Island Street. Federal authorities took custody of the twenty pages of the "Agohazushi," a weekly comic magazine that Washizo published and edited himself on William Street.[32]

Chinese community leaders in fact viewed American values as encouraging immoralities within their communities. Chinese proverbs warned against the four vices of men: compulsive gambling, womanizing among prostitutes, indulgence in food and drink, and opium. San Francisco gained particular notoriety as a breeding ground for these activities. Cantonese writer Yee warned his compatriots traveling across the Pacific Ocean, "[B]e resolute to discipline yourself with virtues; Be aware of your behavior in the barbarian land."[33] In 1905, activists Ng Poon Chew and Patrick Healy declared that the initial round of Chinese prostitutes brought by "unprincipled Chinamen . . . [was] for the gratification of white men."[34] San Francisco officials promoted criminal behavior among Chinese. According to Ng and Healy, when Chinese merchants succeeded in getting a large number of prostitutes onboard a steamer leaving the United States, a certain lawyer of "your Honorable nation" in the employ of an "unprincipled Chinaman" got a writ of habeas corpus and brought all the

women ashore again. The court then decided that they had the right to stay in the country if they so desired. "Those women are still here and the only remedy for this evil and also for the evil of Chinese gambling lies, so far as we can see, is an honest and impartial administration of Municipal Government in all its details, including the police department. If officers would refuse bribes, then unprincipled Chinamen would no longer purchase immunity from the punishment of their crimes."[35]

Certainly not all Chinese forswore morally suspect activities. So often did Jue Lock, known as a Chinese "Mac," frequent a house of prostitution, that the people at the neighboring blacksmith shop could easily identify him to police as a regular patron. Other San Francisco Chinese traveled as far as San Jose to visit with their favorite sex worker.[36] As Chinatown gained particular notoriety as a breeding ground for gambling, opium use, and prostitution, a significant number of Chinese as well as many whites patronized these dens of "immorality." Likely, hard living conditions wrought by American racism fueled Chinese men turning to morally suspect diversions as an escape from the brutality of daily life.

Genteel Japanese

While San Francisco print and leisure culture depicted Chinese men as unmanly, Japanese manliness evoked praise notably for its feminine qualities. In flower arranging and domestic service, Japanese men flourished. Charles Lorrimer in the *Overland Monthly* noted, "With us, flowers are relegated to the province of women and children—most men would scorn to select a bouquet. But in Japan there are men—professors—who devote long lives to elaborate system of flower arrangement." In Japan, "a nation of artists," "no man's or woman's education is complete without the flower training."[37] A typically feminine and therefore frivolous pastime in America became a respectable art form led by "professors" in Japan. The *Wasp* also praised Japanese men for traits typically attributed to women in the United States. "Nimble-fingered" Japanese men received respect in a photographic feature on a cooper's shop.[38] Minnie Wakeman Curtis noted that Geoffrey Lloyd's household allegedly ran far more harmoniously with a Japanese houseboy at the helm than did "a bewomaned home in the western world."[39] San Francisco's community of writers and artists believed Japanese men embodied an aesthetic infused with feminine gentility.[40]

San Franciscans indeed asserted a new masculine ideal, which included characteristics typically attributable to women. Newspapers in San Francisco as well as Indianapolis praised writer Douglass Sherley in 1893 for having a

"fine feminine, but not unmanly quality" in his writing that appealed only to women or men with "a feminine streak."[41] In 1911 readers of the *San Francisco Chronicle* looked to the English to define the "modern man" as one who "act[ed] more naturally in life" and could readily tap into their emotions as women once did, before they too became "modern." The *Chronicle* reported that "nowadays" it was not "unmanly" for a man to cry in public but was rather a sign of healthy masculinity. Men's adoption of public weeping as positive reclaimed it from its negative connotations as a female characteristic common among the weaker, more hysterical sex. Ironically, the modern women who seemed to cry less in public as opposed to their now more emotionally developed male counterparts received renewed insult for not crying. At the theater and at sports events men wept openly, whereas women had forgotten the value of "a good cry."[42]

In 1900 Dora Amsden's essay "No Kagura" in the *Overland Monthly* exposed the favorable complexity of Japanese male sexuality infused with the feminine. Japanese actors with "slender nut brown fingers," literally hypnotized the audience, balancing their personas between the masculine and feminine. "The theater [went] wild with excitement. The spectators dash[ed] their ornaments upon the stage, some of them even tearing off their kimonos and flinging them at the feet of their favorite."[43] The men who appeared as beautiful, elegant women stunned audiences in their gentility and gender transformation. The ability of the Japanese male to hold both masculinity and femininity constituted part of the art and culture of the *No* play. Amsden privileged the theater by comparing it to the Delphic oracles, Shakespeare, and theater of the Grecian days.[44] A man who could successfully embody both the feminine and masculine comprised ideal masculinity. In this context, feminized Japanese men signified refined masculinity. An ideal man at the turn of the century was one who could seamlessly embody both sexes, male and female.

When Francis H. Buzzacott and Mary Isabel Wymore published *Bi-Sexual Man: A Revelation in Philosophy and Eugenics*, they celebrated individuals with both female and male sex organs, noting that the present condition of two separate sexes represented the deteriorated species of once-superior bisexual humans. Vestigial sexual organs in both sexes served as evidence for this evolutionary degeneration into unisexuality. The bisexual man, an individual who embodied both male and female sexes, was superior to the unisexual, since "the most perfect state of any creature is that which it possesses the highest degree of freedom." Bisexual creatures, "being able of their own inherent power thus to extend their existence," were in the "truest sense free and equal."[45] San Franciscans lauded Buzzacott and Wymore's national study. Scientists in Los Angeles also declared "bisexualism" as "better."[46]

As progressive as the embrace of "hermaphroditism" appeared, the promo-
tion of "bisexuality" in fact served as a vehicle to forward the repression of sexual
impulse and the eradication of women. According to Buzzacott and Wymore,
individuals devolved from an original bisexual condition through continued
sexual intercourse. Only chastity and the cultivation of the androgynous mind
could reverse the "degenerative" process and encourage the "reevolvement" of
bisexuality or the embodiment of two sexes in one. "If we would only cease this
abominable practice [sexual intercourse], and endeavor to develop our latent or
dormant bi-sexuality, menstrual issue [and] other sexual evils, would gradually
be done away with, and regeneration of the sexes to the perfect state would oc-
cur."[47] The bisexual man eliminated the need for women, whose very biological
function appeared disgusting or evil.

Notably, the ideal human form embodying both male and female character-
istics had to be a bisexual man rather than a bisexual woman. By eliminating
the reproductive need for women, the return to bisexualism for men through
chastity would solve the "great problems of sexual relations," resulting in "per-
petual peace and prosperity for mankind."[48] Only through the elimination of
sexual impulse and the eradication of women could man and thus the larger
human race be "saved." Man would reproduce on his own, and with this inde-
pendence and freedom the "social problem" between the sexes would also be
solved.[49] In fact, physician Gertrude Streeper with the New York Department
of Health declared that the bisexual woman as opposed to the bisexual man
would be similar to "some of the lowest forms of life," an "abnormality" that
was "neither wholly masculine nor feminine."[50] Those such as Streeper who
protested the increasingly public position of women frequently warned against
the horrid "mannish woman," a woman who hoped to resemble a man. While
feminine qualities increasingly informed the ideal man, a woman who incor-
porated man-like features became a freakish social problem.

As turn-of-the-century depictions of Japanese men reflected a modern man-
hood that embodied ideal qualities of femininity and masculinity, for Japanese
themselves their masculinity hardly existed in as genteel a manner as whites
imagined. In 1897 authorities after a prolonged pursuit finally caught Rinjiro
Obata, who supplied the women in his Japanese bawdy house on Pine Street by
smuggling them in as his wives. In 1908, courts convicted Keizaburo Sofuye of
inducting Chiyo Takahari into prostitution.[51] Others forged intimacy in pragmatic
yet not necessarily refined ways. Noriko Sawada's father sought out a number of
potential brides. In a letter to Sawada, the fourth prospective bride wondered how
many times they would "get it on" the first night. She looked forward to the end of
her virginity. Sawada broke the engagement: an "over-sexed" woman would likely

not remain his wife in a city where men greatly outnumbered women. When the woman who eventually became his wife arrived in San Francisco, she confessed she previously had a child out of wedlock who later died at age three. Sawada responded that he did not care. "She was here and that was all that mattered." Because he was forty-five years old, he had deliberately requested an older wife. He had hardly expected a woman of thirty-five to be a virgin.[52]

Artist Henry Kiyama, who satirized Japanese American life in his illustrated vignettes, drew Japanese men bumbling about to forward their own impulses and desires. His oafish men avoided work and unsuccessfully wooed women. Through his cartoons Kiyama made light of daily difficulties of the San Francisco Japanese community.[53] Short, stocky Japanese men fumbled domestic tasks as "schoolboys" and avoided any unnecessary expense of energy. In one strip a Japanese man stood idly by as a Japanese woman "cursed with awfully plain looks" struggled with a heavy load and child as she disembarked from a long voyage from Japan. A white woman nearby prodded him to assist her, considering they were of the same country. The man, feeling stumped about the exposure of his discourteous conduct, plainly lied that he was Chinese as he retreated.[54] Kiyama's men also admired white women's beauty. They lingered to watch a scantily clad fair-skinned woman who danced onstage at the Panama Pacific International Exposition. The men left the theater grinning, exclaiming how their lives had been "enriched."[55] Kiyama's men who ogled and fantasized about women never became empowered enough to forward themselves in fulfilling their romantic or sexual desires and hardly embodied a refined masculinity.

"The Best Oriental"

In 1910, in a significant turn, Lady Teazle of the *Chronicle*'s society page described the Chinese rather than the Japanese as "gentlemen" and "men of high class." With refined features and shapely hands, Chinese spoke with the expressiveness of a Frenchman but with "tenfold more grace." According to Teazle, many of them boast English university educations and have a dignity and "savoir faire" unequal to that of men in any other nation. She derided "blundering" Americans and "pompous" Englishmen who failed to recognize the high degree of a Chinese man.[56] Chinese men also appeared romantic and sentimental in popular songs such as "The Chinese Butterfly" and "Ching-a-Ling's Bazaar," which infused Chinese masculinity with sensitivity and tenderness.[57] The *Oriental Mission News* advertised modernized Chinese fathers advocating schooling for their daughters through secondary education and even university.[58]

Many historians point to 1900, nearly twenty years after the passage of the 1882 Chinese Exclusion Act, as the end of the most violent period of racism

against Chinese.[59] Political images of Chinese generally improved in the years that followed because their lower numbers now rendered them less threatening. The San Francisco press at times considered the Chinese the "best oriental" and began to defend the right of Chinese to remain in the city despite "demagogue threat[s]" from city officials. Editorials highlighted the importance of upholding treaty rights and elucidated the obvious financial contribution the Chinese made to the city. "Not exactly deadheads," the Chinese had paid 25 percent of the city's revenues, though they consisted of less than one-tenth of the general population."[60] In 1911 the *Overland Monthly* in the same issue featured two articles that marked a distinct turnaround in perceptions of Chinese in America. Thomas Wilson wrote a five-page article to repeal the "unjustifiable" Chinese Exclusion Act, and John Laughlin published an eleven-page exposé on why Chinese children in San Francisco should no longer be restricted from attending school with whites.[61]

With more positive depictions of Chinese men, Japanese simultaneously came to embody barbaric masculinity. After Japan defeated Russia in the Russo-Japanese War in 1905, Japan's rise as an international military power forced the United States to wrestle with the now aggressively expansionist Asiatic nation over trade and territorial agreements.[62] Undoubtedly, Inazo Nitobe's *Bushido*, an English-language text on Japanese values, including the code for samurai, also reinforced for American readers a Japanese masculinity steeped in rigid ethics and warrior stoicism. In newspapers and magazines Japan's military might transformed the nation from "she" to "he" as the Asiatic power, once a feeble grandmother, crystallized into the "yellow peril."[63] Emphasis on the positive feminine aspects of Japanese masculinity completely disappeared. When the previously acclaimed writer Dora Amsden, who detailed Japanese men's feminine elegance, continued to write positively about Japanese aesthetics, she received only criticism amid mounting anti-Japanese sentiment.[64] Japanese masculinity now embodied an anachronistic, savage masculinity. Once-civilized Japanese men with admirable feminine traits quickly became "aggressive," "blood thirsty warrior[s]."[65]

Just seven years earlier in 1900, the *Examiner* had depicted a smaller, less powerful Japan that strategically took into account its size in winning conflicts. The Japanese "science of self-defense . . . made all men equal." The article, devoid of inflammatory language, detailed each maneuver, rendering the "Japanese method" as an effective tool by which "small men may easily overcome large and strong ones." This article on the equalizing force of Japanese martial arts implicated Japanese men as smaller and weaker rather than ruthless, blood-hungry barbarians quick to fight.[66] By 1907, however, when officials arrested E. Anzai for robbery and assault three days after his

release from San Quentin Prison, the *Chronicle* reported Anzai discharging his revolver at the rear of the restaurant he robbed "to show that he was a worthy descendant of the last of the samurai."[67] The samurai reference encapsulated the Japanese man's martial, oppressive, and often irrational masculinity. Never mind that actual samurai would more likely brandish a sword rather than fire a gun.

Images of quick-tempered Japanese masculinity again reflected middle-class whites' lingering concerns over their own appropriate behavior. The *Chronicle* chastised police officer Robert Lean's conduct as "ungentlemanly" when he lunged at a woman telephone operator in uncontrollable impatience.[68] Men enraged from the demands of suburban life, including shopping and a mountain of household repairs, also were condemned as "unmanly."[69] Local papers criticized "unmanly" clergymen as well as husbands who abused their authority and power in both the public and private sphere.[70] Men who beat or maltreated their wives in particular became "degraded brutes in human form." Legislators amended California State Penal Code section 243 by adding twenty lashes to be administered as viable punishment to men who physically abused their wives because a "degraded" animal who would harm his wife could only respond to a brutal flogging.[71]

Japanese men came to embody the city's disdain for unrelenting patriarchs causing unnatural hardship to families they should be protecting. Anti-Japanese agitators used "unmanly" Japanese men as a reason to ban further immigration from Japan. Japanese men were automatons with no concern for the welfare of their wives and children. They oppressed brave little Japanese women who made every effort to cater to their needs. They also labored at double the number of jobs, for cheaper wages, and under horrid conditions that white, American-born men would never tolerate. Their lack of family values and morals made them particularly deficient, "to be scorned by the poorest white laborer and his wife."[72] While white middle-class concerns over their own masculinity provided the details of Japanese masculinity, politics would fan these flames of anti-Japanese sentiment through the language of gender and sexuality.

In 1908 President Theodore Roosevelt and the Japanese government signed the Gentlemen's Agreement, which severely limited immigration from Japan. Concerned about keeping an open door to Japanese markets, the United States negotiated an informal agreement so as not to offend Japan with expansive exclusionary legislation such as the 1882 Chinese Exclusion Act. Under the terms of the informal agreement, Japan would no longer issue travel documents for their citizens to emigrate to the United States; however, Japanese wives and children could be reunited with their husbands and fathers in America. Many of

the Japanese women who migrated after the Gentlemen's Agreement consented to arranged marriages through the exchange of photographs. These women became known as "picture brides," and whites became horrified over this foreign form of marriage.[73] Arranged marriages would not only disturb their increasing investment in romantic love, they would more powerfully awaken racist fears that the Japanese would send over women to multiply like rats in an eventual yellow takeover of America.

Public denouncements of the Japanese came to the fore in greater numbers in the 1910s as Japanese in America accrued small pockets of wealth. Since the federal government already prohibited Japanese immigrants from naturalizing, they remained no threat to white political power. Yet their increasing financial successes stirred the insecurities of white supremacists. Japanese immigrant farmers supplied more than 10 percent of California produce while owning only 1 percent of farmland. Fears of a Japanese takeover of not just the agricultural industry but the entire state's population resulted in the 1913 passage of the Alien Land Law, legislation prohibiting Japanese immigrants from owning land, by the state legislature.[74] This law disallowed "aliens ineligible for citizenship" or, more precisely, immigrant Asians from owning property or land. In the years that followed, debates about Japanese morality intensified as anti-Japanese proponents sought to curtail Japanese American livelihood. For whites who grew guarded about their own sociopolitical power, their fears of displacement remained intimately linked to their manliness. A loss of power would signal emasculation. As overworked Asian immigrant men acquired bits of money through the lowest-paying jobs that whites refused to take, these men strangely loomed like a menacing threat.

The same journals that had previously spoken favorably of Japanese masculinity now did the opposite. As Japanese men "invaded" U.S. farmland with little moral integrity, "poor whites" would be robbed of their financial resources to build families—the foundation of American morality.[75] Many grew anxious about the "invading horde of brown men" who encroached on California's "rapidly vanishing fertile soil." Japanese "politeness" had deceived Americans. They had "cunningly" devised ways, such as the Gentlemen's Agreement, to bring "their women" into California for "propagation."[76] An article on the Alien Land Law illuminated the distinct shift to villainize Japanese men in mainstream print.

Japanese community leaders responded vocally to attacks when white moralists spoke against the practice of Japanese men arranging marriages. K. Kawakami in the *Chronicle* defended Japanese marital unions involving "picture brides" as an extensive venture between two families. He explained that when

a man who desired to marry could not travel to Japan, he solicited the help of his parents. After research into the prospective character, social standing, family relations, genealogy, health, and education of the groom and the bride, the couple exchanged photos and decided for themselves whether they wanted to wed. The wedding occurred at a ceremonial dinner that the bride, both parents, and relatives attended. The groom, unable to afford his fare back to Japan, stayed in the United States. After registration with the proper authorities, governments of Japan and the United States alike viewed the union as legitimate. In many cases potential couples had grown up in the same town or village and had known each other since childhood. As xenophobes decried the practice as unnatural, Kawakami defended it as reasonable and respectable. He concluded, "There is nothing objectionable in the practice of picture marriage which I repeat is a gross misnomer."[77]

Yamato Ichihashi, a faculty member at Stanford University, fought fervently against the increasingly negative presentation of Japanese immigrants that emphasized their deficient masculinity. In 1913, when he published a pamphlet that outlined Japanese masculine superiority, he called the replacement of the Chinese men by the Japanese an "inevitable" process of "survival of the fittest." Japanese men in their superior state had come to America to replace the Chinese who were "growing old and weak." Conjuring images of masculine prowess, Ichihashi proclaimed that the Japanese were not "beaten men of beaten races," as were the other immigrant groups.[78] Ichihashi elevated Japanese men through the denigration of other ethnicities in perhaps one of the oldest unfortunate lessons of Americanization.

By 1920, legislators in immigration hearings engaged in heated discussion opposing sexual liaisons between Japanese men and white women. On July 12 at the St. Francis Hotel images of Japanese procreating madly and working industriously in unhuman-like ways concerned the House Committee on Immigration and Naturalization. Japanese boys and white girls in the same classroom particularly aggravated exclusionists, because the older Japanese schoolboy who started at American school at a later age was "so large" next to the "young girls" of his class. School authorities pushed to segregate.[79] Dailies also now clearly regarded interracial intimacies with whites and Japanese as doomed. When the *Call* highlighted one marriage between an American and a Japanese, it noted with surprise, "East and West sometimes do meet."[80] In 1922 the *Examiner* additionally announced, "Progeny of Japan-White Union Amaze." The article traced the controversial marriage of Helen Frances Emery and Gunjiro Aoki and the astonishment when intelligence tests ranked their children as "genius[es]."[81]

Behind closed doors Japanese community leaders more aggressively countered accusations from government officials regarding their oversexed desire for white women. When the House Committee pressed George Shima as to his views of Japanese and white intermarriage, his response likely did not ease the committee's anxieties. Shima drew an analogy of crop mixing in potatoes as productive. He may have hoped to reassure the committee when he noted that white women proved inaccessible anyway in San Francisco because "Yankee girls" were "expensive." In New York City, though, Shima cited several Japanese marrying Americans. Neither Italian nor Irish, they were "American," "genuine American-born American girls." Shima concluded with a provocative prediction: "In a hundred years, when you come back you will see this warm Japanese blood mixed up with your race." Shima's imaginings of "strapping, young, virile" Japanese men marrying "young, white girls" no doubt inflamed a committee already concerned with the precariousness of white masculinity in the face of Japanese men.[82]

As an ardent Methodist and prominent potato grower, Shima potentially represented the epitome of American masculine civility. He took active measures to end the picture-bride practice because of American criticism and never donated to a Japanese charity. Instead, he had purchased $180,000 of liberty bonds and advised everyone to do the same and to make donations to the Red Cross. He frequently donated sacks of potatoes to charitable causes. Growing potatoes instead of rice, rejecting Buddhism for Christianity, and expounding on the "virility" of Japanese men, Shima, as he stood before an immigration commission, perhaps more aptly embodied ideal American manhood than any of the other white men at the meeting.[83]

The Japan Association also sought to present a domesticated Japanese community that mirrored the best of American values. "We consider it most important and necessary that the Japanese in America should marry and settle down in domestic life, because the home is not only essential to the wholesome existence of individuals, but is also the foundation of a stable national and social structure." Home life inhibited drinking, gambling, and other "evil practices" and greatly improved the "moral condition" of the San Francisco Japanese.[84]

Yet despite these declarations protesting unjust representation of Japanese, they steadily became "shrewd" and "ubiquitous," "colonizing" American farmland, while the Chinese evolved into "steady, honest, and unpretending" men from the "flowery kingdom."[85] John Laughlin in 1911 went even further in depicting Chinese as "manly, intelligent, wise leaders of men."[86] Chinese patriarchy suddenly became a model of manliness when just two decades earlier critics had warned it would bring "barbaric horrors"—namely, slavery, polygamy, and infanticide.[87]

The Work of Representations

Shifting representations of masculinity for both Chinese and Japanese had little material benefit for either community even when seemingly positive. Presumptions of Chinese masculine immorality formed in the 1850s remained in whites' minds and would have damaging effects on the Chinese community. By 1900 it had already furthered half a century of anti-Chinese legislation that curbed their access to the most basic of living conditions. In the 1870s health officials presumed Hansen's disease, more commonly and pejoratively known as leprosy, to be a genetic disease of sexual immorality originating in Chinese. Anti-Chinese crusaders in San Francisco claimed that "generations of syphilis" had resulted in the "moon-eyed leper."[88] As fears mounted that Chinese would spread the disease to whites through intimate or sexual contact, authorities indefinitely quarantined and later deported Chinese back to Hong Kong. Moral authorities and city officials who viewed Chinese as pollutants joined forces to restrict Chinese livelihood and movement in San Francisco. In 1880 the California state legislature prohibited the licensing of marriages between "Mongolians" and "white persons" due to the "vile and degraded" amalgamation that would result.[89] Ten years later, wages for Chinese workers averaged one-half of those for whites.[90] Widespread belief on the morally degraded state of Chinese contributed to the passage of the 1882 Exclusion Law, the first and only federal immigration law that explicitly banned a specific ethnic group from entry into the United States.[91] So thoroughly had anti-Chinese forces quashed Chinese livelihood by 1900 that Asian Americanists mark the turn of the century as one of relatively low anti-Chinese sentiment compared to the 1870s. Yet in the 1890s explorations of white middle-class masculinity would fuel renewed proliferations of deficient Chinese men years after white San Franciscans' most heightened perception of the threatening Chinese had subsided.

Even as representations of Chinese men later improved, earlier images of morally bankrupt, sinister, yet ultimately impotent Chinese would never completely disappear. In 1920 Esther Barbara Bock portrayed an Ah Choo beleaguered by racism at his factory by narrow-minded whites who openly mocked his accent and belittled him. Ah Choo, however, ended up murdering a white coworker, Frank, who had not only ridiculed him but had also sexually harassed the forewoman, Mabel, for whom Ah Choo worked. Ah Choo had developed an interest in Mabel after she treated him with kindness in the face of ill treatment from all of the other workers at the factory. Ah Choo later killed himself on her door stoop the night before her wedding when he discovered that she was engaged to another man.[92] In 1924 a Chinese slaver Ching Chow in the *Overland*

Monthly schemed to kill missionary Miss Patterson. As soon as he knocks her unconscious with a vial, which he presses up against her nose as he accompanies her home from a meeting one night, he falls to his death through an uncovered manhole on the street. Miss Patterson later awakens and walks home, believing that Ching Chow has sacrificed himself to protect her from a wrongdoer.[93]

Representations of Japanese as having refined masculinity or effective fighting skills also did not translate into material benefits. Available employment for Japanese relegated them to menial tasks in the domestic sphere rather than work befitting a refined aesthete or a noble samurai. At the turn of the century Yoshiye Togasaki's father, an educated Japanese man, took any job he could, even if it was housework.[94] Few whites appeared to fear the alleged warrior spirit or recognize the reality that a significant number of Japanese men likely had some knowledge of jujitsu, the mandated training of which was standard in compulsory military service. Artists Chiura Obata and Yoshio Markino, poet Yone Noguchi, and other Japanese recounted countless acts of violence against the Japanese in San Francisco as well as across California.[95]

Earlier accounts of jujitsu as an effective fighting tool for the small Japanese "brownie" laid the groundwork for the mounting representations of Japanese men as aggressive and warlike. Beginning in the 1890s, newspaper reports marveled at how law enforcement and immigration officials in Japan received training in jujitsu. The *San Francisco Call* reported that "almost every cable is humming with accounts of the startling agility of Japanese in their struggle with Russia." In fact, even those in Europe who are not "ardent supporters of the little brown men are forced to applaud their lighting strokes . . . and telling blows." The *Call* declared, "This is the Japanese 'jiu-jistu.'" Interestingly, Japanese men in San Francisco who advertised their domestic services at times also included jujitsu instruction as something they could offer. In the *San Francisco Chronicle*, A. Okada in 1905 called himself a "good young Japanese" looking for a position as a "school boy" to do housework for a "good family." He added, "if you like, I will teach jujitsu." When passenger ships from Japan docked in San Francisco as well, the Japanese crew often held demonstrations of sport and fitness through jujitsu, to the delight of Americans traveling across the Pacific.[96] In 1904 Estelle Wyman, a notably "San Francisco woman," captured the front page of the *San Francisco Chronicle* when she applied jujitsu to a man who accosted her on the streets of New York City.[97]

Still, at a Seventh Street saloon five months later, popular notions of Japanese men as fighting machines did not inhibit Herbert Dreyfus from repeatedly harassing S. Takena. Dreyfus, whom the *Call* reported as "never having heard of jujitsu," amused himself by annoying Takena, a "meek" Japanese porter of "small

stature." He relentlessly poked Takena's ribs and tweaked his hair, ignoring the bartender George Betham's warnings that he "desist his playful maltreatment ere it provoked the worm to turn." Dreyfus replied "not me" and then attempted to kick Takena in the shins. Dreyfus found himself "drawing a parabola" as he flew through the air. He gathered himself from the floor, which had struck "all angles of his anatomy."[98] Dreyfus and others who physically harassed Japanese appeared unaware, if not indifferent, to martial characterizations of Japanese men.

Moreover, as wealthier Americans consumed Japanese culture to enhance their own leisure lives, their embrace did not necessarily translate into a true appreciation of Japanese culture or a commitment to advocate for the betterment of Japanese lives in America.[99] Poet Yone Noguchi frequently spoke out against America's turn-of-the-century fascination with Japanese aesthetics as cheap and insincere.[100] In fact, prevailing discourses of a refined feminine Japan could turn in a moment to highlight its impotency. The *Chronicle* painted Japan as a "decrepit old woman" when discussing Japanese workingmen in Yokohama. The nation's productivity was limited, "all her effort exhausted in the few crude and meager labors by which she barely sustains herself, with no surplus energy for vigorous growth and development."[101] The *Call* also announced Japanese immigrants as "little brown men" who arrived in the United States "scared to death," as opposed to Europeans, who arrived with more confidence.[102] While Japanese masculinity largely signified positive incorporation of civility and femininity in the late 1890s, femininity easily degraded into effeminization and infantalization in a society steeped in misogyny.

At the turn of the century, middle-class whites forged new meanings of manhood as burly immigrant men challenged the social position of overcivilized Americans who had apparently become soft in office jobs. Masculine civility incited public interest and discussion as San Franciscans sought to find an ideal balance of strength, rationality, and self-control. Whites would then use Asians in the city to explore definitions of appropriate masculinity.[103] In the 1890s Chinese symbolized a degraded form of masculinity mired in inescapable sexual immorality while Japanese men appeared genteel and aesthetically refined. Within ten years, however, characterizations would change drastically as Chinese increasingly embodied civilized masculinity and Japanese men became barbaric samurai. Despite the extremes in representation, apparently positive characterizations had little productive effect on Asians and would primarily work to enliven white San Franciscans' expansion of their own gender and sexual mores. Sharp delineations between Chinese

and Japanese additionally provided a stage on which middle-class whites could fortify their own supremacy as the standard of ideal gender even as they negotiated its terms. Indeed, conversations about masculinity would never solely be a playful forging of new meanings of gender. Cultural historian John Kasson noted that "thinking about [white] masculinity in this period meant thinking about sexual and racial dominance as well."[104] As San Francisco's excavation over its own masculinity subsided, public discussions of Chinese and Japanese masculine gender would also dwindle in number and pave the way for the conflation of the two masculinities.

Mindful Masquerades

White Privilege and the Politics of Dress

An actor sporting a hat and suit appeared onstage at the California Theater near San Francisco's Union Square in 1900. Singing "Rag Time Mixes My Brain," the performer, who appeared to be a man, drew crowds as a woman convincingly impersonating a man. While Mary Marble sang about nonsensical American slang that fuddled the brain, her presence as a woman in man-drag likely signaled an additional "mix[ing] of the brain."[1] Not far from the applause of the California Theater, recent immigrants from Japan gathered for a group photograph in Golden Gate Park. Nearly all of the thirty-six men wore Western-style outfits, three-piece ensembles of white collared shirts, buttoned vests, and matching blazers. Some had topped their outfits with ties or tailored hats. The event marked an important moment for these neatly dressed men in American attire.[2] Though separated by only a few miles, Mary Marble and the young immigrant men appeared worlds apart—one of performance and recreation, the other of community building in a harshly anti-Asian city. In other parts of San Francisco, additional forms of dress or undress took place as well. Chinese San Franciscans less deliberately adopted American clothes as Japanese strategically transformed their outfits into American style for acceptance. Meanwhile, white women rushed to department stores to incorporate kimonos into their own wardrobe. As mundane as the wearing of clothes might appear, dressing or crossdressing and its reception collectively clarified the ubiquity of white supremacy and xenophobia in turn-of-the-century San Francisco.

Prevailing assumptions about gender and race facilitated the profitable use of masquerades among whites, while all forms of dress never proved productive for city Asians. White performers beguiled audiences in their gender transformations and made gains at the box office. Japanese immigrants who deliberately engaged in another form of crossdressing as "American" for acceptance continued to suffer from assaults and discrimination as "aliens." Chinese conversely faced criticism as "unassimilable" for supposedly maintaining their ethnic clothing. Meanwhile, fashion-conscious white women coveted the traditional dress of Japanese femininity to enliven their otherwise mundane lives. The juxtaposition of various mindful masquerades illuminated how a city that embraced the successful remaking of oneself would reflect and reinforce white power and gender normativity even as it took pride in its internationalism and open ideals.

Gender Crossings

When Mary Marble crooned onstage in man-drag, she existed as one of many actors who acceptably crossed into a different gender onstage, a popular theatrical specialty across the country.[3] In San Francisco, appearing onstage as a different sex signaled an impressive skill that drew praise from local reviewers. In 1897 a young man with very "shapely legs" skipped across stage at the Columbia Theater. The *Chronicle*'s theater critic described the play, *Devil's Auction*, as "capital entertainment," especially since the young man, in fact, was a woman.[4] A year later at the Columbia Theater, "Stuart," the famous female impersonator, graced the stage in the production of *1492*.[5] In 1899, the *Wasp* praised Gladys Montague, the "champion cake walker and male impersonator of the Pacific Coast," who at age seven already held a collection of medals.[6] For Mary Marble from the California Theater who sang "Rag Time Mixes My Brain" as well, gender impersonation proved to be a productive theatrical strategy. In a previous 1898 play, Marble, along with four other women actors, appeared in male attire at the Columbia Theater in *A Milk White Flag*.[7]

Theater critics consistently praised gender impersonation as art. In 1900 two curly-headed boys, Ellis and Edwin Smedley, enacted the tragic romance between Romeo and Juliet. The *Call* praised the "clever chaps" for their clarity and sincerity in acting. "Adult actors could take a lesson from them."[8] The *Chronicle* also commended Walter Leon, only eight years old, for his recitations, all given with the poses, mannerisms, and characteristic expressions of a little girl. "He is a strikingly handsome youngster [with] long golden curls. Gowned after the most approved feminine style, with his pretty ringlets fluffing about

his delicate face, the clever little fellow will go through his really artistic work with perfect self-possession."[9] In these artistically acclaimed performances, the successful passing into a different gender remained key.

Sympathetic newspaper portrayals of women wearing male attire paralleled theater reviews and seemed to suggest some degree of tolerance for young women who passed as men. In 1898 the *Chronicle* cited Mrs. William Kreiger, who attained local fame with her male attire. Despite initial notoriety, her community in Oakland quickly came to support her. The paper praised her as a "woman of great benevolence," "endear[ing]" to many.[10] In the previous year the *Call* praised twenty-two-year-old Clara Jensen's determination as a "full fledged knight of the road." Dressed in man's garb with a roll of blankets across her back, Jensen had footed it all the way from San Francisco to Fresno in April 1897. She was on her way to her parents' home in Fort Worth, Texas, after her husband of only one year had deserted her.[11]

The city in large part appeared supportive of women taking on men's roles as men. After a stable accident in England led doctors to discover an eighteen-year-old stable groom was a woman, the *Chronicle* highlighted the stable owner's declaration that it would be advantageous for women to race because of their light weight and devotion to the horses.[12] Billy Johnson also received praise from both the *Call* and *Chronicle* for his "correct life," chopping and cording wood for money between jobs, despite his "tramping" lifestyle in a "dusty roads fraternity." Newspapers described Johnson as "good looking" and "affable." Johnson had been fired from a previous restaurant job when the owner's wife suspected something awry with his "smooth face" and "graceful movement." The *Chronicle* markedly referred to Johnson as "he" until "she" pleaded guilty to the charge of impersonation.[13] Neither strongly sensational nor pejorative, both the *Call* and the *Chronicle* might have appeared sensitive even by twenty-first-century standards. Articles extolled these individuals and used pronouns that fit their gender presentation.[14] With so many public accounts of "women passing as men," San Francisco might be construed as having been a significantly trans-gender town—a city where individuals could live as a different sex than the one they were assigned at birth—as early as the 1890s. Indeed, historian Peter Boag asserted that the West was in fact more transgender than previously recognized, noting that individuals who refused to conform to gender norms found freedom in the frontier in significant numbers.[15]

Yet San Francisco had a legacy of mandating gender-appropriate attire. As early as 1863 the San Francisco Board of Supervisors passed a municipal law that criminalized appearing in a public place "in a dress not belonging to his or her own sex." By 1875 the $500 penalty from the original anti-crossdressing

law had increased to a $1,000 fine, six months in jail, or both. By 1900 the police had made more than one hundred arrests for crossdressing.[16] Closer examination of the arrests, however, reveals that not until 1872 did any arrests occur for violating laws that prohibited crossdressing. Beginning in 1872, these crossdressing arrests for the most part averaged two a year. In 1898, however, arrests abruptly rose to twelve. An additional spike in arrests to seventeen occurred twenty years earlier in 1878.[17] The 1898 peak coincides with the increased reports of crossdressing in the city press and could signal law enforcement's mounting anxiety about what the proliferation of these representations might mean. Indeed, the implementation of laws prohibiting specific activities more often signals repression rather than freedom.[18] However, anti-crossdressing municipal codes minimally enforced through the nineteenth century at only two arrests per year, with the exception of two years, may have more powerfully signaled a significant presence—rather than persecution—of transgender acts in San Francisco. Crossdressing may have landed in the municipal code after an undeniable rise in their visible presence offended a specific group of legislators. The very existence of the laws against gender impersonation then points to how even as San Francisco embraced gender crossings in some contexts such as the stage or in employment, other sectors remained absolutely opposed. These two dueling perspectives could coexist precisely because of the fundamental belief that gender as distinct, innate categories could not actually be crossed.

The appearance of individuals who did not wear gender "appropriate" dress in local publications for the most part signaled the city's perception of them as compelling curiosities rather than as an indicator of the city's progressive gender politics. When three men and one woman robbed a bank, the *Chronicle* headline read "Woman Bandit in Male Attire." While the text of the article detailed only the robbery itself, the curiosity of a woman in male attire headlined the heist. The *Chronicle* likely hoped to profit from the titillation of a crossdresser in a story about a bank robbery that was perhaps not unusual otherwise.[19] In a favorable article on Babe Bean, a reporter born as Elvira Virginia Mugarrieta who lived as a man, the *Chronicle* wrote, "The *Stockton Mall* has a special writer who is a curiosity in more respects than one."[20]

In fact, so compelling would Bean's presentation as a man appear that his racial identity became largely erased in a San Francisco print culture that frequently unnecessarily highlighted the race of nonwhite people. Though Bean's father was the first Mexican consul to San Francisco, Bean's Mexican heritage never appeared in any of the accounts. For sure, Bean hid his identity, giving reporters not even a sliver of opportunity to consider his race as other than white. Yet at the very least the city's largest morning newspapers signaled that

he could have appeared more than "just plain white" to those who knew him. The *Call* reported, "Born in the South, Bean has the dark hair and full mouth that tell of love of music, adventure and pleasure." The evoking of music and pleasure paralleled San Francisco's understandings of Southern Europeans, such as Italians, whom San Franciscans embraced yet simultaneously marked as different.[21] Still, as reporters and likely readers grappled with Bean's gender transgression, they focused only on the fact that he identified as a female who adopted male attire so effectively that he could easily pass as a "smooth faced boy."[22]

The city's print culture more typically reduced people of Mexican descent living in America as simply "Mexican," erasing their personhood into a single racialized type. When a United States marshal gunned Pasqual Gonzales in and around the months Bean also appeared in the local papers, the *Chronicle* mentioned Pasqual's name just once in the opening sentence and then referred to him simply as "the Mexican" throughout the article. "Cowboy Pugilist" Peter Everett from Cripple Creek, Colorado, would also be "Mexican Pete" throughout the pages of the *Chronicle*, despite the fact that he was a United States citizen.[23] While Bean seems to have escaped the negative totalizing of his identity into a racialized character, white middle-class fascination over his gender nonconformity would completely overlook Bean's own sense of self as a person, not just white but likely Mexican as well.

These turn-of-the-century gender crossings, so compelling as to even erase race, drew interest precisely because of perceived rigid categories of maleness and femaleness. Indeed, illustrated cross-gender representations served as ridiculous comedy. A 1900 full-page pictorial in the *Call*, titled "How San Francisco Notables Look in Theatrical Roles," assigned fourteen dignified urbanites to female bodies. Heads of San Francisco notables such as Judge W. W. Morrow, Mayor Phelan, David Starr Jordan, and Joaquin Miller perched atop bodies of famous females of the theater such as Cleopatra, Juliet, Cinderella, and Lady Macbeth.[24] As rugged bearded faces sat atop female-gowned bodies, the jarring images entertained readers by the misplaced juxtaposition. In an 1898 cartoon in the *Wasp* Hannibal Flirtatious became the butt of a joke when he approached from behind an individual he believed to be a woman. As he stepped up to offer her an umbrella, he thought to himself, "Ah hah! I'll just ask that beauty to get in out of the wet." When she turned around, she revealed herself to be a male porter. The porter responded, "Naw, I don't want no umbrella, I'm waterin' dere plant see." Flirtatious jumped back in horror, dropping his umbrella and monocle. He was indeed "disillusioned," as the title of the cartoon read.[25] The

humor that framed Hannibal Flirtatious's mistake defused the horror that gender fluidity might bring, the "wrong" gender in the pursuit of a romantic partner. Notably, a larger number of illustrated and narrated sketches that derided men dressing as women additionally pointed to misogyny.[26]

In a most telling cartoon in the *Chronicle*, individuals with undeterminable gender faced explicit derision. The strip titled "Personal Pronouns Up-to-Date" displayed three frames of images that defined gender. The first frame pictured a woman smoking a cigarette and dressed in a fitted blazer, necktie, and bloomers. She wore short hair and a tailored hat. Under her image sat the caption "She." The second frame showed a man in a jacket, collared shirt, belted knickers, and a driving hat. He clutched a golf club, and the caption underneath read "He." In the final image appeared an individual in an overcoat, an oversized bow tie, and a derby hat. Underneath this third image read the caption "It."[27] In 1895 the *Call* pointedly summarized the city's aversion to blurring of the genders when it quoted Reverend D. B. Greigg of the Presbyterian church. Greigg noted that "manliness" or strength and courage was a virtue for both sexes, whereas he found a "mannish" woman to be "intolerable" since she, by definition, in fact strove to be a man.[28]

When the *Chronicle* reported on Babe Bean's 1897 train accident, the headline read "Miss Bean Not an Up to Date Young Man" and accused Bean of "trying to play the boy" by jumping off the train as it was moving. The article underlined Bean's feminine sex in light of her failed attempts at masculinity.[29] Additionally, the *Call*'s praise of male impersonator Alice Condon's performance onstage

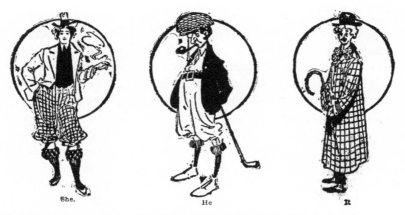

Newly expanded meanings of gender still existed within strict confines of acceptability. "Personal Pronouns Up-To-Date," *San Francisco Chronicle*, June 27, 1897.

reveals an undeniable investment in discrete categories of sex dictated by gendered characteristics. The fourteen-year-old's "strong," "true" voice and pleasing "carrying" quality made her "naturally adapted" for gender transformation. The "Native Daughter Should Have Been a Boy," the headline declared.[30]

As San Franciscans embraced gender crossings, they remained heavily invested in stable categories of male and female. Their convictions coincided with a national consensus that supported discrete biological and moral definitions of gender.[31] During this "golden age of impersonation," performers reinforced notions of polarized gender difference. Actors marketed themselves as magicians, performing the unimaginable feat of crossing into the role of the opposite sex. Gender crossdressing sold as "magic" drew audiences who firmly believed in innate differences between the sexes. Historians Sharon Ullman and Daniel Hurewitz trace how social acceptance of performances such as that of the nationally acclaimed crossdresser Julian Eltinge relied on this fundamental assumption that an impossible divide existed between men and women.[32] Though their physical performances seemed to muddy gender categories, men and women who impersonated the opposite sex in the early twentieth century did not profoundly challenge contemporary notions of discrete and unchangeable gender among the middle-class audiences who enthusiastically and comfortably enjoyed their productions. Instead, socially acceptable gender crossings in San Francisco marked the city's willingness to play within categories that they already viewed as immoveable.

Dressing American

As white female and male impersonators profited by crossing apparently impermeable categories of gender, Japanese immigrants donning Western dress, or *youfuku*, less successfully crossed into what they optimistically believed to be permeable categories of "American." Immigration records, newspaper images, family pictures, group photographs, and individual portraits trace Japanese adoption of youfuku, reflecting immigrants' hopes of gaining acceptance in the United States. Their dress diverged significantly from that of their Japanese contemporaries in Japan, who customarily wore Japanese dress, or *wafuku*. While upper-class men in Japan increasingly adopted Western style as a new trend signifying education and high culture, the vast majority in Japan remained in wafuku.[33] As Japanese San Franciscans recorded themselves on film, they also participated in an American fascination with photography that had recently become accessible to the middle classes. These images thus ad-

ditionally demonstrated their subjects' dedication to, if not success in, being perceived as "American."

Photographs of immigrants arriving at Angel Island Immigration Station before disembarking at San Francisco show that most individuals landed wearing Japanese rather than Western dress.[34] Without access to a clothier or beauty salon for a San Francisco coif, they remained in Japanese style while being detained. In staged group photographs, Japanese women posed in kimonos held together with neatly tied obi. In candid pictures, Japanese women in traditional hairstyles and wafuku stood overlooking the cove or on the roof of the administration building at Angel Island.[35] Interestingly, soon after authorities released women from the immigration detention center, Japanese women appeared in one- or two-piece skirt and dress ensembles. Several issei women, the first generation of Japanese to arrive in the United States, recalled a visit to the Western clothier as one of their first destinations after landing in San Francisco.[36]

In a thirty-eight-page spread congratulating Japan's military prowess in the annexation of Korea, the *Chronicle* included articles on the Japanese in the city as well as across the Pacific. A full-page pictorial displayed portraits of twenty-five "men of prominence" in the "local Japanese colony." All the men had their hair cropped short, appropriate to contemporary styles, and all wore Western suits. Nineteen of the twenty-five also dignified their visages by sporting the bushy mustache common among Americans in the early 1900s. Brief captions accompanied the photographs, detailing advanced degrees from prestigious universities.[37] Clearly, all these men fit ideal American male aesthetics in their style, if not in their race.

Family portraits consistently revealed wives and mothers wearing Western dress.[38] Parents also dressed children in Western clothes. Kay and Sawako Tsuchiya, two and five years old, wore dresses with trimmed collar and sleeves and held delicately dressed dolls. A big white bow held Sawako's hair.[39] In a 1915 portrait, a cook and his wife who labored at the Leonard home on Fulton Street also posed in Western dress. While the man wore a suit, the woman wore a high-necked dress and puffed white hat that resembled a giant cotton ball.[40] Additionally, a 1922 photo of David Fukuda at one hundred days old pictured him in a white trimmed dress, an outfit reflecting lingering Victorian norms.[41]

Even in environments that specifically promoted Japanese culture, photographs revealed participants in Western clothes. In a 1909 photo of the Japanese language school on Sutter Street, adults and children wore appropriately gendered Western garb.[42] An illustration of a group of men at a kendo club showed Japanese men dressed in Western suits or protective kendo gear. For sure, their

collective identity based on ethnicity and culture proved important to the members, not only in their regular meetings for language or kendo training but also in the taking of the group photograph.[43] Their cultural solidarity, however, did not motivate the men to wear Japanese clothing. None wore wafuku in the group photograph.[44]

At wedding ceremonies as well, brides increasingly wore Western-style wedding dresses, not flowing kimonos. In the Ichikawa wedding portrait, the groom wore a white bowtie and long tuxedo jacket, while the bride donned a frilly white dress with delicate trim. A veil, an elaborate hairpiece, and white gloves accessorized her outfit. Flowers bedecked her Mary-Jane shoes.[45] Some couples did exhibit more cultural fusion. In these cases, grooms typically wore tuxedos, but some women wore the more traditional black wedding kimonos. Even for these brides, though, a Western bridal hairpiece and a veil topped their ensembles. One bride wore white gloves with her wedding kimono. For many of the wedding portraits, however, the only item "Japanese" besides the ethnicity of the individuals themselves may have been the decorative fake cherry blossoms that often accessorized the background of the photo shoot.[46]

Japanese women in San Francisco additionally participated in the national trends of portraiture for young American society women. Beauty shots akin to debutante portfolios celebrated blossoming young womanhood. Photography studios such as Motoyoshi and Moriyama in Japantown developed headshots for young women to distribute among friends and family. Hana Ohama wore a lacy white dress, white gloves, and a hat with a big plume hanging over the side. As she sat upright, her positive posture pushed her breasts forward while her hands rested in her lap.[47] Kikuye Okuye's gloved fingers supported her slightly tilted head at the chin. Her dress fell across her shoulders to form a "V" down her front, where it was fastened with a brooch.[48] An additional photograph from the Uakahara family presented a profile of a woman peering out the window as she gently pulled back the curtain. Bedecked in a lacy beaded dress that flowed to the floor, she wore a white flower in her short wavy hair parted to the side. A large diamond ring conspicuously enveloped her left ring finger.[49]

For Japanese San Franciscans, their Western clothing reflected their efforts to gain American acceptance. Japanese Americanist Yuji Ichioka noted that issei community leaders and Japanese government officials detailed a policy of fitting into America, which included how one dressed.[50] Historian Eiichiro Azuma similarly described how the Japanese community grew fearful of white American conflation of Chinese and Japanese as a target of discrimination. Youfuku became a way to outwardly distinguish Japanese from Chinese who apparently refused to conform their clothing to Western standards. Japanese

government officials explicitly denounced Japanese who lacked Western ap-
pearance as "uncivilized" and compared them with the Chinese.[51] Migrating
Japanese additionally left a home country where print media had already popu-
larized narratives of "self-made men" such as Andrew Carnegie, Theodore Roo-
sevelt, and Abraham Lincoln. Young Japanese hoped to project these images of
underprivileged, ambitious men who succeeded in rising from "empty pockets
to millionaires" or "log cabin to the presidency."[52] Part of achieving this goal
meant adopting the very American dress these self-made heroes wore.

An 1899 Togasaki family portrait eloquently portrayed the aspirations of
Japanese immigrants as they sought to enjoy a piece of the American pie. The
young father wore a suit and tie, while the wife wore a dress with black plumed
hat. The two children also wore Western clothes. Yet more telling than merely
the Western-style clothes were the detail and finishing touches of the children's
presentations. The small boy donned an outfit reminiscent of a U.S. soldier's
uniform. Both children clutched American flags. For Asian immigrants prohib-
ited to naturalize by federal law, traditional symbols of American citizenship and
nationalism, the U.S. flag and participation in the military, proved particularly
ironic.[53]

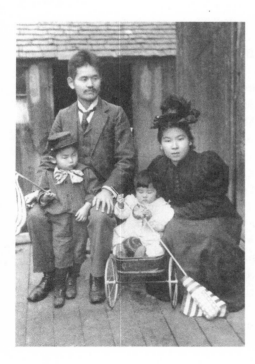

Photograph of Togasaki Family, 1899. Is-
sei Project. Courtesy of National Japanese
American Historical Society, Inc.

Japanese immigrants who took great pride in their national origin less likely hoped to become actual white Americans and more likely aimed to take advantage of American privileges. Japanese in exodus at the turn of the century considered themselves to be both "emigrating" and "colonizing." Immigrants who strove for acceptance and success on the West Coast remained invested in their Japanese identity, and their desire to assimilate then became a part of expressing Japanese nationalism.[54] In American clothes, they hoped for equal access to opportunities that racism would deny based on appearances that associated them as outsiders. For the Japanese, their masquerades became a more serious act of fitting into a city often fearful of the unfamiliar. Their Western costuming existed as mindful masquerades, constructed thoughtfully in their hopes to acquire their American dream rather than arising "naturally" from living in America.[55]

Notably, Japanese self-representations in photographs may have been not completely "American" in form. According to historian Alan Trachtenberg, American photographers had established a distinct sitting protocol for portraiture by the 1870s. Though the middle-class daguerreotype portraits from an earlier time hoped to capture bodies without regard to composure, by the late nineteenth century photographers moved to overcome the "intractable countenance," the face that would not "relax or mellow or glow with 'expression.'" In the late nineteenth century, photographer W. S. Haley explicitly instructed that "[the] posture of person sitting for the portrait should be easy and unconstrained; the feet and hands neither projecting too much, nor drawn too far back; the eyes should be directed a little sideways above the camera, and fixed upon some object there, but never upon the apparatus since this would tend to impart to the face a dolorous, dissatisfied look." Photographer Albert S. Southworth elaborated the chief goal of the portrait is a look of animation, intelligence, and inner character. The photographed should will themselves into a desired expression that matched their self-image and look anywhere but into the lens.[56]

However, few of Japanese San Franciscans' photographs from the early twentieth century displayed animation or mood-inspiring manipulation. Sitters sat stiffly, stared directly into the camera with an expressionless face, and presented what Haley undoubtedly would have criticized as an "intractable countenance." Though Japanese dressed in Western clothes, their poses for the most part remained frozen in a time that preceded 1900s San Francisco by at least two decades. Their poses may have replicated sitting styles of their picture-taking cohorts in Japan. In a photographic exposé by clothing scholars Etsuji Tanida and Mitsue Koike, images of Japanese in Japan from the 1890s and early 1900s all revealed expressionless faces staring directly into the camera.[57]

Japanese American portraiture appeared more conservative in content as well as form. Immigrant women did not appear in the most current styles during the earliest years of the twentieth century. Western dress for Japanese women meant enacting more traditional styles of American dress. While the city's trendiest female dressers donned fashionable bloomers, blazers, neckties, and vests that some commentators criticized as "mannish," Japanese women in San Francisco had themselves photographed in late Victorian gowns. More than just conservative, these outfits may have struck some San Franciscans as outdated in these more "modern" times of the "New Woman."[58] For the immigrant Japanese, dressing "American" more likely meant capturing an imagined, obviously occidental aesthetic rather than keeping up with the most recent and sometimes hair-raising styles.

Dressing "Un-American"

While whites who despised Japanese hardly noticed Japanese Americans' efforts for acceptance in their wholesale rejection of Japanese clothing, sinophobes focused on Chinese components of Chinese American dress to highlight their alien existence in America. At Golden Gate Park and on the city's sidewalks, Chinese men appeared with long queues and clothed in cotton tunics and Chinese shoes. On street corners and public benches, Chinese women wore matching pantsuit-like outfits and pulled their hair tightly back into neat buns.[59] In San Francisco, where men kept their hair cropped short and women wearing bloomers caused controversy, Chinese men wearing long, braided queues and women wearing pants looked like a reversal of appropriate gender presentations. In actuality, the Chinese donned clothing that reflected a fusion of both Western and Chinese influences. Still, whites could only see markers of the alien Chinese to fulfill their own imaginations of what the Chinese symbolized.

While some wealthy city inhabitants purchased exotic photographs of San Francisco Chinese from photographer Arnold Genthe, the less wealthy and, indeed, the majority of the city population participated in a more common discourse that poked fun at the odd Chinese.[60] In one 1901 illustrated satire in the *Wasp*, the Chinese queue became an "American plait" when a young white girl following a Chinese man eyed his queue, cut it off, and reattached it to her own head. In her appropriation of the Chinese queue, crossings became a mix of mockery, cruelty, and incorporation. In the image of a Chinese man wearing an American plait marked as female, the cartoon underscored whites' perception of Chinese men's style as odd, a confusion of gender.[61] According to Robert Lee and Nayan Shah, short stories, newspaper accounts, and political propaganda

in the San Francisco area evoked Chinese men as queer or strange through the second half of the nineteenth century.[62] Many Chinese were aware of the negative impact of their obviously Chinese dress. One anonymous poet elaborated, "A loose gown with wide sleeves brings only scurrilous remarks. And it gets you nowhere, even if you are modern in education."[63] Yet, attitudes toward Western dress held by the Chinese, who frequently associated it with sexual excess and immoral character, inhibited their adoption of such attire, despite the negative attention Chinese clothing brought.

In the Chinese newspaper *Chung Sai Yat Po* Western dress often appeared in advertisements that offered remedies for sexually transmitted diseases. In December 1909 images of men wearing traditional Chinese clothing and advertisements sold goods and services in Chinese. On December 29, however, an ad appeared for Scott's Santal Pepsin Capsules. In the top corner appeared a headshot of a very Western-looking man. Dignified in appearance, with cropped short hair and the requisite bushy mustache of the time, he wore a jacket with a collared shirt and tie. It was the only ad with the text appearing in both English and Chinese. "No cure, no pay," it read, "Cures quickly and permanently the worst cases of Gonorrhea and Gleet, no matter how long standing." For the Chinese, sexually transmitted diseases and their remedies held an American component articulated through the image of dress, style, and language.[64]

The Ohio-based Scott's Santal Pepsin Capsules likely chose *Chung Sai Yat Po* to advertise their product because the company believed the paper reached a market of Chinese men rife with sexually transmitted diseases. They used explicitly sexual language to sell their product during a time when the other products claiming to "restore manhood" did the same in the largest city newspapers, such as the *Chronicle* and *Call*. Yet in the Chinese language newspaper the advertisement's use of English and its accompanying image of a man marked as "American" in his Western dress left a striking connection between sexual disorders and Americanness. The link proved particularly ironic since the tablets had no actual curative value. In 1919 the Federal Bureau of Chemistry ruled that the tablets had fraudulently misled purchasers.[65] As Scott's Santal Pepsin Capsules evoked the language of sexuality to increase sales of pills that in fact did nothing for "gonorrhea and gleet," the company further solidified Chinese views that Americans embodied sexual immorality.

Essayist Sui Sin Far, as well, used American dress as a literary device to signal duplicitous character at the turn of the century.[66] In "A Chinese Ishmael," Far depicts the villain acculturated into white America. Lum Choy, a scarred man of little integrity who intends to pay a high bride price for Ku Yum, "curr[ied] the favor of white people" and "w[ore] American clothes." Far's villain, Choy,

notably in American dress, embodies a despicable man, adopting the image of Western masculinity through his attire.[67]

Poems from San Francisco's Chinatown during the earliest years of the twentieth century additionally reveal how Chinese women wearing Western clothing signified illicit sexual freedom. American dress incited ambivalent reactions among individuals who recognized both its sexually provocative qualities and its disregard for displaying "appropriate" Chinese femininity. Women "all dolled up" in public appeared "elegant and sweet." In their "half Chinese, half American" presentation, they displayed their "fashion expertise" but certainly not their "feminine disposition." The sex appeal of American gender presentation implicated prostitute-like qualities, too. Women "in the business of pleasing men" dressed themselves in the latest American fashion, as did the "beautiful" women of Chinese ancestry born in the America.[68]

Still, as much as resident Chinese appeared alien to scrutinizing eyes, in fact their appearance embodied little of anything authentically or uniquely Chinese. Chinese San Franciscans' dress were not comprised of wholly Chinese ensembles. Their outfits reflected a blend of the cultural influences that permeated San Francisco's Chinatown. In his detailed study of early San Francisco Chinatown photographs, historian John Kuo Wei Tchen observed that as alien as the Chinese seemed to white San Franciscans, the immigrants' physical appearance hardly reflected Chinese traditionalism. Photographs reveal most Chinese in cotton tunic tops, cloth shoes, pants, and wide-brimmed hats. While the tunics and cloth shoes came from China, the pants and Hamburg-style felt hats did not.[69] In 1915, when authorities fished out a Chinese "John Doe" from the San Francisco Bay, he was wearing Kentucky jeans and black gaiters with his Chinese top.[70] Though Chinese immigrants did indeed adopt bits and pieces of American dress, they remained intractably Chinese to the San Francisco eye.

Yet anti-Chinese sentiment would likely not have disappeared even with explicit concessions in clothing and culture from Chinese that signaled westernization. In 1902, "Christianized and Americanized" Sam Sue drove his "rather good-looking" wife Catherine Lynn to suicide over his "cruel treatment." The *Call* referred to him as an "almond-eyed deceiver" who changed his name to Joe Sampson. He revealed his "Mongolian instinct" when he tried to divorce Lynn and take all the community property they had bought and built together. Additionally, when authorities found Ng Wyee Ming, a cook at the Waldorf Café, strangled to death in a lodging-house room, they suspected two white men for the "diabolical" crime. The assailants had bound Ng hand and foot so tightly that the strands cut into his flesh; they had jammed into the socket of his eye a rubber stamp bearing his American name "Charley Daley Sandy." Ng

had used the stamp to sign letters he wrote to his white friends. He dressed in "prosperous-looking American clothes" and "associated with white men" with "little intercourse with people of his own race" despite warnings from a cousin that he should live in Chinatown and not "affect American dress."[71] Historian Mary Ting Lui traces how whites in New York City viewed Chinese who dressed in wholly Western attire as particularly sinister in their facility with not only American culture but also in their ability to seduce white women.[72] No doubt, Western dress would have brought no substantive benefits from xenophobes who would have easily identified another characteristic to condemn the Chinese. For those Chinese who found comfort largely within San Francisco Chinatown, any shifts to more drastically abandon Chinese dress and risk alienation from their own community would have made less-than-perfect sense.

Dressing Japanese

To add insult to injury, San Francisco whites faddishly sought out "kimonas" to spice up their leisure lives amid heavy implications of donning or discarding traditional dress among Asians. Across the nation, feminine Japanese imagery enhanced white people's personal lives on a very public level as Japonisme as an aesthetic movement swept across America. Cultural critic Mari Yoshihara asserted that white women's incorporation of Japanese femininity into their private lives signified a "measure of liberty" for white women on the East Coast. In San Francisco, white women's use of Japanese culture for their own leisure revealed how progressive, middle-class white explorations of their own gender and sexuality and their embrace of internationalism would impose a second crossdressing on Japanese immigrants.[73]

The local press took advantage of imagined Japanese femininity to promote events and products and evoke cultural capital. In the 1890s San Francisco had just embarked on its fascination with Japan. A drawing of a shy Japanese woman hiding her face behind a fan promoted an exhibit on fans at the Golden Gate Park Museum.[74] An illustration of a kimono-clad woman brushing out her thick, waist-long black hair sold "Imperial Hair Regenerator" that promised to make the most streaky, bleached, or gray hair beautiful, glossy, and natural.[75] In 1907 Lady Teazel of the *San Francisco Chronicle* outlined the lives of rich and dignified women of the Bay Area on her "Society Chat" page. In addition to her usual reports outlining the accomplishments of local society ladies, one day she featured large pictures of two women in her full-page column. One youthful brunette in her twenties, Mrs. B. O. Bruce, wore a tennis outfit and carried a racket while posing in front of the net. The other, Mrs. J. Parker Whitney, a

heavier, silver-haired woman, posed stoically, clothed in more elegant attire. Sandwiched between these society ladies and serving as a backdrop to the two photographs, a drawing of a Japanese woman in a kimono sprouted from an enlarged flower. She daintily held a rice-paper umbrella over her shoulder as the rising sun of imperial Japan radiated behind her. Although Lady Teazel had not included even a sentence on a Japanese "society" woman in San Francisco, she evoked Japanese feminine gentility through the illustration in the backdrop. For Teazel and perhaps many of the well-to-do people of San Francisco, a Japanese woman's femininity represented an ideal that even white society women on their own could not evoke.[76]

At afternoon teas, affluent San Franciscans dressed in kimonos threw parties. Japanese luncheons became intensely popular among society ladies weary of the monotony of English-style afternoon teas and matinée lunches. White women took great care in accessorizing their homes and bodies for these afternoon events. In full Japanese garb from the sandals to the haori, partygoers chatted and ate *suimono, yakizakana, sashimi*, or a light snack with *kuchitorimono* and *chawan mori*.[77] Items from the "Orient," including teacups from Turkey or China and even servants "only from Japan," added a distinct flavor to tea parties that left guests raving for days.[78] Department stores known for their "honest values," such as Marks Brothers on Market Street, kept their prices competitive for the popular trend by slashing their "lawn kimonas," normally fifty cents, to nineteen cents.[79]

Japanese San Franciscans wearing kimonos proved to be a pleasing attraction for city elites enraptured with Japanese aesthetic. The San Francisco Women's Board of Foreign Missions sent Japanese American community leader Yonako Abiko a letter requesting that she wear her kimono when she volunteered for a weekend excursion in Bolinas. "I trust that you will find it convenient to take with you the Japanese costume. It will add so much to the joy of the girls."[80] For sure, wearing a kimono, with its delicate fabric, many layers, and multiple ties around the waist, would almost never be "convenient." Still, Abiko appeared familiar with this type of attention and prepared ahead of time. When she embarked on a cruise in 1907, the international passengers began applauding upon her entry into the grand ball. Abiko had worn a kimono at the request of her fellow passengers.[81] European friends as well constantly raved about the beauty of the kimonos. Margherita Palmieri wrote, "I scarcely need to tell you how pleased I should be to have [your photograph] in your pretty national costume if you have one to spare. In fact I am wearing one at this moment, and I think you would be rather amused if you could see it, as I was not able to get one thin enough for summer wear I have had one made of art muslin such as they use for

curtains and I have made two paper chrysanthemums for my hair!"[82] Between men as well, Western writer Charles Warren Stoddard expressed disappointment when Japanese immigrant poet Yone Noguchi appeared before him in a shirt and tie rather than a kimono.[83] For Japanese immigrants who purposely wore Western dress in their daily lives, fulfilling requests to wear kimonos became a forced second crossdressing that underlined their Japanese origin, which they ironically sought to downplay.

Probably few, if any, white women wanted to become ethnically Japanese. Even fewer would have believed that in wearing Japanese dress their race might be perceived as Japanese. Yet many of the middle and upper classes embraced the signifiers of Japanese womanhood to enhance their own lives amid shifting gender trends. White women enacted romantic femininity by incorporating Japanese femaleness into their own lives, which remained securely white. Masquerades provided a way to express desire and fantasy, as San Franciscans hoped to enhance their intimate and leisure lives.[84] For Japanese San Franciscans, who hoped to be recognized as American, with all attending privileges, Japanese dress imagined, enacted, and at times requested by whites no doubt reminded them of their insurmountable alien status.

In fact, whites for the most part enjoyed the privilege of crossdressing in any direction with productive results, even with the existence of municipal laws against impersonation. Both gender and racial masquerades enjoyed a degree of acceptability in which participants effectively passed either on the stage or in everyday life. In theater, actors such as female impersonators drew sold-out audiences and respectable fame. In 1900 "little" Blanche Trelease also impressed audiences with her "laughable Chinese imitations" in the play *Brownies in Fairyland*.[85] On the street, individuals such as Mrs. William Krieger and Babe Bean enjoyed aspects of work and leisure that would have been unavailable to them in female dress.[86] Additionally, white women who bought fancy kimonos or dressed for Japanese-themed tea parties gained cultural capital as worldly women. In 1910 the Columbia Park Boys' Club at 458 Guerrero Street held an "elaborate fundraiser" where the boys held exhibition games in rugby dressed in Chinese and Japanese costumes and later in basketball dressed as girls.[87] In stark contrast, Chinese who dressed across gender appeared in the local press as participating in criminal activity. In 1897 the *Chronicle* described Chinese girls entering the United States dressed as boys as a "celestial trick" to "hoodwink" immigration officials.[88] While Japan-friendly Americans preferred to see their Japanese friends in kimono, the larger number of whites, however, found the course of assimilation so banal that those who apparently resisted it, such as the Chinese, would come under fire for their intractable alienness. In an

ironic double twist, Chinese dressing in American clothes could face criminal charges for impersonation. In 1902 Detective Ed Gibson arrested Hoe Can and Lee Hung in Sullivan Alley for wearing suits and false mustaches. Authorities concluded they were masquerading as Japanese and charged them with a $5 fine or five days in the county jail.[89]

While assimilationists perceive incorporating the clothes of your adoptive country as a natural process, Japanese San Franciscans and their pervasive American masquerades remain, to immigration scholars, the more interesting phenomena to investigate. Whereas Chinese Americanists such as Judy Yung and John Kuo Wei Tchen never explain perhaps the more "natural" phenomena of retaining cultural markers in clothing, Japanese American historians such as Yuji Ichioka and Eiichiro Azuma take great care to elucidate the adoption of Western dress among Japanese immigrants. Research by Barbara Kawakami, Daniel Masterson, and Sayako Funada-Classen also suggest that Japanese immigrants in Hawaii and Latin America during the same period largely chose to maintain Japanese dress when plantation work did not dictate what they could wear.[90] Though urban xenophobes declared the Chinese and their traditional dress odd, Japanese San Franciscans in fact proved more queer in their American masquerades.

Even as San Francisco Japanese deliberately dressing Western proved odd, their masquerades became a very real and perhaps "natural" part of their identities—a mindful presentation of themselves that reflected the hardships they experienced in America. Their location in an urban setting, within a largely white American population, and their desire to gain equal access to privileges of American citizenship could logically add up to Western dress. Youfuku in San Francisco remained a clothing style born out of the conflict inherent to an Asian existence in America and almost immediately became an ordinary part of Japanese immigrant identity.

In previous scholarship crossdressing and racial masquerades have appeared as sites of revolutionary possibility. Cultural critic Eric Lott detailed how masquerades "became less of a repetition of power relations" and more of a "distorted mirror" that signified displacements and discontinuities and that illuminated a "peculiar American structure of racial feeling." Literary critic Laura Browder also highlighted the American tradition of "self-invention" and "testaments to the porousness of ethnic identity," particularly in California.[91] Perhaps for some, power relations could be distorted and identity proved porous. Yet for many more it did not. Precisely because limitations posed by physiology, phenotype, and social proscriptions proved physically impermeable, San Franciscans resorted to their imaginations to escape or stretch social reality.

As individuals committed these acts deliberately under the cover of social acceptability, masquerades revealed how imagination created viable virtual realities within constraining physical actualities. As much as racial categories and thus racial privileges appeared to constantly have potential for redefinition and redistribution, in fact its marker appeared more distinct and less permeable for the many San Franciscans who remained indelibly marked at the turn of the century. Scientists believed that innate characteristics distinguished not just men from women but also Chinese, Japanese, and African Americans from whites.[92] Though racial categories faced a legacy of public blurring through the contestations of language, biological reason, and mixed-race individuals, it would nonetheless be a racial fluidity more readily available for those who could exist in the world as whites or even "dark white."[93]

For Japanese San Franciscans, their near future appeared more inflexible than for those who perceived California as a place of "porous ethnic identity."[94] After the enactment of the 1913 Alien Land Act, the first major anti-Japanese legislation in California banning Japanese land ownership and restricting their tenancy, the Japanese community began a new mission of assimilating Japanese immigrants. Titled *gaimenteki doka*, or external assimilation, it required conforming physical appearance and environment to European American standards in ways that paralleled what the "educated" Japanese had been advocating since the 1890s. By 1915 Japanese immigrant women passing through Angel Island most likely wore Western dress. When Michi Kawaii, an activist for the YWCA, visited California to educate herself on Japanese immigrants and their living conditions, she described picture brides as looking "queer," "for no one had told them their huge pompadours stuffed with 'rats' had long since gone out of style in America, and their efforts to beautify themselves with an excessive use of powders resulted only in giving an impression of uncleanness."[95] For Japanese who dressed in Western clothes, their masquerades signified only the beginning of a longer struggle between their optimism and the reality of overcoming a race-conscious society despite their visually marked bodies.

At the turn of the century, gender and cultural impersonations existed in many forms and held various implications. Together, they illuminated the ways individuals used gender and sexual imagination to enhance their lives and create identities that physical bodies limited or to enact desires that social proscriptions prohibited.[96] Theatrical gender impersonators drew audiences by magically defying gender. Women who wore men's clothes in daily life accessed traditionally male spheres of public life in the local press. Urban whites also sought to "color" themselves for entertainment, as they enacted Asian

personae. For the Japanese who dressed American, crossdressing represented their hopes of accessing the "American dream" during xenophobic times. Masquerades on one level held positive value as acts of self-determination even if they produced little material results. San Francisco's multiple masquerades, full of potential transgressions, more powerfully reinscribed relationships of racial power and gender and sexual normativity. While whites generally profited from their impersonations, anti-Asian sentiment in San Francisco rendered it nearly impossible for Japanese and Chinese to productively dress themselves.

Whites boisterously exploring their own gender and sexuality had little concern for the consequences of their racialized sex acts or their hypocrisy. As gender impersonators onstage received accolades for traversing the seemingly impossible abyss between the sexes, Japanese who crossdressed in American outfits in hopes of crossing the racial divide and gaining acceptance continued to meet persecution as aliens. In an additional twist, anti-Asian whites who lambasted Asians as "cunning" for dressing American simultaneously criticized Chinese as "unassimilable" for *not* wearing Western clothes. While sociologist Clare Sears suggests a direct link between the "policing of gender transgressions" and the "policing of multiple forms of bodily difference," turn-of-the-century impersonations in San Francisco would also suggest that a *celebration* of gender transgressions could also deleteriously affect those seen as racially different.[97] The mythical wide and open San Francisco, a city of expansive sexual and racial possibilities, in reality offered freedoms only for a select social class and could do so precisely because of the overwhelming rule of white power and heterosexuality.

"Conscience Aroused"

Gender and Sexual Disinterest
and the Rise of the "Oriental"

In 1914 the Grand Jury, a governing board charged with ensuring the proper fiscal and administrative operation of San Francisco, reported that the "general moral tone of our city would seem to be far better than it was only a few years ago." San Francisco's prurient interests appeared to have declined, and commercialized vice accordingly became less lucrative. With the city's "conscience" now "aroused," residents lived their lives with more care to appropriate conduct.[1] After more than fifteen years of concerted efforts to institute morality on the part of social conservatives, officials believed their city had finally cleaned up. Narratives of gender and sexuality no longer appeared as abundant as in previous decades. Newspapers printed articles on romantic mishaps and gender expression with less frequency, less interest, and less space than in the past. Advertisements lost overt sexuality as well. Gender and sexual stories with ethnic specificity, in particular, diminished from the pages of the dailies. After vilifying or romanticizing Chinese and Japanese gender and sexuality at the turn of the century, the city's leisure culture now seemed starkly silent on the matter. The quiet, however, would facilitate a second racialization in which the few representations that did appear steadily conflated the Chinese and Japanese into the single "Oriental."

Just a decade earlier, heated public conversations about San Francisco's gender and sex acts had flooded newspapers, magazines, and theater houses. Reports of interracial intimacies, same-sex affection, rising divorce rates, sexual

excess, and shifting gender norms provoked excitement and concern. Journalists, essayists, and playwrights had created Chinese and Japanese representations to enact urban explorations of appropriate womanhood, manhood, and sexual conduct. Depictions of submissive Japanese women proliferated just as increasingly independent white women appeared to be undercutting marital stability. Representations of Chinese women as cunning seductresses multiplied while San Francisco's young people exercised increasing sexual liberty. Additionally, characterizations of Chinese and Japanese men as barbaric monsters or genteel aesthetes mounted as whites sought out virility as a complement to civilized white manliness.[2] While these representations at first marked Chinese and Japanese as different from each other, they simultaneously began to blend, seeding the beginnings of a distinctively pan–Asian American experience in the earliest years of the twentieth century. Parallel hurdles rose against Chinese and Japanese as all racial stereotypes, no matter their specific meanings, fortified white supremacy.

A More Moral San Francisco

According to city reports, San Franciscans had outgrown "low" forms of leisure and now "[i]mmoralities . . . being just what the tourist wants," were "created and maintained solely to catch the dollar of the out-of-town sightseer." "Our people are not interested in them," officials declared. By 1924 municipal departments that had previously complained about vice and crime merely requested new furniture and paint on their office walls in their reports. The Committee of Public Morals and Places of Amusement, the one department charged explicitly with the city's gender and sexual state, proposed only one ordinance to regulate the passageways and stairways of theater houses so that patrons awaiting seats did not crowd the aisle and the entrances. The Grand Jury no longer found the city's morality a problem, as it had previously.[3]

As much as municipal records suggested a reformed city, the private conduct of San Franciscans likely had not changed significantly. Gender and sexual trends from the 1890s that had previously caused a stir continued in the decades that followed. Women pursued education, embraced athleticism, wore "mannish" attire, and freely took to the stage. The YWCA explicitly promoted good health, vigor, and resilience as important characteristics for women.[4] "Healthful outdoor activities" brought a "clear, naturally rosy complexion." The Christian organization promoted "sport dress" among the modern women, discarding encumbering clothes from an earlier time, and joked about gender shifts that had now been occurring for more than twenty years.[5] Glenna Collett of the

YWCA's newsletter noted, "My daughter is wearing knickers and my son is taking a girl's part in the college play."[6] In the Happyland Writer's Club writing contest, twelve-year-old Doris Barr's story of a young girl who assisted in the American Revolution while passing as a man in her brother's outfits enjoyed widespread popularity.[7] In 1917 women at the University of California staged theater performances on campus.[8] Chinese American surgeon Margaret Chung also clothed herself openly in "mannish" attire with tailored suits and ties in the early 1920s, amid hushed whispers that she might be a lesbian.[9]

Couples did not cease seeking out divorces as well. In 1919 Sarah Klemmer fought her husband Leonard's efforts to dissolve their marriage on the grounds of desertion. Eva Oberg lost benefits from her husband's workplace death when the Industrial Accident Commission found that she had filed for divorce before his accident. C. J. Branham sued his wife, Marion, for divorce on the grounds of desertion and cruelty. Jeannie and James Dunphy, Mary and Emil Anderson, and many more moved to dissolve their marriages between 1910 and 1924.[10]

City residents continued defying mandates of legislated morality. Courts found Charles E. Day guilty of violating the white slavery act, transporting Gladys E. Harris from Shreveport, Louisiana, to San Francisco. In 1913 Rosy Guaragna and Hattie F. Brown terminated unwanted pregnancies. In 1918 Austin Tobin confessed to having sexual relations with another man after the two became intoxicated. Albert Bauer committed "adulterous cohabitation" when he took up residence with Lola Miller and her daughter Ida while Lola remained married to Samuel Miller. When courts charged Galen Hickok in 1921 of giving Bertha Casteel an abortion, considered to be an "illegal operation," he adamantly protested, declaring that "professional abortions" should be permitted by law and that they were in fact "essential to society," particularly in the case of young girls who would suffer irrevocable shame and stigma from a pregnancy. As late as 1923 Jimmie Wong found himself in hot water for transporting Chin Sit Jung to San Francisco from Seattle for debauchery and prostitution.[11] Indeed, government officials' declaration of a renewed city with its "conscience aroused" did not necessarily indicate the continuing reality of San Franciscans' "immoralities."

Yet residents certainly seemed less compelled by gender and sexual stories in leisure. The number of narratives on manhood, womanhood, and sexual mishaps that had earlier filled newspapers, magazines, music, and theater decreased significantly. Articles on manliness in the *Chronicle*, which had numbered just over twenty-seven hundred between 1890 and 1900, dropped precipitously by more than 40 percent in the two decades that followed. Mention of the New Woman diminished even more drastically, dropping by 66 percent in the same period.

Similar declines in discussions of racialized sexuality appeared most visibly in the city's print culture. When comparing the *Chronicle*'s August 1918 issue with the same month twenty years earlier, three articles about gender or sexuality made direct references to ethnicity in 1918, as opposed to the seven similar types of articles that appeared in the paper in 1898. It was in the *Call*, however, that the change appeared to be more drastic. In April 1917, not a single gender and sexual article appeared with ethnic specificity. Twenty years earlier, in April 1897, ten stories of romance, sex, and gender with deliberate reference to ethnicity occupied the pages of the *Call*. Finally, when articles reported on Chinese and Japanese, they did so with less sensationalism than previously. In 1918 the *Chronicle* noted plainly with little elaboration that a "Chinese tong war [occurred] in Chinatown over possession of slave girl."[12] Twenty-one years earlier, the *Call* had more creatively narrated arrests of Chinese prostitutes. In 1897 women were "wailing" and "tom-toming" in a way "that the widows of Ashur could not approach."[13] While local publications had earlier capitalized on "obscenity" and "vulgar work" that stirred people to buy, in the 1910s sex and gender narratives, even in sensational headlines, lost the power to capture attention. According to the *Wasp*, no longer would scandalous marriages and "low groggeries of the town" fill local publications and thereby compromise the integrity of more legitimate news of the day.[14]

Advertisements most starkly demonstrated the city's disinvestment in topics on sexuality. Those that once openly discussed sexually transmitted diseases such as gleet and gonorrhea, offering cures for both masculine and feminine ailments, disappeared. Remedies for tired feet, dandruff, and muscular ailments replaced previous notices for electric belts and other products that restored "manliness" or solved "womb complications." Ads such as "'Tiz' for Feet" promised "no more sore, tired, tender, . . . calloused feet or painful corns."[15] Danderine, a scalp tonic, vowed to end dandruff while leaving hair thick, wavy, and beautiful.[16]

In 1900 Lydia Pinkham's vegetable compound promised to cure multiple women's woes, such as "falling of the womb, leucorrhoea, painful menstruation, pain in the groins, terrible pain in the womb, inflammation and abscesses in the ovaries." By 1918 the very same ointment now relieved only muscle aches and pains, particularly those of the back. None of the graphic sexual conditions earlier outlined in 1900 appeared. Customers instead testified about the vegetable compound's efficacy in curing "backaches." Reference to the previous more sexual advertising strategy remained barely discernible at the bottom of the notices. In the smallest print, Lydia Pinkham's vegetable compound did, however, vow to get rid of specific "back pain stemming from female problems"

as late as 1918.[17] So stark did the shift away from sexuality appear that if advertisements signaled consumer need, a population once plagued with problems of the womb or manliness suddenly seemed afflicted instead by disfigured feet and impossible dandruff.

In the *Overland Monthly*, a journal dedicated to the mythic West, racialized gender and sexual stories as well changed in content. By the 1910s and 1920s, Mexicans and Native Americans replaced Chinese and Japanese as subjects. And these stories more specifically focused on gender rather than sexuality. Whereas Asian women appeared clearly as Chinese prostitutes or Japanese geishas in numerous essays at the turn of the century, characterizations of Mexican and Native women that appeared in later decades were less sexualized in depictions that cast them more as anthropological subjects. Stories depicted Mexican women as gentle and serene, patient tillers of the earth, or holders of history.[18] Native women became "graceful maidens" or expert weavers. Essays additionally depicted Native men as silent hunters and "apt and willing workers" who valued tradition and ceremony. Those with "white blood in their veins" were more "successful" in business and farming.[19] Mexican men appeared as dashing caballeros—skilled gentlemen horsemen—or quiet, measured men who tolerated foolish "gringoes" eager to lose their money to get rich quick.[20]

For sure, Mexicans and Native Americans served as important characters in mythologizing the frontier. Many Anglos understood the naming of California to be rooted particularly in indigenous people and Spanish America. One theory, albeit mistaken, ascribed the state's name came from California Native Americans who called themselves "Caoli" because they were descendants of Koreans who had made their way to North America.[21] The more commonly held belief, however, cited the origins of the state's name to Spanish navigators' love of writer Garci Rodríguez de Montalvo's mythical island of black Amazons called "California." Thus, American Indians and Spanish America would come to play a central role in defining the "Old West."[22]

A barrage of new city legislation may have stemmed the previously more public discussion around gender and sexuality. A passage of city ordinances beginning in 1904 prohibited the distribution of any "lewd, lascivious" material, including information on contraception, abortion, or venereal diseases. Ordinance 1335 prohibited the distribution and circulation upon any street or sidewalk or in any doorway or entrance to any building or premises any obscene, lewd, lascivious book, pamphlet, picture, paper, writing, letter, or print or other matter of indecent character, including information of contraception, abortion, or venereal diseases. Ordinance 1366 prohibited the distribution or exhibition of any circular, notice, or advertisement purporting to cure diseases of the sexual

organs, representing the sexual organs of any animals or indicating any lewd or indecent or immoral act, or suggesting abortion.[23] The new ordinances seemed to address a broadly amoral city driven by whites who handed out leaflets and published salacious material for leisure reading.

Twenty-five years earlier, however, the federal government had already declared the distribution of "lewd" content as illegal through the Comstock Act of 1873. This "chastity law," an act that targeted contraception yet declared the mailing of all "obscene" materials a federal crime, ensnared numerous San Franciscans.[24] Clara Shubert violated the law when she sent a bitter postcard to Boje Alberston, calling him a "Piggie."[25] Authorities arrested Robert Farrell, who sent a postcard to his estranged wife, Mary, accusing her of marrying him to cover up her previous lifestyle of sexual promiscuity.[26] C. Marino, who wrote a letter to Frank Cerra in Fresno, declaring, "Perhaps I broke the cunt of his daughter or him in his ass," also protested criminal prosecution.[27] Marino insisted that "breaking the cunt" or "ass" was a common Southern Italian idiom between fathers and their daughters as well as among sisters.[28] Thus the Comstock Law had long policed San Franciscans' written expressions of gender and sexuality for a quarter-century before the new municipal ordinances in the early twentieth century. Those arrested seemed unconcerned, if not unwilling, to admit their expressions were in fact "obscene." Indeed, legal prohibitions did not necessarily inhibit people from acting in ways deemed undesirable. Former FBI agent Edwin Atherton, charged with assessing the efficacy of San Francisco's social purity crusade, noted, "Those persons who think that prostitution and gambling are stopped because of prohibitive legislation, must be likened to the ostrich of popular repute."[29]

Notably, when stiffening prohibitions increased arrests to an unmanageable degree, San Francisco courts arbitrarily disregarded the legal mandates. In 1917 Judge T. I. Fitzpatrick, in an effort to regulate vice, instituted stricter punishment for women who were first-time offenders of immoral conduct. Women faced forty-eight-hour jail sentences for minor offenses such as drunkenness. Delia Smith, who walked aimlessly in the South of Market district, and Doram Smith, convicted of drunkenness, became the first women to fall under Fitzpatrick's new policy.[30] Arrests skyrocketed that year, so much so that Fitzpatrick himself stopped proceedings to demand investigation of police conduct when he found more than 175 women on his court calendar. He then dismissed the cases.[31]

San Francisco's decrease in public explorations of gender and sexuality more likely paralleled larger, inherently conservative trends toward complacency regarding sexual ideology rather than changes in municipal law. By the 1910s many believed that gender and sexual liberation had been achieved. In 1916 Annie

Martin Tyler declared that great progress had been made and that "the young girl of the West" in particular had "become the equal of her brother"—in fact, "often his superior." Citing increased education, job opportunities, and super women such as philanthropists Pheobe Hearst and Jane Stanford, Tyler suggested that women of the West had surpassed East Coast women in their great legacy of historical figures such as Elizabeth Cady Stanton, Susan B. Anthony, and Harriet Beecher Stowe, and should be all the prouder of this advancement.[32]

The city's readership also aligned with nationally accepted conservative views around gender and sexuality in their embrace of T. W. Shannon's 1913 publication *A Guide to Sex Instruction*.[33] Though Shannon appeared to affirmatively recognize the "natural sex instinct" and its open discussion, he in fact advocated for the narrow conscription of sex in action and the elimination of pleasure. While Shannon blamed "prudery" for society's "fearful harvest" of prostitution, white slavery, "wrecked manhood and womanhood," abortion, sex diseases, and divorce, he nevertheless forwarded rigid guidelines of conduct and morality, underscoring sex organs as "vulgar" in his supposedly "unstifled" discussions of sex.

Shannon suggested teaching sex education through analogies of nature— flowers with their "stamen," "pistils," and process of "fertilization." His method dictated lesson plans that deliberately excluded mention of the vagina or penis. He forbade masturbation among girls and boys and warned parents to protect their children from committing the "solitary sin." According to Shannon, older girls or "sex perverts" took "fiendish delight" in teaching "self-pollution" to the other students at public high schools and college. "Many small girls learn how to handle their sexual organs so as to produce a feeling of pleasure without knowing it is violating moral law. Girls often continued this sin for years, injured their own sexual organs, bodies, minds, and souls without knowing the cause." For Shannon, boys also should not masturbate or associate with other boys who masturbated. He noted handling the penis outside of the purpose of cleaning it or urinating as "wrong" and "unnatural." One drop of "vital force" was worth twenty drops of the richest, purest blood. Masturbation would result in depression, insanity, and the misdevelopment of sex organs. For young men who practiced the "sin" while asleep, Shannon advised parents to tie their hands at night. Sexual organs should only be used for reproduction.[34]

Shannon's guide dictated strict codes of behavior to inhibit passion. He prohibited individuals from entertaining obscene company, books, movies, or periodicals containing love stories, or keeping any pictures of improperly dressed female pictures, exposing limbs unnecessarily, dancing and attending theatrical entertainments. He forbade the use of nicotine and alcohol, since both excited

passion, naturally leading to secret sin. He further cited teasing, pinching, and pulling girls' hair as encouraging desire. For preventative measures, Shannon recommended plenty of outdoor exercise, the avoidance of all stimulating foods and drinks, and becoming a Christian, if not already. The guide strictly prohibited "sexual desire."[35] Though Shannon's guide acknowledged that "sex instinct" was in fact a natural part of people's lives, it ultimately promoted sexual repression. His work attracted much attention in schools and homes, serving as a guide for the practical implementation of sex instruction for parents and children by leading educators.[36] Shannon's well received philosophy of sexual control and inhibition would contribute to a culture less open to having public discussion of sexuality to avoid inciting inappropriate passion.

In fact, broader trends in leisure may have most powerfully shaped San Franciscans' shift away from prurient interests in the first quarter of the twentieth century. In the late nineteenth century, a growing literary market enabled by advances in printing had initially fueled readers' interest in sensational stories of "real life" struggle, scandal, and smut among the urban poor or the non-white.[37] In the early 1900s, however, the rise of large-scale amusements such as circuses and theme parks pushed leisure away from print culture into a more consumptive and industrialized form. Developments in motion pictures and motor power increasingly captivated Americans after the 1910s. Popularity in "realism" faded as people looked to the promise of technology to distract them from the burdens of everyday life.[38] San Francisco dailies promoted automobiles such as "Norwalk tires," "Mercer the mechanical masterpiece," the "trail blazer," and the "veteran Cadillac." "Delightful weather" and the "fine condition of roads" encouraged a new culture of leisure for motorists.[39] Newspapers kept up with latest trends in entertainment by featuring "favorite Photoplayers," "moving picture" actors, Victrolas, and the most recent record releases such as the "Dixieland 'jass' band."[40] While stories of a looming world war also began to appear in the San Francisco press, the promise of new forms of leisure through technological advances replaced the city's engagement in the vicissitudes of the "real world."

As public discussions of gender and sexuality decreased, so too did evocations of race. An *Overland Monthly* essay outlining San Francisco's "local color," which aimed to detail compelling characteristics of residents, addressed all but the city's communities of color. "Native son" George Chill took New Yorker Kenneth Cuttle on a tour that highlighted concrete mansions, steep hills, cobblestones, and even ivy geraniums. For the New Yorker Cuttle, Italians, Irish, Quakers, and some other "dark-complected" whites, including Chill himself, proved that San Francisco still retained its "local color." Chill and Cuttle explicitly stated their

deliberate exclusion of Chinatown in considering what composed the city's "local color," even as it served as a significant tourist destination at the turn of the century. When novelist Frank Norris in 1897 wrote, "There are more things in San Francisco Chinatown than are dreamed of in Heaven and earth," he declared what most Americans already knew.[41] Chill and Cuttle, however, reasoned that if they had wanted Chinatown as part of their tour of urban "color," then Cuttle would have had no need to leave New York City. Never mind that Italians and Irish in his San Francisco tour could also be commonly found in New York.[42]

The dismissal of communities of color in this 1916 discussion of San Francisco in the *Overland Monthly* contrasted sharply with the abundance of essays on Chinese and Japanese from earlier decades. It in part reflected changing nationwide interests away from "authentic" depictions of racial and cultural others and also signaled how declining discussions about gender and sexuality would render less opportunity to use people of color as foils of immorality. According to sociologist Joanne Nagel, conversations about race throughout American history would centrally be about gender and sexuality.[43] Within this construction, race and ethnicity coupled with gender and sexuality would become an inseparable union rising and falling together in the American imagination. Thus, amid decreasing public discourse on gender and sexuality, its accompanying helpmate, the character of color, would also fade from center stage.

Attractions that required payment at San Francisco's Panama Pacific International Exposition in 1915 more powerfully indicated how people had become less compelled by topics on race and sexuality. The downtown club of the Chinese pagoda village known at first as "Underground Chinatown," which drew few customers, attracted more guests only after a name change to "Underground Slumming" and the elimination of Chinese characters on the signage.[44] After the adjustment, the "Chinese" parts of the village did not do very well, while the "un-Chinese" parts left with opium addicts, drug fiends, and other immoralities did somewhat better, but not any better than other exhibits devoid of sexual or ethnic themes. Other ethnic attractions across the exposition did not pull in as much revenue as expected. Even Shamrock Isle's Irish singing and clog dancing inspired few paying customers. Exposition official Frank Morton Todd expressed surprise when he observed that exhibits with no ethnic theme remained more popular than the "international" exhibits that served as the main event for Panama Pacific International Exposition.[45] Race as a site of leisure no longer seemed to titillate as it had previously.

Captain Sigsbee, the "educated horse," and Madame Ellis, the "mind reader," proved to be the most successful exhibits in the concessions area. Large numbers of people crowded into the little theater where the duo performed. Captain, the

horse, counted the number of men, women, and children, in the front row of the theater, matched colors, added and subtracted, and played tunes by ringing bells.[46] Madame Ellis sat blindfolded on the stage while her husband, L. H. Ellis, received questions for her to answer, small objects to name, and read numbers off currency and watches with amazing speed and accuracy. Additionally, she advised people on divorces, lawsuits, love affairs, business ventures, and lost articles. Across the city, people chatted excitedly about Madame Ellis and her ability to read minds. Though the single admission fee to both shows totaled only twenty-five cents, the horse and mind reader had pulled in $62,000 by the end of the exposition.[47] The extreme popularity of the talking horse and the mind reader at the Panama Pacific International Exposition made perfect sense for an American public more interested in the possibilities of the future than the grittiness of the present.

All "Orientals" Look the Same

As the city lost interest in discussions of gender, sexuality, and racialized sexualities, lingering stories layered upon the earlier flurry of representations initiated a mass conflation of Chinese with Japanese in American imagination. Between 1880 and 1920 the use of the "Oriental" or "Orient" as a catchall term to refer to Chinese and Japanese quadrupled in the *Chronicle* and came to largely replace an earlier term used to refer to Asians as a racial group. "Mongol" or "Mongoloid," which had been used to signify primarily the Chinese, decreased by fourfold. A rising tide of nearly twenty thousand articles discussing both Chinese or Japanese as "Orientals" in the first two decades of the twentieth century signaled an increasing practice around perceiving these two "races" as a single racialized group.[48] Entrepreneurs increasingly evoked the "Orient" to drum up consumer appeal with no explicit distinction between Chinese and Japanese. Dr. T. Felix Gouraud posted an advertisement for "Oriental Cream" or "Magical Beautifier." Listings for "Oriental" tea appealed to consumers with visuals of women clad in kimonos, wafting out of the top of a lantern or graciously pouring tea.[49]

Newspaper accounts of Chinese and Japanese men promoting prostitution together encouraged a single image of "Oriental" immorality. When police closed houses of ill fame in February 1910 Chinatown, Chinese men then reportedly went to Japanese "bawdy" houses.[50] Three weeks later the *Call* reported "Japanese woman sold to Chinese" when Japanese K. Morita sold his wife N. Inada to "Chinese highbinders" for $250 in gold. According to the *Call*, the Japanese Inada refused to go to the Mission Home when police arrived to take her

away from the "Chinese brothel," paralleling pervasive depictions of willing Chinese prostitutes.[51]

The appearance of "Oriental" parties, too, that invoked Chinese and Japanese culture outnumbered gatherings previously themed as strictly Japanese.[52] As early as 1902, "young ladies" of the Christian Endeavor Society of the First Methodist Church began to decorate their church in "gay colors of the Orient," donned Chinese and Japanese "costumes" for their "Oriental evening," and entertained more than two hundred guests with a program "of an oriental nature."[53] By 1920 at Ethelbert Cardiff's "Oriental" themed wedding shower, Zoe Cardiff, Ver Jensen, and Evelyn Stoddard pranced about in silken Chinese blouses in a house adorned with cherry blossoms and pussy willows, "always the favorite Chinese and Japanese decorations." A "Chinese flower girl" also appeared shouldering a bamboo pole with hanging baskets at each end filled with notably Japanese flowers. Party organizers also distributed scorecards with "dainty hand-painted riksha girls." Japanese and Chinese cultural icons mingled and merged to produce a single "gay affair" enhanced by "Oriental color" at Cardiff's party.[54]

In 1916 Jesslyn Howell Hull's short story in the *Overland Monthly* embodied a legacy of Chinese and Japanese stereotypes. Wah Sing, a cranky antisocial laundry man, worked twice a week for a young white couple and their baby named Cuddles. The baby immediately took to Wah Sing, and the two played games each time he visited. When Cuddles fell ill, the concerned Wah Sing volunteered to cook and clean for the distraught couple. Cuddles, unable to recover, eventually dies, and a depressed Wah Sing asks for a memento of the baby from the parents. He promises to check in on the Allens the next day. When Wah Sing does not show up, Mr. Allen goes to Wah Sing's shack and finds him dead on his cot, clutching Cuddles's slipper with her photo propped on a chair placed next to his bed.[55]

Hull described Wah Sing as a "Chinaman . . . anything but attractive." Yet he was also "silent" and a loner, characteristics more frequently associated with existing stereotypes of Japanese men as a lone samurai of few words as opposed to more clamorous Chinese men who typically appeared in groups of "highbinders" engaged in morally suspect activities such as gambling or facilitating prostitution. As Wah Sing took up household chores for the Allens, he became more than just a "laundry boy" as an excellent homemaker, a role more commonly attributable to fastidious Japanese houseboys who, according to the *Call*, reportedly ran households better than white women.[56] Hall additionally paints Wah Sing as a "slave" to Cuddles, a word more frequently used to describe the position of Chinese women coerced into sex work. So "devoted" to Cuddles

was Wah Sing that he makes the ultimate sacrifice to the baby whom he "worshipped" and "adored" by following her in death. Wah Sing's dying parallels popular notions of Japanese women's devotion to men. In countless essays, these women as a symbol of self-sacrificing, loyal geisha embraced death when they were stricken with inconsolable grief due to separation from their white male lovers. Hull's rendering of Wah Sing as a slave and martyr feminizes him in its reminder of prevailing tropes of Chinese and Japanese women. While emasculating men of color serves a useful tool to maintain white patriarchal power, this particular feminization of Wah Sing also had a specific "Oriental" context. Turn-of-the-century whites specifically perceived Japanese men, rather than Chinese, as embodying feminine qualities. Moreover, Wah Sing's death paralleled Japanese women dying for their white male lovers as a high form of devotion and sacrifice. Hull's characterizations of Wah Sing seamlessly comprised nearly all the existing stereotypes for Chinese and Japanese men as well as women from the first two decades of the twentieth century. The essay, titled "A Yellow Angel," sought to underscore the generosity of Wah Sing, who though "repelling," supported one young white couple through the death of their child.[57]

In 1905 the *Call* gallingly contributed to the Asian conflation when it wrote "China Brings Adventurers from Orient" for the headline of an article that traced Japanese K. Ikeuchi's journey to marry his hometown "sweetheart" and bring her to the United States.[58] As separately as narratives of Chinese and Japanese charged San Francisco debates around gender and sexuality from opposite ends in the late nineteenth century, they quickly merged into the pan-Asian "Oriental."[59]

Foreshadowing of the conflation took place almost immediately after Japanese began arriving in significant numbers, even as the bulk of representations of Chinese versus Japanese served to distinguish them sharply from each other. Fears of possible mistaken identity compelled whites initially to make the distinction, particularly since anti-Chinese legislation written for the "Mongoloid" immigrant did not necessarily include the Japanese, allowing them to enjoy for a short period fewer restrictions than the Chinese. In 1900 the *Call* revealed anxiety over confusing the two ethnicities when it claimed devious Chinese posing as Japanese would pass through immigration regulations that specifically barred Chinese. The 1882 Chinese Exclusion Act had barred the entry of Chinese into America for nearly two decades, whereas exclusionary laws around Japanese would not arise until the Gentlemen's Agreement of 1907. According to the *Call*, Chinese men would go as far as cutting off their queues to pass as Japanese.[60] Chinese and Japanese could then become indiscernible from one another even for professionals charged with the responsibility of barring the entry of one group but not the other. In home decorating, however, lumping

Chinese and Japanese together appeared to be less high stakes. When Harry P. Whitney and his new wife, Gertrude Vanderbilt, sought "Oriental goods" in 1897 to decorate their New York apartment, they stopped in San Francisco to purchase $40,000 worth of home furnishings from Chinese as well as Japanese curio shops.[61]

In 1900 Ernestine Coughran told "A Japanese Story of To-day" in the *San Francisco Call* when she traced the tragedy of "little Cheo," who could not be with her lover Tuo Cha in Japan. Cheo traveled to America with her "good friend Kaya Han" only to be sold into prostitution by the very man she might marry. Eventually, Tuo Cha appears, and he marries Cheo, giving her "no cause to cry and spoil her pretty soft eyes."[62] While Coughran declared her story to be Japanese, it in fact more accurately narrated a jumble of Chinese and Japanese significations that marked the beginnings of a cultural movement merging Chinese and Japanese indistinguishably into the single "Oriental."

Coughran combined existing discourses of Chinese and Japanese femininity in the sympathetic portrayal of a timid and dutiful Japanese woman who is duped into migrating to America, only to be sold into sexual slavery. In 1900, sympathetic depictions of Chinese women would be impossible, since Chinese

Ernestine Coughran, "The Rescue of Cheo: A Japanese Story of To-day," *San Francisco Call*, January 14, 1900.

prostitutes embodied degenerate morality in their willingness to be sex workers in popular imagination. Only through the Japanese woman, who symbolized a romanticized geisha, could Coughran draw readers into a sympathetic narrative involving an Asian woman prostitute. Kaya Han, the man who deceptively brings Cheo to the United States, appears in illustrations in a suit, marking him visually as Japanese, yet he behaves in a manner more attributable to narratives of Chinese men at the time. He physically beats Cheo and sells her to a "Chinaman" for sexual slavery. When Cheo's first love, Tuo Cha, suddenly appears from Japan to marry her, he follows a courtship path to marriage through the Chinese Mission Home that existed for Chinese men who approached white women missionaries for Chinese wives.[63] Also, Coughran, in her naming of her characters as Cheo, Tuo Cha, and Kaya Han, used names more typical in China than in Japan. In the central illustration of the protagonist Cheo as well, she appears wearing both a Japanese kimono and Chinese phoenix crown. A curling dragon, an icon more liberally used in China versus Japan, then frames the image of Cheo. Coughran, in her "Japanese Story of To-Day," borrowed heavily from existing accounts of Chinese in San Francisco; in doing so, she created a narrative that contributed to the conflation of Chinese and Japanese in the city. Racialized gender and sexual representations, such as those in Coughran's short story, that merged Chinese and Japanese into a single "Oriental" multiplied across the first two decades of the twentieth century in the city's print and leisure culture.[64]

The "Oriental" in Practice

Chinese and Japanese had already been facing similar struggles of denigration and discrimination soon after their arrival. Prevailing notions of Chinese women prostitutes affected not just Chinese but also Japanese women. Authorities harassed Japanese women, assuming them to be prostitutes even as they appeared in the city's creative world as holding romanticized femininity. Immigration officials also questioned the legitimacy of Japanese women's presence in America through immigration legislation designed to bar Chinese women specifically from entry into America.[65] Officials arrested Raku Kataoka at least twice for importing a woman, whom she claimed was her stepdaughter, and an additional woman, Kiyoji Watanabe, for immoral purposes. Courts eventually acquitted Kataoka on both arrests.[66] Japanese Sonoe Nitta, too, would face deportation when officials charged her alleged husband, Haruzo Nitta, of bringing her to the United States for "immoral purposes"—a violation of the law that Chinese immigrants frequently fought against to justify the right of their wives

to stay in America.[67] As early as 1898, intense opposition to Japanese immigration based on Japanese women's immorality began to appear on the legislative floor—so much so that Japanese diplomat Hirokichi Mutsu published a protest in the *Overland Monthly* to speak out against the attack. "In a community where prostitutes from every land find lodgment—despite the law—it is hardly fair to single out the women of Japan as exceptionally offensive. They are not only few in number but are also quiet in demeanor, seldom being heard from in connection with scenes of turbulence or police court proceedings."[68]

Before 1908, "prostitutes, in all likelihood, comprised the majority" of the estimated one thousand Japanese women who lived in the United States, according to historian Yuji Ichioka.[69] Regardless, in popular imagination Chinese women singularly signified immoral prostitution in short stories, plays, and musicals. Authorities, though, would still persecute Japanese women under the presupposition of their involvement in sex work. With seeds of Chinese female immorality already sown, understanding Japanese women as degenerate likely became an easy association to make. As sixteen-year-old Clara Newton prepared for an evening of sex work, she contemplated telephoning the "Chinese" to buy a "silk kimona and chemise." "Why, I could make good money," she said to herself as she considered the eighteen men coming to visit her that night. For Newton, a Chinese merchant seemed to be a logical place to purchase a Japanese kimono for a more sexually suggestive appearance.[70] Notions of Chinese prostitutes and compliant Japanese women easily blended together to create a single view of sexualized Asian femininity.

Notably, assumptions of Japanese women as innocent geishas symbolizing feminine submission and vulnerability provided an additional frame for their prosecution as prostitutes. Law enforcement used white slavery laws intended to "protect" white women to arrest Japanese but not Chinese women. In 1910, when authorities charged Japanese Jagero Ito of "white slavery" by bringing Rin Tazawa to San Francisco for immoral purposes, Japanese women now seemed to fall under the category of "white," a racial marker that signified feminine vulnerability in American's fight against urban immorality.[71] While Chinese women depicted as willing sex workers had little access to the white version of feminine vulnerability, Japanese women who appeared as doe-eyed geisha could become "white slaves" without being racially white.[72] In the 1910s when moralists concerned themselves with a crusade against white slavery that included Japanese women, it in fact pointed to popular perception of Japanese women's sexuality rather than their racial category. Japanese women fulfilling a fantasy of lost traditional femininity could only be innocent victims in the war against forced sex work. Thus, as officials prosecuted Japanese for prostitution, their

presumptions of Japanese as both willing and unwilling sex workers could simultaneously exist without contradiction as they borrowed from the opposing tropes of the Chinese prostitute and the Japanese geisha. Chinese and Japanese women all the while remained racially different from each other even as their conflation as prostitutes took place. In 1907 the *Chronicle* included Japanese among French, Austrian, Russian, and Italian women, but not Chinese, in their expose on white slavery.[73] As Japanese women became "white slaves," Chinese remained "yellow slaves" in popular and legal discourse, even as both were seen as victims of male immorality in later anti-vice crusades.[74]

Furthermore, though representations of Chinese men as sexually degenerate had subsided by 1905, they too could not escape the negative connotations that Japanese men evoked after the Russo-Japanese war. As articles came to depict marriages with Japanese men in a negative light, Chinese men also became swept up within growing sentiment that unions of white women and Asian men were doomed. The *Call* painted a pathetic white wife, Wong Sun Yue, who sat alone in her Chinese tearoom and curio shop on Grant Avenue, because her husband preferred China and she preferred the United States. "The Oriental atmosphere and the bric-a-brac are all that remain of her famous oriental romance—that and the indelible impression on her own personality left by her years as a Chinese wife."[75] Though she was the sister of Mrs. Harry Gould, one of the wealthiest women in America, she lived a sad and lonely existence.

The shift in public sentiment against Chinese husbands at the same time Japanese men were becoming villainized becomes powerfully obvious in the press's treatment of Emma Fong Kuno's first marriage to Chinese Walter Fong and second marriage to Japanese Yoshi S. Kuno. In 1897 Emma Fong and her first husband, Walter Fong, enjoyed approval from the local press after earlier decades of violent scapegoating of Chinese as disease carriers had passed. When the couple first got married, the *Chronicle* celebrated their union, describing Walter as "unusually handsome" and noting Emma as "bright," "attractive in her personality," with a "snow-white complexion."[76] A year later, in 1898, the *Chronicle* still praised Walter Fong as "hard working," "scholarly," "with most polished manners" and his marriage to a "pretty American girl" Emma as the "crown" to his scholastic career at Stanford.[77] When rumors circulated on campus that she had disgraced her family, Stanford University president David Starr Jordan responded by defending Emma's choice of husband. Jordan declared that any family in the state of California might be proud to have Walter Fong as a member. Such public approval from the famous eugenicist Jordan demonstrates how even he, who valued a specific gene pool in creating a fit nation, could entrust the future of the American people to an individual who was not white.[78]

However, twenty years later, in 1922, a scathing editorial attack on interracial marriages immediately followed Emma Fong Kuno's autobiographical account of her "Oriental husbands" printed in the *Bulletin*.[79] Mounting demonization of Japanese male sexuality would also directly affect the Chinese.

In 1921, writer Jeanette Dailey directly protested growing intolerance toward interracial marriage and racial discrimination using a character of Chinese rather than Japanese ethnicity. In a short story about a recently married blonde, blue-eyed woman, Lilian eloped with a man fervently against miscegenation. She discovered later, at the birth of her Asiatic looking son, that she was half-Chinese. Her utopic life shattered; Lilian proclaimed that her husband Maurice would hate her, and she lighted her intoxicating yet poisonous incense to give comfort to herself and her baby. "At last she rested in that country where there are no lines drawn, of color, or of race, and where every child is loved of God." Dailey, who aimed to position the outcome of Lilian's life as a sad statement of society's intolerance, also highlighted the social dangers of miscegenation with someone of Chinese ancestry.[80]

As the 1920s approached, San Francisco appeared morally reformed. Newspapers, advertisements, fashion, the Panama Pacific International Exposition, and municipal reports cumulatively demonstrated how explorations of gender and sexuality, particularly those laced with ethnicity, no longer "sold" in the city as in previous decades. As the production of public attitudes toward alternative identities and expression narrowed in local publications, it left a public quiet that less frequently engaged in contentious discourse. The quiet, however, did not necessarily point to better lives for Chinese and Japanese in San Francisco. The fewer number of depictions that appeared in the 1910s and 1920s sparked a conflation of Chinese and Japanese into the pan-ethnic American "Oriental" as the city moved part and parcel with nationwide shifts toward more moral conservatism and intensified racism.[81] For Asians in America, what took place in the cultural consciousness of San Francisco whites would reverberate nationally due to their reputation as an "international city." While turn-of-the-century hypervisibility and over-representation fueled burgeoning sexualized stereotypes of Chinese and Japanese, their significantly reduced visibility in following decades then advanced the conflation of the two ethnicities into the single despised "Oriental."

Epilogue
Homosexuality as Asian

On February 16, 1918, police began a ten-day raid of two flats at 2525 and 2527 Baker Street to end a "vice ring" that had been ongoing for two years. "A large number of vicious men" had used the apartments as a rendezvous site after Hugh Allan, a singer, and Clarence Thompson, a decorator, had begun renting the flats. The police had placed a Chinese servant to collect evidence. By Tuesday, February 26, authorities had arrested eleven men from various walks of life, including businessmen, office clerks, two police officers, and military personnel as high ranking as a colonel. At the end of the three-year investigation in 1921, thirty-one men had been implicated.[1] That same year, a homicidal homosexual appeared in the *Overland Monthly* in the figure of a Japanese house servant named Taka. His debut in the popular literary journal paralleled increasing visibility of male same-sex sexuality across the most respectable men in San Francisco. The projection of homosexuality upon Japanese and the broader "Oriental," however, would signal more than just anxiety around middle-class white male sexuality. The "Oriental" became a vehicle through which white men could forge otherwise illicit sexuality amongst themselves.

At least five men appeared to be at the center of the Baker Street Club—musician Hugh Allen, insurance agent Oscar S. Frank, Lieutenant David H. Upright of the U.S. military, insurance broker Edgar Spiegelberg, and businessman Richard Hotaling. Hugh Allen had originally rented out 2525 Baker Street as a music studio. His good friend Oscar Frank lived just a few doors down and

played an instrumental role in securing the rental. David Upright hand selected other military men to whom he would extend dinner invitations to Allen's flat, such as Tebe Creighton, a lieutenant in the Aviation Corps. Spiegelberg, too, picked up a number of young military men and brought them to Baker Street. Finally, Richard Hotaling appeared to serve as mentor to a number of the young men, securing employment and paying the medical bills for at least one struggling German immigrant named Ralph Teichmann.[2] Hotaling took his role seriously, as he explained to investigators: "They called me 'Uncle Dick.' There is no prouder title I want to aspire to than be called 'Uncle Dick.' I feel proud when anyone meets me and calls out 'Uncle Dick, Uncle Dick.'"[3] The extensive network of men functioned less like a club and more accurately as an ever-widening circle of "tempermental" men. Authorities considered Hugh Allen and Oscar Frank to be the "chief offenders" or "prime movers" in the case. Frank in particular had "quite a few love affairs," and his testimony, which he believed he had given under the condition of immunity, became the primary way the investigation compiled such a long list of men involved.[4]

In the weeks immediately following the arrests, a number of the men escaped possible imprisonment by leaving town, going as far as to skip posted bail. Others who went to court found the outcome in their favor because prosecutorial evidence was weak and no corroborating witnesses came forth. Many of the actual sex acts took place in a darkened room with more than a handful of men, which made definitively identifying individuals particularly difficult. When James Mackey, a receiving teller at Hibernia Bank, inadvertently turned on the lights at an upstairs party at A. G. Langenberger's home on Thanksgiving in 1917, a man shouted "son of a bitch" and demanded that he turn off the lights.[5] Ignatius Connors and Joseph Murray, two beat cops assigned to the neighborhood, avoided prosecution despite their involvement since the police chief declined to pursue criminal actions against them once they resigned from their positions.

The public for the most part believed all the men involved got away with more than they should have, even as many of them faced irreversible public shame with the publication of their names in the local press. Edgar Spiegelberg shot himself in the head when he became implicated in the Baker Street scandal. Still, many believed that "unusual efforts were being made to evade punishment" for these men—so much so, that even after the police court exonerated the men, a new grand jury convened to investigate.[6]

The grand jury transcript revealed a vibrant network of well-established men throughout the city who approached each other on street corners and local establishments. Men "of importance" such as businessmen, military officers,

and members of the elite Bohemian and Olympic Clubs populated the growing roster of men. These self-declared "queers" gathered not just on Baker Street but also at Bert Litle's house near the corner of Taylor and Greenwich Streets in the Russian Hill District of San Francisco for "musical evenings" as well as at the ranch home of Spiegelberg in Hollister, California.[7] A number of them drove cars, considered a luxury in the 1910s. Spiegelberg seemed particularly active, approaching young soldiers on the street, offering rides in his "machine," arranging meet-ups at various locations, such as Sultan Baths and Turkish Baths, and then inviting them for dinner and drinks at 2525 Baker Street.[8] Nineteen-year-old Walter Frank had gone on several outings with Spiegelberg after accepting a ride from him while waiting for a car to take him to the ferry. On their second meeting Spiegelberg gave Frank a wristwatch and took him to Baker Street. The local paper had normalized strangers approaching one another with acts of kindness in their reports of people offering rides and gifts to soldiers who came to San Francisco. Eighteen- and nineteen-year-old soldiers regularly accepted friendly solicitations without hesitation from strangers.[9] Tebe Creighton received a similar invitation from Hugh Allen to join him for dinner at his flat on December 19, 1917. A total of four men gathered for several highballs, spaghetti, and "a great deal of wine." The group then drove back and forth to the elite all-male Bohemian Club throughout the evening. Creighton felt partly sick when Oscar Frank then pulled him over onto a bed and unfastened his clothes.[10]

On Baker Street many of the young men claimed it was their first time to encounter such parties of "all gentlemen" and "no ladies," where men sang or shared poems and short stories. Soldier John Bosworth ate sandwiches and enjoyed music and conversation among a group of eight to twelve men on his first visit.[11] Salesman Ralph Teichmann remembered Oscar Frank in makeup giving "Shakespearean imitations."[12] James Mackey also recalled Frank impersonating various "actresses," "principally in the nude."[13] At other parties, such as those hosted by William Hatteroth, men would dress as women, call each other "Miss," inquire as to who made their dresses, and dance with each other in a "love-making" manner.[14] At Bert Litle's home, Spiegelberg took off some his clothes, wrapped himself in the living room drapery, and began dancing. Oscar Frank then followed suit with a Sarah Bernhardt burlesque performance.[15] Upstairs, a second party would begin, at which fellatio and anal sex, known more commonly as "browning," might ensue. For these weekend parties, guests would begin arriving on Saturday and not leave until Monday morning.[16]

Many perceived the Baker Street "vice ring" as typical of California's and more specifically San Francisco's "lack of morals" where "perversion steadily grew." In April 1919 Michael Williams in the *Catholic World* claimed that "more

than fifteen hundred names—a millionaire and a clergyman among them—including some very well-known people of San Francisco, women as well as men, are in the hands of the police, recorded as habitués of this resort; a place like the one in Taylor Street in London, where Oscar Wilde and his circle celebrate their orgies."[17]

Baker Street, though, served as more than just a place of "orgies," as the press preferred to highlight. Men shared stories of past loves as well as theories on how men became "tempermental" or "queer." Richard Hotaling explained to twenty-four-year-old Ralph Teichmann that being "tempermental" was inherited and determined "by nature," that it was not "a crime" and "people who are made queer are not to be blam[ed] for it."[18] Notably, love, rather than sex, between men seemed to be at the root of the public outrage. Grand jurors pressed for confessions that someone specifically "loved" another and that they were "in relationships" with one another to demonstrate the "infamous crime against nature." The implicated men largely scoffed at the grand jury's accusations that they fell "in love" at Baker Street, even as at least one man Robert Ryles developed a crush on Tebe Creighton. The "Vice Ring," however, did in fact serve as more than just a site of sexual pleasure.[19] It provided a space of intergenerational intimacy and queer affirmation in a world in which men deemed "tempermental" lived on the margins.

In January 1919, nearly a year after the Baker Street arrests, the California State Supreme Court weighed in on one particular case that had climbed all the way to its courtroom. In the matter regarding Clarence Lockett and Don A. Gono, judges threw out all possible convictions of the two men since the crime for which they were being prosecuted was not a word commonly known or clearly defined. The term "fellatio" did not appear in any English language dictionary and therefore was neither English nor Anglicized. The court reasoned that fellatio, with its Latin origin, was "unintelligible" to "a man of common understanding." While the word's verb form "fellare" originally applied to a child at a mother's breast, the Roman poet Martial used "fellator" to refer to what the court described as the "sexually degenerate" practices. To make matters more confusing, both sexologists Havelock Ellis and Richard von Krafft-Ebing described fellatio as an act between a man and a woman, which did not apply in the case of the all-male Baker Street club. Stedman's Medical Dictionary additionally defined "fellator" as the one who "takes the buccal part in fellatorism" or the active agent, and then simultaneously cited "fellatio" as a synonym for "fellatorism" and in turn "irrumation," which applied "to the passive and not to the active agent in a perverted practice." Without a clear definition of what constituted fellatio, between members of which gender and in what position, it

would become impossible to convict anyone of fellatio by its very meaning. The court ruled that prosecuting an individual for a crime not clearly definable was unconstitutional, voiding section 288a of the California penal code, which cited fellatio as a federal offense since the word, according to the Supreme Court, was as esoteric as if written "in Egyptian or Mexican hieroglyphics or in Japanese or Chinese characters." While the investigation lingered for two more years, all cases would eventually be dropped, and those who had been sentenced would also be freed.[20]

The unintelligibility of the term "fellatio" might seem flimsy, if not absurd, in the court's decision to release the men of the Baker Street club.[21] Yet the court's reasoning was not an isolated or an anomalous event. Five years earlier the California Appellate court had grappled with the identical problem of defining fellatio, non-English as it was, and had reversed the conviction of J. E. Carrell of Sonoma County. In fact, not until the 1930s would "fellatio" begin to appear in the higher state courts, specifically in Kentucky and then later in Maine, in a manner that appeared it had now become common English. In the California courts, "fellatio" would reappear in 1942, and this time with no question to its meaning, when the appellate court refused to grant Marcello Battilana a new trial for the rape, sodomy, and forced fellatio of a cabaret dancer.[22] While the case involving Lockett and Gono would prove landmark in its decision that prosecuting a person for a term not clearly defined such as fellatio was unconstitutional and therefore illegitimate, the prolonged detention of these two specific men pointed to how race and class could differentially affect individuals across the same crime. In contrast to the men in the Baker Street Club, who were all white and held office jobs if they were not in the military, Clarence Lockett was African American and Don Gono appeared to have sold trinkets out of his home.[23] Many others involved in the grand jury investigation, including William Hatteroth and Edgar Spiegelberg, who had earlier tried to kill himself, had already fled the city and could not be detained.[24]

At the end of World War I, as men returning home gathered in urban areas, same-sex intimacy did become more visible and clearly defined than ever before. "Homo-sexuality" loomed as a terrible threat to national security. Previously admissible homoerotic texts that had appeared with some regularity disappeared from the San Francisco press. Sodomy cases, too, increased at the California state appellate and supreme courts, clustering in the late 1910s. From 1897 to 1924, nine sodomy cases from San Francisco appeared in these courts, with the dominant number taking place in the ten years before 1924. Two of these cases appeared between 1897 and 1905, one in 1912, and six between 1915 and 1924. Though the cases could have reflected a general increase in acts,

national trends toward the criminalization of male homosexuality more likely motivated intensified policing of gender and sexual expressions.

In 1921, seven months after the authorities closed the last of the Baker Street cases, a short story titled "Taka," by Florence Estella Taft in the *Overland Monthly*, detailed a same-sex romance between a white man, Fred Robinson, and his "Jap servant," Taka. The two men had met in college when Fred's "distinction" and "personality" inspired in Taka a "dog-like faithfulness." Taka quit school upon Fred's graduation to "follow him about, careful of every need and ever conscious of his comfort—for no other reason in the world than that he had found his man." Fred's wife, Miriam, feared the "brazen" Taka and had unsuccessfully urged Fred to dismiss him multiple times. She at one point declared an ultimatum, demanding that Fred choose between herself and Taka. Fred refused to dismiss Taka, citing that he had done nothing wrong and that it would be unjust to terminate him on "childish whims." Yet Miriam saw something else in Fred's eyes. "For the fraction of a second his eyes seemed to hold in them the same kind of glint that always rested in the black eyes of Taka's." Additionally, Taft described Taka's singular devotion to Fred as so intense that anything or anybody necessary to Fred's happiness became an obstacle to be gotten out of the way. "His ardency for one man in no way included what to the man was the one woman." When Miriam confronted Taka that one of them must leave and that she would provide money for his ticket to return to Japan, Taka advanced with a smile, clenching a two-edged dagger. "It was the smile of a man who gambled and lost and was making one last effort in desperation to regain his treasure." As he went to plunge the dagger into her heart "in just the right spot," he declared fiercely, "He can't belong to us both. He shall be mine." Miriam stepped back, stumbling over a pedestal, and sent a vase of flowers to the floor. Upon hearing the crash, Fred entered the room. Taka stumbled and glanced at Fred's face, which was no longer approving. In a wave of desperation, he plunged the knife into his own heart. Taft wrote, "Abandoned by Robinson, nothing was left for him." Moreover, as Fred soothed Miriam, she knew that the "devotion had not been one-sided and that in one corner of his heart would remain the scar which had been made by the dagger of Taka." For the author, the Japanese homicidal, homosexual, and suicidal college dropout played the perfect role in enacting a convincing and compelling love drama.[25] The publication of "Taka" months after the close of the Baker Street investigation would be no small coincidence. As same-sex sexuality became the new gender and sexual frontier, white writers, perhaps predictably, painted what they called "homo-sexuality" in racialized tones.

Notably, accounts of the Baker Street Club suggested an Asian racialization already in process in how whites understood and facilitated same-sex sexuality between men before the appearance of "Taka." The police's placement of a "Chinese Servant," who secretly collected evidence at the residence, could occupy a space of sex between men without raising any suspicion. And the California Supreme Court's alignment of fellatio as esoteric as "Chinese or Japanese characters," rather than a term understood in common English, rendered the term and thus the sex act more familiar in China and Japan than in America. Moreover, in the grand-jury inquiry when Baker Street participants explicitly brought up race or ethnicity, they referred exclusively to Asia.

Testimony detailed how the Baker Street men themselves used Chinese and Japanese art, stores, and lodging houses to facilitate their forbidden intimacies. Tebe Creighton was looking at "some Japanese and Chinese art in the window" along Geary Street when Max Koenig approached him and made a date to meet later at the St. Francis Hotel.[26] Army Field Clerk M. J. Hughes was also standing front of a "Japanese Store" around 5 P.M. when the aforementioned Tebe Creighton approached him and asked him if he liked the gown in the window, before making plans to meet again at the St. Francis Hotel.[27] When Hughes wanted more privacy, he took men to "a place in Chinatown, perfectly safe and run by a Chinese." Creighton himself preferred to go to a location on Pine Street just below Kearny, a lodging house—again in Chinatown. As for Walter Schneider, he just happened to be led to 2525 Baker Street the day of the raid to assist with "alien trouble," a term used to refer to Japanese immigrants at the time.

The Orient in part came to define the very meaning of "tempermental men," or men who sought out the company of other men. Those implicated in the Baker Street Club defined "tempermental" as having an appreciation for art and music. And, as collectibles from Japan and China rose in popularity among Americans through the embrace of first Japonisme and later Chinoiserie in the first quarter of the twentieth century, a "tempermental" man would most certainly be a lover of Asian objects. Thus, admiring the storefront window of a Japanese or Chinese store signaled availability for other cruising men. China and Japan explicitly facilitated same-sex sexuality for men who sought intimacy with other men in San Francisco.

It would not be the first time that middle-class whites, stretching the limits of their own gender and sexual norms, would produce provocative gendered and sexualized associations of Chinese and Japanese in the city. A decade earlier, as more white women wore ties and bloomers, talked back to their male lovers or fathers, and divorced at higher rates, images of docile, obedient geisha in silk

robes willing to sacrifice all for their white male lovers proliferated in newspapers, magazine, and local theater productions. Then, as white women adopted more sexually alluring dress and kissed their lovers openly under lampposts amid mounting concern over white women forced into sex work, representations of Chinese women as prostitutes flourished in newspapers, magazines, plays, and musicals. The Baker Street Club, too, even as its members faced persecution, pointedly served as another instance of an expansion in sexuality as men forged intimacy and fulfillment with one another outside of the conventions of the heterosexual household. Within a national context wherein at least two other "homosexual orgies" took place in Los Angeles and Long Beach, California, the Baker Street Club received far less public denouncement and outcry and sparked no significant public reaction in San Francisco, according to historian Paul A. Herman.[28] While the Baker Street men faced three years of irrevocable shame in being coercively outed and investigated, the supreme court ruled to acquit them of the charge of fellatio to "value the liberty of the individual . . . even the most debased wretch in the land."[29] For the fictional Taka, however, his century-long life as an Asian American homosexual was just about to begin.

For sure, the hypersexual Asian woman and the asexual, effeminate, or queer Asian American man has persisted powerfully and continues to have resonance into the early twenty-first century.[30] *Discriminating Sex* argues that its origins might very well be located in turn-of-the-century San Francisco, a time and a place where middle-class whites, in their pursuit of entertainment and self-fulfillment, evoked Chinese and Japanese femininity and masculinity to further their own expressions of "modern" gender and sexuality. While whites initially perceived the two Asian ethnicities as two distinct "races," one yellow and the other brown, the city quickly conflated the two into the single "Oriental," a racial type that from its birth would inextricably be laden with gender and sexual meaning. For Chinese and Japanese in America, the popular rise of the "Oriental" would then formidably shape their reception. In "wide open" and "international" San Francisco—a city of freewheeling sexuality "that knows how" in terms of coexisting with a diverse populace—white pleasure and fulfillment would come at the expense of the Asian American experience.

Notes

Acknowledgments

1. Numerous publications had made this connection in the contemporary period though the illumination of how same-sex marriage, transnational adoption, as well as gay cruises contribute to economic inequality, nearly always racialized, both domestically and internationally. See Marlon M. Bailey, Priya Kandaswamy, and Mattie Udora Richardson, "Is Gay Marriage Racist?" in *That's Revolting: Queer Strategies for Resisting Assimilation*, edited by Mattilda, aka Matt Bernstein Sycamore (Brooklyn, N.Y.: Soft Skull, 2004), 87–96; David Eng, *The Feeling of Kinship: Queer Liberalism and the Racialization of Intimacy* (Durham, N.C.: Duke University Press, 2010); and Jasbir Puar, "Circuits of Queer Mobility: Tourism, Travel, and Globalization," *GLQ: A Journal of Lesbian and Gay Studies* 8, no. 1 (2002): 101–37.

Introduction

1. *Wasp*, July 15, 1899, 6.

2. William L. O'Neill, *Divorce in the Progressive Era* (New Haven, Conn.: Yale University Press, 1967); K. M. Gilham, "I'se Her Black and Tan Adonis," (1899).

3. Francis Powers, *First Born: A Chinese Drama in One Act* (1897); Weldon B. Durham, *American Theatre Companies, 1888–1930* (Greenwood Press: New York, 1987), 9.

4. "Says Society Winks at the Social Evil," *San Francisco Call*, March 6, 1900.

5. Sadie Brown first met Ah Sing when he was a servant in her father's house ten years earlier. "Women Opium Fiends," *San Francisco Chronicle*, March 17, 1900, p. 4; "White Woman Found in an Opium Joint," *San Francisco Call*, March 17, 1900.

6. "Her Daughter Nora Played Center Rush," *San Francisco Chronicle*, January 9, 1898.

7. Oscar Lewis, *San Francisco: Mission to Metropolis* (San Diego, Calif.: Howell-North, 1980); Michael Kazin, *Barons of Labor: The San Francisco Building Trades and Union Power in the Progressive Era* (Urbana: University of Illinois Press, 1987); William Issel and Robert W. Cherny, *San Francisco, 1865–1932: Politics, Power and Urban Development* (Berkeley: University of California Press, 1986).

8. From 1900 to 1920, the Census Bureau categorized individuals with Spanish surnames as "white." Not until 1970 would Latinos be considered a distinct group as "Hispanic" in the U.S. Census.

9. Frank Soule, John H. Gihon, and James Nisbet, *The Annals of San Francisco* (Palo Alto, Calif.: Lewis Osborn, 1966); Gary F. Kurutz, "Popular Culture on the Golden Shore," *California History* 79, no. 2 (Summer 2000): 280–315.

10. Available at http://www.sfgenealogy.com/sf/history/hgpop.htm (accessed December 1, 2013). See also Campbell Gibson and Kay Jung, "Historical Census Statistics on Population Totals by Race, 1790 to 1990, and by Hispanic Origin, 1970 to 1990, for the United States Regions, Divisions, and States." Available at http://www.census.gov/population/www/documentation/twps0056/twps0056.html (accessed December 1, 2013.

11. Among foreign-born whites, women made up 38 percent of the population. Bureau of the Census, *Twelfth Census of the United States, Population, 1900,* prepared by the U.S. Census Office (Washington, D.C., 1901); Bureau of the Census, *Thirteenth Census of the United States, Population, 1910,* prepared by the Department of Commerce, Bureau of Census (Washington, D.C., 1913); United States Bureau of the Census, *Fourteenth Census of the United States, Population, 1920,* prepared by the Department of Commerce, Bureau of Census (Washington, D.C., 1921).

12. Patricia Hill Collins and Evelynn Hammonds have noted how Black hypervisibility decidedly serves to control and oppress African Americans. Patricia Hill Collins, *Black Sexual Politics: African Americans, Gender, and the New Racism* (New York: Routledge, 2004); Evelynn Hammonds, "Toward a Geneology of Black Female Sexuality: The Problematic of Silence," in *Feminist Theory and the Body: A Reader*, edited by Janet Price and Margaret Shildrick (New York: Routledge, 1997), 249–59; Barbara Berglund, *Making San Francisco America: Cultural Frontiers in the Urban West, 1846–1906* (Lawrence, KS: University Press of Kansas, 2007).

13. Lewis, *San Francisco*; Kazin, *Barons of Labor*; Issel and Cherny, *San Francisco, 1865–1932*. While Philip Ethington underscored that the beginning of the twentieth century held more democratic promise than the previous era of political elitism and self-interest, Geographer Gray Brechin painted a darker San Francisco as a growing "empire," gouging the environment as well as those with less financial and political power. Philip J. Ethington, *The Public City: The Political Construction of Urban Life in San Francisco, 1850–1900* (New York: Cambridge University Press, 1994); Gray Brechin, *Imperial San Francisco: Urban Power, Earthly Ruin* (Berkeley: University of California Press, 1999).

14. Yuji Ichioka *The Issei: The World of First Generation Japanese Immigrants: 1885–1924* (New York: Free Press, 1988); Albert S. Broussard, *Black San Francisco: The Struggle for Racial Equality in the West, 1900–1954* (Lawrence: University Press of Kansas, 1993); Sucheng Chan, *Asian Americans: An Interpretive History* (New York: Twayne, 1991); Yong Chen, *San Francisco, 1850–1943: A Trans-Pacific Community* (Stanford, Calif.: Stanford University Press, 2000); Tomás Almaguer, *Racial Fault Lines: The Historical Origins of White Supremacy in California* (Berkeley: University of California Press, 1994); Alexander Saxton, *The Rise and Fall of the White Republic: Class Politics and Mass Culture in Nineteenth Century America* (New York: Verso, 1990). Theorists such as Michael Omi and Howard Winant who find their home in ethnic studies have explicitly cited race as opposed to gender or sexuality as the most influential motivation in "racial projects" in America. Michael Omi and Howard Winant, *Racial Formation in the United States: From the 1960s to the 1990s* (New York: Routledge, 1994).

15. Clare Sears, *Arresting Dress: Cross Dressing, Law, and Fascination in Nineteenth Century San Francisco* (Durham, N.C.: Duke University Press, 2014).

16. Rachel C. Lee, "Journalistic Representations of Asian Americans and Literary Responses, 1910–1920," in *An Interethnic Companion to Asian American Literature*, edited by King-Kok Cheung (New York: Cambridge University Press, 1997), 249–273; Karen Kuo, *East Is West and West Is East: Gender, Culture, and Interwar Encounters between Asia and America* (Philadelphia: Temple University Press, 2013). For previous works on unchanging anti-Asian representation in San Francisco see, William Wu, *The Yellow Peril: Chinese Americans in Fiction, 1850–1940* (Hamden, Conn.: Archon, 1982); Roger Daniels, *The Politics of Prejudice: The Anti-Japanese Movement in California and the Struggle for Japanese Exclusion* (Berkeley: University of California Press, 1962); Jules Becker, *The Course of Exclusion, 1882–1924: San Francisco Newspaper Coverage of the Chinese and Japanese in the United States* (San Francisco: Mellen Research University Press, 1991).

17. Deborah Gray White, *Ar'n't I a Woman? Female Slaves in the Plantation South*, rev. ed. (1985; reprint, New York: Norton, 1999).

18. Rosenzweig, *Eight Hours for What We Will: Workers and Leisure in an Industrial City, 1870–1920* (New York: Cambridge University Press, 1983); Kathy Peiss, *Cheap Amusements: Working Women and Leisure in New York City, 1880 to 1920* (Philadelphia: Temple University Press, 1986); Eric Lott, *Love and Theft: Blackface Minstrelsy and the American Working Class* (New York: Oxford University Press, 1993); Lawrence Culver, *The Frontier of Leisure: Southern California and the Shaping of Modern America* (New York: Oxford University Press, 2010).

19. Herbert Asbury, *Barbary Coast: An Informal History of San Francisco's Underworld* (New York: Capricorn, 1966); Curt Gentry, *The Madams of San Francisco: An Irreverent History of the City by the Golden Gate* (Garden City, N.Y.: Doubleday, 1964); Susan Stryker and Jim Van Buskirk, *Gay by the Bay: A History of Queer Culture in the San Francisco Bay Area* (San Francisco: Chronicle Books, 1996); Louis Sullivan, *From Female to Male: The Life of Jack Bee Garland* (Boston: Alyson, 1990); Roger Austen, *Genteel Pagan: The Double Life of Charles Warren Stoddard*, edited by John W. Crowley (Amherst: University of Massachusetts Press,

1991). See also Amy Sueyoshi, *Queer Compulsions: Race, Nation, and Sexuality in the Affairs of Yone Noguchi* (Honolulu: University of Hawai'i Press, 2012).

20. Lynn Gordon, *Gender and Higher Education in the Progressive Era* (New Haven, Conn.: Yale University Press, 1990); Christine Stansell, *City of Women: Sex and Class in New York, 1789–1860* (New York: Knopf, 1986); Elaine May, *Great Expectations: Marriage and Divorce in Post-Victorian America* (Chicago: University of Chicago Press, 1980); David Halperin, *What Do Gay Men Want? An Essay on Sex, Risk, and Subjectivity* (Ann Arbor: University of Michigan, 2007); Michael Warner, *The Trouble with Normal: Sex, Politics, and the Ethics of Queer Life* (Cambridge, Mass.: Harvard University Press, 2000); Judith Halberstam, *Queer Art of Failure* (Durham, N.C.: Duke University Press, 2011).

21. Karen Brodkin, *How Jews Became White Folks and What That Says about Race in America* (New Brunswick, N.J.: Rutgers University Press, 1998); Noel Ignatiev, *How the Irish Became White* (New York: Routledge, 1995); Thomas A. Guglielmo, *White on Arrival: Italians, Race, Color, and Power in Chicago, 1890–1945* (New York: Oxford University Press, 2003); George Lipsitz, *The Possessive Investment in Whiteness: How White People Profit from Identity Politics* (Philadelphia: Temple University Press, 1998).

22. For the instability of whiteness, particularly in California, see Laura Browder, *Slippery Characters: Ethnic Impersonators and American Literature* (Chapel Hill: University of North Carolina Press, 2000), 74, 76.

23. Gail Bederman, *Manliness and Civilization: A Cultural History of Gender and Race in the United States, 1880–1917* (Chicago: University of Chicago Press, 1995), 11; James McGovern, "David Graham Phillips and the Virility Impulse of the Progressives," *New England Quarterly* 39 (1966): 334–55.

24. Mari Yoshihara notes how America's relationship to China and Japan, unlike that of Europe and Near East, was an "informal empire" consolidated by unequal trade agreements, commerce, and cultural exports rather than direct political rule. Mari Yoshihara, *Embracing the East: White Women and American Orientalism* (New York: Oxford University Press, 2003), 7; Edward Said, *Orientalism* (New York: Vintage, 1978).

25. Yoshihara, *Embracing the East*.

26. John Kasson, *Amusing the Million: Coney Island at the Turn of the Century* (New York: Hill and Wang, 1978), 4–6.

27. In 1940, the federally funded Work Projects Administration, in their history of San Francisco journalism, *History of Journalism in San Francisco: Technological Growth of the Press, 1850–1900*, vol. 6 (San Francisco: WPA, 1940), devoted an entire chapter to the *Examiner*'s fraudulent reporting; *Wasp*, March 12, 1898, p. 3.

28. John P. Young, *Journalism in California* (San Francisco: Chronicle Publishing Company, 1915); Edward Cleveland Kemble, *A History of California Newspapers* (New York: Plandome, 1927); San Francisco Chronicle, *The San Francisco Chronicle and Its History* (San Francisco: San Francisco Chronicle, 1879); *History of Journalism in San Francisco*, vols. 1–7 (San Francisco: WPA, 1939–1941); John Bruce *Gaudy Century: The Story of San Francisco's Hundred Years of Robust Journalism* (New York: Random House, 1948).

29. Willliam O'Neill, *Divorce in the Progressive Era* (New Haven, Conn.: Yale University Press, 1967), 57.

30. Historian Robert A. Bennett characterized Harte and other contributors to the *Overland Monthly* as "original men" who kept the world from becoming "dull and stagnant." Robert A. Bennett, *The Bohemians: American Adventures from Bret Harte's Overland Monthly* (Walla Walla, Wash.: Pioneer, 1987); Ernest R. May, "The Overland Monthly under Bret Harte" (M.A. thesis, UCLA, 1949).

31. Book Club of California, *Some Unusual California Magazines* (San Francisco: The Club, 1975); Herrick, "Sweet Singing Lark, Be Thou My Clark, and Know Thy When to Say 'Amen!'" *The Lark*, May 1, 1897.

32. The magazine, published until 1946, characterized itself with its brilliantly colored pictorial sermons. "Greeting," *Wasp*, August 5, 1876, 3; Book Club of California, *Some Unusual California Magazines*.

33. "Greeting," *Wasp*, August 5, 1876, 3; Roger Olmstad, "The Cigar Box Papers: A Local View of the Centennial Electoral Scholars," *California Historical Quarterly* 55, no. 3 (Fall 1976): 256-69; Lois Foster Rodecape, "Tom Maguire, Napoleon of the Stage," *California Historical Society Quarterly* 21 (1942): 239-275. The virulent attacks on the Chinese in the earlier issues of the *Wasp* may have disappeared with the departure of openly anti-Chinese Ambrose Bierce, who served briefly as editor for five years in the 1880s.

34. Among the general population, the rate of illiteracy in residents above age ten was 3.1 percent in 1900, 2.1 percent in 1910, and 1.9 percent in 1920. Bureau of the Census, *Twelfth Census*; Bureau of the Census, *Thirteenth Census*; Bureau of the Census, *Fourteenth Census*.

35. Literary Critic Tania Modleski asserted how popular literature in the late nineteenth century revealed society's insecurities about its own changing sexual and gender norms. Tania Modleski, *Loving with a Vengeance: Mass Produced Fantasies for Women* (New York: Routledge, 1990).

36. Misha Berson, *The San Francisco Stage: From Golden Spike to Great Earthquake, 1869–1906*, vol. 2 (San Francisco: San Francisco Performing Arts Library and Museum, 1992), 10–11; Dean Goodman, *San Francisco Stages: A Concise History, 1849–1986* (San Francisco: Micro Pro Litera, 1986); Kathy Peiss, *Cheap Amusements: Working Women and Leisure in Turn-of-the-Century New York* (Philadelphia: Temple University Press, 1986); Rosenzweig, *Eight Hours*; Lizabeth Cohen, *Making a New Deal: Industrial Workers in Chicago, 1919–1939* (New York: Cambridge University Press, 1990); Steven Ross, *Working-Class Hollywood: Silent Film and the Shaping of Class in America* (Princeton, N.J.: Princeton University Press, 1998).

37. A cadre of specialized and nationally respected art critics arose from the city presses. Among the best known were the *Chronicle*'s drama critic Peter Robertson, the *Call*'s opera reviewer Blanche Partington, and Ambrose Bierce, who submitted reviews to the *Wasp*, among other opinion journals. Actors across the nation perceived San Francisco critics as having notably distinguished taste. Berson, *San Francisco Stage*.

38. Miriam Silverberg, "The Modern Girl as Militant," in *Recreating Japanese Women, 1600–1945*, edited by Gail Lee Bernstein (Berkeley: University of California Press, 1991).

39. I had hoped to cite less serious violations of the municipal code yet was unable to do so due to source restrictions. Records of municipal misdemeanors such as wearing clothes of the opposite sex have been systematically destroyed. The San Francisco Superior Court reportedly saves only misdemeanors for the previous five years. Crimes that remained in the Superior Court were catalogued by last name without a record of the defendants' offenses. Felony cases of gender and sexual matters proved more accessible.

Chapter 1. A Peculiar Obsession

1. *Description of Unknown Dead 1913–1919*, San Francisco Office of the Chief Medical Examiner's Records (SFH 30), San Francisco History Center, San Francisco Public Library.

2. Filmmaker Valerie Soe created an experimental short video critiquing the racist notion that "all Orientals look the same." Valerie Soe, "Fighting Fire with Fire: Detournement, Activism, and Video Art," in *Countervisions: Asian American Film Criticism*, edited by Darrell Y. Hamamoto and Sandra Liu (Philadelphia: Temple University Press, 2000), 180.

3. Alexander Saxton, *The Indispensable Enemy: Labor and the Anti-Chinese Movement in California* (1971; reprint, Berkeley: University of California Press, 1995); Sucheng Chan, *This Bittersweet Soil: The Chinese in California Agriculture, 1860–1910* (Berkeley: University of California Press, 1986).

4. Robert G. Lee, *Orientals: Asian Americans in Popular Culture* (Philadelphia: Temple University Press, 1999).

5. For more on how anti-Chinese sentiment grew from anti-Black sentiment see Saxton, *Indispensable Enemy*, 259. For a more detailed account see Najia Aarim-Heriot, *Chinese Immigrants, African Americans, and Racial Anxiety in the United States, 1848–1882* (Urbana: University of Illinois Press, 2006).

6. Lafcadio Hearn, *Glimpses of Unfamiliar Japan* (1894; reprint Rutland, Vermont: Tuttle, 1986), xi.

7. Carl Dawson, *Lafcadio Hearn and the Vision of Japan* (Baltimore, Md.: Johns Hopkins University Press, 1992). When America sought to understand Japan again during post–World War II occupation fifty years later, scholars referred to Hearn once again as a crucial "interpreter of Japan." Daniel Stemple, "Lafcadio Hearn: Interpreter of Japan," *American Literature* 20, no. 1 (March 1948): 1–19.

8. "Lafcadio Hearn Dies in Japan," *San Francisco Chronicle*, September 29, 1904; "Lafcadio Hearn: His New Volumes of Japanese Sketches," *New York Times*, October 17, 1900.

9. Edmund Buckley, "Studies of New Japan," *The Dial: A Semi-Monthly Journal of Literary Discussion, Criticism, and Information* 15 (April 16, 1895): 241.

10. Several of Hearn's essays from *Glimpses of Unfamiliar Japan* were published in various newspapers as well as the *Atlantic Monthly* in the early 1890s. His essays largely

foreground Shintoism, Buddhism, peasant life, and traditional festivals. One chapter out of twenty-seven in *Glimpses of Unfamiliar Japan* featured what we would understand today as the geisha whom Hearn named instead as the "dancing girl." Hearn, *Glimpses of Unfamiliar Japan.*

11. Inazo Nitobe, *Bushido: The Soul of Japan* (New York: Putnam's, 1905); Ruth Benedict, *The Chrysanthemum and the Sword: Patterns of Japanese Culture* (1946; reprint, Boston: Houghton Mifflin, 1989). In her 1989 reprint, Benedict noted that not until after World War II would the number of publications on Japan skyrocket by the hundreds.

12. William Hosley, *The Japan Idea: Art and Life in Victorian America* (Hartford, Conn.: Wadsworth Atheneum, 1990); Carol C. Clark, *American Japonism: Contacts between America and Japan, 1854–1910* (Cleveland: Cleveland Museum of Art, 1975); Mari Yoshihara, *Embracing the East: White Women and American Orientalism* (New York: Oxford University Press, 2003); Amy Sueyoshi, "Intimate Inequalities: Interracial Affection and Same-Sex Love in the 'Heterosexual' Life of Yone Noguchi, 1897–1909," *Journal of American Ethnic History* 29, no. 4 (Summer 2010): 22–44.

13. John Kuo Wei Tchen, *New York before Chinatown: Orientalism and the Shaping of American Culture, 1776–1882* (Baltimore, Md.: Johns Hopkins University, 1999) 292.

14. Amy Sueyoshi, *Queer Compulsions: Race, Nation, and Sexuality in the Affairs of Yone Noguchi* (Honolulu: University of Hawaii Press, 2012); Roger Austen, *Genteel Pagan: The Double Life of Charles Warren Stoddard* (Amherst: University of Massachusetts Press, 1991).

15. "American Barbarism: The Apostle of Estheticism Exposes Our Sins," *San Francisco Chronicle*, March 30, 1882.

16. Marlon Hom, *Songs of Gold Mountain: Cantonese Rhymes of San Francisco Chinatown* (Berkeley: University of California Press, 1987). For how Chinese in San Francisco in fact wore a mixture of American and Chinese clothing styles see John Kuo Wei Tchen and Arnold Genthe, *Genthe's Photographs of San Francisco Old Chinatown* (New York: Dover, 1984).

17. Sui Sin Fah, "A Chinese Ishmael," *Overland Monthly* 34, no. 199 (July 1899): 43–49.

18. The Japanese government issued codes of conduct for its expatriate population in the United States to differentiate themselves sociopolitically from the Chinese. Eiichiro Azuma, *Between Two Empires: Race, History, and Transnationalism in Japanese America* (New York: Oxford University Press, 2005).

19. Sui Sin Far, "Leaves from the Mental Portfolio of an Eurasian," *Independent*, January 21, 1890. Accessed November 10, 2014, http://essays.quotidiana.org/far/leaves _mental_portfolio.

20. Yuji Ichioka, *The Issei: The World of First Generation Japanese Immigrants, 1885–1924* (New York: Free Press, 1988); Chan, *Asian Americans*; Judy Yung, *Unbound Feet: A Social History of Chinese Women in San Francisco* (Berkeley: University of California Press, 1996); Chen, *Chinese San Francisco*; Ronald Takaki, *Strangers from a Different Shore* (Boston: Little, Brown, 1998); Eiichiro Azuma, *Between Two Empires: Race, History and Transnationalism in Japanese America* (New York: Oxford University Press, 2005); Yoshio Markino, *A Japanese*

Artist in London (Philadelphia: Jacobs, 1910); Rev. John Hood Laughlin, "Chinese Children in American Schools," *Overland Monthly* 57, no. 5 (May 1911): 507.

21. Yong Chen, *Chinese San Francisco, 1850–1943: A Trans-Pacific Community* (Stanford, Calif.: Stanford University Press, 2000); Martha Gardner, "Working on White Womanhood: White Working Women in the San Francisco Anti-Chinese Movement, 1877–1890," *Journal of Social History* 33, no. 1 (October 1999): 73–95; Neil Shumsky, *The Evolution of Political Protest and the Workingmen's Party of California* (Columbus: Ohio State University Press, 1991). See also Mai Ngai, *The Lucky Ones: One Family and the Extraordinary Invention of Chinese America* (Boston: Houghton Mifflin Harcourt, 2010).

22. Sucheng Chan, *Asian Americans: An Interpretive History* (Boston: Twayne, 1991); Alexander Saxton, *Rise and Fall of White Republic: Class Politics and Mass Culture in Nineteenth-Century America* (New York: Verso, 1990); George Anthony Peffer, *If They Don't Bring Their Women Here: Chinese Female Immigration before Exclusion* (Urbana: University of Illinois Press, 1999). Peggy Pascoe noted that Chinese prostitutes endured conditions more similar to slavery than voluntary sex work. Peggy Pascoe, *Relations of Rescue: The Search for Female Moral Authority in the American West, 1874–1939* (New York: Oxford University Press, 1990).

23. Brian Gaines and Wendy Tam Cho, "On California's 1920 Alien Land Law: The Psychology and Economics of Racial Discrimination," *State Politics and Policy Quarterly* 4, no. 3 (Fall 2004): 278.

24. Albert S. Broussard, *Black San Francisco: The Struggle for Racial Equality in the West, 1900–1954* (Lawrence: University of Kansas, 1993), 2.

25. Douglas Henry Daniels, *Pioneer Urbanites: A Social and Cultural History of Black San Francisco* (Philadelphia: Temple University Press, 1980).

26. Pleasant, seen as one of the city's earliest African American millionaires, seems to have funded abolitionist Johns Brown's raid on Harpers Ferry, a failed slave revolt that fanned sectional tension between North and South and served as one of a number of critical events that led to the Civil War. Lynn M. Hudson, *The Making of "Mammy Pleasant": A Black Entrepreneur in Nineteenth-Century San Francisco* (Urbana: University of Illinois Press, 2003).

27. Amy Louise Wood, *Lynching and Spectacle* (Chapel Hill: University of North Carolina Press, 2009).

28. Broussard, *Black San Francisco*, 2–3.

29. Randy Roberts, *Papa Jack: Jack Johnson and the Era of White Hopes* (New York: Free Press, 1983).

30. Al-Tony Gilmore, *Bad Nigger! The National Impact of Jack Johnson* (Port Washington, N.Y.: Kennikat, 1975), 60.

31. Gail Bederman, *Manliness and Civilization: A Cultural History of Gender and Race in the United States, 1880–1917* (Chicago: University of Chicago Press, 1995).

32. When an amateur sociologist declared, "I tell you it's a question of racial supremacy," laughter of those "with more common sense" as well as technical chatter among the fight fans drowned out his attempts at a "long-winded talk." "Jeffries Fight-

ing Days Over, Thinks Tad," *San Francisco Examiner*, July 4, 1910; "Chronicle First with 'Johnson Wins,'" *San Francisco Chronicle*, July 5, 1910.

33. "Local Opinions on the Big Fight," *San Francisco Chronicle*, July 5, 1910.

34. Alfred Henry Lewis, "Black Is Faster and Cleverer: Hits Harder, Cleaner, Oftener," *San Francisco Examiner*, July 5, 1910; "The Negro Won His Victory over the White Man with Ridiculous Ease," *San Francisco Examiner*, July 5, 1910.

35. Taylor and Broussard attribute San Francisco's apparently unique African American experience to the hard work and persistent activism of Black San Franciscans whom historian Douglas Daniels referred to as "pioneers." Willard Gatewood, *Aristocrats of Color: The Black Elite, 1880–1920* (Bloomington: Indiana University Press, 1990); Broussard, *Black San Francisco*; Daniels, *Pioneer Urbanites*.

36. John L. Cowan, "In the Lair of the Bear: The Japanese Question," *Overland Monthly and Out West Magazine* (January 1907): 88–89.

37. Herbert La Pore, "Prelude to Prejudice: Hiram Johnson, Woodrow Wilson, and the California Alien Land Law Controversy of 1913," *Southern California Quarterly* 61, no. 1 (April 1979): 106.

38. *Description of Unknown Dead 1907–1924*, San Francisco Office of the Chief Medical Examiner's Records (SFH 30), San Francisco History Center, San Francisco Public Library.

39. *Description of Unknown Dead 1913–1919*.

40. Ichioka, *Issei*; "Chinese Cook Is Foully Slain," *San Francisco Call*, May 22, 1908.

41. "Japanese Shot by a Chinese," *San Francisco Call*, December 20, 1902.

42. *Description of Unknown Dead 1913–1919*.

43. Authorities named one deceased Mexican explicitly as "John Doe Mexican." *Description of Unknown Dead 1902–1924*, San Francisco Office of the Chief Medical Examiner's Records (SFH 30), San Francisco History Center, San Francisco Public Library; *Description of Unknown Dead 1906–1917*, San Francisco Office of the Chief Medical Examiner's Records (SFH 30), San Francisco History Center, San Francisco Public Library.

44. *Description of Unknown Dead 1902–1907*, San Francisco Office of the Chief Medical Examiner's Records (SFH 30), San Francisco History Center, San Francisco Public Library; *Description of Unknown Dead 1907–1913*, San Francisco Office of the Chief Medical Examiner's Records (SFH 30), San Francisco History Center, San Francisco Public Library; *Description of Unknown Dead 1913–1919*; *Description of Unknown Dead 1919–1924*, San Francisco Office of the Chief Medical Examiner's Records (SFH 30), San Francisco History Center, San Francisco Public Library. Though television crime shows today often depict medical examiners being able to determine the race of an individual with only skeletal remains, physical anthropologists widely believe that these assignations are not only scientifically imprecise but also socially constructed due to racist motivations. See Diana Smay and George Armelagos, "Galileo Wept: A Critical Assessment of the Use of Race in Forensic Anthropology," *Transforming Anthropology* 9, no. 2 (July 200): 19–29.

45. *Description of Unknown Dead 1906–1917.*

46. Yong Chen, *Chinese San Francisco, 1850–1943: A Trans-Pacific Community* (Stanford, Calif.: Stanford University Press, 2000), 2.

47. Ibid., 73.

48. Ronald Takaki, *Strangers from a Different Shore* (New York: Penguin, 1989), 200.

49. Chen, *Chinese San Francisco,* 3.

50. Takaki, *Strangers from a Different Shore,* 200–202;

51. Ichioka, *Issei,* 51.

52. Ibid., 57–62.

53. Ibid., 569.

54. Ibid., 7–19, 157, 176.

55. The *Soko Shimbun* was retitled the *Soko Shimpo* in 1893 and *Soko Jiji* in 1895. Ichioka, *Issei,* 20–21.

56. Sui Sin Far, "Leaves from the Mental Portfolio of an Eurasian," *Independent,* January 21, 1890. Accessed November 10, 2014, http://essays.quotidiana.org/far/leaves_mental_portfolio.

57. Martha Mabie Gardner, "Working on White Womanhood: White Working Women in the San Francisco Anti-Chinese Movement, 1877–1890," *Journal of Social History* 33, no. 1 (Autumn 1999): 73–95.

58. Initial additions of Chinese and Japanese occurred only on the California survey. Claudette Bennett, "Racial Categories Used in the Decennial Censuses, 1790 to the Present," *Government Information Quarterly* 17, no. 2 (2000): 161–80.

59. Peter Skerry, *Counting on the Census? Race, Group Identity, and the Evasion of Politics* (Washington, D.C.: Brookings Institution Press, 2000), 42.

60. Peffer, *If They Don't Bring*; Yung, *Unbound Feet*; Eithne Lubheid, *Entry Denied: Controlling Sexuality at the Border* (Minneapolis: University of Minnesota Press, 2002).

61. Roger Daniels, *Politics of Prejudice: The Anti-Japanese Movement in California and the Struggle for Japanese Exclusion* (Berkeley: University of California Press, 1977); La Pore, "Prelude to Prejudice."

62. John Kasson, *Amusing the Million: Coney Island at the Turn of the Century* (New York: Hill and Wang, 1978), 5.

63. Janet Gray, ed., *She Wields a Pen: American Women Poets of the 19th Century* (London: Dent, 1997).

64. For Miller's article in the *Overland Monthly* see George Amos Miller, "The New Woman in the Orient," *Overland Monthly* 52, no. 6 (December 1908): 501.

65. A. B. Westland, "A Chinese Misalliance," *Overland Monthly* 37, no. 1 (January 1901): 611–15.

66. Mary Bell, "Sing Kee's China-Lily," *Overland Monthly* 30, no. 180 (December 1897): 531–39; Mary Bell, "The Chinese Motif in Current Art," *Overland Monthly* 31, no. 183 (March 1898): 236–43.

67. All ten of Thomas B. Wilson's publications occurred between 1905 and 1911: "The Yellow Peril, So-Called," *Overland Monthly* 45, no. 2 (February 1905): 133–37;

"The War of the Classes," *Overland Monthly* 45, no. 6 (June 1905): 7–11; "The Asiatic Giant," *Overland Monthly* 46, no. 1 (July 1905): 39–42; "Chinese Railways," *Overland Monthly* 57, no. 5 (May 1911): 539–48; "Why the Chinese Exclusion Law Should be Modified," *Overland Monthly* 57, no. 5 (May 1911): 491–96; "The Chinese Character," *Overland Monthly* 57, no. 6 (June 1911): 19–25; "An Economic Question: Fair Trade versus Free Trade," *Overland Monthly* 58, no. 1 (July 1911): 49–53; "The New Nationalism," *Overland Monthly* 58, no. 2 (August 1911): 141–43; "Old Chinatown," *Overland Monthly* 58, no. 3 (September 1911): 229–37; "Court-Made Laws," *Overland Monthly* 58, no. 6 (December 1911): 467–69.

68. Annette White Parks, *Sui Sin Far / Edith Maude Eaton: A Literary Biography* (Urbana: University of Illinois, 1995); Amy Sueyoshi, *Queer Compulsions.*

69. Ray B. Brown, "Mark Twain and Captain Wakeman," *American Literature* 33, no. 3 (November 1961): 320–29; Edgar Wakeman, edited by Minnie Wakeman Curtis, *The Log of an Ancient Mariner* (San Francisco: Bancroft, 1878).

70. Ernest Peixotto, *Romantic California* (New York: Scribner's, 1910), 129, 130, 142.

71. Charlton Lawrence Edholm, "San Francisco, An Impressionist Picture," *Overland Monthly* 47, no. 1 (January 1906): 33-42.

72. For pejorative depictions see Lydio F. Tomasi, ed., *The Italian in America: The Progressive View* (New York: Center for Migration Studies, 1972); Salvatore LaGumina, *Wop! A Documentary History of Anti-Italian Discrimination in the United States* (San Francisco: Straight Arrow, 1973); Francesco Cordova, ed., *Studies in Italian American Social History* (Totowa, N.J.: Rowman and Littlefield, 1975); Marco Rimanelli and Sheryl Lyn Postman, eds., *The 1891 Lynching and U.S. Italian Relations* (New York: Peter Lang, 1992). For works that trace a unique California experience see Paola A. Sensi-Isolani and Phyllis Cancilla Martinelli, eds., *Struggle and Success* (New York: Center for Migration Studies, 1993); Micaela di Leonardo, *The Varieties of Ethnic Experience: Kinship, Class, Gender Among California Italian Americans* (Ithaca, N.Y.: Cornell University Press, 1984); Dino Cinel, *From Italy to San Francisco: The Immigrant Experience* (Stanford, Calif.: Stanford University Press, 1982); Gloria Ricci Lothrop, ed., *Fulfilling the Promise of California: An Anthology of Essays on Italian American Experience in California* (Spokane, Wash.: Clark, 2000).

73. Dino Cinel, *From Italy to San Francisco*; Richard Dillon, *North Beach: The Italian Heart of San Francisco* (Novato, Calif.: Presidio, 1985); Deanna Paoli Gumina, *The Italians of San Francisco, 1850–1930* (New York: Center for Migration Studies, 1978).

74. Winfield Scott, "Old Wine in New Bottles," *Sunset: The Pacific Monthly* 30, no. 5 (May 1913): 520.

75. Mayor James Rolph, Jr., "Italy Dedication" (speech presented at the Panama Pacific International Exposition, San Francisco, California, 26 April 1915).

76. U.S. House of Representatives, *Japanese Immigration Hearings Before the Committee on Immigration and Naturalization* (1921; reprint, New York: Arno Press, 1978).

77. Cinel, *From Italy to San Francisco*; Dillon, *North Beach*; Gumina, *Italians of San Francisco.* "S.F. Mayor Ed Lee Declares Victory," SFGate.com, November 10, 2011. Accessed Feb-

ruary 22, 2014 at http://www.sfgate.com/politics/article/S-F-Mayor-Ed-Lee-declares -victory-2323854.php.

78. For Italians as "not just plain white folks" see A. Kenneth Ciongoli and Jay Parini, eds., *Beyond the Godfather: Italian American Writers on the Real Italian American Experience* (Hanover, N.H.: University Press of New England, 1997), 313. For more on how Italians remained essentially white despite previous scholarship that argues that Italians became white see Thomas A. Guglielmo, *White on Arrival: Italians, Race, Color, and Power in Chicago, 1890–1945* (New York: Oxford University Press, 2003).

79. *Wasp*, July 3, 1897, 13.

80. "The Rag Tags Celebrate by Sitting Down to a Thanksgiving Dinner," *San Francisco Chronicle*, November 21, 1897.

81. "American Citizenship," *San Francisco Call*, March 4, 1900.

Chapter 2. A Wide-Open Town?

1. Stephen Longstreet, *The Wilder Shore: A Gala Social History of San Francisco's Sinners and Spenders, 1849–1906* (Garden City, N.Y.: Doubleday, 1968); Herbert Asbury, *Barbary Coast: An Informal History of San Francisco* (New York: Pocket, 1933); Michael Kowalewski, "Romancing the Gold Rush: The Literature of the California Frontier," *California History* 79, no. 2 (Summer 2000): 204–25; Frank Soule, John H. Gihon, and James Nisbet, *The Annals of San Francisco* (Palo Alto, Calif.: Osborn, 1966); Gary F. Kurutz, "Popular Culture on the Golden Shore," *California History* 79, no. 2 (Summer 2000): 280–315; Nan Alamila Boyd, *Wide Open Town: A History of Queer San Francisco to 1965* (Berkeley: University of California Press, 2003), 2–5. So powerfully has San Francisco's reputation as a place of freedom pervaded American consciousness that queer migrants have continued to seek refuge in the city for an image that began more than a century ago. Boyd, *Wide Open Town*, 1–2; Kath Weston, "Get Thee to a Big City: Sexual Imaginary and the Great Gay Migration," *GLQ: A Journal of Lesbian and Gay Studies* 2, no. 3 (1995): 253–77.

2. "Will Be the Bride of a Japanese Preacher," *San Francisco Chronicle*, March 2, 1898.

3. Robert G. Lee, *Orientals: Asian Americans in Popular Culture* (Philadelphia: Temple University Press, 1999); Mary Ting Yi Lui, *Chinatown Trunk Mystery: Murder, Miscegenation, and Other Dangerous Encounters in Turn-of-the-Century New York City* (Princeton, N.J.: Princeton University Press, 2005) 76, 77, 144; Nayan Shah, *Stranger Intimacy: Contesting Race, Sexuality, and Law in the North American West* (Berkeley: University of California Press, 2011), 28.

4. Fitzhugh W. Brundage, *Lynching in the New South: Georgia and Virginia, 1880–1930* (Urbana: University of Illinois Press, 1993); Glenda Elizabeth Gilmore, *Gender and Jim Crow: Women and the Politics of White Supremacy in North Carolina, 1896–1920* (Chapel Hill: University of North Carolina Press, 1996); Amy Louise Wood, *Lynching and Spectacle* (Chapel Hill: University of North Carolina Press, 2009), 7.

5. Reports of Mexican and Native American pairings with whites were completely absent. In the context of anti-miscegenation laws, journalists likely chose to write

about the most forbidden relations as defined by law—those involving Asian and African Americans. For more on the history of anti-miscegenation see Peggy Pascoe, *What Comes Naturally: Miscegenation Law and the Making of Race in America* (New York: Oxford University Press, 2009).

6. "Tripped into a Jap's Heart," *San Francisco Chronicle*, February 17, 1898.

7. "College Girl Weds Japanese," *San Francisco Chronicle*, August 31, 1907.

8. "Suicide of an Unlucky Negro," *San Francisco Chronicle*, July 29, 1897.

9. "A Wife Stands in Love's Way," *San Francisco Chronicle*, March 14, 1898.

10. "Chinese Lothario Rescued by Wife," *San Francisco Call*, July 25, 1902.

11. "A Brooklyn Bicycle Girl Remembered by Li Hung Chang," *San Francisco Chronicle*, April 1, 1897.

12. "Fright Caused Her Death," *San Francisco Examiner*, December 27, 1897; "Mad Act of Jealous Japanese," *San Francisco Call*, December 27, 1897.

13. "Death May Have Come from Fright," *San Francisco Chronicle*, December 27, 1897.

14. Ibid.; "Fright Caused Her Death"; "Mary Castillo Did Not Die of Fright," *San Francisco Chronicle*, December 28, 1897.

15. "Tauchi Held for Murder," *San Francisco Examiner*, January 5, 1898. Judge Low's statement is not as supportive of Asians as it may seem. He explained, "The Japanese and Chinese are particularly hard to deal with. They look much alike to the police, and particularly in such a case as this it would be almost impossible to detect and arrest one of them, unless the others regarded the police as friendly to them."

16. "George Tauchi Held to Answer for Murder," *San Francisco Chronicle*, January 12, 1898.

17. "George Tauchi Held for Murder," *San Francisco Call*, January 12, 1898.

18. "Tauchi is in Jealous Rage," *San Francisco Examiner*, January 11, 1898.

19. "Mad Act of a Jealous Japanese."

20. "He Admits That He Is Guilty," *San Francisco Call*, January 5, 1898.

21. For details on the Sigel murder and its implications see Lui, *Chinatown Trunk Mystery*.

22. Lui, *Chinatown Trunk Mystery*; "Death May Have Come from Fright"; "Mary Castillo Did Not Die of Fright"; "Fright Caused her Death"; "Mad Act of a Jealous Japanese." For more on Mexicans at the turn of the century identifying as "Spanish" see Tomás Almaguer, *Racial Fault Lines: The Historical Origins of White Supremacy in California* (Berkeley: University of California Press, 1994).

23. Sadie Brown first met Ah Sing when he was a servant in her father's house ten years before. "Women Opium Fiends," *San Francisco Chronicle*, March 17, 1900; "White Woman Found in an Opium Joint," *San Francisco Call*, March 17, 1900.

24. "Death May Have Come from Fright."

25. "Two Girls Seek Death," *San Francisco Chronicle*, March 1, 1898.

26. Ida B. Wells-Barnett, *Crusade of Justice: The Autobiography of Ida B. Wells*, edited by Alfreda Duster (Chicago: University of Chicago Press, 1970); Ida B. Wells-Barnett, *On Lynching* (New York: Arno, 1969).

27. "Women Cause Two Stabbings," *San Francisco Call*, December 26, 1896.

28. "She Was Kissed by a Chinaman," *San Francisco Call*, February 21, 1897.

29. "Stolen Kisses Land a Chinese in Jail," *San Francisco Chronicle*, February 21, 1897; "She Was kissed by a Chinaman"; "Six Months for a Kiss," *San Francisco Call*, March 4, 1897.

30. "Teaching a Jurist," *San Francisco Chronicle*, March 20, 1891; "Mashing Not a Crime," *San Francisco Chronicle*, October 2, 1893; "Masher Is Arrested," *San Francisco Chronicle*, February 15, 1907.

31. *San Francisco Ordinances 1898* (San Francisco: Phillips and Smyth, 1898), 34–35, 48; *San Francisco Ordinances 1904* (San Francisco: Hiester Print, 1904), 410.

32. Estelle Freedman, *Redefining Rape: Sexual Violence in the Era of Suffrage and Segregation* (Cambridge, Mass.: Harvard University Press, 2013).

33. "Torao Kawasaki—Japanese Consulate, Battery and Sansome, San Francisco," Survey on Race Relations, Special Collections, Hoover Library, Stanford University, Stanford.

34. Yoshio Markino, *A Japanese Artist in London* (London: Chatto and Windus, 1912), 5.

35. In the ceremony conducted through interpreters, at the bride's request the word "obey" was omitted from their vows. "Refuses to Issue Marriage License—'Cupid' Danforth Declines to Comply with Application of a Japanese and Swedish Woman," *San Francisco Call*, January 13, 1905.

36. "Would Marry a Vagrant," *San Francisco Chronicle*, January 26, 1898.

37. Laws in California dating from 1879 prohibited Asians and African Americans from marrying whites. Not until the mid-twentieth century would anti-miscegenation laws be struck from the books. Rachel F. Moran, *Interracial Intimacy: The Regulation of Race and Romance* (Chicago: University of Chicago Press, 2001), 31.

38. Moran, *Interracial Intimacy*; Peggy Pascoe, "Race Gender and Intercultural Relations: The Case of Interracial Marriage," *Frontiers* 12, no.1 (1991): 5–19; Candice Lewis Bredbenner, *A Nationality of Her Own: Women Marriage and the Law of Citizenship* (Berkeley: University of California Press, 1998).

39. Bill Ong Hing, *Making and Remaking Asian America through Immigration Policy, 1850–1990* (Stanford, Calif.: Stanford University Press, 1993); Megumi Dick Osumi, "Asians and California's Anti-Miscegenation Laws," in *Asian and Pacific American Experiences: Women's Perspectives*, edited by Nobuya Tsuchida (Minneapolis: Asian/Pacific Learning Resource Center and University of Minnesota, 1982): 1-37.

40. Moran, *Interracial Intimacy*; Martha Hodes, ed., *Sex Love Race: Crossing Boundaries in North American History* (New York: New York University, 1999); Werner Sollors, ed., *Interracialism: Black and White Intermarriage in American History, Literature, and Law* (New York: Oxford University Press, 2000); Robert J. Sickels, *Race, Marriage and the Law* (Albuquerque, N.M.: University of New Mexico Press, 1972).

41. For more on Kuno see "Intimate Inequalities: Interracial Affection and Same-sex Love in the 'Heterosexual' Life of Yone Noguchi, 1897–1909," *Journal of American Ethnic*

History 29, no. 4 (Summer 2010): 22–44; Henry Yu, "Mixing Bodies and Cultures: The Meaning of American's Fascination with Sex between 'Orientals' and 'Whites'" in *Sex, Love, Race: Crossing Boundaries in North American History*, edited by Martha Hodes (New York: New York University Press, 1999), 444–46.

42. "He Speaks All the Tongues of the East," *San Francisco Chronicle*, April 19, 1897.

43. "Lee Yuen Would A-Wooing Go," *San Francisco Call*, December 30, 1897.

44. "His Love Was Spurned," *San Francisco Chronicle*, March 12, 1902.

45. Roger Austen, *Playing the Game: The Homosexual Novel in America* (New York: Bobbs-Merrill, 1977); Caroll Smith-Rosenberg, *Disorderly Conduct: Visions of Gender in Victorian America* (New York: Knopf, 1985); Eve Sedgwick, *Between Men: English Literature and Male Homosocial Desire* (New York: Columbia University Press, 1985); Peter Boag, *Constructing Same-Sex Affairs: Constructing and Controlling Homosexuality in the Pacific Northwest* (Berkeley: University of California Press, 2003). Colin Johnson asserted that same-sex sexual encounters among tramping men in the early 1900s were "not only common, but celebrated as an integral part of everyday life." Colin R. Johnson, "Casual Sex: Towards a 'Prehistory' of Gay Life in Bohemian America," *Interventions* 10, no. 3 (2008): 305.

46. "Killed by His Partner's Hand," *San Francisco Chronicle*, March 4, 1898.

47. "The Salute," *Wasp*, October 9, 1897; *San Francisco Call*, March 3, 1900; "In Childhood's Realm," *San Francisco Call*, February 28, 1897.

48. When Butler died at age ninety, Ponsonby passed away eighteen months later "in her loneliness, refusing to be consoled." "A Romance of Wales: Two Ladies of Liangollen Who Lived a Strange Life," *San Francisco Chronicle*, January 3, 1897.

49. Women in the club smoked cigarettes, practiced fencing, boxing, and pistol shooting, wrote a poem or story every month, and made a full report on marriage proposals. "Aim to Live without the Men—Twenty Oklahoma Girls Form a Unique Bachelor Club," *San Francisco Chronicle*, December 6, 1897.

50. Stevenson, who wrote under the pseudonym Mayne, hoped to protect his reputation in a book with nationwide circulation that pointed to San Francisco's particular sexuality. Xavier Mayne, *The Intersexes: A History of Similisexualism as a Problem in Social Life* (1908; reprint, New York: Arno Press, 1975). For more on Mayne see John Lauritsen, "Edward Irenaeus Prime-Stevenson (Xavier Mayne)," in *Before Stonewall: Activists for Gay and Lesbian Rights in Historical Context*, edited by Vern L. Bullough (Haworth, 2002), 35–40.

51. "Oscar Wilde to Go from Prison to France," *San Francisco Chronicle*, March 7, 1897. Oscar Wilde, a literary legend, gained fame for his writings, wit, and sense of style. Charged with sodomy, Wilde endured a prison sentence in the late nineteenth century. He and his family faced great shame and hardship in the years that followed. For one of numerous books on Wilde see Barbara Belford, *Oscar Wilde: A Certain Genius* (New York: Random House, 2000).

52. "The Theatres," *Wasp*, June 22, 1901.

53. Archibald Henderson, "The Theatre of Oscar Wilde," *Overland Monthly* 50, no. 1 (July 1907): 11.

54. For more see D'Emilio and Freedman. Western writer Charles Warren Stoddard wrote of reading banned publications on erotic fraternal love from Europe. Roger Austen, *Genteel Pagan: The Double Life of Charles Warren Stoddard*, edited by by John W. Crowley (Amherst, Mass.: University of Amherst Press, 1991).

55. Alan Dale, *A Marriage below Zero* (New York: Dillingham, 1889); Mayne, *Intersexes*; Richard A. Kaye, "The Return of Damon and Pythias: Alan Dale's *A Marriage below Zero*, Victorian Melodrama, and the Emergence of a Literature of Homosexual Representation," *College Literature* 29, no. 2 (Spring 2002): 51–52.

56. While literary historian Roger Austen declared Stoddard's book San Francisco's "first gay novel," in fact Yone Noguchi had published his queer novel *American Diary of a Japanese Girl* the previous year (1902). For more on *American Diary of a Japanese Girl* see Amy Sueyoshi, "Miss Morning Glory: Orientalism and Misogyny in the Queer Writings of Yone Noguchi," *Amerasia Journal—Special Issue: Further Desire* 37, no. 2 (2011): 2–27.

57. Charles Warren Stoddard, *For the Pleasure of His Company: An Affair of the Misty City* (San Francisco: Robertson, 1903). The novel was not Stoddard's first homoerotic book. In fact, in 1873 he published perhaps his more famous work, *South Sea Idylls*, in which he outlined his relationship with Kana Ana. For more on Charles Warren Stoddard's life and works see Austen, *Genteel Pagan*.

58. "There Is Little Hope for His Recovery," *San Francisco Post*, January 20, 1904; "1907 Stodddard's Clippings #6," Special Collections, Bancroft Library, University of California at Berkeley, Berkeley; Austen, *Genteel Pagan*, 149.

59. "1907 Stodddard's Clippings #6"; Yone Noguchi, "In the Bungalow with Charles Warren Stoddard: A Protest against Modernism," *National Magazine* (December 1904); Charles Phillips, "1907 Stoddard's Clippings #6."

60. "1907 Stodddard's Clippings #6"; Charles Warren Stoddard, "Miss Juno," in *The Spinner's Book of Fiction*, collected by the Book Committee of the Spinner's Club (San Francisco: Elder, 1907), 261–301.

61. Austen, *Genteel Pagan*, xxvi. See also Peter Gay, *The Tender Passion* (New York: Oxford University Press, 1986), 202.

62. Art historian Melissa Dabakis noted how coded public exchange that occurred around the appropriateness of the Tilden's work pointed to "confusion regarding the propriety of the homosocial gaze." Melissa Dabakis, "Douglas Tilden's Mechanics Fountain: Labor and the 'Crisis of Masculinity' in the 1890s," *American Quarterly* 47, no. 2 (June 1995): 216.

63. *People v. Samuel P. Robbins*, 154 P. 317 (1915); "Samuel Robbins to Be Given a New Trial, *San Francisco Chronicle*, November 20, 1914.

64. Nayan Shah, "Between 'Oriental Depravity' and 'Natural Degenerates': Spatial Borderlands and the Making of Ordinary Americans," *American Quarterly* 57, no. 3 (September 2005): 703–25.

65. In other parts of the United States, however, even being white may not have protected individuals from prosecution for "crimes against nature." Historian Laurence

Murphy argued that nineteenth-century America, on the whole, vigorously frowned upon all sorts of sexual indiscretions, including "pederasty, buggery, fellatio, and . . . masturbation." According to Murphy, the legal persecution of "sodomy" broadly as sex acts with no reproductive purpose between both same- and different-sex couples increased through the early twentieth century. Lawrence R. Murphy, "Defining the Crime Against Nature: Sodomy in the United States Appeals Court, 1810–1980," *Journal of Homosexuality* 19, no. 1 (1990): 49–66.

66. See "Reports of the San Francisco Police Chief" from 1897 to 1905, San Francisco History Center, San Francisco Public Library.

67. *People v. Carroll* (May 22, 1905) 81, p. 680.

68. Christine Stansell, *American Moderns: Bohemian New York and the Creation of a New Century* (New York: Holt, 2000), 251; Elizabeth Wilson, *Bohemians: Glamorous Outcasts* (London: Tarius, 2000), 183; Sueyoshi, *Queer Compulsions*. For more details on the San Francisco's Bohemian characters such as Jack London, Ambrose Pierce, Joaquin Miller, and Ina Coolbrith see Franklin Walker, *San Francisco's Literary Frontier* (New York: Knopf, 1939).

69. Austen, *Genteel Pagan*.

70. "I'll carve dat nigger when we meet" (1898), Song Sheets, *Examiner* Series, San Francisco History Center, San Francisco Public Library.

71. K. M. Gilham, "I'se Her Black and Tan Adonis" (1899), Song Sheets, *Examiner* Series, San Francisco History Center, San Francisco Public Library.

72. Max Moranth, "The Vocal and Theatrical Music of Bert Williams and His Associates," in *American Popular Entertainment*, edited by Myron Matlow (Westport, Conn.: Greenwood, 1979), 112; James Dorman, "Shaping the Popular Image of Post-Reconstruction American Blacks: The 'Coon Song' Phenomena of the Gilded Age," *American Quarterly* 40, no. 4 (December 1988): 453.

73. Not until the 1910s would coon shouters begin to "black up" or apply blackface. Pamela Brown Lavitt, "First of the Red Hot Mamas: 'Coon Shouting' and the Ziegfeld Girl," *American Jewish History* 87, no. 4 (December 1999): 253–90. See also Eric Lott, *Love and Theft: Blackface Minstrelsy and American Working Class* (New York: Oxford University Press, 1993); Annemarie Bean, James Hatch, and Brooks McNamara, eds., *Inside the Minstrel Mask: Readings in Nineteenth-Century Blackface Minstrelsy* (Hanover, N.H.: Wesleyan University Press, 1996); Robert Toll, *Blacking Up: The Minstrel Show in Nineteenth Century America* (New York: Oxford University Press, 1974).

74. Lavitt, "First of the Red Hot Mamas," 258.

75. For a brief historiography on the racist nature of these performances see Hudson, "Entertaining Citizenship," 181.

76. Lori Harrison-Kahan, *The White Negress: Literature, Minstrelsy, and the Black-Jewish Imaginary* (New Brunswick, N.J.: Rutgers University Press, 2011). Pamela Brown Lavitt notes, "How easily coon shouting now astounds and offends us, but at the turn of the century this star vehicle was a pliant platform for Jewish female performers to communicate meaningful messages—mainstream and disruptive—about beauty, female

sexuality, marriage and intermarriage, race and ethnic adaptation. Jewish and female audiences enjoyed reading between the lines." Lavitt, "First of the Red Hot Mamas," 259, 289.

77. Harrison-Kahan, *White Negress*. Sophie Tucker, a celebrated coon shouter, maintained a "lesbian-like" relationship with the founder of San Francisco's first Chinese hospital, Margaret Chung. For Sophie Tucker and Margaret Chung's relationship as "lesbian-like" see Judy Tzu-Chun Wu, *Mom Chung and the Fair-Haired Bastards: A Thematic Biography of Doctor Margaret Chung, 1889–1959* (Berkeley: University of California Press, 1998).

78. Daphne Brooks, *Bodies in Dissent: Spectacular Performances of Race and Freedom, 1850–1910* (Durham, N.C.: Duke University Press, 2006), 214.

79. Schroeder, 139.

80. Brooks, *Bodies in Dissent*, 214. For more on the significance of "coon songs" for both whites and Blacks see also Patricia R. Schroeder, "Passing for Black: Coon Songs and the Performance of Race," *Journal of American Culture* 33, no. 2 (June 2010): 139–53.

81. While Lynn Hudson has asserted to the decreasing popularity of minstrelsy at the time, she has also underscored how lingering performances served as the centerpiece at the city's most prestigious affairs as the "pièce de résistance" that testified to the staying power of negative representations of blackness in California. Lynn M. Hudson, "Entertaining Citizenship: Masculinity and Minstrelsy in Post Emancipation San Francisco," *Journal of African American History* 93, no. 2 (Spring 2008): 181.

82. Harold Vernon, "Honey, You've Done Me Wrong" (1898), Song Sheets, *Examiner* Series, San Francisco History Center, San Francisco Public Library.

83. "Bye-Bye My Babykins Bye-Bye" (1901), Song Sheets, *Examiner* Series, San Francisco History Center, San Francisco Public Library. History Center.

84. Benjamin McArthur, *Actors and American Culture, 1880-1920* (Philadelphia: Temple University Press, 1984).

85. Anthropologist Karen Brodkin asserts that Jews in America did not become white until the 1950s. Karen Brodkin, *How Jews Became White Folks and What That Says about Race in America* (New Brunswick, N.J.: Rutgers University Press, 1998).

86. G. J. Yenewinne, "My Philippino Lady" (1899), Song Sheets, *Examiner* Series, San Francisco History Center, San Francisco Public Library History Center.

87. Andrew D. Amron, "Reinforcing Manliness: Black State Militias, the Spanish-American War, and the Image of the African American Soldier, 1891–1900," *Journal of African American History* 97, no. 4 (2012): 401–26.

88. Christine Bold, "Where Did the Black Rough Riders Go?" *Canadian Review of American Studies* 39 (2009): 273–97.

89. Historian Herbert Asbury cites the 1906 earthquake and fire inciting the cleanup. Municipal ordinances also reveal that legislation for moral reform began appearing in 1903. Asbury, *Barbary Coast*), 282–84; *San Francisco General Ordinances 1904* (San Francisco: Hiester Print, 1904).

90. William Issel and Robert Cherny, *San Francisco, 1865–1932: Politics, Power, and Urban Development* (Berkeley: University of California Press, 1986), 108.

91. Donna Dennis, *Licentious Gotham: Erotic Publishing and its Prosecution in Nineteenth Century New York* (Cambridge, Mass.: Harvard University Press, 2009).

Chapter 3. "Deliver Me from the Brainy Woman"

1. "Cobb Honeymoon Dimmed by Trifles Light as Air—Bride Objected to Sleeping with Window Open and Groom Drew the Line When She Began Wearing His Neckties," *San Francisco Call*, March 22, 1900; "Willing to Share His Joys," *Wasp*, October 2, 1897, 2; "No Chance to Talk," *Wasp*, April 22, 1899, 15; "Pointers," *Wasp*, June 18, 1898, 20.

2. Elaine May, *Great Expectations: Marriage and Divorce in Post Victorian America* (Chicago: University of Chicago Press, 1980).

3. By the end of the 1920s one out of every six marriages nationally ended in the courtroom. May, *Great Expectations*; William L. O'Neill, *Divorce in the Progressive Era* (New Haven, Conn.: Yale University Press, 1967).

4. [n.t.], *San Francisco Call*, January 6, 1898.

5. "Baby Pleaded for Its Mama," *San Francisco Call*, December 31, 1897.

6. *Ann Gorman v. Patrick Gorman*, 134 Cal. 378 (1901).

7. *Thurlow McMullin v. Virginia McMullin*, 140 Cal. 112 (1903).

8. "Pawned Diamonds for Daily Bread," *San Francisco Call*, June 4, 1897.

9. "Smith Divorce Involve Big Church Scandal," *San Francisco Call*, March 3, 1900; "Rev. Guy Smith Is a Gay Lover," *San Francisco Call*, March 21, 1900; "Smith's Troubles Are Multiplying," *San Francisco Call*, March 22, 1900.

10. "A Halt in the Mad March of Divorce," *San Francisco Chronicle*, July 18, 1897.

11. Lynn D. Gordon, *A Gender and Higher Education in the Progressive Era* (New Haven, Conn.: Yale University Press, 1990).

12. Charles Dana Gibson, the creator of the "Gibson Girl," introduced her vitality and beauty to the nation when he began drawing for *Life* magazine in 1890. Lois W. Banner, *American Beauty* (New York: Knopf, 1983); Howard Chandler Christy, *American Girl: As Seen and Portrayed by Howard Chandler Christy* (New York: Moffat, Yard, 1906).

13. "Something about Games for Girls," *San Francisco Chronicle*, March 28, 1897.

14. "Home Study Circle," *San Francisco Call*, February 4, 1900.

15. "The Sweet Girl Graduate Is Confronted with a New and Puzzling Problem—Her Future," *Wasp*, June 22, 1901, cover.

16. "The Woman and the Hour," *San Francisco Chronicle*, April 27, 1897.

17. [n.t.], *San Francisco Chronicle*, January 5, 1897; "Want a Woman Appointed," *San Francisco Call*, February 8, 1900; "Women to Act as Census Takers," *San Francisco Chronicle*, January 24, 1897; "Women as Home Builders," *San Francisco Chronicle*, November 28, 1897; "This Girl Is a Fire Fighter—Loves Flame and Smoke, and Dressed in Red Flannel Fire Clothes and Flaring Helmet, with an Axe in Her Dainty Hands, She Is

an Inspiring Spectacle," *San Francisco Call*, January 24, 1897; "These Nuns Have Just Become Blacksmiths," *San Francisco Call*, January 24, 1897; "Young Woman Undertaker," *San Francisco Chronicle*, January 1, 1897; "Women Lighthouse Keepers," *San Francisco Chronicle*, June 4, 1898.

18. "The Ideal Woman," *San Francisco Chronicle*, April 11, 1897.

19. "Social Side Lights," *Wasp*, March 18, 1899.

20. "Text of Cardinal Gibbon's Famous Sermon—His Indictment of Women Suffragists and Society Leaders as 'The Worst Enemies of Their Sex," *San Francisco Call*, February 18, 1900.

21. "A Halt in the Mad March of Divorce," *San Francisco Chronicle*, July 18, 1897.

22. "Taylor Told Lies to Deceive His Wife," *San Francisco Chronicle*, December 28, 1897; The Deserter, "A San Francisco Romance," *Wasp*, January 9, 1897, 9.

23. "Mrs. Burdette Addresses Young Women Students," *San Francisco Call*, March 1, 1900.

24. "Educated Women," *San Francisco Chronicle*, September 26, 1897.

25. "About the New Woman," *San Francisco Call*, February 15, 1897.

26. The *Chronicle* expounded on the shame of sex discrimination. "It was necessary to get rid of Miss Stainaker without placing on the records of the department the confession that a woman had been denied a position she had honorably earned, because of her sex." "Barred Because She Is a Woman," *San Francisco Chronicle*, January 22, 1897.

27. Allen Guttman, *Women's Sports: A History* (New York: Columbia University, 1991).

28. Ibid.; Susan K. Cahn, *Coming on Strong: Gender and Sexuality in Twentieth Century Women's Sport* (New York: Free Press, 1994).

29. "This Woman Handy with the Mitts," *San Francisco Chronicle*, January 30, 1897.

30. Rebecca Mead, *How the Vote Was Won: Woman Suffrage in the Western United States, 1886–1914* (New York: New York University Press, 2004). For more on the women activists and the fight for suffrage in San Francisco see Susan Englander, *Class Conflict and the Coalition in the California Woman Suffrage Movement, 1907–1912: The San Francisco Wage Earners' Suffrage League* (Lewiston, N.Y.: Mellen, 1992).

31. James H. Marshall and Walter Wolff, "A Frisco Girl" (1897), Song Sheets, *Examiner* Series, San Francisco History Center, San Francisco Public Library.

32. "Winter Girl," *San Francisco Chronicle*, January 16, 1898.

33. "California Women as Court Reporter," *San Francisco Chronicle*, February 28, 1897.

34. "Winter Girl," *San Francisco Chronicle*, January 16, 1898.

35. "On the Golf Links with California's Fairest Athletes," *San Francisco Call*, February 18, 1900.

36. "California Women as Court Reporter," *San Francisco Chronicle*, February 28, 1897; "American Women in the World of Sport," *San Francisco Call*, February 7, 1897. Sandra Myres underscored how "Westering" women as early as 1809 became more independent because of the rugged conditions and their isolation from their familial network, forming the beginning of what would later become the New Woman. Sandra

L. Myres, *Westering Women and the Frontier Experience, 1800–1915* (Albuquerque: University of New Mexico Press, 1982).

37. Reginald Dyck, "Willa Cather's Reluctant New Woman Pioneer," *Great Plains Quarterly* 23, no. 3 (Summer 2003): 161–73.

38. Charlotte Rich notes how the feminism of this period "has been considered a regression" from the human-rights-based more radical movement to gain women's suffrage fifty years earlier. Charlotte Rich, *Transcending the New Woman: Multiethnic Narratives in the Progressive Era* (Columbia: University of Missouri Press, 2009), 14. See also Cecily Devereux, "New Woman, New World: Maternal Feminism and the New Imperialism in the White Settler Colonies," *Women's Studies International Forum* 22, no. 2 (1999): 175–84; Iveta Jusová, *The New Woman and the Empire* (Columbus: Ohio State University Press, 2005).

39. "Our Oriental Neighbors," *Wasp*, February 25, 1899, 8; "The Tale of Fan," *San Francisco Chronicle*, February 21, 1897; W. D. Tillotson, "The Houses Where Gods Do Dwell," *Overland Monthly* 46, no. 6 (December 1905): 562-73.

40. Hester A. Benedict, "Kamako," *Overland Monthly* 37, no. 3 (March 1901): 780.

41. George Amos Miller, "The New Woman in the Orient," *Overland Monthly* 52, no. 6 (December 1908): 501.

42. "Half Hour with Romancers—Villain and Hero Combined," *San Francisco Call*, January 1, 1905.

43. "Suspected Poolroom for Women Raided," *San Francisco Call*, February 21, 1900; "Women Must Not Bet on Horse Races," *San Francisco Chronicle*, March 20, 1898.

44. Leonard Franklin Sawvel, "Nita, Child of the Sun," *Overland Monthly* 52, no. 4 (October 1908): 378.

45. "An Embarrassing Order," *Wasp*, April 2, 1898, 12; Blanche Partington, "With the Players and the Music Folk," *San Francisco Call*, January 29, 1905; "Her Daughter Nora Played Center Rush," *San Francisco Chronicle*, January 9, 1898.

46. Kate Simpson-Hayes, "Little Madam Na-Mura," *Overland Monthly* 54, no. 3 (September 1909): 268.

47. Dorothy Feinmore authored all the following articles. "Friendship and Love Are Akin," *San Francisco Call*, January 29, 1905; "To Be Free to Love We Must Work," *San Francisco Call*, May 14, 1905; "Old Love Can Be Outgrown," *San Francisco Call*, February 13, 1905; "Women Who Scold in Public," *San Francisco Call*, February 20, 1905; "The Woman Married Five Years," *San Francisco Call*, March 5, 1905; "The Man with Two Sweethearts," *San Francisco Call*, May 1, 1905; "Young Wives Need Much Tact," *San Francisco Call*, March 12, 1905; "Helplessness of a Man in Love," *San Francisco Call*, May 3, 1905.

48. Translated by Seizo Oka, "Missing Person Advertisement," *Shin Sekai*, April 30, 1913; "Missing Person Advertisement with Reward," *Shin Sekai*, July 1, 1914; Translated by author, "Reward $25, Missing Person," *Nichibei Shimbun*, September 12, 1912.

49. Hisako Hibi and her mother, who immigrated to San Francisco in 1920, described their lifestyles as "much freer." Shimizu is her maiden name. "Hibi, Hisako,"

oral history transcript, March 23, 1986, Issei Project, National Japanese American Historical Society, San Francisco.

50. "Lovesick Japanese Commits Suicide," *San Francisco Chronicle*, January 20, 1898.

51. "Blew Up His Wife and Baby," *San Francisco Chronicle*, March 30, 1898.

52. Olive Dilbert, "Umeko-san," *Overland Monthly* 50, no. 4 (October 1907): 343.

53. Minnie Wakemen Curtis, "An American's Experiences in Housekeeping in Yokohama," *San Francisco Chronicle*, 13 June 1897, p. 1.

54. "Kotsuru Taka Not a Bride," *San Francisco Call*, February 18, 1905; "To Guard Japanese Girl," *San Francisco Call*, January 26, 1905.

55. "Through the Opera Glass," *Wasp*, October 30, 1897, 14–15; "A Musical Comedy," *San Francisco Chronicle*, October 17, 1897; "Dramatic and Musical Review," *San Francisco Chronicle*, November 7, 1897.

56. Sidney Jones, *The Geisha; A Story of a Tea House* (Boston: Agents, White-Smith, 1896), 4.

57. *Ibid.*, 8, 16, 21.

58. "Is an Osculatory Epidemic Probable?" *Wasp*, August 13, 1898, 5.

59. "Feed Him with Kisses," *San Francisco Chronicle*, February 24, 1897.

60. "The Theatre," *Cambridge Review* 27 (1905/1906): 68; "The Geisha," *Cambridge Review* 20 (1898/1899): 263; "'The Geisha' at Daly's," *New York Times*, November 9, 1897; Edward A, Dithmar, "The Drama," *New York Times Magazine*, November 14, 1897, 13; "The Theatres," *New York Times Magazine*, September 13, 1896, 10; "'The Geisha' at Daly's," *New York Times*, March 22, 1898.

61. "'The Geisha' at Daly's: The New Musical Comedy form London Received with Approbation," *New York Times*, September 9, 1896; "The Theatres," *New York Times Magazine*, September 27, 1896, 12. Ironically, New York audiences who at the turn of the century condemned *The Geisha*, embraced it in 1919. *The Geisha* remade and sold to a different audience twenty years later would be more appreciated in a different historical context. "'The Geisha' Gayly Revived," *New York Times*, October 25, 1919, 14.

62. "Through the Opera Glass," *Wasp*, October 30, 1897, 14–15; "A Musical Comedy," *San Francisco Chronicle*, October 17, 1897; "Dramatic and Musical Review," *San Francisco Chronicle*, November 7, 1897; Tabitha Twiggs, "The Old Maid's Diary," *Wasp*, November 6, 1897, 12.

63. *Ibid.*, 21.

64. Minnie L. Wakeman Curtis, "Experiment of American Family in Japanese Housekeeping," *San Francisco Chronicle*, June 27, 1897.

65. "Pedagogues Gather to Discuss Themes of Moment to Scholars," *San Francisco Call*, May 3, 1905.

66. *San Francisco Chronicle*, October 1, 1907.

67. "The Social Problem," *San Francisco Call*, February 14, 1900.

68. Gertrude Holloway, "A Coquette," *Wasp*, November 5, 1898.

69. Grace Hibbard, "Japanese Love Song," *San Francisco Chronicle*, March 13, 1898.

70. Caroll Smith-Rosenberg, *Disorderly Conduct: Visions of Gender in Victorian America*

(New York: Oxford University Press, 1985). For more on the homoerotic potential, if not reality, of stage performers, see Jennifer Costello Berezina, "Public Women, Private Acts: Gender and Theater in Turn-of-the-Century American Novels," in *Separate Spheres No More: Gender Convergence in American Literature, 1830—1930*, edited by Monika M. Elbert (Tuscaloosa: University of Alabama Press, 2000); Eric Lott, *Love and Theft: Blackface Minstrelsy and the American Working Class* (New York: Oxford University Press, 2013).

71. Cultural critic Mari Yoshihara detailed how white women on the East Coast contributed to the formation of American Orientalism. Mari Yoshihara, *Embracing the East: White Women and American Orientalism* (New York: Oxford University Press, 2003).

72. Henry Kiyama, *Four Immigrants Manga: A Japanese Experience in San Francisco, 1904–1924* (Berkeley, Calif.: Stone Bridge, 1999).

73. "Maruoka, Ryoko," oral history transcript, July 20, 1989, Issei Project, National Japanese American Historical Society, San Francisco.

74. "A Fair Japanese Bachelor of Letters," *San Francisco Chronicle*, May 24, 1898.

75. NJAHS, Issei Project, box "Women Oral History Transcripts," (Nisei), folder "Togasaki, Yoshiye Dr.," August 10, 1985.

76. "Visit with Mr. George Shima 'Potato King' of California,—Mrs. Park," July 14, 1924, Survey on Race Relations, Hoover Library, Stanford.

77. International Conference of Women Workers to Promote Permanent Peace, 1915, Abiko Family Papers, Japanese American Research Project, Young Research Library Special Collections, Los Angeles.

78. Abiko Yonako Diaries, 1920–1921, Abiko Family Papers, Japanese American Research Project, Young Research Library Special Collections, Los Angeles.

79. Abiko Yonako Diaries, 1922-1923, Abiko Family Papers, Japanese American Research Project, Young Research Library Special Collections, Los Angeles.

80. While only a fraction of women in Japan identified as "New Women" at the turn of the century, the Imperial Rescript on Education (1890) and the Boshin Edict (1908) encouraged education for women both as gendered and national subjects. Richard Reitan, "Claiming Personality: Reassessing the Dangers of the 'New Woman' in Early Taishō Japan," *Positions* 19, no. 1 (Spring 2011): 83–107.

81. Shiori Nomura, "The Voices of Women on Birth Control and Childcare: A Japanese Immigrant Newspaper in Early Twentieth Century USA," *Japan Forum* 21, no. 2 (2009):255–76.

82. "Modern Ideas Accepted by Oriental Folk," *San Francisco Chronicle*, September 3, 1922.

83. "Japanese Educators to Teach Economics," *San Francisco Chronicle*, September 17, 1911.

84. W. S. Gilbert, *The Mikado and Other Plays* (New York: Boni and Liverwight, 1917), 11.

85. W. A. Darlington, *The World of Gilbert and Sullivan* (New York: Crowell, 1950), 124, 126. See also Hesketh Pearson, *Gilbert and Sullivan: A Biography* (New York: Harper and Brothers, 1935), 158.

86. "Casino" *Theatre* 12 (July–December 1910) 4.

87. "'The Mikado' Barred," *Literary Digest* 34, no. 21 (May 27, 1907): 838; Pearson, *Gilbert and Sullivan*, 289.

88. "Through the Opera Glass," *Wasp*, October 30, 1897, 14–15; "A Musical Comedy," *San Francisco Chronicle*, October 17, 1897; "Dramatic and Musical Review," *San Francisco Chronicle*, November 7, 1897.

89. Josephine Lee, *The Japan of Pure Invention: Gilbert and Sullivan's* The Mikado (Minneapolis: University of Minnesota Press, 2010), viii, xiv, 145.

90. For how Yum-Yum is not a Japanese name see Lee, *Japan of Pure Invention*, 144–45. Gilbert, *Mikado and Other Plays*, 15.

91. "Young Ladies Will Appear in 'Mikado,'" *San Francisco Call*, February 20, 1900; "Co-eds Will the 'Mikado,'" *San Francisco Call*, January 22, 1905. As late as the 1920s, Sonia Sunwoo recalled participating in the production of *The Mikado* at her elementary school. Sonia Sunwoo, guest speaker at the University of California at Los Angeles, May 10, 2001. In 2008 the Lamplighters Music Theatre once again produced *The Mikado* at the Yerba Buena Center in San Francisco. "The Mikado—Opens 56th Season of Lamplighters Music Theatre," San Francisco Sentinel.com, August 8, 2008. Accessed 31 January 2011 at http://www.sanfranciscosentinel.com/?p=15390.

92. *The Lark* asserted how San Francisco specifically suffered from a declining romance. "Centuries of Love: The Decrescence of Romance," *Lark*, February 1, 1897.

93. J. M. Scanland, "An Italian Quarter Mosaic," *Overland Monthly* 67, no. 4 (April 1906): 332.

94. Ernest Peixotto, *Romantic California* (New York: Scribner's, 1910), 40.

95. Ibid., 129, 130, 142.

96. Deanna Paoli Gumina, "Connazionali, Stenterello, and Farfariello: Italian Variety Theater in San Francisco," in *Fulfilling the Promise of California: An Anthology of Essays on the Italian American Experience*, edited by Gloria Ricci Lothrop (Spokane, Wash.: Clark, 2000), 157–67; Lawrence Estavan, ed., *The Italian Theater in San Francisco* 10 (San Francisco: San Francisco Theater Project, WPA, 1939).

97. Charles Warren Stoddard, *For the Pleasure of His Company, An Affair of the Misty City* (San Francisco: Robertson, 1903), 195.

98. "Italy's Deserted Cities," *San Francisco Chronicle*, January 31, 1897.

99. Mayor James Rolph Jr., "Italy Dedication" (speech presented at the Panama Pacific International Exposition, San Francisco, April 26, 1915).

100. Jans Van Dusen, "Francesca: A Tale of Fisherman's Wharf," *Overland Monthly* 37, no. 2 (February 1901): 659–65; Mabel Nelson Thurston, "Madeleine" *Sunset: The Pacific Monthly* 30, no. 1 (January 1913).

101. "The Call's Homestudy Circle—Biographical Studies for Girls," *San Francisco Call*, February 24, 1900.

102. Paul Pry, "Social Side Lights," *Wasp*, May 7, 1898, 15.

103. "Professor Moses Talks of Ancient Japan," *San Francisco Chronicle*, November 24, 1897; "Text of Cardinal Gibbon's Famous Sermon: His Indictment of Women Suf-

fragists and Society Leaders as 'The Worst Enemies of Their Sex,'" *San Francisco Call*, February 18, 1900.

104. "Aged Woman Kills Child and Herself," *San Francisco Chronicle*, May 6, 1913.

105. *San Francisco Foundling Asylum 1869–1908: Children's Agency Placing-Out Index Book; Associated Charities of San Francisco—Annual Reports 1904–1910*, Family Service Agency of San Francisco (SFH), San Francisco History Center, San Francisco Public Library, San Francisco. Out of 437 babies and children who came through the agency, only one was listed as Asian, specifically of mixed heritage—Chinese and Mexican.

106. Ida's husband refused to participate in her murder pact and found the bodies of both the boy and his wife when he came home. "Aged Woman Kills Child and Herself," *San Francisco Chronicle*, May 6, 1913.

107. "Modern Ideas Accepted by Oriental Folk," *San Francisco Chronicle*, September 3, 1922.

108. "Wife Estranged Twelve Years Seeks Divorce," *San Francisco Call and Post*, April 2, 1917.

109. "Wife Gives Up Husband to Affinities," *San Francisco Call and Post*, April 5, 1917.

110. "Repenting at Leisure," *San Francisco Call*, June 4, 1897; "Mother Takes Eloping Wife," *San Francisco Call*, January 27, 1905. See chapter 1 for more on newspaper reporting of divorces.

111. Lorrimer published his notes while traveling from Kobe to Shimonoseki by way of Miyajima. Charles Lorrimer, "Travel Letters," *Overland Monthly* 53, no. 3 (March 1909): 211.

112. "Visit with Mr. George Shima 'Potato King' of California—Mrs. Park," July 14, 1924, Major Document no. 134, Survey on Race Relations, Hoover Library, Stanford.

113. "About the Collection," Survey of Race Relations, Stanford University. Accessed July 14, 2013, at http://collections.stanford.edu/srr/bin/page?forward=about. Stanford M. Lyman, "The Race Relations Cycle of Robert E. Park," *Pacific Sociological Review* 11, no. 1 (Spring 1968): 16–22.

114. Judy Yung, *Unbound Feet: A Social History of Chinese Women in San Francisco* (Berkeley: University of California Press, 1995).

115. Among African American men the census reported 58 percent as single. For foreign and native-born white men, 49 percent were single. Bureau of the Census, *Twelfth Census of the United States, Population, 1900*, prepared by the U.S. Census Office (Washington, D.C., 1901); Bureau of the Census, *Thirteenth Census of the United States, Population, 1910*, prepared by the Department of Commerce, Bureau of Census (Washington, D.C., 1913); United States Bureau of the Census, *Fourteenth Census of the United States, Population, 1920*, prepared by the Department of Commerce, Bureau of Census (Washington, D.C., 1921).

116. Dorothy Feinmore, "Marriages of Convenience," *San Francisco Call*, April 19, 1905.

117. Charles Lorrimer, "The Japanese Art of Flower Arrangement," *Overland Monthly* 47, no. 2 (February 1906): 116-23.

118. Mary Gibbons Copper, "The Transformation of Hana," *Overland Monthly and Out West Magazine* 62, no. 4 (October 1913): 368.

119. From 1897 to 1901 the rate increased by 34.5 percent. From 1902 to 1906 the rate increased by 12.8 percent. As divorce increased, state legislatures, mostly in the East, enacted more than one hundred pieces of legislation to curtail its increasing rate. Nelson Blake, *The Road to Reno: A History of Divorce in the United States* (New York: Macmillan, 1962); O'Neill, *Divorce in the Progressive Era*; May, *Great Expectations*.

120. Not until 1916 would San Francisco hold the highest national average in divorce. Bureau of Census, *Marriage and Divorce 1916*, prepared by the Department of Commerce, Bureau of the Census (Washington, D.C., 1919). Scholars have attributed Nevada's high rate of divorce to its relatively lenient divorce laws and residency requirement. Bureau of Census, *Marriage and Divorce 1867-1906*, prepared by the Department of Commerce, Bureau of the Census (Washington, D.C., 1909); Bureau of Census, *Marriage and Divorce 1916*; Blake; O'Neill, *Divorce in the Progressive Era*; May, *Great Expectations*.

121. For the divorces as taking place recklessly see, "Marriages Are Ill Sorted," *San Francisco Chronicle*, July 12, 1898.

Chapter 4. Prostitution Proliferates

1. "Dramatic and Musical," *San Francisco Chronicle*, June 27, 1897.

2. "Alcazar Actors Wear the Queue," *San Francisco Call*, May 11, 1897; Francis Powers, *First Born: A Chinese Drama in One Act* (1897); Weldon B. Durham, *American Theatre Companies, 1888–1930* (New York: Greenwood, 1987), 9.

3. Herbert Asbury, *The Barbary Coast: An Informal History of the San Francisco Underworld* (New York: Garden City, 1933).

4. Curt Gentry, *The Madams of San Francisco: An Irreverent History of the City by the Golden Gate* (Sausalito, Calif.: Comstock, 1964); *Final Report of the Grand Jury, December 10, 1904* (San Francisco, 1905); John F. Seymour Papers, Bancroft Library, Berkeley; *Final Report of the Grand Jury*; San Francisco Municipal Reports from 1896–1917.

5. Gentry, *Madams of San Francisco*; Jacqueline Baker Barnhart, *The Fair but Frail: Prostitution in San Francisco, 1849–1900* (Reno: University of Nevada Press, 1986); Asbury, *Barbary Coast*.

6. *Final Report of the Grand Jury*; San Francisco Municipal Reports from 1896–1917.

7. Ruth Rosen, *The Lost Sisterhood: Prostitution in America, 1900–1918* (Baltimore, Md.: Johns Hopkins University Press, 1982); John D'Emilio and Estelle Freedman, *Intimate Matters: A History of Sexuality in America* (Chicago: University of Chicago Press, 1997); Barnhart, *Fair but Frail*; Ronald A. St. Laurence, "The Myth and the Reality: Prostitution in San Francisco, 1880–1913" (master's thesis, California State University, Hayward, 1974). See also *San Francisco Municipal Report, 1884–1885* (San Francisco: Hinton, 1885), unpaginated map at end.

8. Mark Connelly, *The Response to Prostitution in the Progressive Era* (Chapel Hill: University of North Carolina Press, 1980); Brian Donovan, *White Slave Crusades: Race, Gender,*

and Anti-Vice Activism, 1887–1917 (Urbana: University of Illinois Press, 2006); Pamela Haag, "'Commerce in Souls': Vice, Virtue, and Women's Wage Work in Baltimore, 1900–1915," *Maryland Historical Magazine* 86, no. 3 (1991): 292–308.

9. Alan Hunt, "Regulating Heterosocial Space: Sexual Politics in the Early Twentieth Century," *Journal of Historical Sociology* (March 2002): 1–34.

10. M. Joan McDermott and Sarah Blackstone, "White Slavery Plays of the 1910s: Fear of Victimization and the Social Control of Sexuality," *Theatre History Studies* 16 (1996):141–56. Gail Bederman also traced how officials used laws prohibiting white slavery to police interracial intimacies. Gail Bederman, *Manliness and Civilization: A Cultural History of Gender and Race in the United States, 1880–1917* (Chicago: University of Chicago Press, 1995).

11. *Final Report of the Grand Jury*; San Francisco Municipal Reports from 1896–1917.

12. "Personals," *San Francisco Chronicle*, March 29, 1897.

13. Ibid., May 2, 18974.

14. Ibid., July 17, 1897.

15. Ibid., July 6, 1898.

16. Ibid., September 27, 1897.

17. Ibid., October 8, 1897; January 25, 1898; September 12, 1898; August 21, 1898.

18. Kathy Peiss, *Cheap Amusements: Working Women and Leisure in New York City, 1880–1920* (Philadelphia: Temple University Press, 1986).

19. "Personals," *San Francisco Chronicle*, December 3, 1897, and July 31, 1898.

20. Ellen K. Rothman, *Hands and Hearts: A History of Courtship in America* (New York: Basic, 1984); Florence Howe Hall, "Etiquette for Men," *Harper's Bazaar* (November 1907): 1096; Beth L. Bailey, *From Front Porch to Back Seat: Courtship in Twentieth Century America* (Baltimore, Md.: Johns Hopkins University Press, 1988).

21. "Kicked When Brophy Kissed the Bride," *San Francisco Chronicle*, August 31, 1897.

22. "Under the Ray," *Wasp*, July 24, 1897, 10; Tabitha Twiggs, "The Old Maid's Diary," *Wasp*, August 27, 1898, 12.

23. [n.t.], *Wasp*, June 5, 1897, 3.

24. "Kissing Charged as Her Offense," *San Francisco Chronicle*, January 26, 1897.

25. She added, "The grip causes grip, the way the young people grip each other around the waist when they're spoonin' in the open air without their winter overcoats on is enough to bring on grip of another kind." Tabitha Twiggs, "The Old Maid's Diary," *Wasp*, January 9, 1897, 8.

26. Tabitha Twiggs, "The Old Maid's Diary," *Wasp*, February 5, 1898, 14.

27. "The Theaters," *Wasp*, June 4, 1898, 18.

28. "It Was Juniori," *Wasp*, August 19, 1899, 14.

29. "Society Girls in Vaudeville," *San Francisco Call*, March 4, 1900.

30. *Wasp*, April 29, 1899, 15.

31. The Story Teller, "Heavy Price," *Wasp*, May 29, 1897, 9.

32. "Social Side Lights," *Wasp*, March 18, 1899, 12.

33. "This Week's New Bills," *New York Times*, January 21, 1900.

34. "Olga Nethersole in 'Sapho': A Dramatic 'Sensation,'" *Literary Digest* 20, no. 8 (February 24, 1900): 241.

35. "This Week's Bills," *New York Times*, January 28, 1900.

36. Arthur Symons, *Academy and Literature* 62, no. 1566 (May 10, 1902): 487; "Ireland," *London Times*, October 16, 1902; "Ireland," *London Times*, October 20, 1902.

37. "Olga Nethersole in a Police Court: Actress Accused of Offending Public in the Presentation of 'Sapho,'" *San Francisco Call*, February 22, 1900; "Olga Nethersole Must Stand Trial," *San Francisco Call*, March 6, 1900; *San Francisco Call*, March 23, 1900; "'Sapho' May Not Show Here," *San Francisco Call*, March 4, 1900; "Some of the Lines in 'Sapho' Which Have Caused So Much Talk," *San Francisco Call*, March 11, 1900; Clyde Fitch, *Sapho*; *San Francisco Call*, March 25, 1900.

38. Tabitha Twiggs, "The Old Maid's Diary," *Wasp*, June 12, 1897, 12.

39. *Wasp*, July 15, 1899, 6.

40. "The Cost of a Chinese Slave," *Wasp*, March 18, 1899, 7; "A Great City's Curse," *Illustrated World*, January 16, 1897, page unknown, record group 21, Old Circuit and District Courts, Criminal Case Files 1851-1912, box 247, case 3364.

41. "Slave Dealers Are Ready for Business," *San Francisco Call*, March 3, 1900.

42. *Wasp*, October 2, 1897, 4; "The Cost of a Chinese Slave," *Wasp*, March 18, 1899, 7.

43. Yung, *Unbound Feet*; George Anthony Peffer, *If They Don't Bring Their Women Here: Chinese Female Immigration before Exclusion* (Urbana: University of Illinois Press, 1999); Benson Tong, *Unsubmissive Women: Chinese Prostitutes in Nineteenth Century San Francisco* (Norman: University of Oklahoma Press, 1994), 159.

44. Ann H. Chinn, interview by Suellen Cheng, October 26, 1979, interview 5, Chinese American Oral History Project, Special Collections, Young Research Collection, University of California at Los Angeles.

45. May Lum, interview by Suellen Cheng, December 13, 1979, interview 42, Chinese American Oral History Project, Special Collections, Young Research Collection, University of California at Los Angeles.

46. Ruth K. Wong, interview by Suellen Cheng, March 21, 1983, interview 61, Chinese American Oral History Project, Special Collections, Young Research Collection, University of California at Los Angeles.

47. Stella Louis, interview by Munson Kwok and Eugene Moy, April 23, 1982, interview 159, Chinese American Oral History Project, Special Collections, Young Research Collection, University of California at Los Angeles.

48. Patrick J. Healy and Ng Poon Chew, *A Statement for Non-Exclusion* (San Francisco: N.p., 1905), 77.

49. Annette White-Parks, *Sui Sin Far/Edith Maude Eaton* (Chicago: University of Illinois Press, 1995), xvi.

50. Sui Sin Far, *Mrs. Spring Fragrance* (Chicago: McClurg, 1912), vii.

51. "A Chinese Ishmael," Sui Sin Fah, *Overland Monthly* 34, no. 199 (July 1899): 43-49.

52. Far, Mrs. Spring Fragrance, 2.

53. Far, Mrs. Spring Fragrance, 161–178.

54. White-Parks, *Sui Sin Far*, 37; Sui Sin Far, "Leaves from the Mental Portfolio of an Eurasian," *New York Independent* 66 (January 1909): 125–32; Yin Xiao-huang, *Chinese American Literature since the 1850s* (Chicago: University of Illinois Press, 2000).

55. Amy Ling, "Edith Eaton: Pioneering Chinamerican Writer and Feminist," *American Literary Realism* 16 (Autumn 1983): 292; William F. Wu, *The Yellow Peril: Chinese Americans in American Fiction, 1850–1940* (Hamden, Conn.: Archon, 1982), 53–54.

56. Marguerite Stabler, "The Sale of Sooy Yet: The Story of Modern Delilah," *Overland Monthly*, (May 1900): 414–16. The reference to Delilah in the title is to the Old Testament story in which Delilah betrayed Samson's love for her, causing him blindness and eventually death. *Holy Bible, New Revised Standard Version* (Grand Rapids, Mich.: Zondervan, 1990): Judges 16:1–31.

57. "Centuries of Love: The Decrescence of Romance," *The Lark*, February 1, 1897.

58. *San Francisco Call*, April 4, 1897; *San Francisco Call*, May 16, 1897; *San Francisco Chronicle*, December 22, 1897.

59. "Didn't Marry for Love: Strange Confession of Mrs. Baumgarten Made in Open Court," *San Francisco Call*, April 3, 1897; Edith Huntington, "Marriage a la Mode," *Wasp*, July 5, 1902, 18.

60. Peggy Pascoe, Relations of Rescue: The Search for Female Moral Authority in the American West, 1874–1939 (New York: Oxford University Press, 1990).

61. "Wailing Women in Chinatown," *San Francisco Chronicle*, March 23, 1897.

62. "Police Still Active in Chinatown District," *San Francisco Call*, January 12, 1900.

63. "Slaves in San Francisco," *San Francisco Chronicle*, March 24, 1897.

64. RG 21, Old Circuit and District Courts, Criminal Case Files 1851-1912, box 293, case 3910.

65. Many feminist theorists argue sex work for women is not "true consent" in a world that grants little socioeconomic power to women. Karen Peterson-Iyer, "Prostitution: A Feminist Ethical Analysis," *Journal of Feminist Studies in Religion* 14, no. 2 (Fall 1998): 29; Carole Pateman, *The Sexual Contract* (Stanford, Calif.: Stanford University Press, 1988).

66. J. Stitt Wilson, *The Barbary Coast in Barbarous Land; or, The Harlots and the Pharisees* (Berkeley, Calif.: Wilson, 1913); J. Stitt Wilson, *How I Became a Socialist and Other Papers* (Berkeley, Calif.: Wilson, 1912).

67. Hirata, "Free, Indentured, Enslaved: Chinese Prostitutes in Nineteenth Century America."

68. "Miss Higgins of the Presbyterian Mission Speaks," August 1, 1924, major document 55, Survey of Race Relations, Hoover Library, Stanford.

69. Hirata also noted how Chinese viewed sex work to support families as an act filial loyalty. Hirata, "Free, Indentured, Enslaved," 6.

70. "A Blow at the Chinese," *San Francisco Chronicle*, April 8, 1897; *Overland Monthly* (June 1913): 531–41.

71. "Wise and His Men Blamed," *San Francisco Chronicle*, January 31, 1897.

72. "The History and Problem of Angel Island," Major Document 150, Survey on Race Relations, Hoover Library, Stanford; Peffer, *If They Don't Bring*.

73. "Failed in His Attempt to Bribe Chief Biggy," *San Francisco Call*, February 13, 1900.

74. Record Group 85, Records of the Immigration and Naturalization Service, San Francisco District, Arrival Investigation Case Files, 1884-1944, box 288, case 10302/2.

75. Record Group 21, Old Circuit and District Courts, Criminal Case Files 1851-1912, box 292, case 3901.

76. Record Group 21, Old Circuit and District Courts, Criminal Case Files 1851-1912, box 293, case 3916; Record Group 21, Old Circuit and District Courts, Criminal Case Files 1851-1912, box 368, case 4716, 4718.

77. Peffer, *If They Don't Bring*.

78. For the two articles see "Trying to Rescue Chinese Slave," *San Francisco Call*, October 1, 1902, and "Chinese Maid Is Taken from Captors," *San Francisco Call*, December 15, 1902.

79. For the three articles see Adriana Spadoni, "Devils, White and Yellow," *Overland Monthly* 44, no. 1 (July 1904): 80–84; Mrs. E. V. Robbins, "Chinese Slave Girls," *Overland Monthly* 51, no. 1 (January 1908): 100–103; and L. Warren Wigmore, "Revenge of Ching Chow," *Overland Monthly* 82, no. 2 (February 1924): 60–63.

80. "Crusade against Immorality," *San Francisco Call*, January 10, 1901; "Attack on Chinese Vice," *San Francisco Call*, May 4, 1901; "Da Silva Is Now in County Jail," *San Francisco Chronicle*, September 27, 1904.

81. Notably, before 1903 only one ordinance dealt directly with obscenity and acceptable morality. Order 2825, approved November 24, 1894, prohibited the use of mechanical contrivances or devices for the reproduction of obscene, indecent, or vulgar language or words or sounds, picture or object, exhibition, representation, reproduction. *San Francisco General Ordinances* (San Francisco: Hiester Print, 1904).

82. Hotels or public gardens, or to any charitable exhibition of entertainment given by any amateur dramatic association or literary society or to any ball were excluded.

83. *Final Report of the Grand Jury, 27 February 1909* (San Francisco, 1910).

84. *Final Report of the Grand Jury, 4 March 1910* (San Francisco, 1911).

85. Barnhart, *Fair but Frail*. Local Madame Sally Stanford declared San Francisco as an "open town and people were happy about it." Sally Stanford, *The Lady of the House: The Autobiography of Sally Stanford* (New York: Putnam, 1966).

86. Prostitution could only occur in an area roughly bounded by Commercial Street, Pacific Street, Bartlett Alley, and Washington Place.

87. Women would have to pay fifty cents for each exam. San Francisco Municipal Reports, 1910-1911 (San Francisco: Neal); Julius Rosenstirn, "Municipal Clinic of San Francisco," *Medical Record* 83, no. 11 (March 15, 1913): 467–73.

88. Mark Thomas Connelly, *The Response to Prostitution in the Progressive Era* (Chapel Hill: University of North Carolina Press, 1980), 12–15. The following year when the police appointed a committee to regulate sex work, they continued to call it a "social evil," presenting complaints from the North Beach Improvement Club's Committee

on Morals on various "evils" and "deplorable conditions" where Kearny Street joined Pacific Street. *Final Report of the Grand Jury, 4 March 1910* (San Francisco, 1911).

89. Julius Rosenstirn, *Our Nation's Health Endangered by Poisonous Infection through the Social Malady: The Protective Work of the Municipal Clinic of San Francisco and Its Fight for Existence* (San Francisco: Town Talk, 1913).

90. Previous scholars have characterized Rosenstirn's approach as lingering and outdated at the beginning of America's most zealous and best-recorded campaigns against prostitution. While earlier Victorians saw prostitution as a "necessary evil," by the turn of the century Americans reclassified it as a "social evil" in an effort to abolish it. Rosen, *Lost Sisterhood*.

91. The Panama Pacific International Exposition commemorated the discovery of the Pacific Ocean and the construction of the Panama Canal. Frank Morton Todd, *Story of the Exposition* (New York: Putnam's, 1921).

92. *Final Report of the Grand Jury, 16 December 1914* (San Francisco, 1915).

93. "Barbary Coast Made Thing of the Past," *San Francisco Examiner*, September 23, 1913.

94. Wilson, *Barbary Coast*.

95. "Chinese Woman Ends Life," *San Francisco Call*, December 11, 1902; "Trying to Rescue a Chinese Slave," *San Francisco Call*, October 1, 1902; "Prefers Death to an Existence of Shame," *San Francisco Call*, July 11, 1908.

96. Robbins, "Chinese Slave Girls," 101.

97. Roy Temple, "The Young Wife and the Fan," *Overland Monthly* 61, no. 4 (April 1913): 399.

98. L. Clifford Fox, "Pursuing the Smuggler," *Overland Monthly* 61, no. 6 (June 1913): 532.

99. George Amos Miller, *China Inside Out* (New York: Abingdon, 1917); "Briefs on New Books," *Dial* 62 (April 5, 1917): 315.

100. Joe Meyer and G. P. Hulten, "Down in Chinatown" (1920), Song Sheets, *Examiner* Series, San Francisco History Center, San Francisco Public Library.

101. "Chinese Women Making Fight for Suffrage," *San Francisco Chronicle*, October 2, 1921.

102. Nayan Shah, *Contagious Divides: Epidemics and Race in San Francisco's Chinatown* (Berkeley: University of California Press, 2001), 79; Peffer, *If They Don't Bring*.

103. Robert G. Lee, *Orientals: Asian Americans in Popular Culture* (Philadelphia: Temple University Press, 1999), 90.

104. In Brian Donovan's national study on white slavery, only in San Francisco does white slavery in fact become "yellow slavery." Donovan, *White Slave Crusades*, 110.

105. "Puzzling over a Girl's Age," *San Francisco Chronicle*, July 19, 1899.

106. Examination by the U.S. Department of Labor, Immigrations Service, Port of San Francisco, 10/29/1924, Record Group 85, box 1116, file 15843/3–14.

107. Record Group 21, U.S. District Court, Northern District of California, San Francisco, Criminal Case Files 1912-1934, box 120, series 31, case 8119.

Chapter 5. Managing Masculinity

1. Peter Filene, *Him/Her/Self: Sex Roles in Modern America* (Baltimore, Md.: Johns Hopkins University Press, 1986); Charles Rosenberg, "Sexuality, Class and Role in Nineteenth-Century America," *American Quarterly* 35 (May 1973): 131–53; Norman Vance, *The Sinews of the Spirit: The Ideal of Christian Manliness in Victorian literature and Religious Thought* (Cambridge: Cambridge University Press, 1985); Margaret Marsh, "Suburban Men and Masculine Domesticity," *American Quarterly* 40 (June 1988): 165–86; Mark C. Carnes and Clyde Griffen, eds., *Meanings for Manhood: Constructions of Masculinity in Victorian America* (Chicago: University of Chicago Press, 1990); Gail Bederman, *Manliness and Civilization: A Cultural History of Gender and Race in the United States, 1880–1917* (University of Chicago Press: Chicago, 1995).

2. "Editor Assaulted for Attacking Wife Beaters," *San Francisco Call*, March 10, 1910; "Answer Is Filed in M'Gauley Suit," *San Francisco Chronicle*, October 4, 1905.

3. Robert G. Lee, *Orientals: Asian Americans in Popular Culture* (Philadelphia: Temple University Press, 1999), 88; Jachinson Chan, *Chinese American Masculinities: From Fu Man Chu to Bruce Lee* (New York: Routledge, 2001); Rachel C. Lee, "Journalistic Representations of Asian Americans and Literary Responses, 1910–1920," in *An Interethnic Companion to Asian American Literature*, edited by King-Kok Cheung (New York: Cambridge University Press, 1997): 249–73; Yen Le Espiritu, *Asian American Women and Men: Labor, Laws, and Love* (Thousand Oaks, Calif.: Sage, 1996), 111.

4. Roger Daniels, *The Politics of Prejudice: The Anti-Japanese Movement in California and the Struggle for Japanese Exclusion* (New York: Aetheneum, 1967); Alexander Saxton, *The Rise and Fall of the White Republic: Class Politics and Mass Culture in Nineteenth Century Politics* (London: Verso, 1990).

5. "A Blow at the Chinese," *San Francisco Chronicle*, April 8, 1897; "Slave Dealers Are Ready for Business," *San Francisco Call*, March 3, 1900; Francis Powers, *First Born: A Chinese Drama in One Act* (1897); "Strange Disclosures about Opium Dens," *San Francisco Chronicle*, June 19, 1897; *Wasp*, July 3, 1897, 13.

6. "Wanner Must Pay," *San Francisco Call*, August 6, 1892.

7. "Twelve Jurors Say Amy Murphy Killed Herself," *San Francisco Call*, February 8, 1900; "Coroner's Jury Finds Amy Murphy a Suicide," *San Francisco Chronicle*, February 9, 1900; "Poulin Escapes Punishment for Moral Crime," *San Francisco Call*, February 11, 1900; "Horace Poulin Jailed and His Victim Buried," *San Francisco Call*, February 7, 1900.

8. In the first decades of the twentieth century, more than a dozen literary groups announced poetry- and couplet-writing contests in the local paper *Chung Sai Yat Po*. Marlon Hom, *Songs of Gold Mountain: Cantonese Rhymes from San Francisco Chinatown* (Berkeley: University of California Press, 1987).

9. Ibid., 153.

10. Ibid., 241.

11. "Accounts for It," *Wasp*, May 15, 1897, 11.

12. "Autobiography of Mr. Luke Chess," October 1924, box 31, major document 293, Survey on Race Relations, Hoover Library, Stanford; Don Hang Wong, interviewed by Jean Wong, November 15, 1974, interview 134, Chinese American Oral History Project of Southern California, Young Research Library Special Collections, Los Angeles (hereafter cited as CAOHP).

13. Jo Hathaway, "Ah Foy Yam," *Overland Monthly* 34, no. 203 (1899): 447.

14. A number of white employers complained about having "no control over white boys" and thus having no choice but to hire the "despised" Chinese, since they are more easily manipulated. J. Torrey Connor, "An Ode to John," *Overland Monthly* 33, no. 197 (May 1899): 433. Patrick J. Healy and Ng Poon Chew, *A Statement for Non-Exclusion* (San Francisco: [N. p.], 1905), 82–83.

15. "A Lecture on Sex and Marriage," *San Francisco Call*, May 31, 1897; "Be a Man Now," *San Francisco Chronicle*, April 11, 1897; *San Francisco Call*, March 5, 1897; "I Am Man," *San Francisco Chronicle*, September 13, 1898; "Man's Character Shown by the Top of His Hat," *San Francisco Call*, February 4, 1900; "True Manliness," *San Francisco Chronicle*, February 10, 1897; "What Makes Men Strong," *San Francisco Chronicle*, March 24, 1897; "Lost Manhood," *San Francisco Call*, May 14, 1905; "A History of the Decline of Manhood," *San Francisco Call*, March 13, 1897; "Manhood Restored," *San Francisco Chronicle*, April 17, 1897; "The Call's Home Study Circle," *San Francisco Call*, March 10, 1900.

16. "Proper suiting for the Well Dressed Young Man of the Rising Generation," *San Francisco Call*, March 11, 1900.

17. The Professor, "Under the Ray," *Wasp*, September 4, 1897, 10; Nayan Shah, *Contagious Divides: Epidemics and Race in San Francisco's Chinatown* (Berkeley: University of California Press, 2001).

18. The remaining two composed of one Japanese and one "African."

19. San Francisco Municipal Reports 1896-1917; *Twelfth Census of the Population, 1900*, vol. 1, Population; *Thirteenth Census of the Population, 1910*, vol. 1, Population.

20. Barriers to treatment may also point to why more Chinese than whites died of syphilis. Joan B. Tranner, "Chinese as Medical Scapegoats, 1870–1905," *California History* 57, no. 1 (Spring 1978): 82–85.

21. Interview with Ora Yuen by Suellen Cheng and Munson Kwok, January 19, 1980, CAOHP.

22. Alfred, born in 1910, was named after the dentist who apprenticed his father, Alfred E. Blake. Interview with Alfred Lee by Beverly Chan, January 16, 1980, CAOHP.

23. The Professor, "Under the Ray," *Wasp*, September 4, 1897, 10.

24. Mary Bell, "Sing Kee's China-Lily," *Overland Monthly* 30, no. 180 (December 1897): 531-38.

25. For more on white slavery narratives protesting state-supported prostitution see Mara L. Keire, *For Business and Pleasure: Red Light Districts and the Regulation of Vice in the United States, 1890–1933* (Baltimore, Md.: Johns Hopkins University Press, 2010), 73–74.

26. Peggy Pascoe, *Relations of Rescue: The Search for Female Moral Authority in the American West* (New York: Oxford University Press, 1990); Hom, *Songs of Gold Mountain*.

27. James C. N. Paul and Murray L. Schwartz, *Federal Censorship: Obscenity in the Mail* (New York: Free Press, 1961). For an example of the policing of birth control see Record Group 21, Old Circuit and District Courts, Criminal Case Files 1851-1912, box 278, case 3723. Though the act today remains technically "on the books," its provisions remain largely unenforced due to their unconstitutionality.

28. Record Group 21, Old Circuit and District Courts, Criminal Case Files 1851-1912, box 279, case 3743.

29. Record Group 21, Old Circuit and District Courts, Criminal Case Files 1851-1912, box 288, case 3873.

30. Record Group 21, U.S. District Court, Northern District of California, San Francisco, Criminal Case Files 1912-1934, box 308, case 14637.

31. Record Group 21, Old Circuit and District Courts, Criminal Case Files 1912-1934, box 418, case 5355.

32. For Frank Mukai see Record Group 21, Old Circuit and District Courts, Criminal Case Files 1851-1912, box 352, case 4495. For Minoru Maita see Record Group 21, Old Circuit and District Courts, Criminal Case Files 1851-1912, box 263, case 3523. For Bunzo Washizo see Record Group 21, Old Circuit and District Courts, Criminal Case Files 1851-1912, box 263, case 3521.

33. Hom, *Songs of Gold Mountain*, 288–89.

34. Healy and Chew, *Statement for Non-Exclusion*, 77.

35. Ibid., 78.

36. Record Group 85, Records of the Immigration and Naturalization Service, San Francisco District, Return Certificate Application Case Files of Chinese Departing, box 222, case 12017/23069; Record Group 85, Records of the Immigration and Naturalization Service, San Francisco District, Arrival Investigation Case Files, 1884-1944, box 288, case 10302/2.

37. Charles Lorrimer, "The Japanese Art of Flower Arrangement," *Overland Monthly* 47, no. 2 (February 1906): 116-23.

38. "Our Oriental Neighbors," *Wasp*, February 4, 1899, 5.

39. M. L. Wakeman Curtis, "Love and the Dai Butsu," *Overland Monthly* 31, no. 181 (January 1898): 14-24.

40. Amy Sueyoshi, *Queer Compulsions: Race, Nation, and Sexuality in the Affairs of Yone Noguchi* (Honolulu: University of Hawai'i Press, 2012).

41. "Kentucky's Oscar Wilde," *San Francisco Chronicle*, September 17, 1893.

42. "Men Who Shed Tears," *San Francisco Chronicle*, December 13, 1911.

43. Dora E. Amsden, "Dramatic Art in Japan," *Overland Monthly* 36, no. 212 (1900): 101.

44. Ibid., 100.

45. Francis H. Buzzacott and Mary Isabel Wymore, *Bi-Sexual Man* (Chicago: Donohue, 1912), 25.

46. "In the Realm of Bookland," *Overland Monthly* 61, no. 5 (May 1913): 515; A. J. "Sex Determination," *Los Angeles Times*, March 1, 1898.

47. Buzzacott and Wymore, *Bi-Sexual Man*, 61.

48. Ibid., 54–55.

49. "In the Realm of Bookland." "People," meaning men exclusively (since women would be eradicated), could then "meet on a footing of mutual respect and esteem and enjoy a perfect communion, sharing their inmost thoughts and feelings with one another." "No bar of shame or sex consciousness [would] separate them." Buzzacott and Wymore, *Bi-Sexual Man*, 55–56.

50. Gertrude M. Streeper, "Should a Married Woman Work?" *San Francisco Chronicle*, December 29, 1912.

51. For Rinjiro Obata see "A Japanese Arrested," *San Francisco Chronicle*, June 20, 1897. Record Group 21, Old Circuit and District Courts, Criminal Case Files 1851-1912, box 251, case 3412. For Keizaburo Sofuye see Record Group 21, Old Circuit and District Courts, Criminal Case Files 1851-1912, box 362, case 4598.

52. Nikki Bridges, Women Oral History Transcripts (Nisei), November 23, 1985, Issei Project, National Japanese American Historical Society, San Francisco.

53. Ethnic cartoons have frequently served as protests against racial and economic inequity. Ronald Owen Laird Jr., *Still I Rise: A Cartoon History of African Americans* (New York: Norton, 1997); Ilan Stavans, *Latino U.S.A: A Cartoon History* (New York: Basic, 2000); M. Thomas Inge, *Anything Can Happen in a Comic Strip* (Columbus: Ohio State University Libraries, 1995).

54. Henry Kiyama, *Four Immigrants Manga: A Japanese Experience in San Francisco, 1904–1924* (Berkeley, Calif: Stone Bridge, 1999), 83.

55. Ibid., 99.

56. Teazle wrote of an Englishman who was introduced to a Chinese man and "from the first, patronized the little celestial in a most demonstrative way." When the Englishman said, "I see me man, that you speak very good English for a Chinese," Wong replied, "Yes, I have always had a great many Englishmen in my employ." Lady Teazle, "Society Chat," *San Francisco Chronicle*, July 4, 1910.

57. Harry Waxman, "The Chinese Butterfly," score, 1922, San Francisco History Room, San Francisco New Main Library; Howard Johnson, "Ching-a Ling's Jazz Bazaar Words," score, 1920, San Francisco History Room, San Francisco New Main Library.

58. Survey on Race Relations, box 8, *Oriental Mission News*, San Francisco, January 1923, "San Francisco Chinese Night School," 1.

59. Healy and Chew, *Statement for Non-Exclusion*, 82–83; Alexander Saxton, *The Indispensable Enemy: Labor and Anti-Chinese Movement in California* (Berkeley: University of California Press, 1971); William Courtney, "San Francisco's Anti-Chinese Ordinances: 1850–1900" (master's thesis, University of San Francisco, 1959); Jules Becker, *The Course of Exclusion, 1882–1924: San Francisco Newspaper Coverage of the Chinese in the United States* (San Francisco: Mellen Research University Press, 1991) 198.

60. "The Bubonic Board," *San Francisco Call*, March 11, 1900.

61. Thomas B. Wilson, "Why the Chinese Exclusion Law Should Be Modified," *Overland Monthly* 62, no. 5 (May 1911): 491- 94; Rev. John Hood Laughlin, "Chinese Children in American Schools," *Overland Monthly* 57, no. 5 (May 1911): 500–510.

62. Walter La Feber, *The American Age: U.S. Foreign Policy at Home and Abroad, 1750 to Present* (New York: Norton, 1994).

63. Inazo Nitobe, *Bushido: The Soul of Japan* (New York: Putnam's, 1905); "The Japanese Workingman at His Home in Yokohama," *San Francisco Chronicle*, July 4, 1897; Thomas B. Wilson, "The Yellow Peril, So-Called," *Overland Monthly* 45 no. 2 (February 1905): 133-36. See also Margaret A. Brooks, "Japan, the Youngest Born," *Overland Monthly* 33, no. 196 (April 1899): 313.

64. Reviewers found her later works uninteresting, a compendium of "extravagant statements." Dora E. Amsden, *Impressions of Ukiyo-ye: The School of the Japanese Colour-Print Artists* (San Francisco: Elder, 1905); "Color-Prints by Masters of Japanese Art," *Dial* 39 (July 1–December 16, 1905): 16; "Hiroshige and His Followers," *Dial* 53 (July 1–December 16, 1912): 248; Dora E. Amsden and John Stewart Happer, *The Heritage of Hiroshige* (San Francisco: Elder, 1912).

65. "In the Lime Light—H.I.H. Prince Fushimi of Japan, Embassador Extraordinary to the United States, "*Overland Monthly* 45, no. 1 (January 1905): 16; Charles T. Calame, "Apropos of the War in the Far East," *Overland Monthly* 45, no. 5 (May 1905): 375-82.

66. "How You Become the Physical Equal of any Man Alive," *Sunday Examiner Magazine*, March 4, 1900, n.p.

67. "Jap Ex-Convict Robs a Woman," *San Francisco Chronicle*, October 2, 1907.

68. "Lean Threatened 'Hello' Girls," *San Francisco Chronicle*, October 25, 1897.

69. "In Lighter Vein," *San Francisco Chronicle*, August 11, 1908.

70. "Reviews of the Latest Literature," *San Francisco Chronicle*, December 20, 1896; "Generosity an Important Feature with Truly Progressive Man," *San Francisco Chronicle*, March 11, 1906.

71. "Flogging for Wife Whippers," *San Francisco Chronicle*, March 31, 1876.

72. George Amos Miller, "The New Woman in the Orient," *Overland Monthly* 52, no. 6 (December 1908): 501; Japanese and Korean Exclusion League, *Japanese Immigration: Occupations, Wages, Etc.* (San Francisco: The League, 1907), 11.

73. Bill Ong Hing, *Making and Remaking Asian America though Immigration Policy, 1850– 1990* (Stanford: Stanford University Press, 1993), 29, 54.

74. Ibid., 30.

75. Percy Edwards, "The Industrial Side of the Alien Land Law Problem," *Overland Monthly* 42, no. 2 (August 1913): 190.

76. "Kawaoka Case, In the Matter of the Estate and Guardianship of Mitsuto Kawaoka, et al., Minors," *Consulate-General of Japan, Documental History of Law Cases Affecting Japanese in the United States, 1916-1924* (New York: Arno, 1978), 928-30.

77. Kawakami further articulated the "pioneer" Japanese, starting from nothing and building up businesses to evoke sympathy for "American" values. "Japanese Immigration and the Japanese in California," *San Francisco Chronicle*, January 14, 1920.

78. Yamato Ichihashi, *Japanese Immigration* (San Francisco: Japanese Association of America, 1913) 47. For more on Ichihashi see Yamato Ichihashi, *Morning Glory, Evening Shadow: Yamato Ichihashi and His Internment Writings, 1942–1945*, edited by Gordon H. Chang (Stanford, Calif.: Stanford University Press, 1997).

79. U.S. House of Representatives, *Japanese Immigration Hearings before the Committee on Immigration and Naturalization* (New York: Arno, 1978), 20–21, 48.

80. "East and West Sometimes Do Meet, as Marriage of Occident and Orient Shows," *San Francisco Call*, December 20, 1923.

81. They had been married for fourteen years in 1922. Liberty Emery was in fact the daughter of the late Archdeacon John A. Emery of the Episcopal Church of San Francisco. "Progeny of Japan White Union Amaze," *San Francisco Examiner*, November 11, 1922.

82. U.S. House, *Japanese Immigration Hearings*, 66–67.

83. Ibid., 14.

84. "Japanese Immigration and the Japanese in California," *San Francisco Chronicle*, January 14, 1920.

85. Percy Edwards, "The Industrial Side of the Alien Land Law Problem," *Overland Monthly* 42, no. 2 (August 1913): 190.

86. Rev. John Hood Laughlin, "Chinese Children in American Schools," *Overland Monthly* 57, no. 5 (May 1911): 508.

87. H. Latham, "Chinese Slavery," *Overland Monthly and Out West Magazine* 3, no. 2 (February 1884): 178.

88. Yong Chen, *Chinese San Francisco: 1850–1943* (Stanford, Calif.: Stanford University Press, 2000), 85.

89. Shah, *Contagious Divides*, 98, 99.

90. Chen, *Chinese San Francisco*; Alexander Saxton, *Indispensable Enemy: Labor and the Anti-Chinese Labor in California* (Berkeley: University of California Press, 1971).

91. The law in language suspended the entry of Chinese laborers but exempted merchants, students, teachers, diplomats, and travelers. Sucheng Chan, *Asian Americans: An Interpretative History* (Boston: Twayne, 1991), 54–55.

92. Esther Barbara Bock, "Ah Choo," *Overland Monthly* 76, no. 3 (September 1920): 49–56, 87–89.

93. L. Warren Wigmore, "The Revenge of Ching Chow," *Overland Monthly* 82, no. 2 (February 1924): 60, 81, 87.

94. "Help Wanted, Employment Wanted," *San Francisco Call*, February 15, 1905; "Situations Wanted," *San Francisco Chronicle*, March 24, 1898; "Want Ads," *San Francisco Call*, March 31, 1897. Occasionally, an ad appeared for more dignified work, such as an apprenticeship to learn dentistry. "Want Ads," *San Francisco Call*, March 20, 1900; Yoshiye Togasaki, August 10, 1985, oral history, Issei Project, National Japanese American Historical Society, San Francisco. See also Yuji Ichioka, *The Issei: The World of First Generation Japanese Immigrants: 1885–1924* (New York: Free Press., 1988).

95. Obata, Chiura, autobiography, box 1, folder copy file 1, Dr. Chiura Obata Collection, National Japanese American Historical Society, San Francisco; Yoshio Markino,

A Japanese Artist in London (Philadelphia: Jacobs, 1910), 4–6, 72; Yone Noguchi, *Story of Yone Noguchi Told by Himself* (London: Chatto and Windus, 1914). Twenty miles outside Sacramento, fifteen hooded men hung six Japanese until they seemed to have expired, then cut them loose so they regained consciousness, and chased them out of town with all their belongings. "War on Japanese at Orangevale," *San Francisco Chronicle*, January 10, 1897.

96. "Police Who Are Linguists," *San Francisco Call*, April 11, 1897; "Japanese System of 'Jiu-Jitsu,'" *San Francisco Call*, February 28, 1904; "Situations Wanted—Male," *San Francisco Chronicle*, January 23, 1905; "Tenyo Maru Brings a Valuable Cargo," *San Francisco Call*, January 26, 1912.

97. "Jiu-Jitsu Too Much for Him," *San Francisco Chronicle*, December 30, 1904.

98. "Ah Him's Hallucination Loses Police Indulgence," *San Francisco Call*, May 18, 1905.

99. Mari Yoshihara, *Embracing the East: White Women and American Orientalism* (New York: Oxford University Press, 2003); Amy Sueyoshi, "Intimate Inequalities: Interracial Affection and Same-Sex Love in the 'Heterosexual' Life of Yone Noguchi, 1897–1909," *Journal of American Ethnic History* 29, no. 4 (Summer 2010): 22–44.

100. Miss Morning Glory, *American Diary of a Japanese Girl* (New York: Stokes, 1902), 14, 229–230. See also Sueyoshi, *Queer Compulsions*.

101. "Japanese Workingman at His Home."

102. "How Uncle Sam Watches the Immigrant and Catches the Smuggler," *San Francisco Call*, January 28, 1900.

103. In not just the realm of gender and sexuality would whites project their anxieties on Asians. San Francisco police claimed that the Chinese carried out 95 percent of the gambling in Chinatown, declaring, "Chinatown is a matter of public shame, a blot on the good name of the city." Again, arrests demonstrated the contrary. A disproportionately large percentage of white men were charged with having lottery tickets in their possession. *Final Report of the Grand Jury, 10 December 1904* (San Francisco, 1905).

104. John Kasson, *Houdini, Tarzan, and the Perfect Man: The White Male Body and the Challenge of Modernity in America* (New York: Hill and Wang, 2001), 19.

Chapter 6. Mindful Masquerades

An earlier version of this chapter was published in *Frontiers: A Journal of Women Studies* 26, no. 3 (2005): 67–100, and reprinted in *Contingent Maps: Rethinking the North American West and Western Women's History*, edited by Susan E. Gray and Gayle Gullett (Tucson: University of Arizona Press, 2014). I thank University of Nebraska Press for their permission to publish the essay.

1. So popular did her musical number become that its song sheet appeared in the Musical Supplement Section of one *San Francisco Examiner* issue. Gustav Luders, "Rag Time Mixes My Brain," score, 1900, San Francisco History Center, San Francisco New Main Public Library, San Francisco.

2. Photograph of "recent arrivals" in Golden Gate Park, 1900, Issei Project, National Japanese American Historical Society, San Francisco. Hereafter, the project will be cited as the Issei Project.

3. Roger Baker, *Drag: A History of Female Impersonation in the Performing Arts* (New York: New York University Press, 1994); Eric Lott, *Love and Theft: Blackface Minstrelsy and the American Working Class* (New York: Oxford University Press, 1993); Robert Toll, *On with the Show* (New York: Oxford University Press, 1974).

4. "Entertainment in Play and Music," *San Francisco Chronicle*, January 19, 1897.

5. First Nighter, "The Theaters," *Wasp*, March 5, 1898, 19.

6. "Gladys Montague," *Wasp*, September 16, 1899, 6.

7. In *A Milk White Flag*, Ada Mansfield, Maud Harris, Eva Hill, and Ilma Pratt played the "messenger boys." Mary Marble," *Wasp*, September 10, 1898, 13; "Programme for a Milk White Flag," 1897, San Francisco Performing Arts Library and Museum, San Francisco.

8. "Two Clever Little Players," *San Francisco Call*, March 11, 1900.

9. Interestingly, Walter Leon, who drew crowds in 1898 to the San Francisco stage for passing successfully as a girl, found no audience in New York City when local authorities banned him from performing. "A Boy Rival for Girl Actors," *San Francisco Chronicle*, February 14, 1897.

10. "Wore Male Attire for Years," *San Francisco Chronicle*, May 24, 1898.

11. Jensen had initially eloped with the man, who then took her to San Francisco before deserting her. "Goes as a Tramp in Man's Attire," *San Francisco Call*, April 5, 1897.

12. "Woman's New Occupation," *San Francisco Chronicle*, November 16, 1897.

13. "In Man's Attire This Girl Toiled," *San Francisco Call*, March 9, 1897; "Female Tramp in Male Attire—Peculiar Santa Rosa Case," *San Francisco Chronicle*, March 9, 1897.

14. The Gay and Lesbian Alliance against Defamation (GLAAD), founded in 1985, has been providing education to media on producing fair, accurate, and inclusive representation of individuals in the queer community. Two criteria among others include positive depictions and the appropriate use of pronouns that mark self-proclaimed gender identity rather than natal sex. GLAAD, "Media Resource Kit," http://www.glaad .org/media/resource_kit_detail.php?id=3163 (accessed July 7, 2005).

15. Peter Boag, *Re-dressing the America's Frontier Past* (Berkeley: University California Press, 2011). Clare Sears additionally asserted the need for "trans-ing" the Gold Rush. Clare Sears, "All That Glitters: Trans-ing California's Gold Rush Migrations," *GLQ: Gay and Lesbian Quarterly* 14, no. 2–3 (2008): 183–402. See also Louis Sullivan, *From Female to Male: The Life of Jack Bee Garland* (Boston: Alyson, 1990).

16. Clare Sears, "Electric Brilliancy: Cross-Dressing Law and Freak Show Displays in Nineteenth Century San Francisco," *WSQ: Women's Studies Quarterly* 36, nos. 3 and 4 (Fall/Winter 2008): 170, 171, 172, 178.

17. *San Francisco Municipal Report*, 1863 to 1900.

18. Clare Sears argues that crossdressing laws and accompanying convictions, though only misdemeanors, created a restrictive culture of gender normativity. Clare Sears, *Arresting Dress: Cross Dressing, Law, and Fascination in Nineteenth Century San Francisco* (Durham, N.C.: Duke University Press, 2014).

19. "Woman Bandit in Men's Clothes," *San Francisco Chronicle*, August 22, 1897.

20. Sullivan, *From Female to Male*, 8; "Babe Bean," *San Francisco Chronicle*, January 16, 1898.

21. I borrow the term "just plain white" from numerous publications in whiteness studies contesting that communities of people who might be considered white in the twenty-first century were in fact not white during an earlier time. For one example see Rudolph Vecoli, "Are Italian Americans Just White Folks?" *Italian Americana* 13, no. 2 (Summer 1995): 149–61. For the Call's depiction of Bean see "In Man's Attire Tenants an Ark," *San Francisco Call*, August 24, 1897.

22. "Wears Trousers but Her Tongue Is Silent," *San Francisco Chronicle*, August 24, 1897. Ironically, this erasure of Babe Bean's ethnicity would reverberate into the scholarship of contemporary works that would document his life. See Sullivan, *From Female to Male*; Emile LaRocque, "The Manipulation of Gender Ideals: The Lives of Elvira Virginia Mugarrieta, Babe Bean, Beebe Beam, and Jack Bee Garland" (master's thesis, Sarah Lawrence College, 2005).

23. "Mexican Fatally Wounded," *San Francisco Chronicle*, June 12, 1898; "Mexican Pete in Town," *San Francisco Chronicle*, February 28, 1898. "'Mexican Pete' in His Ring Costume," *San Francisco Chronicle*, April 5, 1898; "Mexican Pete a Sorry 'Dub,'" *San Francisco Chronicle*, April 23, 1898.

24. "How San Francisco Notables Look in Theatrical Roles," *San Francisco Call*, February 18, 1900.

25. "Disillusioned," *Wasp*, July 16, 1898, 20.

26. For more on transgender misogyny see Julia Serrano, *Whipping Girl: A Transsexual Woman on Sexism and the Scapegoating of Femininity* (Emeryville, Calif.: Seal, 2007).

27. "Personal Pronouns Up-to-Date," *San Francisco Chronicle*, June 27, 1897.

28. "The New Woman," *San Francisco Call*, October 10, 1895.

29. "Miss Bean Not an Up to Date Young Man," *San Francisco Chronicle*, August 31, 1897.

30. "Native Daughter Who Should Have Been a Boy," *San Francisco Call*, March 11, 1900.

31. Peggy Pascoe described distinct gender roles based on innate differences between the sexes as facilitating missionary rescue homes. Peggy Pascoe, *Relations of Rescue: The Search for Female Moral Authority in the American West, 1874–1939* (New York: Oxford University Press, 1990).

32. Marjorie Garber, *Vested Interests: Cross-Dressing and Cultural Anxiety* (New York: Routledge, 1992); Lesley Ferris, ed., *Crossing the Stage: Controversies in Cross-Dressing* (New York: Routledge, 1992); Sharon R. Ullman, *Sex Seen: The Emergence of Modern Sexuality in America* (Berkeley: University of California Press, 1997); Daniel Hurewitz,

Bohemian Los Angeles and the Making of Modern Politics (Berkeley: University of California Press, 2007).

33. Etsuji Tanida and Mitsue Koike explained that the lack of women adopting Western dress could be attributed to their lesser involvement in public life. Etsuji Tanida and Mitsue Koike, *Nihonnjinn: Sandai no Onnatachi* 7, no. 36 (February 25, 1981). Feminist scholars might argue that women perceived as the bearers of culture and tradition have historically been socially pressured not to adopt newer cultural trends.

34. Angel Island, often referred to as the Ellis Island of the West Coast, served as the immigration processing station for immigrants arriving along the Pacific Coast. Erika Lee and Judy Yung, *Angel Island: Immigrant Gateway to America* (New York: Oxford University Press, 2010).

35. Photograph of Angel Island Immigration Station, 1912, Issei Project.

36. Photograph of Angel Island, 1916, Issei Project.

37. "Men of Prominence: Local Japanese Colony," *San Francisco Chronicle*, October 22, 1911.

38. Photograph of Iwata family, December 6, 1920, Issei Project; photographs of Japanese American women, 1913, December 6, 1920, Issei Project; photographs of Abiko family, 1921, Abiko Family Papers, Japanese American Research Project, Charles E. Young Research Library, University of California at Los Angeles. The Abiko Family Papers are hereafter cited as AFP.

39. Photograph of Kay Okamoto, 1911, Issei Project.

40. Photograph of cook and his wife, 1915, Issei Project.

41. Photograph of David Fukuda, March 28, 1922, AFP.

42. Photograph of Japanese language school, 1909, Issei Project.

43. Philip Stokes noted group photos demonstrated a greater need to mark solidarities, to take every possible step to map the forms of one's personal society. Philip Stokes, "The Family Photograph Album: So Great a Cloud of Witnesses," in *The Portrait in Photography*, edited by Graham Clarke (London: Reaktion, 1992), 193–205.

44. "How Japanese Warriors Are Made," *San Francisco Call*, January 17, 1897.

45. Photograph of Ichikawa wedding, February 28, 1915, AFP.

46. Interestingly, even the blossoms could be inauthentic, as they appeared to be artificial. Photographs of wedding, July 11, 1916(?), AFP.

47. Photograph of Hana Ohama, February 12, 1912, Issei Project.

48. Photograph of Kikuye Okuye, October 4, 1915, AFP.

49. Photograph of Uakahara family, March 1921, AFP.

50. Things Japanese had to be "eschewed" as much as possible. Outward appearances of how Americans perceived Japanese couples became important as officials advised wives to walk alongside their husbands rather than behind to avoid reinforcing the stereotype of the tyranny of Japanese husbands. Yuji Ichioka, *The Issei: The World of First-Generation Japanese Immigrants: 1885–1924* (New York: Free Press, 1988).

51. Eiichiro Azuma, *Between Two Empires: Race, History, and Transnationalism in Japanese America* (New York: Oxford University Press, 2005).

52. Eiichiro Azuma, "Interstitial Lives: Race, Community, and History among Japanese Immigrants Caught between Japan and the United States, 1885–1941" (PhD diss., University of California at Los Angeles, 2000), 48.

53. Photograph of Togasaki Family, 1899, Issei Project. The Nationality Act of 1790 limited the privilege of naturalization to "any alien, being a free white person." Asians, not being white, could become citizens only if they were born in the United States.

54. Azuma, *Between Two Empires*.

55. Homi Bhabha described "mimicry" as being like a camouflage, not a harmonization of a repression of difference, but a form of resemblance that differs from or defends its presence through display. Homi K. Bhabha, *The Location of Culture* (New York: Routledge, 1994), 85.

56. Alan Trachtenberg, *Reading American Photographs: Images as History, Matthew Brady to Walker Evans* (New York: Hill and Wang, 1989), 26, 27.

57. Tanida and Koike, *Nihonnjinn: Sandai no Onnatachi*.

58. For more on the "New Woman," see Jean V. Matthews, *The Rise of the New Woman: The Women's Movement in America, 1875–1930* (Chicago: Dee, 2003).

59. Photographs of Chinese in San Francisco, 1905, Special Collections, Bancroft Library, University of California at Berkeley, Berkeley.

60. Historian John Tchen documented how Genthe went as far as altering his photographs to project a more "Chinese" image. For more details, see Arnold Genthe and John Kuo Wei Tchen, *Genthe's Photographs of San Francisco's Old Chinatown* (New York: Dover, 1984).

61. "How a Chinese Queue Became an American Plait," *Wasp*, December 21, 1901, page unknown.

62. Robert Lee, *Orientals: Asian Americans in Popular Culture* (Philadelphia: Temple University Press, 1999); Nayan Shah, *Contagious Divides: Epidemics and Race in San Francisco's Chinatown* (Berkeley: University of California Press, 2001).

63. Marlon K. Hom, *Songs of Gold Mountain: Cantonese Rhymes from San Francisco Chinatown* (Berkeley: University of California Press, 1987), 206.

64. *Chung Sai Yat Po*, December 29, 1909.

65. "Misbranding of Scott's Santal Pepsin Capsules. *U. S. v. 70 Packages of Scott's Santal Pepsin Capsules*," Case no. 7490 (September 24, 1920), United States National Library of Medicine, National Institute of Health. See http://archive.nlm.nih.gov/fdanj/handle/123456789/45537 (accessed August 18, 2012).

66. Literary scholars consider Far to be one of the earliest Asian American writers. Xiao-huang Yin, *Chinese American Literature since the 1850s* (Urbana: University of Illinois Press, 2000); Dominika Ferens, "Edith and Winnifred Eaton: The Uses of Ethnography in Turn-of-the-Century Asian American Literature" (PhD diss., University of California, Los Angeles, 1999).

67. Sui Sin Far, "A Chinese Ishmael," *Overland Monthly* 34, no. 199 (1899): 43–49.

68. Hom, *Songs of Gold Mountain*, 229, 312.

69. Genthe and Tchen, *Genthe's Photographs*.

70. *Description of Unknown Dead 1913–1919*, San Francisco Office of the Chief Medical Examiner's Records (SFH 30), San Francisco History Center, San Francisco Public Library.

71. "Chinese Cook Is Foully Slain," *San Francisco Call*, May 22, 1908.

72. "Chinese Cook Wins Her Love," *San Francisco Call*, December 31, 1902; "Wedded a Chinese to Her Sorrow," *San Francisco Chronicle*, December 31, 1902; Mary Ting Lui, *Chinatown Trunk Mystery: Murder, Miscegenation, and Other Dangerous Encounters in Turn-of-the-Century New York City* (Princeton, N.J.: Princeton University Press, 2005).

73. Mari Yoshihara, *Embracing the East: White Women and American Orientalism* (New York: Oxford University Press, 2003), 100.

74. "Something That Is Worth Everybody's Money," *San Francisco Chronicle*, June 12, 1897.

75. "Imperial Hair Generator," *San Francisco Chronicle*, April 18, 1897.

76. Lady Teazel, "Society Chat," *San Francisco Chronicle*, October 13, 1907.

77. "The Japanese Luncheon Fad," *San Francisco Call*, February 14, 1897.

78. "Third Violet," *San Francisco Chronicle*, January 17, 1897.

79. "Sale of Lawn Kimonas," *San Francisco Call*, May 25, 1905.

80. Woman's Board of Foreign Missions, San Francisco, to Abiko Yonako, October 14, 1922, AFP.

81. Diary of Yonako Abiko, 1906–1907, AFP.

82. Margherita Palmieri to Yonako Abiko, July 1908, AFP.

83. Yone Noguchi, "In the Bungalow with Charles Warren Stoddard: A Protest against Modernism," *National Magazine* (December 1904): 306. For more on Noguchi and Stoddard's relationship see Amy Sueyoshi, *Queer Compulsions: Race, Nation, and Sexuality in the Affairs of Yone Noguchi* (Honolulu: University of Hawai'i Press, 2012).

84. For more on white privilege and cultural appropriation, see Mary C. Waters, *Ethnic Options: Choosing Identities in America* (Berkeley: University of California Press, 1990).

85. "Clever Child in Her Debut," *San Francisco Call*, March 14, 1900.

86. The San Francisco Lesbian and Gay History Project argued that many women who passed as men obtained socioeconomic privileges that would not have been available to them as women. San Francisco Lesbian and Gay History Project, "She Even Chewed Tobacco," in *Hidden from History: Reclaiming the Gay and Lesbian Past*, edited by Martin Duberman, Martha Vicinus, and George Chauncey Jr. (New York: Meridian, 1989).

87. "Plan Campaign for Clubhouse Funds," *San Francisco Call*, March 13, 1910.

88. "Chinese Girls Dressed as Boys," *San Francisco Chronicle*, July 25, 1897.

89. "Chinese Masqueraders," *San Francisco Call*, April 30, 1902.

90. Barbara Kawakami, *Japanese Immigrant Clothing in Hawaii, 1885–1941* (Honolulu: University of Hawai'i, 1993); Daniel M. Masterson with Sayaka Funada-Classen, *The Japanese in Latin America* (Urbana: University of Illinois Press, 2004).

91. Laura Browder, *Slippery Characters: Ethnic Impersonators and American Literature* (Chapel Hill: University of North Carolina Press, 2000), 74, 76.

92. E. Nathaniel Gates, ed., *Racial Classification and History* (New York: Garland, 1997); Matthew Frye Jacobson, *Whiteness of a Different Color: European Immigrants and Alchemy of Race* (Cambridge, Mass.: Harvard University Press, 1997); Audrey Smedley, *Race in North America: Origin and Evolution of a World View*, 2nd ed. (Boulder, Colo.: Westview, 1999); Stephen Jay Gould, *The Mismeasure of Man*, rev. ed., (New York: Norton, 1996); Michael Adas, *Machines as the Mismeasure of Men: Science, Technology, and Ideologies of Western Dominance* (Ithaca, N.Y.: Cornell University Press, 1989); George W. Stocking, *Victorian Anthropology* (New York: Free Press, 1987); Matthew Frye Jacobson, *Barbarian Virtues: The United States Encounters Foreign People at Home and Abroad, 1876–1917* (New York: Hill and Wang, 2000).

93. I use the term "dark white" to point to literary critic Christina Mesa's use of the term when she referred to those individuals who accessed whiteness despite their dark pigmentation. Christina Mesa, "White Guise and Dark White Women: Purity and Miscegenation in Nineteenth-Century American Culture" (PhD diss., Stanford University, 1999).

94. Browder, *Slippery Characters*, 76.

95. Eiichiro Azuma, *Between Two Empires*, 50, 56.

96. Lott, *Love and Theft*, 18; Jessica Munns and Penny Richards, "The Clothes That Wear Us," in *The Clothes That Wear Us: Essays on Dressing and Transgressing in Eighteenth-Century Culture*, edited by Jessica Munns and Penny Richards (Cranbury, N.J.: Associated University Presses, 1999), 26.

97. Sears, "Electric Brilliancy," 184. See also Clare Sears, *Arresting Dress: Cross-Dressing, Law, and Fascination in Nineteenth Century San Francisco* (Durham, N.C.: Duke University Press, 2014).

Chapter 7. "Conscience Aroused"

1. *Final Report of the Grand Jury, 16 December 1914* (San Francisco, 1915); *Final Report of the Grand Jury, 14 August 1924* (San Francisco, 1925).

2. For more on whiteness as signifying civilized manliness see Julian Carter, *Heart of Whiteness: Normal Sexuality and Race in America, 1880–1940* (Durham, N.C.: Duke University Press, 2007).

3. *Final Report of the Grand Jury, 16 December 1914; Final Report of the Grand Jury, 14 August 1924.*

4. Glenna Collett, "Sports for Women," *Lantern* 6, no. 2 (September 1924): 4. For more on the goals of the YWCA see Judith Weisenfeld, *African American Women and Christian Activism: New York's Black YWCA, 1905–1945* (Cambridge, Mass.: Harvard University Press, 1997).

5. "What's the Matter Now Grumps?" *Lantern* 6, no. 4 (November 1924): 14.

6. Collett, "Sports for Women," 4.

7. Memorandum, March 27, 1914, Doris Barr Stanislawski's Papers, Bancroft Library, Berkeley.

8. "Girls of University Stage Their Parthenia Show," *San Francisco Call and Post*, April 13, 1917.

9. Judy Tzu-Chun Wu, *Mom Chung of the Fair-Haired Bastards: The Life of a Wartime Celebrity* (Berkeley: University of California Press, 2005).

10. *Leonard L, Klemmer v. Sarah Louise Klemmer*, 1919 Cal. App. LEXIS 836 (1919); *London Guarantee and Accident Company v. Industrial Accident Commission*, 184 P. 864 (1919); *C. J. Branham v. Marion K. Branham*, 232 P. 471 (1924); *James C. Dunphy v. Lydia M. Dunphy*, 118 P. 445 (1911); *Emil Anderson v. Mary Anderson*, 228 P. 715 (1924).

11. Record Group 21, U.S. District Court, Northern District of California, San Francisco, Criminal Case Files 1912-1934, box 120, series 31, case 8126; *People v. Guaragna*, 137 P. 279 (1913); *People v. Wright*, 138 P. 349 (1914); *People v. Austin W. Tobin*, 179 P. 553 (1918); *Moore Shipbuilding Corporation v. Industrial Accident Commission*, 196 P. 257 (1921); *People v. Hickock*, 204 P. 555 (1921); Record Group 21, U.S. District Court, Northern District of California, San Francisco, Criminal Case Files 1912-1934, box 290, case 14025.

12. "Chinese Tong Wars," *San Francisco Chronicle*, August 20, 1918.

13. "Chinatown in Tears," *San Francisco Call*, March 23, 1897.

14. *Wasp*, March 12, 1913, 3.

15. "'Tiz' for feet," *San Francisco Call and Post*, April 19, 1917.

16. "Dandruff Goes!" *San Francisco Call and Post*, April 18, 1917.

17. "Questions for Women," *San Francisco Call*, February 24, 1900. "How a Young Girl Suffered," *San Francisco Chronicle*, August 2, 1918; "Backache Soon Disappeared," *San Francisco Call and Post*, April 19, 1917.

18. Harry E. Burgess, "The Passing of the Pachecos," *Overland Monthly and Out West Magazine* 68, no. 3 (September 1916): 251–54; M. C. Frederick, "Senora Arellanes," *Overland Monthly and Out West Magazine* 68, no. 4 (October 1916): 315–16.

19. Agnes Shea, "The Hoopas Then and Now," *Overland Monthly and Out West Magazine* 68, no. 5 (November 1916): 9–17; May M. Longembaugh, "The Snake Dance at Chimopovy: Cushman Indian School," *Overland Monthly and Out West Magazine* 68, no. 4 (October 1916): 15–23; Ruth Jocelyn Wattles, "Sketches of Indian Life: The Navajo Wedding," *Overland Monthly and Out West Magazine* 68, no. 2 (August 1916): 170–73.

20. M. C. Frederick, "The California Caballero and His Caballo," *Overland Monthly and Out West Magazine* 67, no. 2 (February 1916): 15–20; Daisy Kessler Biermann, "A Bordertown Barbecue," *Overland Monthly and Out West Magazine* 67, no. 1 (January 1916): 13–20.

21. American Indian studies theorists have critiqued the notion of Native American peoples as descendants of Asians. See Vine Deloria, *Red Earth, White Lies: Native Americans and the Myth of Scientific Fact* (New York: Scribner, 1995).

22. Edward Everett Hale, "The Queen of California," *Atlantic Monthly* 13, no. 77 (March 1864): 265–79; William Greer Harrison, "Romance of the Word 'California,'" *Overland Monthly and Out West Magazine* 63, no. 6 (December 1916): 11–12; Waldo R. Smith, "Is the Old West Passing?" *Overland Monthly and Out West Magazine* 67, no. 3

(March 1916): 23–32; Paul H. Dowling, "Crossing the Plains in a 1915 Model Prairie Schooner," *Overland Monthly and Out West Magazine* 67, no. 2 (February 1916): 5–11.

23. San Francisco Municipal Ordinances of 1904.

24. For more on the Comstock Act see Ana Garner, "Wicked or Warranted? U.S. Press Coverage of Contraception 1873–1917," *Journalism Studies* 16, no. 2 (March 2015): 228–42; Donna Dennis, *Licentious Gotham: Erotic Publishing and Its Prosecution in Nineteenth-Century New York* (Cambridge, Mass.: Harvard University Press, 2009).

25. Record Group 21, Old Circuit and District Courts, Criminal Case Files 1912-1934, box 420, case 5393.

26. Record Group 21, Old Circuit and District Courts, Criminal Case Files 1851-1912, box 253, case 3433.

27. Record Group 21, Old Circuit and District Courts, Criminal Case Files 1851-1912, box 259, case 3499.

28. Record Group 21, Old Circuit and District Courts, Criminal Case Files 1851-1912, box 259, case 3499.

29. William Issel and Robert W. Cherny, *San Francisco: Power, Politics, and Urban Development, 1865–1932* (Berkeley: University of California Press, 1986), 109.

30. "Jail for Vice Policy Begins for Women," *San Francisco Call and Post*, April 5, 1917.

31. Reportedly, police officials had responded to increasing pressure from the San Francisco Church Federation to make good on promises to the vice suppression committee. "Vice Cases Dismissed by Judge," *San Francisco Call and Post*, April 2, 1917.

32. Annie Martin Tyler, "Outline of the Progress of Women in the Last Sixty Years," *Overland Monthly* 67, no. 4 (April 1916): 299–301.

33. "In the Realm of Bookland," *Overland Monthly* 61, no. 4 (April 1913): 411.

34. Shannon additionally forbade extramarital sex, condemning to hell those who committed the sin of "fornication."

35. Prof. T. W. Shannon, *A Guide to Sex Instruction* (Louisville, Ky.: Pentecostal, 1910).

36. "In the Realm of Bookland," 411.

37. John Kasson, *Houdini, Tarzan, and the Perfect Man: The White Male Body and the Challenge of Modernity in America* (New York: Hill and Wang, 2001).

38. Janet Davis, "Cultural Watersheds in *Fin de Siecle* America," in *A Companion to American Cultural History*, edited by Karen Haltunen (Malden, Mass.: Blackwell, 2008): 166–80.

39. "Norwalk Tires," *San Francisco Call and Post*, April 7, 1917; "California Climate Offers Motorist All the Thrills of Four Seasons in a Day," *San Francisco Call and Post*, April 21, 1917; "Delightful Weather and Fine Condition of Roads Draw Motorist to Country," *San Francisco Call and Post*, April 7, 1917.

40. "Film Flashes of Favorite Photoplayers," *San Francisco Call and Post*, April 18, 1917; "We Will Send This Victrola," *Call and Post*, April 23, 1917.

41. Raymond Rast, "The Cultural Politics of Tourism in San Francisco's Chinatown, 1882–1917," *Pacific Historical Review* 76, no. 1 (2007): 29.

42. Roger Sprague, "Local Color in San Francisco," *Overland Monthly* 68, no. 1 (July 1916): 10–21.

43. Kasson, *Houdini*; Joane Nagel, *Race, Ethnicity, and Sexuality: Intimate Intersections, Forbidden Frontiers* (New York: Oxford University Press, 2003).

44. The Chinese commissioner-general objected to the name "Underground Chinatown" and persuaded the exposition to change the exhibit name. Frank Morton Todd, *The Story of the Exposition*, vol. 2 (New York: Putnam's/Knickerbocker, 1921).

45. Ibid.

46. Captain would select ribbons in colors that corresponded with women's hats.

47. Frank Morton Todd, *The Story of the Exposition*, vol. 2 (New York: Putnam's/Knickerbocker, 1921).

48. Historians of race have documented how what we consider ethnicity today was in fact understood as race at the turn of the century. For an example of this conflation on the U.S. Census see Sharon Lee, "Racial Classifications in the U.S. Census, 1890–1990," *Ethnic and Racial Studies* 16, no. 1 (January 1993): 75–94.

49. *San Francisco Call*, February 11, 1900; *San Francisco Chronicle*, October 1, 1907; *San Francisco Chronicle*, October 8, 1907.

50. "Biggy Makes More Raids," *San Francisco Call*, February 9, 1900. See also Yuji Ichioka, "Ameyuki-san: Japanese Prostitutes in Nineteenth Century America," *Amerasia Journal* 4, no. 1 (1977): 1–22.

51. "Japanese Woman Sold to Chinese," *San Francisco Call*, February 27, 1900.

52. For more on white women embracing Japan in particular to enhance their leisure lives see Mari Yoshihara, *Embracing the East: White Women and American Orientalism* (New York: Oxford University Press, 2003).

53. "Young Ladies Are to Receive in Quaint Oriental Raiment," *San Francisco Call*, March 5, 1902.

54. "Oriental Color Enhances Gay Affair for January Bride," *San Francisco Chronicle*, January 11, 1920.

55. Jesslyn Howell Hull, "A Yellow Angel," *Overland Monthly* 62, no. 3 (March 1916): 189-90.

56. "The Social Problem," *San Francisco Call*, February 14, 1900.

57. Hull, "Yellow Angel," 189-90.

58. "China Brings Adventurers from Orient," *San Francisco Call*, March 17, 1905.

59. Even at its height of use, "Mongol" or "Mongoloid" appeared in only 557 articles in the years between 1880 and 1889.

60. "How Uncle Sam Watches the Immigrant and Catches the Smuggler," *San Francisco Call*, January 28, 1900. For more on Asian American immigration law see Bill Ong Hing, *Making and Remaking Asian American through Immigration Policy, 1850–1990* (Stanford, Calif.: Stanford University Press, 1993).

61. "Harry P. Whitney and His Bride Here," *San Francisco Chronicle*, February 14, 1897. Gertrude Vanderbilt was the daughter of Cornelius Vanderbilt.

62. Ernestine Coughran, "The Rescue of Cheo: A Japanese Story of To-day," *San Francisco Call*, January 14, 1900.

63. For more on the Mission Home see Peggy Pascoe, *Relations of Rescue: The Search for Female Moral Authority in the American West, 1874–1939* (New York: Oxford University Press, 1990).

64. Coughran, "Rescue of Cheo."

65. For immigration legislation aimed at excluding Chinese women specifically, see George Anthony Peffer, *If They Don't Bring Their Women Here: Chinese Female Immigration before Exclusion* (Urbana: University of Illinois Press, 1999).

66. Record Group 21, Old Circuit and District Courts, Criminal Case Files 1851-1912, box 255, case 3459; "Japanese Woman Acquitted," *San Francisco Chronicle*, December 7, 1897.

67. Record Group 21 United States District Court, Northern District of California, San Francisco, U.S. District Courts 1851–1972 Criminal Case Files, box 380, case 4879.

68. Hirokichi Mutsu, "A Japanese View of Certain Japanese-American Relations," *Overland Monthly* 32, no. 191 (November 1898): 406-14.

69. The 1908 Gentlemen's Agreement, which barred the entry of Japanese laborers, allowed for Japanese men to bring their wives into America. Ichioka, "Ameyuki-san," 2.

70. *People v. Clara Newton*, 106 P. 247 (1909).

71. Record Group 21 United States District Court, Northern District of California, San Francisco, U.S. District Courts 1851–1972 Criminal Case Files, box 397, case 5134.

72. Though 420 Japanese had earlier become naturalized as United States citizens in a nation that only allowed "free, white persons" to be naturalized, by 1906 the federal government had ceased issuing naturalization documents to Japanese immigrants. In 1922 the United States Supreme Court more explicitly stated Japanese as not white. Yuji Ichioka, "The Early Japanese Immigrant Quest for Citizenship: The Background of the 1922 Ozawa Case," *Amerasia* 4, no. 2 (1977), 2; Ian Haney-López, *White by Law: The Legal Construction of Race* (New York: New York University Press, 1996).

73. "War on White Slave Traffic," *San Francisco Chronicle*, October 5, 1907.

74. For how Chinese were considered "yellow slaves" see Brian Donovan, *White Slave Crusades: Race, Gender, and Anti-Vice Activism, 1887–1917* (Urbana: University of Illinois Press, 2006), 110.

75. "Chinese White Wife Separated," article from the *San Francisco Call*, December 21, 1921, Major Document 223, Survey on Race Relations, Hoover Library, Stanford University.

76. "A Stanford Girl Weds a Chinese," *San Francisco Chronicle*, June 20, 1897.

77. "Chinese Reform Association," *San Francisco Chronicle*, August 7, 1898.

78. "Torao Kawasaki—Japanese Consulate, Battery and Sansome, San Francisco," Survey on Race Relations, Special Collections, Hoover Library, Stanford University; "1 Stanford Girl Weds 1 Chinese," *San Francisco Chronicle*, June 20, 1897. For more on David Starr Jordan's views on eugenics see David Starr Jordan, *The Blood of the Nation: A Study of the Decay of Races through the Survival of the Unfit* (Boston: American Unitarian Association, 1902).

79. Though historian Henry Yu argues that attitudes toward intermarriage between "Orientals" and "whites" had swung from a fascination with exotic couples into the 1920s to an obsession with hybridiziation in the 1950s, interracial couples appear to have lost their exotic appeal shortly after the turn of the century in the San Francisco area. Henry Yu, "Mixing Bodies and Cultures: The Meaning of America's Fascination with Sex between 'Orientals' and 'Whites,'" in *Sex, Love, Race: Crossing Boundaries in North American History*, edited by Martha Hodes (New York: New York University Press, 1999).

80. Jeannette Dailey, "Sweet Burning Incense," *Overland Monthly* 72, no. 2, (January–February 1921): 9–14.

81. John D'Emilio and Estelle Freedman, *Intimate Matters: A History of Sexuality in America* (Chicago: University of Chicago Press, 1997).

Epilogue

1. "Confessions Disclose Vice Ring in S.F.," *San Francisco Chronicle*, February 28, 1918; "Four S.F. Vice Hearings Today," *San Francisco Chronicle*, March 15, 1918; "Two Policemen Are Implicated in Vice Ring," *San Francisco Chronicle*, March 3, 1918; "Baker Street Cases Dropped by Court," *San Francisco Chronicle*, March 8, 1921; "Pair Accused of Vice Held after Hearing," *San Francisco Chronicle*, March 12, 1918; "Grand Jury Opens Inquiry on Baker Street Club Cases," *San Francisco Chronicle*, April 30, 1918.

2. *Crocker-Langley San Francisco Directory for the Year Commencing 1917* (San Francisco: Crocker, 1917); Meeting of the Grand Jury of the City and County of San Francisco, State of California. Testimony and Proceedings Before Grand Jury on Indictment of William Hatteroth on Charge of Violating Section 288a of the Penal Code of the State of California (1918); San Francisco District Attorney's Office Trial Transcript and Clippings Scrapbooks, 1918–1968, SFH 93 box 1, San Francisco Public Library, 22, 36, 126, 211.

3. Meeting of the Grand Jury, 134.

4. Ibid., 227–228.

5. Ibid., 117.

6. "Salesman Arrested in Ring Case," *San Francisco Chronicle*, March 5, 1918; "Witness Tells Court of Vice Ring's Acts," *San Francisco Chronicle*, March 9, 1918; "Vice Suspect Fires Bullet into His Head," *San Francisco Chronicle*, March 19, 1918.

7. Meeting of the Grand Jury, 8–9, 36, 184, 198.

8. Ibid., 8.

9. Ibid., 29–34.

10. Ibid., 22–23.

11. Ibid., 3–6.

12. Ibid., 46.

13. Ibid., 74.

14. Ibid., 85. On May 6, 1918, at the Grand Jury hearing, Walter Schneider, a woman's clothing designer, would recant this statement that police recorded five months earlier on February 17, 1918, due to the fact that he was intoxicated when he was interrogated.

15. Ibid., 198–199.

16. Ibid., 142.

17. C. M. Waage, "The Case of California," *Catholic World* 109 (April–September 1919): 379.

18. Meeting of the Grand Jury, 56–57.

19. Ibid., 25.

20. In the Matter of Clarence Lockett for a Writ of Habeas Corpus. In the Matter of Don A. Gono for a Writ of Habeas Corpus, 179 Cal. 581 (1919); "Baker-St. Vice Case Thrown out of Court," *San Francisco Chronicle*, January 11, 1919; "'Baker-Street' Cases Dropped by Court," March 8, 1921. Clarence Lockett appeared to be African American as identified by the *San Francisco Chronicle*.

21. In 1998 John Loughery asserted a different reason for the termination of the investigation: it was "called off only when the names of several well-connected individuals were mentioned in court." John Loughery, *The Other Side of Silence: Men's Lives and Gay Identities, A Twentieth Century History* (New York: Holt, 1998). The *San Francisco Chronicle*, however, more specifically attributes the dismissal of the court cases as tied to the California State Supreme Court ruling that deemed unconstitutional the prosecution of a crime not commonly understood by the public. See "Baker-St. Vice Case Thrown out of Court," *San Francisco Chronicle*, January 11, 1919.

22. *People v. J.E. Carrell*, 31 Cal. App. 793 (1916); *Miller v. Commonwealth ex rel., etc.*, 247 Ky. 479 (1933); *State of Maine v. Amedee Cyr.*, 135 Me. 513 (1938); *People v. Marcello Battilana*, 52 Cal. App. 2d 685 (1942).

23. Don Gono first appears in the 1920 city directory as selling eucalyptus novelties out of his home on 526 O'Farrell. Crocker-Langley San Francisco Directory, 1920.

24. Meeting of the Grand Jury, 226.

25. Florence Estella Taft, "Taka: A Story of the Yellow Man and a Wild Rose Which Would Not Be Potted," *Overland Monthly* 78, no. 4 (October 1921): 16-19, 66, 74.

26. Meeting of the Grand Jury, 29, 221.

27. Ibid., 216–18. M. J. Hughes would later be directly involved in the ten-day investigation that took place at 2525 Baker Street as he interviewed twenty-three men with Lieutenant Colonel C. W. Thomas Jr., Inspector General of the United State Army, and Lieutenant Charles Goff of the Police Department.

28. Paul A. Herman, "American Homophobia: 'The Homosexual Menace' in Twentieth Century American Culture," (PhD diss., Stanford University, 2005), 69.

29. "Baker Street Vice Case Thrown out of Court." *San Francisco Chronicle*, January 11, 1919.

30. Celine Parreñas Shimizu, *The Hypersexuality of Race: Performing Asian/American Women on the Screen and on the Scene* (Durham, N.C.: Duke University Press, 2007); Celine Parreñas Shimizu, *Straitjacket Sexualities: Unbinding Asian American Manhoods in the Movies* (Stanford: Stanford University Press, 2012).

Index

AMY SUEYOSHI is the associate dean of the College of Ethnic Studies at San Francisco State University. She is the author of *Queer Compulsions: Race, Nation, and Sexuality in the Affairs of Yone Noguchi.*

THE ASIAN AMERICAN EXPERIENCE

The University of Illinois Press
is a founding member of the
Association of American University Presses.

University of Illinois Press
1325 South Oak Street
Champaign, IL 61820-6903
www.press.uillinois.edu